Volume 33

DIRECTORY OF WORLD CINEMA

AMERICAN INDEPENDENT 3

Edited by John Berra

intellect Bristol, UK / Chicago, USA

First published in the UK in 2016 by
Intellect Books, The Mill, Parnall Road, Fishponds, Bristol, BS16 3JG, UK

First published in the USA in 2016 by Intellect Books, The University of Chicago Press,
1427 E. 60th Street, Chicago, IL 60637, USA

A catalogue record for this book is available from the British Library.

Publisher: May Yao
Publishing Managers: Jelena Stanovnik & Matt Greenfield

Cover photograph: *Wendy and Lucy* (Kelly Reichardt, 2008). Field Guide Films/Film Science/
 Glass Eye/The Kobal Collection
Copy-editor: Emma Rhys
Cover designer: Emily Dunn
Typesetter: John Teehan

Directory of World Cinema ISSN 2040-7971
Directory of World Cinema eISSN 2040-798X

Directory of World Cinema: American Independent 3 ISBN 978-1-78320-656-8
Directory of World Cinema: American Independent 3 ePDF ISBN 978-1-78320-657-5

Printed and bound by Short Run Press, UK.

MIX
Paper from
responsible sources
FSC® C014540

DIRECTORY OF WORLD CINEMA

AMERICAN INDEPENDENT 3

ACKNOWLEDGEMENTS

This third volume of the *Directory of World Cinema: American Independent* departs from the format of its predecessors in that, rather than collating reviews of key titles under genres or movements, it is a collection of in-depth essays on directors who have largely concentrated on working outside the industrial mainstream, or on its margins.

Such a thorough overview of the American independent sector has been made possible thanks to the wide-ranging interests of academics and critics who constitute this volume's contributor base. By combining considerable knowledge of the wider field with individual approaches to their chosen film-makers, these contributors have provided focused discussion of more than forty directors. In some cases, these essays shed new light on established names whose works have been widely celebrated to the point that their works have transcended their low-budget or leftfield origins to become part of the popular landscape; in others, these essays introduce the output of lesser-known, even neglected, film-makers who are equally deserving of scholarly attention. An edited collection such as this is always a team effort, and I wish to express my deepest gratitude to everyone who has provided material for this volume. The enthusiasm and diligence that are characteristic of the contributors to this series have made it an immensely rewarding experience in my role as editor, and I greatly look forward to collaborating with all concerned on future projects.

I wish to take this opportunity to pay special tribute to Masoud Yazdani, the founder and chairman of Intellect Books, who tragically passed away on 18 February 2014, aged 58, following a battle with cancer. I have collaborated regularly with Intellect since 2008, and received many wonderful publishing opportunities as a result of Masoud's enthusiasm for the field of film studies. Throughout these projects, I always found Masoud to be extremely generous with his time and was particularly inspired by the manner in which he supported a range of interdisciplinary initiatives that may not have otherwise found a home. In 2009, Masoud kindly invited me to the Bristol office for the day and discussed many aspects of academic publishing, providing both warm encouragement and practical advice at a critical juncture in my academic career. At this meeting, we discussed the development of the Directory of World Cinema series, which was then in the planning stages, with several volumes having been commissioned, but the exact format still to be decided. At that point, Masoud was using Intellect's academic magazine *Film International* as a loose model, and had various pages from that publication on his desk, composited to suggest what the Directory of World Cinema could be in terms of content and layout. Since then, I've had highly satisfying experiences working with other academic publishers, but this remains a uniquely collaborative experience in that I was able to shape a series from its inception with the direct support of a publishing chairman who truly valued the creative input of others. As the series gained steam, Masoud

and I remained in contact, and it was actually his suggestion to devote this third volume to studies of directors. Masoud's dedication to print media and digital frontiers will be greatly missed. I would like to extend my deepest condolences to Masoud's family, the staff at Intellect, and all authors/editors who were similarly fortunate to work with him.

I would also like to thank the team at Intellect Books, whose commitment to innovative academic publishing continues to make the Directory of World Cinema such a crucial series in the field of film studies. The commitment of May Yao, Mark Lewis, James Campbell, Matt Greenfield, Holly Rose and Jelena Stanovnik has resulted in a series that has maintained its high production standard and international visibility at a time when traditional print publishing faces considerable challenges in terms of maintaining relevance and commercial viability.

In addition to editorial duties for the *Directory of World Cinema: American Independent*, I have continued to publish research in the field of American independent cinema in a number of academic collections. As such, I would like to thank Geoff King, David Lindvall, Claire Perkins and Constantine Verevis for their editorial guidance over the past few years and for generating projects that have added to the ever-growing academic discourse that reveals American independent cinema to be such a vital contribution to, and commentary on, the contemporary cultural landscape.

On a very personal note, I would like to thank my wife Meng Yan; my parents, Paul and Janet; my sister Becky and brother-in-law Neil; my nieces Evie and Layla; and my in-laws Meng Zhao-quan and Wang Tieli.

John Berra

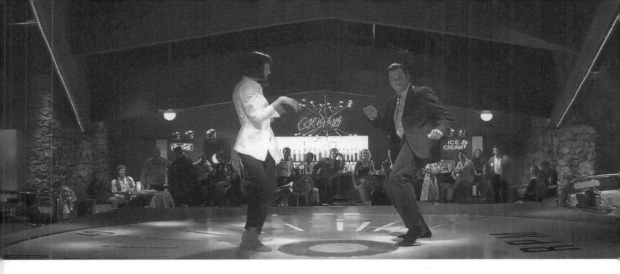

Pulp Fiction © 1994 A Band Apart, Jersey Films, Miramax

INTRODUCTION BY THE EDITOR

The two previous volumes of the *Directory of World Cinema: American Independent* have been comprised of essays and reviews, sectioned by movements or genres that are specific to a sector of national film production that is so multifaceted that it actively defies finite definition. With its ever-widening range of film-makers, subject matter, financing methods and distribution channels, any attempt to encapsulate what is meant by 'American independent cinema', whether taken as a cultural or industrial term, or an amalgamation of the two, risks being overly inclusive or too exclusive. As such, it is anticipated that this third volume, with its focus on directors in the form of 44 essays on film-makers of note, may infuriate as much as it satisfies purely through its selection of film-makers who can individually be assigned the moniker of 'American independent film-maker' yet do not fit into one workable paradigm.

Such reactions are largely the result of the intertwined forces of cultural capital and industry economics, which in certain periods of contemporary film history (the 'New Hollywood' of the 1970s, the alternative culture gold rush of the 1990s and the subsequent development of major studio sub-divisions) have pulled independent production towards the popular nexus of Hollywood, whereas other seismic shifts (the blockbuster mentality of the 1980s, the 2008 financial crisis) have forced it back to the margins. In this respect, the *Directory of World Cinema: American Independent* has, at least in part, subscribed to Yannis Tzioumakis's argument that the sector constitutes, 'a discourse that expands and contracts when socially authorized institutions (film-makers, trade publications, academics, film critics, and so on) contribute towards its definition at different periods in the history of American cinema' (2006: 11). Even in the relatively short time period since the publication of the previous volume of this series in 2013, the widespread advents of crowdfunding and Video on Demand (VOD) have recongfigured the American independent landscape with regards to the production and consumption of films that present an alternative, or opposition, to the mainstream fare offered by the major studios.

Emmanuel Levy notes that different conceptions of what constitutes an American independent film are often based on whether the qualifying emphasis is placed on production background or evidence a personal vision (1999: 3). Academic definitions of 'American independent cinema' vary in their specificity as a result of their focus or mode of inquiry, with some studies spanning the early years of film production in the United States to the present day, while others argue for highly specific niches or marginal film-making clusters. The former camp includes Greg Merritt (2000) and Tzioumakis (2006 and 2013), who chart the development of American independent cinema from its roots in the Studio Era of the 1930s. Merrit's study begins in the Studio Era, when the term was, 'an insult, synonymous with grind-house dreck' (2000: xiii), and runs up to the modern era where films made outside the studio system are distributed by the very corporations that their creators supposedly oppose and develop a cachet with audiences through festival buzz, awards recognition, and the cultural superiority that is now implied through such works being labelled as 'independent' by media commentators and savvy marketers (Merrit 2000: xiii). Geoff King (2005) navigated his initial analysis of American independent cinema around three interrelated points – their industrial location, the aesthetic sensibility of the film-makers and how the films relate to the wider cultural landscape. Since then, he has investigated the divergent nature of independent production through examination of 'Indiewood' (King 2009), a cross-pollination of independent and Hollywood studio culture and production methodology, then he examined the digital frontiers that have been pursued by the mumblecore movement and the rigorous social realism of such humanist film-makers as Kelly Reichardt and Ramin Bahrani (King 2013). King identifies the 'institutionalization' that happens to various waves of independent cinema, notably the self-conscious 'qurikiness' of such studio sub-division fare as *Little Miss Sunshine* (Jonathan Dayton and Valerie Faris, 2006) and *Juno* (Jason Reitman, 2007), but points to the revitalization of independent spirit represented by Andrew Bujalski, Aaron Katz and the Duplass Brothers.

Other studies have also focused on the late 1980s and beyond, often examining a cross-section of film-makers or works that have been produced through particular fringe organizational structures. Derek Hill (2008) groups Wes Anderson, Sofia Coppola, Michel Gondry, Charlie Kaufman, Richard Linklater and David O Russell as 'American New Wave film-makers' who have pursued their respective paths while finding increasing commercial success as mainstream audiences become gradually accustomed to their idiosyncratic sensibilities. Alisa Perren (2012) considers the rise of Miramax, from niche distributor to independent studio to sub-division of Walt Disney to the eventual sale of the company by its founders Bob and Harvey Weinstein to their corporate benefactor. Her study frames Miramax at the centre of an American independent film culture that grew out of the studio classics divisions of the 1980s – Cinecom, United Artists Classics, 20th Century Fox International Classics – whereby financiers cultivated long-term, mutually beneficial relationships with film-makers whose regular output and public personas came to exemplify an 'independent' approach to American cinema. Peter Biskind (2004) salaciously chronicled the rise of Miramax as it ultimately oversaturated the specialty market with prestige product, but a more incisive discussion of the sector since the mid-1980s has been presented by Michael Z Newman (2011), who examines the formulation of media institutions that have led to the taste culture that both surrounds and consumes contemporary independent, or 'indie', works.

Merritt insists that, 'throughout celluloid history, the most enthralling tales

have come from the nonstudio sector' (2000: xiv) and much of the allure of American independent cinema – the romantic ideal of creating work that will be judged on artistic merit rather than box office performance, its idealistic stance against corporate culture and conformity – stems from seat-of-the-pants accounts of practically realizing low-budget productions. When the quality of the film delivers on the promise of its backstory, the result can be culturally combustible, pushing the sector to new heights of relevance and prompting seismic mainstream shifts as Hollywood studios seeks create renewal through the accommodation or implementation of independent elements via new narrative approaches or talent sourcing. Film-makers as diverse as Dennis Hopper, Steven Soderbergh and Quentin Tarantino leapt to the forefront of film culture with their breakthrough works *Easy Rider* (1969), *sex, lies and videotape* (1989) and *Pulp Fiction* (1994), respectively, which were much imitated but never replicated in terms of box office results. Such 'out of nowhere' successes have positioned directors as stars of American independent cinema, the real names above the title even when the cast list might include heavyweight stars.

Today, the term 'American independent film-maker' is used to refer to everyone from micro-budget pioneers like Randy Moore and Sean Baker, who made *Escape from Tomorrow* (2013) and the iPhone-shot *Tangerine* (2015), respectively, to a now well-established figure like Paul Thomas Anderson, who regularly works with studio resources and used his clout to mount the star-packed *Inherent Vice* (2014), a near-impenetrable adaption of Thomas Pynchon's 1970-set detective story that was supported by Warner Bros. *Escape from Tomorrow* is a surrealist horror film which was shot guerilla-style on consumer-grade camcorders at various Disney Land parks across the United States. Although the film itself is sporadically effective in its subversive appropriation of Disney iconography as a means of charting the

Tangerine © 2015 Duplass Brothers Productions, Through Films

psychological disintegration of a repressed father on the final day of his family's vacation, much of the cultural conversation surrounding *Escape from Tomorrow* revolved around the surreptitious production method and whether or not the notoriously litigious Walt Disney corporation would attempt to block its release (Guerrasio 2013). Indeed, the director was so careful about – or paranoid of – Disney finding out about his project that he went to South Korea to edit the film and supervise the visual effects processes which were necessary to fully realize his disquieting interpretation of a popular leisure institution. When the anticipated legal battle failed to materialize, *Escape from Tomorrow* soon went from being a hot talking point to a mere curiosity for connoisseurs of strange cinema and a potential footnote for Disney historians (Jones 2013), but its initial rush of press attention nonetheless focused on the resourcefulness of the film-maker.

The directors discussed in this volume constitute a cross-section of American independent cinema and provide a rough history of its sector through the manner in which their careers have intersected with developments in production method, distribution strategies, audience interest and collective preferences for particular themes or the exploration of pertinent social issues. Widely regarded as the 'godfather' of American independent cinema, John Casavetes made such unflinching character studies as *Shadows* (1959), *Faces* (1968) and *A Woman Under the Influence* (1974), which exert a strong influence on the sector today with their pursuit of truth and realism through use of improvisation, while his approach to operating on his own terms (funding films personally by taking acting roles in commercial productions) has served as a model for similarly multitasking talents. The 1980s saw a new creative explosion fuelled by such film-makers as Jim Jarmusch, Spike Lee and Wayne Wang who made a virtue of low budgets to deliver early works that engaged audiences with unique perspectives on American culture, largely focusing on marginal characters who would not even receive a supporting presence in a major studio release. American independent cinema is sometimes summarized as being primarily concerned with character while surveying both urban and rural environments, but many of its directors work within genre, acknowledging narrative conventions and audience expectations as much as they subvert them. This volume features essays on Samuel Fuller, and George A Romero and Zalman King who have collectively tackled such narrative forms as war movies, horror and erotica, but have used pulp storytelling to smuggle social-political commentary to often unsuspecting audiences.

The 'Films of the Year' section provides a critical round-up of twelve significant American independent features from 2013–14: *Advantageous* (Jennifer Phang, 2015), *Blue Ruin* (Jeremy Saulnier, 2014), *Boyhood* (Richard Linklater, 2014), *Citizenfour* (Laura Poitras, 2014), *The Guest* (Adam Wingard, 2014), *Inside Llewyn Davis* (Ethan Coen and Joel Coen, 2013), *Listen Up Philip* (Alex Ross Perry, 2014), *Nightcrawler* (Dan Gilroy, 2014), *Spring Breakers* (Harmony Korine, 2013), *Upstream Color* (Shane Carruth, 2013), *Welcome to New York* (Abel Ferrara, 2014) and *Whiplash* (Damien Chazelle, 2014). To avoid overlap, and to ensure that the volume is as varied as possible, such high calibre recent works as Sofia Coppola's *The Bling Ring* (2013), Spike Jonze's *Her* (2013), Jeff Nichols's *Mud* (2013), Wes Anderson's *The Grand Budapest Hotel* (2014), David Gordon Green's *Joe* (2013) and Kelly Reichardt's *Night Moves* (2014) have been covered in essays on their directors. With regards to a few film-makers who may seem notable by their absence to newcomers to this series, essays on Stuart Gordon, Charlie Kaufman, David Lynch and John Waters can be found in the first volume,

while essays on Paul Thomas Anderson, Gregg Araki, Hal Hartley, Monte Hellman, Alexander Payne, Alan Rudolph and James Toback were featured in the second volume.

John Berra

References

Biskind, Peter (2004) *Down and Dirty Pictures: Miramax, Sundance and the Rise of Independent Film*, London: Penguin Bloomsbury.

Guerrasio, Jason (2013) 'How the Director of "Escape From Tomorrow" Made a Crazy Guerrilla Movie In Disney World – And Got Away With It', *indieWire*, 9 October, http://www.indiewire.com/article/how-the-director-of-escape-from-tomorrow-made-a-crazy-guerilla-movie-in-disney-land-and-got-away-with-it. Accessed 24 July 2015.

Hill, Derek (2008) *Charlie Kaufman and Hollywood's Merry Band of Pranksters, Fabulists & Dreamers: An Excursion into the American New Wave*, London: Kamera.

Jones, JR (2013) 'All the Disney World's a Stage in "Escape from Tomorrow"', *Chicago Reader*, 23 October, http://www.chicagoreader.com/chicago/escape-from-tomorrow-ray-moore-disneyland-disney-world-music-box/Content?oid=11314733. Accessed 24 July 2015.

King, Geoff (2005) *American Independent Cinema*, London: IB Tauris.

————— (2009) *Indiewood USA: Where Hollywood Meets Independent Cinema*, London: IB Tauris.

————— (2013) *Indie 2.0: Change and Continuity in Contemporary American Indie Film*, London: IB Tauris.

Levy, Emmanuel (1999) *Cinema of Outsiders: The Rise of American Independent Film*, New York & London: New York University Press.

Merrit, Greg (2000) *Celluloid Mavericks: The History of American Independent Film*, New York: Thunders Mouth Press.

Newman, Michael Z (2011) *Indie: An American Film Culture*, New York: Columbia University Press.

Perren, Alisa (2012) *Indie, Inc.: Miramax and the Transformation of Hollywood in the 1990s*, Austin: University of Texas Press.

Tzioumakis, Yannis (2006) *American Independent Cinema: An Introduction*, Edinburgh: Edinburgh University Press.

————— (2013) *Hollywood's Indies: Classics Divisions, Specialty Labels and American Independent Cinema*, Edinburgh: Edinburgh University Press.

FILMS OF THE YEAR

ADVANTAGEOUS

BLUE RUIN

BOYHOOD

CITIZENFOUR

THE GUEST

INSIDE LLEWYN DAVIS

LISTEN UP PHILIP

NIGHTCRAWLER

SPRING BREAKERS

UPSTREAM COLOR

WELCOME TO NEW YORK

WHIPLASH

Advantageous

Studio/Distributor:

DK Entertainment
Good Neighbors Media
Film Presence
I Ain't Playin' Films

Director:

Jennifer Phang

Producers:

Robert Chang
Ken Jeong
Jacqueline Kim
Moon Molson
Theresa Navarro
Jennifer Phang

Screenwriters:

Jacqueline Kim
Jennifer Phang

Cinematographer:

Richard Wong

Art Director:

Joshua Petersen

Synopsis

Gwen Koh is a spokesperson for the Center for Advanced Health and Living. That is, until her job is terminated just as her daughter Jules is eager to enroll in an expensive, elite school where acceptance is dependent on Gwen keeping up appearances with the other mothers. Gwen, a single mother due to a family secret, lives in a future time where few jobs pay well enough to provide for families and child prostitution is rampant as a symptom of these macro-economic problems. When the Center re-offers Gwen her position if she participates in their new consciousness-transferring procedure, the result of which involves acquiring a completely different body, Gwen is torn whether to take the offer to benefit her daughter's future, but at the risk of losing her own self.

Critique

Working within the science fiction genre can be a herculean task for an independent film crew. Whereas big Hollywood studios hope to generate massive revenues that will recover the expense of high quality special effects, independent productions don't have access to the huge budgets required to realize such visuals. Yet, if a film-maker can manage sparse special effects along with an intricate story structure, they can arguably get more onscreen bang for their buck. Success in science fiction is often more about what's lurking behind the present than what exists in future frontiers. As the oft-quoted line from William Gibson goes, 'The future is already here – it's just not evenly distributed.'

Advantageous © 2015 D.K. Entertainment, Good Neighbors Media,
I Ain't Playin' Films

Composer:

Timo Chen

Editors:

Sean Gillane
Jennifer Phang

Duration:

90 minutes

Cast:

Jacqueline Kim
Samantha Kim
James Urbaniak
Jennifer Ehle

Year:

2015

In the case of utopian visions, that quote highlights that the gadgets and technology on display already exist but only wealthy folks have first-adopter access. The measure of success of Jennifer Phang's (director/co-writer) and Jacqueline Kim's (co-writer) dystopian vision in *Advantageous* is how it reveals a future that enhances our present dysfunctions, particularly the plight of the precariat class – those who cannot find regular employment that provides a living wage. The Millennial generation has entered the workforce as corporations continue to cut jobs, keep wages stagnant and demand freelance labour so all benefits go to the corporation with all risk going to labour. In the future depicted in *Advantageous*, the precariat class has seen its numbers expand even further.

Advantageous follows Gwen (Jacqueline Kim) and her daughter Jules (Samantha Kim, not related) in an unidentified year in the future. Much of this future is familiar – there is greater use of hologram and wireless communication technology, while some buildings are cooled by massive waterfalls that cascade along their sides. But what is new is the ability to 'transfer' to another body. *Advantageous*'s advantage is that the how here matters less than the why – why does Gwen volunteer for such a risky procedure?

Gwen lives in a time when the precariat class has expanded to encompass the majority. She has very few options when her employment with the Center for Advanced Health and Living is terminated. She is a single mother and this job-loss will impact her daughter's future. If Jules is not able to align herself with certain elite schools and friendships, her future life options will be limited. Right here we have allusion to our present parental anxieties to give our children every educational advantage over other people's children, a task disproportionately imposed on mothers. In this future state, child prostitution is rampant. When Gwen's former colleague (James Urbaniak) hints that the company might be willing to take her on again as spokesperson if she is willing to transfer to another more marketable body, all these single-mom economic pressures push Gwen to participate.

Advantageous resonates with viewers from demographics that Hollywood blockbusters ignore – women and people of colour. Gwen and her daughter are Korean American. There is a growing movement in the United States calling for more films about women and minorities that are not centred on white men. These viewers want films directed and written by women and minorities as well. *Advantageous* has delighted viewers starving for a high-quality genre film, plus one made by and about Asian American women. Ken Jeong of the television comedy *Community* (NBC, 2009-14; Yahoo! Screen, 2015) plays the husband of Gwen's cousin, and came onboard as a co-producer after seeing the initial short-form version of *Advantageous* (2013) that was part of the 2011 *FUTURESTATES* series produced by ITVS (Independent Television Service). Jeong and his wife wanted to see more stories about Asian American women that would speak to their daughters. Interestingly, these desires for greater diversity went

even beyond the film's intent. Although Phang has said that Gwen's new body, Gwen 2.0 (Freya Adams), was meant to be ethnically ambiguous (Adams has played Indian, Native American, Irish American and Arab American in other projects), many reviewers have seen Gwen 2.0 as white and that Gwen's switch to 2.0 is an example of pressure to deny her Korean-ness in order to obtain advantages in the corporate world. This underscores how, in spite of authorial intent, the audience might interpret aspects of the film within the zeitgeist floating around in society in unforeseen ways.

Phang and Kim's film was successful not at the box office, but in the vox populi. *Advantageous* benefited from social media because fans recommended it to 'like'-clicking folks. It also fills a void in the science fiction genre where women are usually only let in if they look good in spandex and while kicking ass. *Advantageous* is a cerebral film, resonating with merging social movements and expanding demographic trends. Gwen doesn't have to be a fighting machine here. She needs to be human. *Advantageous* is the type of film more independent film-makers should be attempting in order to better compete where the Hollywood hulks fear to tread.

Adam Hartzell

Blue Ruin

Studio/Distributor:

RADiUS-TWC

Director:

Jeremy Saulnier

Producers:

Macon Blair

Richard Peete

Tyler Bryne

Alex Orr

Screenwriter:

Jeremy Saulnier

Cinematographer:

Jeremy Saulnier

Art Director:

Brian Rzepka

Editor:

Julia Bloch

Duration:

90 minutes

Synopsis

Upon being told of the release of his parents' killer, socially reclusive and emotionally crippled Dwight (Blair) takes it upon himself to seek vengeance after years of living in isolation. Following his parents' killer, a son of the Cleland family, which waged a feud with Dwight's two decades prior, into a stripclub during a celebration of his release, Dwight enacts his revenge. Then Dwight goes on the run; however, the incident reawakens the family feud, subsequently putting his sister Sam (Hargreaves) and her family in danger. Dwight has no choice but to finally put an end to the enmity once and for all.

Critique

In terms of its narrative content, *Blue Ruin* is a raw and very self-conscious rendition to the American revenge movie that would satisfy even the most hardened fanboy of the violent genre.

Deserving foremost mentioning is Ruin's protagonist Dwight, whose wide-eyed vulnerability bolsters the film's self-reflexive rendition of the genre. It is not difficult to see how this character is the film's conceptual focal point, as explained by Saulnier in a feaurette on the film's DVD release as being a 'traditional blood-soaked narrative but putting a knucklehead at the helm of it'. The film's first act follows Dwight, knot-bearded and stained-clothed, rummaging through trash for his dinner and sleeping in a blue

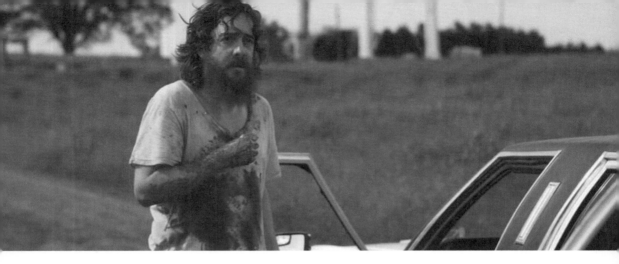

Blue Ruin © 2013 Film Science, The Lab of Madness, Neighborhood Watch, Paradise City

Cast:

Macon Blair
Amy Hargreaves
Devin Ratray
Kevin Kolack

Year:

2014

ruined '92 Pontiac. However, it is not until he shaves, revealing his gentle, boyish face that he resembles the antithesis of an American revenge hero. Intentionally, Blair's emotionally-crippled Dwight provides a more authentic, human face to a conventionally stoic typecast; it rejects the archetypal muscled and cool masculine hero of the 1980s and 1990s, and instead places a petrified, weak-stomached and physically ordinary suburban man as its vengeful knight. A first leading role, Blair delivers a strong, often mute performance, whose diffidence occasionally adds a comic relief to the ominous aura as he struggles against generic expectations, such as when an arrow wound to the leg proves to take more than just antiseptic and elbow grease to remove. In addition, genre tropes also take salience in Saulnier's script – 'No speeches,' as gun-savvy friend Ben (Ratray) laconically advises after Dwight's hesitancy almost has him killed, 'You point the gun, you shoot.'

Beyond character and script, however, *Blue Ruin*'s unorthodox trajectory also works against the traditional norms of the revenge drama. The central act of vengeance itself is merely an inception to calamitous repercussions following an act of violence made to vindicate a past trauma. Despite this, Dwight's trajectory of tentative violence is no less satisfying as narrative events redirect his path towards a climactic harrowing showdown. Perhaps the main shortcoming here is that, with all its initial visionary efforts to be an anti-revenge tale, the violence is far from unsatisfying as it is preceded by slow, teeth-grinding suspense with a hero deserving all sympathy.

Furthermore, style plays an important role in the film's self-conscious rendition to the revenge genre. Saulnier's wide-angled compositions and gliding pans help effectuate a meditative, slow-paced visual aesthetic, sinisterly evoking a tranquil tone to the enveloping carnage. To help bolster this effect is the film's dreamy

ambient score and neon aesthetic – exploiting everything from the light of Virginia's boardwalk fairground to porch bug-zappers – *Blue Ruin* is cut from the same fabric as the current trend of neo-noirs such as *Drive* (Nicolas Winding Refn, 2011) and *Nightcrawler* (Dan Gilroy, 2014), where stress on atmospheric synthesizer scores and glossy facets within a dark, ominous locale pays homage to 1980s genre stalwarts John Carpenter and Michael Mann.

However, with the narrative set in Virginia, Ruin brings this aesthetic into the rural space, a milieu which is significant in two ways: Textually, the setting allows Saulnier to pay homage to films such as *Easy Rider* (Dennis Hopper, 1969), *Deliverance* (John Boorman, 1972) and *The Texas Chain Saw Massacre* (Tobe Hooper, 1974), films that have portrayed the American rural south as a landscape for uncompromising violence. Contextually, Saulnier exploits the locality of his native Virginia, allowing easy access to familiar locations to help production to flow within extemporaneous conditions due to the tight six-week shooting schedule.

Although Ruin harks back to a 1970s style of American revenge cinema with its self-conscious attitude towards genre and aesthetic minimalism, it exemplifies itself as an exceptionally modern piece of independent film-making. Acquiring its $420,000 budget from independent financiers through the global online crowd-funding platform Kickstarter, Saulnier and his company Lab of Madness were able to bypass restrictions that would have no doubt been in place if the picture were made under the auspices of a studio. In light of this, one could argue that *Blue Ruin*'s raw 1970s-esque vibrancy is a reflection of the film's financially nonchalant production as Saulnier's film is strongly reminiscent of an era prior to the aggressive introduction of the high concept blockbuster.

James Vujicic

Boyhood

Studio/Distributor:

Detour Filmproduction
IFC Films

Director:

Richard Linklater

Producers:

Richard Linklater
Jonathan Sehring
John Sloss
Cathleen Sutherland

Screenwriter:

Richard Linklater

Synopsis

Boyhood chronicles various milestones in the life of Mason Jr. He is introduced as a first grader waiting for his divorced mother, Olivia, to pick him up from school. Mason shares a room with his older sister, Samantha, with whom he is close, but they often fight. Olivia decides to move to Houston to earn a degree and make a better life for her family. Around this time, Mason Sr returns from Alaska and visits his kids in Houston. Olivia soon marries university professor Bill, and moves her family in with his. However, Bill is abusive, and Olivia takes her kids and moves away to San Marcos where Mason and Samantha adjust to their new lives. Mason goes camping with his father and they bond further. Olivia meets and marries Iraq War veteran Jim, whom she later divorces. Mason turns 15 and his father takes him to visit his new wife's family on his birthday. As Mason matures, he develops an interest in

Cinematographers:

Lee Daniel

Shane F Kelly

Art Directors:

Rodney Becker

Melanie Ferguson

Editor:

Sandra Adair

Duration:

165 minutes

Cast:

Patricia Arquette

Ellar Coltrane

Lorelei Linklater

Ethan Hawke

Year:

2014

photography and gets his first serious girlfriend, Sheena. Mason and Sheena visit Samantha at college, where they have sex. However, the couple eventually breaks up. Mason gets a job washing dishes in a restaurant, wins a silver medal for his photography and receives a college scholarship. As Mason graduates high school and heads off to college, he becomes a responsible adult, ready to embrace the freedom he has always felt he deserved.

Critique

Boyhood is a coming-of-age film like no other. Writer-director Richard Linklater shot his 'intimate epic' over a twelve-year period enabling the cast to literally age before viewers' eyes. Linklater's previous effort to follow the same characters over a lengthy time frame produced *Before Sunrise* (1995), *Waking Life* (2001), *Before Sunset* (2004) and *Before Midnight* (2013). *Boyhood* is different, however, because it chronicles Mason Jr growing up over the course of a single film.

Mason begins as an irresponsible first grader who does not hand in his homework assignments because, he says, the teacher 'never asked for them'. Mason may be passive, but he respects his mother, who prioritizes her kids' welfare. While she doles out tough love, Olivia also wants a better life for herself and her children. This involves moving the family periodically. Mason is continuously confronted with issues of responsibility. His new stepfather, Bill, lectures him about managing his time so that he can complete his chores. However, Mason does not have much respect for Bill, who in one scene takes him to a barber to have his long hair shaved

Boyhood © 2014 Deteour Filmproduction, IFC Productions

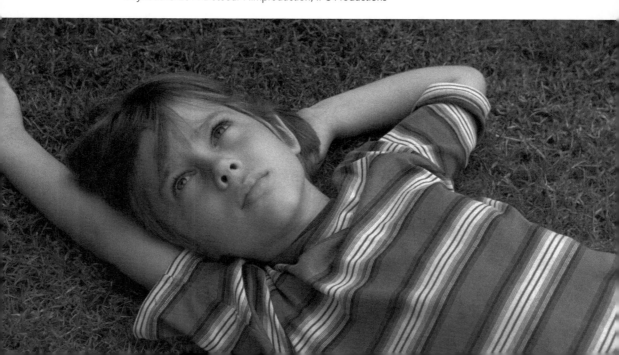

into a crew cut. As haircuts in fiction symbolize life changes, Mason undergoes an emotional and physical transformation at this key moment: he acknowledges how he has too few opportunities for self-expression. When Bill reveals himself to be an abusive drunk, Olivia leaves him, taking her children away. Mason again realizes that his mother places responsibility over freedom. In contrast, Mason's father is a more laid-back parent, showering his kids with presents and taking them out bowling or to ball games, or on camping trips. A big kid himself, Mason Sr eventually grows up as well, finding a new wife, having another son and eventually trading in his sports car for a minivan, much to Mason Jr's chagrin.

Linklater's organic storytelling style allows viewers to make parallels between Mason and his dad in the same way the characters do. This is what *Boyhood* does best: it captures the rhythms of the characters lives naturally, and in an engaging, sympathetic fashion. The film is seamlessly edited, putting as much emphasis on birthdays and graduations as it does on moving and break-ups. *Boyhood* rarely pivots on big dramatic events – Olivia's leaving Bill, and Mason breaking up with Sheena – which may be why the film is so affecting. Linklater mirrors reality without manufacturing cloying melodrama. Mason is a quiet kid who becomes a thoughtful teen. In one of the film's most powerful scenes, Mason's photography teacher Mr Turlington lectures him about discipline and commitment, rather than encouraging his promising student to create art. This episode about having a work ethic is nicely contrasted with two other scenes, one in which the manager at the restaurant where Mason works tries to motivate him to work harder, and an unexpected but highly satisfying moment when a young man thanks Olivia for encouraging him to get an education.

Because *Boyhood* was filmed over twelve years, the themes of responsibility and education resonate. The film shows how Mason receives the same messages over time from different sources and in different ways, and how he processes – or rejects – what he absorbs. Does his early behaviour playing video games lead to his interest in photography? Is his photography a way of looking at and keeping the word at a distance? Viewers are able to draw their own conclusions because they experience Mason's life as he does.

Another reason *Boyhood* is so strong is that Linklater allows his teenage characters to behave like real teenagers – they lie, talk trash and are self-absorbed. They also fight with their siblings and disrespect their parents. This is what makes the heart-to-heart chats in the film so credible and so powerful. When Mason wonders aloud why can't he go one day without someone riding him, the weight of his teen angst is palpable. Moreover, Mason's talk with his father about his break-up with Sheena provides another keenly observed moment. Mason Sr tells his son in arguably the most poignant moment that only 'you are responsible for you'. Such advice liberates and emboldens Mason, setting him on the path to adulthood as witnessed in *Boyhood*'s open ending where he achieves a measure of independence. It's a rewarding scene in a film full of extraordinary, ordinary and awkward ones.

Remarkably well acted by the entire cast, and written and directed with extreme tenderness and care by Linklater, *Boyhood* is a singular cinematic experience.

Gary M Kramer

Citizenfour

Studio/Distributor:

HBO Films
Participant Media
Praxis Films
Radius-TWC

Director:

Laura Poitras

Producers:

Mathilde Bonnefoy
Laura Poitras
Dirk Wilutzky

Cinematographers:

Kirsten Johnson
Trevor Paglen
Katy Scoggin

Editor:

Mathilde Bonnefoy

Duration:

114 minutes

Cast:

Edward Snowden
Glenn Greenwald
William Binney
Jacob Appelbaum

Year:

2014

Synopsis

Film-maker Laura Poitras is contacted by a National Security Administration whistleblower using the codename Citizenfour. After a protracted encrypted e-mail correspondence the whistleblower agrees to meet Poitras and *Guardian* journalists Glenn Greenwald and Ewan MacAskill in a Hong Kong hotel. The source is Edward Snowden, an NSA analyst who has an enormous cache of evidence on the illegal mass surveillance of e-mail and telephone traffic by US intelligence agencies, and for eight days Snowden gives full disclosure on the scope and scale of this secret activity. Whilst Poitras records events inside the hotel the repercussions of the story breaking across the global media make Snowden a fugitive. As the US government begins to close in, Snowden finds himself having to escape to Russia. The extent of the data being amassed begins to create outrage around the world and is shown to have extended to the US spying of governments regarded as its allies. The film ends with Snowden in Moscow and further revelations on the mass covert surveillance about to be made public.

Critique

'This is not science fiction!' declares National Security Agency (NSA) whistleblower Edward Snowden to two almost incredulous *Guardian* journalists after he explains to them the extent to which the US government has been illegally collecting and recording the telephone calls, e-mail traffic and electronic transactions of not only its enemies but also of its allies and own citizens. Snowden has revealed how a vast global surveillance system has been put in place to monitor electronic communication traffic on a mass scale in order to create a reservoir of 'metadata' on all of our movements and activities that, as one Occupy Wall Street activist puts it, 'is made up of facts but not necessarily true'. An unimaginably vast library of seemingly innocuous pieces of unrelated information that when put together produce a record of our movements and activities that, as the film explains, could be used by who knows who to make a case of who knows what against any of us. Thus, is this the most bizarre of all paranoid conspiracy theories or the most egregious invasion of privacy ever committed by a democratically elected government?

Citizenfour is the third film in a trilogy that director Laura Poitras has made on post-9/11 America; films that have led her to be put on a secret watch-list causing her frequent detention and interrogation when travelling across the US border. Her two previous films, *My*

Country, My Country (2006), a film about the Iraq War; and *The Oath* (2010), an expose of Guantanamo Bay, have obviously made both her activities and contacts of great interest to US intelligence agencies. It was this that instigated NSA analyst Edward Snowden to contact her in 2012, under the name *Citizenfour*, and begin a tentative encrypted e-mail correspondence that resulted in them meeting in a hotel in Hong Kong where, over eight days, Snowden revealed the extent of the secret surveillance and the lengths that the US government had gone to in concealing and denying its existence. The heart of the film then is these edgy, claustrophobic discussions between Snowden and two journalists from the *Guardian* newspaper, Glenn Greenwald and Ewan MacAskill. Snowden carefully takes his time to feel safe enough to open up in their company and on camera and, as the film progresses, the full extent of his extraordinary story is made clear. The magnitude of the billions of calls, e-mails and transactions being collected on a daily basis are soon difficult to even comprehend and, on an even more chilling note, the extent of the use of drones for surveillance and air strikes is made apparent.

Unusually, as the film's director, Poitras is directly involved in these events; she is present during the hotel meetings, even at one point moving Snowden to her own room to avoid the attentions of the media (and probably US agents). At the same time her film also ventures outside the confines of the hotel and shows the worldwide outrage to the revelations as they are published in *The Guardian*.

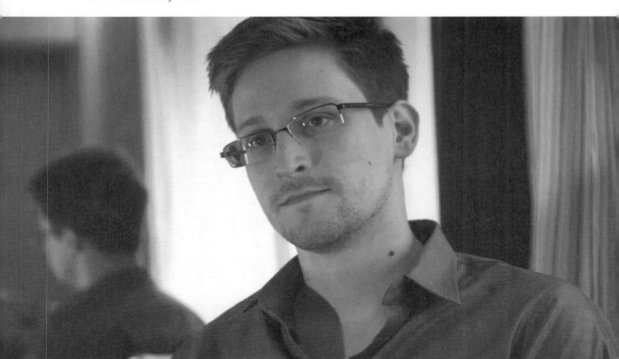

As tense as the events of the film are, it is not without its amusing moments; most bizarrely, Snowden putting a blanket over himself as he types his password into his laptop and then advises Greenwald to do the same. This creeping sense of paranoia infiltrates the last section of the film as Poitras has to move to Berlin to avoid the attentions of the US government and Snowden attempts to flee to somewhere that will not extradite him back to the United States. In an ironic twist, he finds refuge in the Russia of Vladimir Putin. The final meeting between Snowden and Greenwald in Moscow is conducted by them scribbling notes on scraps of paper that, once read, are torn into tiny pieces – you never know who might be listening and looking! *Citizenfour*, which won the Academy Award for Best Documentary in 2015, presents a withering critique of the US government, which is especially pertinent as we expected this sort of thing from the Bush administration but, as the film, shows, much of this surveillance has been initiated during the presidency of Barack Obama, who came into office ostensibly to end such abuses.

The revelations that we have all been spied upon for more than a decade could leave an audience in hopeless despair but Poitras creates a loose set of links between forces of resistance and opposition, most notably the Occupy Wall Street movement, Julian Assange, and, in the final scene of the film, new sources of information beginning to come forward to blow the whistle. Since the film's release, the Obama administration has been forced to curtail much of this NSA activity and, although there may be less to this than meets the eye, we might also have that rare instance of a film that has had the power to change things.

Martin Carter

The Guest

Studio/Distributor:

Hanway Films
Picturehouse
Snoot Entertainment

Director:

Adam Wingard

Producers:

Keith Calder
Jessica Wu

Screenwriter:

Simon Barrett

Cinematographer:

Robby Baumgartner

Art Director:

Thomas S Hammock

Synopsis

Still grieving the loss of their eldest son, Caleb, who was serving in Afghanistan, the Peterson family receives a surprise visit from recently discharged soldier David Collins, who claims to have been a member of Caleb's unit. Earnestly explaining that he has come to honour a promise that he made to take care of the family should anything happen to David, the stranger is welcomed into the household by the bereaved parents, Laura and Spencer. Assuming the role of a highly skilled guardian, David helps teenage daughter Anna deal with her troublesome ex-boyfriend, teaches youngest son Luke self-defence moves so that he can defeat school bullies, and removes a rival employee from Spencer's workplace so that the patriarch can finally receive the promotion to which he believes he is entitled. When the suspicious Anna calls the military base to ask about David, however, a private corporation operation headed to Major Carver is put into action. It transpires that David is actually a former test subject for a military programme who has been conditioned to kill everyone who has a clue about his real identity

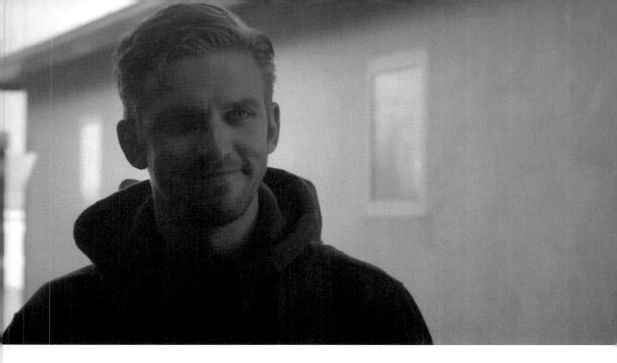

The Guest © 2014 HanWay Films, Snoot Entertainment

Composer:

Steve Moore

Editor:

Adam Wingard

Duration:

100 minutes

Cast:

Dan Stevens
Maika Monroe
Brendan Meyer
Lance Reddick

Year:

2014

if his cover is threatened. Mayhem ensues once David realizes that his location has been compromised, with Anna and Luke's efforts to evade his merciless clean-up plan culminating in a climax at the local school's Halloween dance.

Critique

The Guest is a terrific throwback to the independent genre films of the 1980s which would usually receive a moderate theatrical push before finding true appreciation as VHS rentals. Indeed, on a repeat reviewing, having already sampled its blend of exploitation thrills and social-political smarts, one almost expects Adam Wingard's film to open with the New World or Vestron logo. It has a more specific debt, though, to the output of Larry Cohen whose satirical 'B'-movies would mix genres with aplomb while sustaining a sharp line in social-political critique: *The Guest* is part home-invasion thriller, part action movie, part horror flick, with a dash of science fiction thrown in via the deliberately vague backstory and sheer indestructability of its titular antagonist. Wingard demonstrates a surfeit of technical ambition that enables the film to transcend its low-budget origins and feel like a much bigger movie. More importantly, he also has a similar approach to political debate – *The Guest* does not make an explicit statement but it has a subversive subtext that questions the involvement of private contractors in the US military and post-traumatic impact of conflict on those who experience unjust wars through the service of their loved ones.

Much like David Robert Mitchell's supernatural horror *It Follows* (2015) and Riley Stearns's psychological thriller *Faults* (2015) – the latter of which was also produced by Snoot Entertainment, and utilizes some of the same cast and crew members as *The Guest* – Wingard's film is set in a post-recession wasteland that recalls the small towns many 1980s films, thereby making it at once retro and relevant. This is a flailing place where a stagnant office environment is about as good as it gets in terms of career prospects, while those who do not complete their education are left to work in the service industry, sell guns, get high and sleep around. Anna (Maika Monroe) is assertive enough to look into David's background, but has not applied her intelligence to improving her employment prospects and has settled into a mundane job at a diner. Recalling the raw bleakness of Tim Hunter's classic *River's Edge* (1986), there is a pervading nihilism in the scenes that examine youthful malaise, with alcohol and cheap drugs providing momentary escape from daily drudgery. However, this is also a town that has been irrecoverably ruptured by the 'war on terror', as Caleb is presumably just one of many dutiful young citizens who have been co-opted into the Bush administration's folly in the Middle East. The unquestioning haste with which the Petersen family latches onto David as a substitute for Caleb may smack of convenience, but it also speaks of a void in their unit – and the community as a whole – which they are desperate to fill. The home is filled with pictures of Caleb and each member of the family latches onto David in order to deal with his absence, as a son or an older brother. David also becomes an idealized projection of what such heartland communities expect soldiers to be: strong, upstanding protectors who reaffirm all-American values at difficult times. But this modern version of Captain America, complete with First Avenger hairstyle, has gone haywire, with his sense of justice now secondary to the mission of self-preservation, whatever the cost.

One of the more prominent members of the mumblegore crowd with past credits including *A Horrible Way to Die* (2010) and *You're Next* (2013), Wingard understands that the escalation of violence is most effective when it rises from a credible environment and well-defined relationships. *The Guest* is judiciously paced, yet has a relatively calm first half with David (Dan Stevens) earning the trust of the Petersen family before cutting loose with a barrage of mayhem. Wingard reveals David's abilities with a vicious barroom brawl which sees the interloper easily defeating the gang of bullies who have been picking on Luke (Brendan Meyer), with Steve Moore's synthesizer score kicking in to not signal the film's 1980s lineage but David's mechanical response to anyone who signifies a threat. Some of his monstrosity is even left to the imagination – David facilitates the promotion of Spencer (Leland Orser) by murdering his initially appointed co-worker, with the killing occurring off-screen. *Halloween* (John Carpenter, 1978) and its unfairly derided sequel *Halloween III: Season of the Witch* (Tommy Lee Wallace, 1983) serve as structural models, with events unfolding in the week before the school's seasonal party, and Wingard plays with horror elements – a scarecrow looks out over the desolate landscape in an ominous establishing shot and the

walls of Anna's bedroom are adorned with Goth memorabilia – but never makes a full commitment to any genre in order to maintain an air of unpredictability. Appropriately for a film with a multifaceted genre identity, *The Guest* concludes in a hall-of-mirrors as Anna and Luke try to hide from David at the school party, with Wingard making splendid use of gaudy set design and pulsating electro-pop.

The Guest ends on an amusing note of implausible glibness, as if Wingard wants to undercut his critique by reminding the audience that this is 'just' a genre movie. However, as much as its shock tactics may grab the attention and encourage a spurt of midnight madness fandom, it's the film's tacit engagement with current issues that ultimately enable it to stand out from the rest of the splatter pack.

John Berra

Inside Llewyn Davis

Studio/Distributor:

Anton Capital Entertainment (ACE)
CBS Films
StudioCanal

Directors:

Ethan Coen
Joel Coen

Producers:

Ethan Coen
Joel Coen
Scott Rudin

Screenwriters:

Ethan Coen
Joel Coen

Cinematographer:

Bruno Delbonnel

Art Director:

Deborah Jensen

Composer:

T Bone Burnett

Editors:

Ethan Coen
Joe Coen (both as Roderick Jaynes)

Synopsis

In the winter of 1961, folk singer and former merchant marine Llewyn Davis finds himself at a crossroads. Llewyn's partner, with whom he recorded the album *If I Had Wings*, has committed suicide, and his own solo recording *Inside Llewyn Davis* has proved commercially unsuccessful. Llewyn's musical performances around Greenwich Village, though much admired, are not financially remunerative, and he relies on the kindness (and the couches) of his friends, including the Gorfeins and the Berkeys. One morning, as he is leaving the Gorfeins' apartment, their cat escapes, and Llewyn finds and brings him to the Berkeys. The cat, along with its female lookalike, will resurface and escape a number of times throughout the narrative. At the Berkeys, he learns from Jean that she is pregnant, possibly with his child, and wants an abortion. Llewyn records a new song ('Please, Mr Kennedy') with Jean's husband Jim and Al Cody and agrees to a payment of $200. He learns at the gynecologist's office that his former girlfriend had not terminated her pregnancy two years before and instead moved to Akron with their baby. Llewyn travels with two musicians to Chicago where he auditions for Bud Grossman, the owner of the Gate of Horn folk club. Grossman finds Llewyn unsuitable as a soloist. Refusing to be incorporated into a trio, Llewyn returns to New York to rejoin the marines, only to learn that his licence was thrown out. The film ends where it started, with Llewyn performing at the Gaslight Café.

Critique

An imaginative, neo-historical view of the folk scene from which Bob Dylan has yet to emerge (Robert Allen Zimmerman changed his name to Dylan in 1962), the film's first spoken words, 'You probably heard that one before', gestures towards its familiarity and its cyclical structure, something which executive music producer T

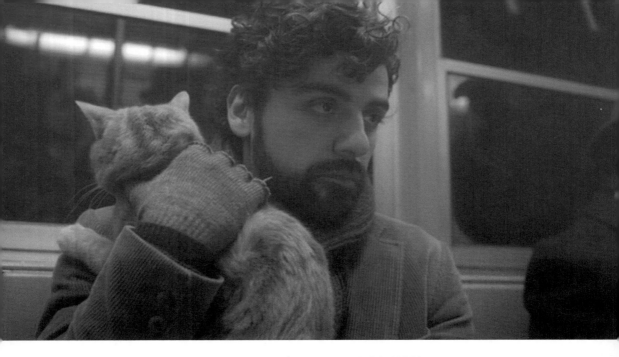

Inside Llewyn Davis © 2013 Anton Capital Entertainment (ACE), CBS Films, StudioCanal

Duration:

105 minutes

Cast:

Oscar Isaac
Carey Mulligan
John Goodman
Justin Timberlake

Year:

2013

Bone Burnett, in an interview for the film's making-of documentary, has likened to a folk song:

> It starts out you hear about an incident so the first incident is the first verse. And the second verse is a whole new story. It takes you through these verses to get to the end and you get to where you were in the beginning. But you know a lot more than you did when you saw it the first time and that's what happens in these folk songs.

The title *Inside Llewyn Davis*, shared with Llewyn's (Oscar Isaac) solo album, is suggestive of interiority and our proximity to the character. The film persistently juxtaposes instances of journeys, while asking what we are to make of them: its ending, as in the beginning, finds Llewyn performing in the cafe; the Gorfeins' cat, who leaves the Berkleys' apartment only to find his way home, is tellingly named Ulysses; and Llewyn sees a poster of Fletcher Markle's *The Incredible Journey* (1963) in front of a theatre, one that, like *Inside Llewyn Davis*, heralds 'A fantastic true-life drama'. The characters seem to be locked in a cycle from which they cannot escape, and yet the film offers counterevidence; for instance, the reaction shots of Llewyn looking at the road signs to Akron where his child resides when he drives back to New York are suggestive of possible departures; and in the final shots we see him saluting 'Au revoir' to the departing cab that takes away his assailant – against the interdiegetic tune of Dylan's 'Farewell' (1963).

Inside Llewyn Davis recalls many of the themes that we have come to associate with the Coen brothers' dark comedies. *A Serious Man* (2009), for instance, is prefaced with an epigraph from the medieval French rabbi Rash, 'Receive with simplicity everything that happens to you', and this is followed by a framing narrative set in a Polish *shtetl* wherein a Jewish man tells his wife that he was helped by Traitle Groshkover when his cart broke down on a cold winter's night. She tells him that Groshkover had died three years before and, when Groshkover visits them at their home, she stabs him with an icepick. This early-twentieth-century story may seem incongruent with the story proper, which, set in Minnesota in 1967, relays a series of unfortunate circumstances in the physics professor Larry Gopnik's life. Early in *Inside Llewyn Davis*, by comparison, we witness Llewyn being beaten up, and we only learn in the film's final moments that this is possibly because he was heckling another performer – he does this and is attacked again. Both films effectively mix elements of the tragic and the comic and they demonstrate the more profound views of life to be gained by looking at it from a different perspective. If in *A Serious Man*, Gopnik's experiences seem trivial in light of even more pressing concerns (i.e. his health problems – his doctor wishes to see him urgently and in person after receiving his X-ray results – and the tornado that hits Minnesota at the end of the film), then in *Inside Llewyn Davis*, the titular character (and we) recognize that his week is transformative despite its relatively short duration. As he tells Jean when he apologizes for forgetting that her abortion is on Saturday: 'I was away… Well, it seemed like it was a long time but it was just a couple of days, yeah.'

Recognized by the Cannes Film Festival with a Grand Prize of the Jury, *Inside Llewyn Davis* is the Coen brothers' first major work about folk music, though this figured prominently in *O Brother, Where Art Thou?* (2000). The sound of the film is matched by the muted wide-screen cinematic language of cinematographer Bruno Delbonnel and Deborah Jensen's subdued art direction. *Inside Llewyn Davis* may not have gained the cult following of *Fargo* (1996), or critically superseded the Coen brothers' acclaimed adaptation of Cormac McCarthy's novel *No Country for Old Men* (2007), but it certainly speaks to their incredible versatility.

Tom Ue

Listen Up Philip

Studio/Distributor:

Faliro House Productions
Sailor Bear
Tribeca Film
Washington Square Films
Director:
Alex Ross Perry

Synopsis

As he awaits the publication of his second novel, temperamental New York-based writer Philip Lewis Friedman feels increasingly alienated in his adopted city as its constant noise and teeming crowds prevent him from making creative headway. An invitation to lunch at the home of his reclusive idol Ike Zimmerman results in a mentor–protégé relationship with the celebrated writer offering Philip the use of his Massachusetts hideaway. Rejecting a promotional tour arranged by his publishing house, Philip

Producers:

Joshua Blum
Toby Halbrooks
James M Johnston
David Lowery
Katie Stern

Screenwriter:

Alex Ross Perry

Cinematographer:

Sean Price Williams

Art Director:

Fletcher Chancey

Composer:

Keegan DeWitt

Editor:

Robert Greene

Duration:

108 minutes

Cast:

Jason Schwartzman
Elisabeth Moss

accepts Ike's hospitality. This causes friction in Philip's relationship with his photographer girlfriend, Ashley, a situation that is further exacerbated when Ike recommends Philip for a temporary teaching position at a New England college. Although teaching provides Philip with a measure of financial stability, his brutally honest manner contributes to his outsider status amongst the faculty. A regretful Philip eventually returns to New York to see if he can make amends to Ashley.

Critique

Listen Up Philip completes a loose trilogy of writers for Jason Schwartzman, a performer whose consummate dryness is ideal for portraying practitioners of the literary arts. Often curiously aloof from whatever is occurring around him, Schwartzman's studied nonchalance evidences a prickly undercurrent that prevents his screen persona from being conveniently summarized as deadpan or ironic. While he spent much of the 2000s in ensembles, Schwartzman's signature roles are his lead turns as precocious high school playwright in Wes Anderson's breakthrough feature *Rushmore* (1998) and blocked novelist turned unlicensed private detective Jonathan Ames in the HBO series *Bored to Death* (2009–11). Based on the show's creator, Ames was wracked with insecurity and self-doubt, often floundering in his dual public identities of promising young writer and amateur sleuth, but buoyed by

Listen Up Philip © 2014 Faliro House Productions, Sailor Bear, Washington Square Films

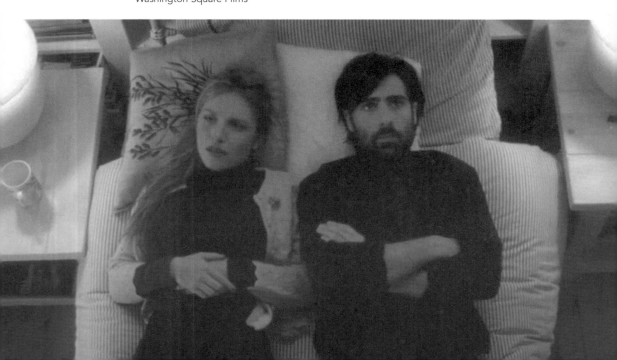

Krysten Ritter
Jonathan Pryce
Year:
2014

his friendships with comic book artist Ray (Zach Galifianakis) and magazine editor George (Ted Danson). The titular literary wunderkind that Schwartzman inhabits in *Listen Up Philip*, however, has little need for such relationships to maintain his sense of self-worth. As with Jonathan, Phillip is a New York novelist with a history of failed relationships, but this really marks Schwartzman's return to the narcissism of Max Fisher, with the teenage dramatist's self-aggrandizing tendencies propelled into adulthood.

Schwartzman and writer-director Alex Ross Perry find their intentionally uncomfortable rhythm with a series of early scenes in which Philip interacts with ex-girlfriends, a disabled college buddy, the marketing team at his publishing house, and a fellow writer of a similar age whose fame level currently exceeds his own. Philip's piercing verbosity suggests that he is perfecting a schtick that revolves around raw honesty: running the gamut from image control (refusing to be photographed next to a 1920s printing press for publicity materials to accompany his new book) to personal bridge burning (expressing disgust at a former classmates' comparative lack of achievement), Philip throws in the occasional smile and cheerfully acknowledges that he is an 'asshole' but it soon becomes clear that such behaviour is more indicative of a premature case of hubris than it is of myth-making. He belittles how Ashley (an affecting Elisabeth Moss) approaches her career, even though she has been kindly supporting him financially, and has no interest in anything that anyone else has to say unless it is advice dispensed by the spiteful Ike (Jonathan Pryce, splendidly channelling Philip Roth and Gore Vidal), when he should instead take heed of his mentor's isolation. Reserving any depth of feeling for his writing, Philip not only keeps others at arm's length, but puts little effort into teaching his craft, effectively dismissing a classroom of students with the condescending remark, 'In my experience, most of you will probably abandon writing, creatively or otherwise, shortly after graduating.'

Tragically, Philip aspires to be like the cantankerous Ike whose decision to shut out the world to maintain his literary standing has cost him the love of his daughter Melanie (Krysten Ritter); Ike's mentoring of Philip stems from the perverse amusement that he finds in nudging his protégé towards becoming a younger version of himself rather than from a genuine investment in his development. After a semester of being strategically undermined by fellow faculty member Yvette (Joséphine de La Baume) on the grounds that novelists do not belong in academia, Philip embarks on an affair with his colleague that culminates with her sobbing because of his insensitivity: 'We began by hating one another, I think we're coming back down the other side now,' is his detached encapsulation of their brief romance to Ike, who is living vicariously through Philip's personal and professional mistakes. Upon realizing that Yvette is in a state of distress, Philip calmly states, 'I want you to contextualize my sadness to put whatever you're going through into perspective,' then lies down next to her on the bed and assumes a position more suitable for psychoanalysis than emphatic consolation. Even when he's not onscreen, the aftershock of Philip's ego makes his presence felt through the emotional rupture that

it has left in its wake. Left alone in the city, Ashley is forced to deal with sudden abandonment and reflects on how much energy she had expounded on an unfulfilling relationship, sensitive to reminders lurking at familiar corners of the metropolis, at least until she realizes that it is in her best interests to move on.

Perry's style is deceptively loose-limbed, with the film's ragged aesthetic sometimes making it play like a rough assembly with a lack of regard for smooth transitions and a penchant for digressions as potential storylines (Philip's book tour, a freelance assignment covering another writer) and then abruptly dropped as Perry follows his protagonist's whims rather than a conventional structure. The proceedings seem to take place in the present day, but cellphones and the Internet are notable by their absence, while many of the casual fashions suggest earlier decades, and the book covers that occasionally pop up are very retro, much like the typeface used for the credits. Shooting on 16mm gives Sean Price Williams's cinematography a 1970s graininess that lends the film the quality of a faded memory, with even the scenes that take place in summer having an autumnal feel. This creates a sense of distance that is enhanced by Eric Bogosian's omniscient narration, which affords Philip some understanding but relatively little sympathy. In tandem with Schwartzman's brittle performance, the handheld camerawork – which favours tight framing but is always roving – challenges the viewer to get close to the subject, often panning away from Philip at the moments when a genuine emotion threatens to break through his cultivated surface, yet remains fixed as he launches into a venomous tirade or indulges in mock-sincerity.

A splendidly caustic seriocomedy that has no qualms about the fact that its audience reach will likely be as limited as that of its protagonist's highbrow fiction, *Listen Up Philip* strives for scrutiny rather then accessibility and in doing so creates an unflinching portrait of artistic self-absorption.

John Berra

Nightcrawler

Studio/Distributor:

Bold Films

Open Road Films

Director:

Dan Gilroy

Producers:

Jennifer Fox

Tony Gilroy

Jake Gyllenhaal

David Lancaster

Michel Litvak

Synopsis

Self-educated hustler Louis 'Lou' Bloom ekes out a living in Los Angeles by stealing materials from construction sites while keeping his eye out for an opportunity that will catapult him out of his squalid existence. After a chance encounter with freelance stringer (news gathering specialist) Joe Loder at the scene of a car crash, Lou decides to get into the television business, which entails stealing a bike in order to exchange it for a camcorder and a police scanner. Entering a highly competitive field, Lou's willingness to go the extra mile is immediately rewarded when he oversteps the mark at a crime scene to record the death of a carjacking victim, thereby instigating a rivalry with Joe. Lou sells his footage to Nina Romina, a morning news producer at a struggling network who

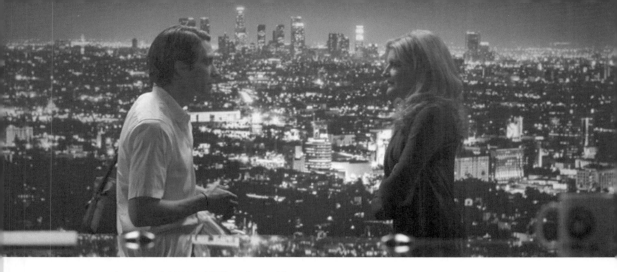

Nightcrawler © 2014 Bold Films, Sierra/Affinity

Screenwriter:

Dan Gilroy

Cinematographer:

Robert Elswit

Art Director:

Naaman Marshall

Composer:

James Newton Howard

Editor:

John Gilroy

Duration:

117 minutes

Cast:

Jake Gyllenhaal
Rene Russo
Riz Ahmed
Bill Paxton

Year:

2014

needs sensationalistic material to increase ratings and ensure that she receives contract renewal. Encouraged by his initial success, Lou hires the cash-strapped Rick Carey as his 'intern' and sets about capturing more graphic footage by any means necessary. In his calculated bid to climb to the top of his chosen industry, Lou will not only put himself and Rick at great physical risk, but will even engineer newsworthy situations, a dangerous strategy that brings this ambitious freelancer to the attention of the police department.

Critique

A savage take on how to make it in America, the fiendishly sly neo-noir *Nightcrawler* is an arresting directorial debut from Dan Gilroy, whose past screenplay credits include such underwhelming mainstream fare as *Two for the Money* (D.J. Caruso, 2005) and *The Bourne Legacy* (Tony Gilroy, 2012). By making his first feature outside the studio system, Gilroy has been relieved of the need to make his characters conventionally likeable, and takes full advantage of this freedom by focusing on a protagonist who can rationalize any amoral action based on its necessity to his career progression. For all his elaborate scheming – which runs the gamut from trespassing to blackmail to manipulating life-threatening circumstances – Louis 'Lou' Bloom (Jake Gyllenhaal) is an alarmingly honest individual who speaks directly, often wearing his innate opportunism on his sleeve. When called a 'thief' to his face by the manager of a construction site, Lou shows no sign of offence, and even seems to respect the man's decision not to offer him work based on his evident criminal nature. By taking a protagonist who has jettisoned any sense of right and wrong before the main narrative begins, Gilroy is able to chronicle Lou's career progression not as the gradual corruption of an individual in a specific line of

work, but as the combustible result that occurs when an amoral rookie enters a field that is often defined by morally questionable decision-making.

Nightcrawler hinges on Gyllenhaal's committed portrayal of Lou, which could slip into self-awareness, but a gaunt Gyllenhaal never wavers in his dedication to conveying Lou's tunnel vision. Lou's borderline-religious devotion to business-speak is at times amusing, and Gilroy acknowledges the near-absurdity of Gyllenhaal's straight-faced delivery of various maxims for success by having his employers or competitors dismiss him as an over-eager amateur, at least until they notice the fierce edge that lurks behind his outward naivety. Shifts of power occur in the second half with the supporting players proving to be superb foils to Gyllenhaal by fleshing out the characters who are pulled into Lou's orbit, thereby preventing *Nightcrawler* from becoming a flashy one-man show. Nina starts out by recognizing Lou's potential but lowballing him when buying his footage. When asked out to dinner at a Mexican restaurant, she goes along with the intention of letting Lou down gently be explaining that he does not mix work and relationships, only to be forced into a sexual arrangement in exchange for continued first option on his footage. Joe decides to expand his operation and tries to recruit Lou, with a rivalry being instigated when Lou flat-out rejects his offer: the veteran initially has the upper hand with his multiple crews, but Lou wins the battle of the stringers by turning his competition into the news by tampering with Joe's van in order to cause a crash and record the aftermath. However, it is Rick who becomes the film's true unwitting victim, a decent under-achiever who is berated and exploited by Lou in exchange for the occasional morsel of praise and basic pay. In social-economic terms, there is little difference between Lou and Rick, but the former's reservoir of self-esteem enables him to exert considerable influence on his employee as both mentor and oppressor. Lou seems to equate success with the ability to wield power, as despite his rapid rise, he remains a frugal operator, largely restricting his spending to professional necessities.

Although it is first and foremost a character study – albeit one that studies a character who does not change or grow in any respect beyond his professional standing – *Nightcrawler* has been described as a twenty-first-century descendent of Sidney Lumet's media satire *Network* (1976) for its perceived attack on the tabloid presentation of television news. Gilroy certainly points to the use of fear mongering to maintain ratings, with Nina pushing urban crime coverage that mines shock value from carjackings and home invasions at the expense of wider investigations of the city's social fabric. A veteran news producer, Nina is surely suspicious of Lou's method, but too hooked on the visceral nature of his footage to care, ultimately dismissing the legal concerns of her assistant by telling him, 'I think Lou is inspiring all of us to reach a little higher.' Lou's manipulations can be seen as a side effect of network reliance on freelancers for newsworthy material. As a self-trained stringer, he develops professionally without being 'burdened' by such journalistic ethics: within a few months, he goes from trespassing at crime scenes to moving a corpse in order to get a better shot, and

eventually instigates a shoot-out with no concern for the safety of bystanders or law enforcers. Rick will also prove to be part of Lou's vision when he is coldly directed into the line of fire in order to provide his report with a parting image that viewers will be unable to turn away from. As captured by Robert Elswit's mesmerizing deep focus digital photography, Los Angeles is the perfect city for Lou's particular brand of crime coverage. With its desolate urban landscape of strip malls, parking lots, diner chains, and secluded suburban developments, this is a city inhabited by people who prefer to look the other way when something unpleasant occurs across the street or at the neighbouring gated residence.

The final scene sees Lou with a real operation, having copied Joe's idea of hiring multiple crews to cover different areas of the city, although he still seems destined to be an outsider, operating on the streets rather than in the newsroom. Yet this is not a tragic portrait of an alienated individual forever destined to be looking in from the margins; rather, it is all the more disturbing because this particular sociopath is more than happy to be out there in pursuit of his uniquely skewed version of the American dream.

John Berra

Spring Breakers

Studio/Distributor:

A24
Annapurna Pictures
Muse Productions
Radar Productions

Director:

Harmony Korine

Producers:

Charles-Marie Anthonioz
Jordan Gertner
Chris Hanley
David Zander

Screenwriter:

Harmony Korine

Cinematographer:

Benoît Debie

Art Director:

Almitra Corey

Composers:

Cliff Martine
Skrillex

Synopsis

A quartet of 'poor' college students – Faith, Candy, Brittany and Cotty – find they are unable to afford their trip south to party in Florida. Rather than miss the party of the year, Candy, Brit and Cotty stage an audacious robbery to acquire the necessary funds: they hold up a diner and rob the customers, snatching purses and wallets and fleeing in a stolen car. Once in Florida, after days of partying, a drunken evening ends with the four girls, clad in luminously bright bikinis, arrested and jailed. They are soon released after being bailed out by local musician and small-time gangster, Alien, who is interested in meeting the sexy, rebellious girls. Once under Alien's quasi-protective wing, the four are inducted into a world of nihilistic consumerism, drugs, weapons and crime. While Faith opts to return to the college, the other girls elect to remain with Alien, and embrace a world of crime and increasing violence, all the while, calling home and talking to their families about the personal growth, spiritual and enlightening experiences they are having.

Critique

Spring break has come to define the college experience for at least some of North America's college students, as they head to beachside suburbs and resorts in order to unwind from their studies in a world of alcohol, parties and sex. Wet T-shirt contests, beer drinking and the predictable bump-and-grind of ritual hedonism at the celebration of youth finally free (albeit temporarily) to transgress the conservative lifestyles experienced at home and on campus.

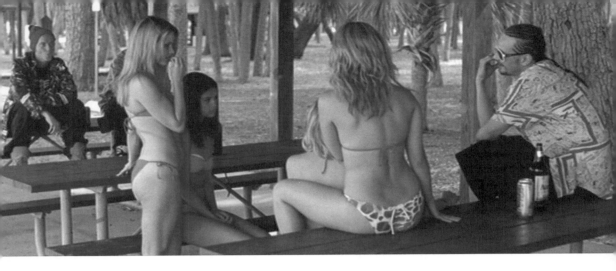

Spring Breakers © 2013 Annapurna Pictures, Division Films, Muse Productions, Radar Pictures

Editor:

Douglas Crise

Duration:

94 minutes

Cast:

James Franco
Selena Gomez
Vanessa Hudgens
Ashley Benson
Rachel Korine

Year:

2013

Harmony Korine's film opens with images depicting spring break; a slow-motion celebration of partying and play – people are seen dancing, drinking, splashing in the ocean, pouring beer onto girls' breasts, and shaking bottles of beers in masturbatory gestures. Although the film is not a documentary there is a sense of authenticity that is present in this opening scene. But when these scenes are repeated later in the film, with Alien's stoned drawl intoning 'spring break… spring break… forever' there is a sense that they represent an idealized fantasy version of the student vacation. Simultaneously the phrase 'spring break… forever' becomes repeated at key points throughout the film, a lyrical refrain that punctuates the film.

The depiction of the four students in the first section of the film emphasizes the relentless party atmosphere and frames the narrative action within footage shot during spring break celebrations, with the party forming the backdrop to the action. Middle-class students at play. But as the film progresses, there is a change in the visual style, the emphasis moving away from the quasi-naturalism aesthetic of the earlier scenes to a brighter, vivid emphasis on colour.

The immersion of the four partiers into the obsessive, self-absorbed, actualized gangster (or perhaps 'gangsta') fantasy of Alien's world is marked by a visual move to an increasingly bright, luminescent and unreal/hyperreal palette. Director of cinematography Benoît Debie's previous credits include Gaspar Noé's *Irreversible* (2002) and *Enter the Void* (2009), two movies by an auteur that explored the visual potentialities of narrative film-making. In *Spring Breakers*, the shift to brighter colours serves to create an increased hyper-pop-art aesthetic in which the excesses of the protagonists' world are emphasized. These excesses are not just those associated with the protagonists' personal experiences

and transformed perspectives but also of the fragmented and often contradictory generational desires and lusts: this hyperreal aesthetic is further emphasized by the editing, which uses flash-forwards to create momentary temporal shifts.

When Alien (James Franco) takes the young women to his house, he stands in his crib showing them his myriad possessions boasting over and over, 'This is the fuckin' American dream. This is my dream y'all… Look at my shit… […] I've got *Scarface* on repeat, constant y'all… […] Look at my shit. Look at my shit.' His is the voice of an excess and consumerism that knows no limits to fulfilling an endless desire for an identity created primarily through appropriation – whether via the cultural representation of crime that is uniquely Floridian – the Miami-based *Scarface* (Brian De Palma, 1983) on repeat – the perception of taste and class via his boasting of using 'Calvin Klein Escape! Mix it up with Calvin Klein Be', the excess of potential violence as both a symbol of his wealth and means to potentially acquire more wealth via the presence of numerous guns and knives. Even his bed is described through pop culture: 'That ain't a fuckin' bed; that's a fuckin' art piece. My fuckin' spaceship! USS Enterprise on this shit. I go to different planets on this motherfucker!' Like Candy, Britt and Cotty, he understands that through appropriating signifiers and actions he can become an ideal version of himself, an identity seems to be forged from a white appropriation of a particular fantasy of an African American street culture.

The sense of the hyperreal increases throughout the second half of the film. During one central scene the girls stand around Alien's piano, which is located next to the water on a raised deck, in the beautiful pink glow of the setting sun. The three college girls carry automatic weapons and are clad in animal-print bikinis and jogging pants, with pink balaclavas (sporting unicorn logos) to hide their faces. Asking Alien to play a song for them, he proceeds to play Britney Spears' hit 'Everytime' on the piano and in a surreal sequence the three girls join in singing with him, before dancing with their weapons raised high in the air. The scene cuts to a montage sequence of the gang robbing and threatening people with guns, while Spears' song plays on the soundtrack. This sequence is remarkable, not least because in the vast majority of mainstream Hollywood crime films the criminal gang's actions are invariably punctuated with more aggressive, harder music, not the delicate tones of Britney Spears' particular brand of pop. Moreover, during the sequence the film creates a depiction of youth, crime, desire and culture that transforms all of these elements into a pop-video aesthetic.

There is also something akin to Jean-Luc Godard's *Weekend* (1967) in *Spring Breakers*, which offers its exploration of a specific culture through the framing mechanism of the vacation. Both works use the holiday backdrop as a method of creating a détournement during which the recognizable order collapses and dreams, or corrupted dreams, are realized through a violence that erupts through the everyday.

As the narrative unfolds it becomes apparent that while Alien presents himself as the gangster it is the girls who truly embrace

the violent potentials of the criminal life, including pushing guns into Alien's mouth as he mock-fellates them. In many ways the film fits into the girl gang genre, which includes works as diverse as *Heathers* (Michael Lehmann, 1988), *Faster, Pussycat! Kill! Kill!* (Russ Meyer, 1965) and even *Caged Heat* (Jonathan Demme, 1974). In its vivid depiction of youth and culture, *Spring Breakers* creates a world in which, behind the flat, sexy pop aesthetic, the college girls are perhaps empowered, strong women, but the world they fantasize about, and momentarily create, with Alien is ultimately empty.

Jack Sargeant

Upstream Color

Studio/Distributor:

ERBP

Director:

Shane Carruth

Producers:

Shane Carruth

Casey Gooden

Ben LeClair

Screenwriter:

Shane Carruth

Cinematographer:

Shane Carruth

Art Director:

Darrah Dean Gooden

Composer:

Shane Carruth

Editors:

Shane Carruth

David Lowery

Duration:

96 minutes

Cast:

Amy Seimetz

Shane Carruth

Thiago Martins

Andrew Sensenig

Year:

2013

Synopsis

After conceiving of a new drug involving a live roundworm, a mysterious man (identified in the end credits as 'The Thief') abducts Kris, drugs her and uses the suggestive power of this drug to steal money from her. Once she awakens from her narcotic state and injures herself trying to get rid of the worms infesting her body, she's lured by another mysterious man, 'The Sampler', who transfers the worms into a pig. Having lost her job and assets as a result of the horrifying episode, Kris tries in earnest to put her life back together and it is during this recuperation process that she meets Jeff on a bus. As they get to know each other, they eventually realize they both have undergone the same traumatic experiences, and thus try to make sense of it all, especially when this leads them to act in strange ways. In the end, all roads lead back to The Sampler, who at one point is seen ruthlessly disposing of piglets after the pig containing Kris's worm has given birth. Considering Kris's newly discovered infertility as a result of The Thief's experiment, perhaps a key to her own personal happiness lies in The Sampler's pig farm.

Critique

The opening prologue of Shane Carruth's sophomore feature *Upstream Color* tells you, through pure sound and image, just about everything you need to know about what is to come, stylistically and thematically. For one thing, there's the quick editing rhythms: somewhat in the manner of Terrence Malick, Carruth and co-editor David Lowery give you brief jump-cut flashes of images, seemingly impatient to get to the next shot and/or scene. Then, there are the images themselves glimpsed within these shots whizzing past you: airy natural-light compositions that mark a stark contrast from the gloomy mundanity of Carruth's debut *Primer* (2004). Perhaps most important, however, is the mini-narrative these first five minutes spin, in which worms injected into the bodies of a couple of young boys result in the boys not only moving perfectly in sync together, but also anticipating each other's physical movements in ways that suggest that a deeper human connection has been forged.

Upstream Color © 2013 erbp

Creepy, elliptical, strangely haunting and altogether beguiling – that's the prologue in a nutshell, and once the narrative proper begins, the rest of the film follows suit. In telling the tale of a romance that arises between two people who have both undergone the same trauma, Carruth eschews the usual expository signposts in storytelling and character development. There's dialogue in the film, sure, but much of it is purely functional, giving you the bare minimum of what you need to know about these characters, their circumstances and the mysterious world surrounding them. Instead, Carruth uses technique – carefully calibrated editing, masterfully attenuated soundscapes, boldly coloured imagery, and so on – to suggest, moment-by-moment, mental states and grander themes. *Upstream Color*, in that sense, fulfils that Bressonian ideal of a pure cinema, one that uses technique to heighten our awareness of what Carruth presents to us onscreen.

Such a sharpening of a viewer's senses is fitting for a film that is, in some ways, about opening oneself up to the world, in all its ecstatic highs, terrifying lows and, perhaps most importantly, the mysteries in-between. Beyond the shared trauma that it turns out both Kris and Jeff share, what is it that brings these two people together? Neither seems fully aware of what drives them – but then, universal human experience, especially when it comes to love, can often be just as inexplicable. It's that kind of mystery inherent in the natural world that *Upstream Color* is attempting to evoke through its metaphysical vision, one in which not everything is meant to be logically explained. If control was the stylistic and thematic mantra of *Primer*, then Carruth lets it all go the second time out, aligning himself with the irrationality of his characters while uncannily managing to retain a certain intellectualized distance from it.

His ambition has certainly increased in *Upstream Color* – not just in his increased reliance on bright, open-air imagery but in their unspoken cosmic implications. God-like signifiers abound: The Thief

is glimpsed during Kris's mentally addled state at one point as a mere disembodied voice on the soundtrack, then seen with his face covered by a light that he describes as 'the sun'; The Sampler is seen capturing and manipulating real-world sounds, the editing juxtapositions to similar noises in Kris's and Jeff's ordinary lives, suggesting an attempt at building a world from scratch. But there's only so much they can do to try to control the world around them; eventually, nature intrudes, sometimes positively, sometimes negatively. In the world of *Upstream Color*, violence (the drowning of pigs) can sometimes lead to awe-inspiring beauty (the blue substance that ushers forth from the dead pigs' wounds and turns flowers to that exotic colour); animals and human beings forge strange spiritual connections with each other; and nature sometimes offers unexpected pathways to personal happiness (Kris finding a deliverance from her inability to bear children at the hands of a piglet).

Gustav Mahler famously offered this dictum: 'A symphony is like the world; it must embrace everything.' In that sense, *Upstream Color* is symphonic in the best sense: a riot of puzzle-box narrative and surreal formal invention that converges into a wide-ranging vision of the world – mysterious, mesmerizing and, in the end, strangely affecting. Such is the power of cinema that a film as outwardly metaphysical as this can leave one looking at the real world in front of our own eyes with such renewed wondrous vigour.

Kenji Fujishima

Welcome to New York

Studio/Distributor:

IFC Films
Wild Bunch

Director:

Abel Ferrara

Producer:

Adam Folk

Screenwriters:

Abel Ferrara
Chris Zois

Cinematographer:

Ken Kelsch

Art Director:

Tommaso Ortino

Synopsis

Welcome to New York is based upon the real-life case of Dominique Strauss-Kahn, head of the IMF and presumptive candidate for President of France, who was arrested in New York City on charges of sexually assaulting a chambermaid in his hotel room. These charges were later dismissed. The film follows the public events of the case closely, but a disclaimer states that the private lives of the characters are invented. The movie follows Devereaux, the character based on Strauss-Kahn, through a night of partying with prostitutes in his hotel room, his assault of the chambermaid the next morning, lunch with his daughter at a swanky restaurant, and a cab ride to the airport. Then he is taken off his plane, arrested, and processed through the criminal justice system (handcuffed, left in a holding cell, subjected to a strip search). Devereaux's wife Simone comes from Paris to arrange – and above all to pay for – his defence. Devereaux is released on bail and consigned to house arrest in an expensive Manhattan town house where he reflects on his life, and argues bitterly with Simone, who is furious at his stubbornness and inability to change. Finally, we learn that the case has been dismissed. The last scene shows Devereaux returning to his old ways, flirting with the housemaid.

Editor:

Anthony Redman

Duration:

125 minutes (French version)
105 minutes (USA version)

Cast:

Gerard Depardieu
Jacqueline Bisset
Marie Mouté

Year:

2014

Critique

Welcome to New York is largely a character study. The film continues Abel Ferrara's long-time concern with exploring characters in the grip of pathological, self-destructive obsessions. Stylistically, the film shows Ferrara at his most restrained. *Welcome to New York* has a flat and even static look, without the expressionistic lighting and delirious camera movements of much of Ferrara's work. This is because the film aims, on the one hand, to give an almost documentary re-enactment of the events in the Dominique Strauss-Kahn case, and on the other hand, to focus on the bleak inner life of the main character.

The film is dominated by Gerard Depardieu's performance as Devereaux, which is amazing both physically and psychologically. Here is a man who takes his position of power entirely for granted. The first part of the film is the most ostensibly scandalous, showing Devereaux partying in his hotel room. But the effect is more pathetic than orgiastic, as Devereaux grunts over the bodies of nubile young women, squirts them with whipped cream and douses them in champagne, and gets off on watching them make out with one another. The assault itself takes as little screen time as it probably took in real time; we can see how traumatized the chambermaid is, but also how Devereaux himself could have thought nothing of it, and simply gone on with whatever else he was doing.

Welcome to New York © 2014 Belladonna Productions

The second part of the film, showing Devereaux's arrest and confinement, works largely as a police procedural, showing the bureaucratic details of arrest and the processing of suspects. We see Devereaux handcuffed, placed in a holding cell, and so on. The real intensity here comes when Devereaux is strip-searched. On command, he takes off all his clothes and squats down nude, presenting his ass to the officers who are examining him. Depardieu was truly beautiful in his youth; but this is no longer the case in his mid-sixties. Here, the camera pitilessly displays his flabby, distended belly and wrinkled flesh. There's also a sense of extreme dissonance in the way that Devereaux is exposed to procedures that people of his power and privilege rarely have to deal with, but which are routine for people from other segments of society. The prison guards, and the other prisoners in the holding cell, are largely non-white. The former are not sadistic, but just doing their jobs; the latter are bemused to find this obviously well-to-do white man among them.

The third part of the film shows Devereaux under house arrest in a sleek, modernist $60,000-a-month Manhattan townhouse. Devereaux's exceedingly wealthy wife Simone (played by Jacqueline Bisset with tightly coiled bitterness and anger) rents the townhouse, employs slick and expensive lawyers, and lets Devereaux know of her irritation and disappointment. She has spent years grooming him for success, and trying to get him to outgrow his sex addiction. He responds with little more than sullen refusal. He is sure that all these events are just the result of a plot against him; he tells her that the accusation of rape is absolutely false, because 'all he did' was jerk off in the housemaid's face (he declines to mention that he was forcibly holding her against a wall, and she was begging to be let go). He also tells a psychiatrist (whom he doesn't want to see in the first place, but talks to at Simone's insistence) that he feels nothing whatsoever inside, either about the assault or about his life in general. And in an interior monologue, as he stares out the windows of the townhouse at night, he recalls how easily his youthful idealism gave way to total cynicism. The poor will always be with us, he thinks, and you can't do anything to change their fate. As he tells the psychiatrist, 'no one can save anyone', because 'no one wants to be saved'.

In many of Ferrara's films, his protagonists explode in anger and anguish: Harvey Keitel's corrupt cop in *Bad Lieutenant* (1992) or Forest Whitaker's talk show host and Matthew Modine's arrogant film director in *Mary* (2005). But Devereaux instead seems to implode, to collapse inside himself as into a black hole. Where those other characters, however depraved, are seeking redemption, Devereaux is not. Self-obsessed but not self-aware, and even complacent in his absolute lack of self-insight, Devereaux takes his own power for granted. His appetites are monstrous, and yet at the same time utterly banal. He seems unable to distinguish between sex via seduction, sex for pay, and outright rape. Ferrara's unsparing direction and Depardieu's unforgettable performance show us that the true death of the spirit comes not from some boundlessly energetic display of evil, but rather out of a sort of flaccid, self-cancelling negativity.

Steven Shaviro

Whiplash © 2014 Blumhouse Productions, Bold Films, Right of Way Films

Whiplash

Studio/Distributor:

Blumhouse Productions
Bold Films
Right of Way Films
Sierra/Affinity
Sony Pictures Classics

Director:

Damien Chazelle

Producers:

Jason Blum
Nicholas Britell
Garrick Dion
Jeanette Volturno-Brill

Screenwriter:

Damien Chazelle

Cinematographer:

Sharone Meir

Art Director:

Hunter Brown

Editor:

Tom Cross

Duration:

107 minutes

Synopsis

A freshman at the fictional prestigious Shaffer Conservatory in New York City, loner Andrew Neiman is given a chance just a few days before a local jazz competition to stand as an alternate drummer in the studio band led by conductor Terrence Fletcher. Andrew, at first enthusiastic, is quickly disillusioned by Fletcher's show of ruthlessness and perfectionism, especially towards the performance of Hank Levy's complex jazz piece 'Whiplash'. However, eager to follow in the footsteps of his idol Buddy Rich, Andrew grows increasingly determined to step up as the band's core drummer, and to eventually become the greatest jazz drummer of all time. Abandoning everything, Andrew must bear the full brunt of Fletcher's wrath, and literally spill sweat, blood and tears on his instrument to fulfil his dream.

Critique

A wide-angled shot gazes down a darkened corridor to Andrew Neiman, who then proceeds to play a drum solo that echoes rousingly as the camera slowly tracks towards our lonesome drummer. This is the first shot of Damien Chazelle's second feature, one that accurately sets the film's electrifying energy, as well as encapsulates the solitary narrative of a young man's aspiration for greatness. A sharp turn in tone from Chazelle's *Guy and Madeline on a Park Bench* (2009) – which is somewhat of an urban love letter to the free-flowing spirit of jazz – much of *Whiplash*'s vitality lies in the vexatious relationship between Andrew and JK Simmons's tyrannical Fletcher. Dressed completely in black attire,

Cast:

Miles Teller
JK Simmons
Paul Reiser
Melissa Benoist

Year:

2014

veins throbbing out from beneath his bald head and jacked arms, Fletcher resembles an aged Beatnik, hardened through time. Having navigated between menacing roles such as feared white supremacist Schillinger in the prison-set television drama *Oz* (HBO, 1997–2003), and the loveable paternal role in *Juno* (Jason Reitman, 2007), Simmons's disposition manifests from a cool patience to predatory viciousness, as one unforgettable scene displays when Fletcher probes Andrew with increasing malice if the latter is 'rushing' or 'dragging' his tempo.

The rationality behind Fletcher's barbarity is an anecdote of how jazz legend Charlie Parker's determinism was born after a cymbal was thrown at his head, and that 'good' and 'job' are the two most harmful words in the English language. In addition, drummer phenomenon Buddy Rich's own reputation as a tyrant to his own players also provided itself as a character influence. Through Fletcher's tyranny, the viable energy and tone of Andrew's playing and that of the film impinges into agitation, yet it if anything becomes more engrossing. *Whiplash* has been seen as a music-themed offspring of Stanley Kubrick's war-horror classic *Full Metal Jacket* (1987), and the similarity is obvious when comparing Fletcher's likeness to the bullish Sgt Hartman's poetically colourful wordplay. However, *Whiplash* does not paint as ominous a picture of the ill-fated result of abusive drilling as Kubrick's picture quite did.

Andrew himself degenerates into somewhat of a deplorable character. In his constricted, relentless pursuit for greatness he unflinchingly abandons girlfriend Nicole (Melissa Benoist), and as portrayed during a tense dinner-party sequence he proclaims to see no use of friends and sardonically denounces the achievements of his cousins' third-league football accomplishments. Nevertheless, we find our sympathies being drawn towards him. A few times we see Chazelle have Andrew race against the clock and encounter unexpected obstacles, proving that none-too innovative narrative techniques and a highly motivated protagonist are all you need to get the audience cheering. Even though an incident involving one of Fletcher's former students should deter our hopes for Andrew to reach his goal for eminence, here classic film-making prevails over moral rationality.

Therefore, up until its poignant climax the audience's judgement towards Fletcher is somewhat obscured as there is an ambiguity underlining his intentions. Does Andrew defy Fletcher's ruthlessness or is he being led by it? Such ambiguity is at the heart of Chazelle's high-concept screenplay for Eugenio Mira's taut thriller *Grand Piano* (2013), wherein a classical pianist is forced to overcome his stage fright while caught in the crosshairs of a sniper rifle with the marksman taunting him through an earpiece ('Just think of me as the voice inside your head telling you that good isn't good enough tonight'). This theme is derived from Chazelle's experience in a competitive high school jazz band – under a Fletcher-like leader – that is, incessant practice leads to artistic betterment.

Expanded from an eighteen-minute short, which also starred Simmons and received much acclaim at the 2013 Sundance Film Festival, *Whiplash* favours the rapid tempo of its tight twenty-day

shooting schedule over an intricate melody or complex narrative. Chazelle oscillates between slow motion and extreme close-ups of blood, sweat and tears splashing off the cymbals, and it is no surprise that editor Tom Cross constructed the standoffs between Andrew with the legendary fight sequences of *Raging Bull* (Martin Scorsese, 1980) in mind. Indeed, *Whiplash* is as much about music as *Raging Bull* is about boxing – not very much. In each film the respective craft is merely the means to explore the jealous and obsessive nature of its subjects. However, whereas this nature leaves LaMotta destroyed, *Whiplash*, with its less than harrowing culmination, ostensibly justifies it.

In addition to bringing a lump to the throats of anyone next time they hear a jazz number, Chazelle has undoubtedly produced a vibrant, superbly acted picture and perhaps the most watchable one of the year.

James Vujicic

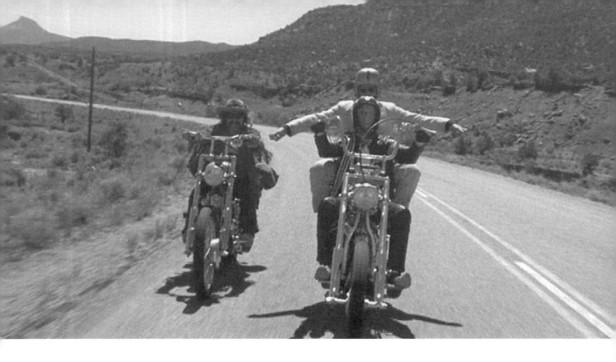

Easy Rider © 1969 Pando Company Inc.,
Raybert Productions

INDUSTRY SPOTLIGHT
BBS PRODUCTIONS

BBS Productions was a motion picture sub-division of Columbia Pictures which functioned from 1969–74. Formally named Raybert Productions after its founders Bob Rafelson and Bert Schneider, the company took on the name BBS when former manager of singer Bobby Darin, Steve Blauner, joined as a third partner after the box office success of the company's second feature *Easy Rider* (Dennis Hopper, 1969). That film earned the studio a huge profit – generating an astounding $41,000,000 from a mere $340,000 budget. Its success reversed the downward financial trajectory Hollywood had endured throughout the 1960s, when a string of family-oriented mega-budgeted pictures such as *Cleopatra* (Joseph Mankiewicz, 1963), *Doctor Dolittle* (Richard Fleischer, 1967) and *Star!* (Robert Wise, 1968) suffered at the box office, subsequently driving the already fragile industry into a panic-inducing economic downturn.

In a bid to replicate *Easy Rider*'s success, Columbia proposed a six-picture deal with BBS. The contract secured a theatrical release of each picture, and placed the right of final cut in the hands of Schneider as head producer. A production budget of $1 million per movie was also agreed with the studio, on the condition that any budget overruns

come out of the producers' pockets. The resulting pictures were *Five Easy Pieces* (Bob Rafelson, 1970), *The Last Picture Show* (Peter Bogdanovich, 1971), *A Safe Place* (Henry Jaglom, 1971), *Drive, He Said* (Jack Nicholson, 1972), *The King of Marvin Gardens* (Rafelson, 1972) and the documentary *Hearts and Minds* (Peter Davis, 1974). As Schneider explained,

> We do not care what the story content of a film is, who the stars are, or if there are stars involved. We are concerned only with who is making the film. If his energy and personality project something unique, he is given the freedom and help to express himself. (Cagin and Dray 1984: 81)

Although produced by a diverse set of film-makers, each of these films, in varying ways, adhered stylistically to the tradition of storytelling synonymous with that of the 'new' Hollywood: a loosening of classical storytelling norms and an acquisition of more 'European' storytelling conventions, such as character-driven pieces often lacking neat resolutions, and the integration of more self-conscious stylistic devices. This trend was precipitated by the young aspiring film-makers' unprecedented exposure to foreign art cinema with the founding of the New York Film Festival and the rise of the arthouse theatre in the early 1960s, where films from the likes of François Truffaut, Jean-Luc Godard and Ingmar Bergman suggested new methods of storytelling. In addition, the gradual dissolution of the Hayes Production Code during the 1960s enabled film-makers to experiment with explicit themes and content concerning female sexual promiscuity, graphic violence and moral ambiguity. *Bonnie and Clyde* (Arthur Penn, 1967), *The Graduate* (Mike Nichols, 1967) and *They Shoot Horses, Don't They?* (Sidney Pollack, 1969) are examples of major studio releases that exemplified changes in both style and content. However, it was *Easy Rider* which truly brought the 'new' Hollywood into industrial propitiousness when it initiated the BBS/Columbia deal, prompting other studios to open their own youth-oriented subsidiaries. Indeed, it was a trend which Ned Tanen – the executive producer overseeing Universal Pictures's youth-oriented production company – befittingly coined the '*Easy Rider* syndrome' (Pye and Miles 1999: 73).

With regards to most of the film-makers at BBS, it was the extemporaneous independent film-making practices under American International Pictures where BBS acquired a budget-savvy aptitude towards production. Under the wing of 'B-Movie King' Roger Corman – who from 1954 to 1960 alone had almost forty productions to his name – actors and technicians worked in conditions where time and money were fiercely scarce, occasionally having to shoot at least two movies in a matter of days on the same set. Almost all of the film-makers at BBS had participated in Corman's productions during the 1960s: *The Wild Angels* (Roger Corman, 1966), *The Trip* (Roger Corman, 1967), *Psych Out* (Richard Rush, 1967) and *Targets* (Peter Bogdanovich, 1968) are a selection of titles directed or produced by Corman to which Hopper, Fonda, Bogdanovich, Jaglom and Laszlo Kovacs (who would become the in-house cinematographer for BBS) had collaborated prior to BBS.

Television production also provided lessons in haphazard filming techniques, as was the case with Raybert Productions during the production of *The Monkees* (NBC, 1966–68), a satirical television show depicting the fictitious adventures of the pop/rock group. *The Monkees* was filmed using speedy and parsimonious production methods, where rudiments such as background lighting were sacrificed to enable the number of set-ups per episode to reach a daily average of 78 to 100. Not only did these financial constraints teach film-makers to budget efficiently, they also provided an insouciant creative atmosphere enabling new talents to try their hands at various crafts.

Fusing the two media together constituted a multifaceted approach to film-making that helped nurture a sense of egalitarianism through artistic camaraderie. If there was one figure that most epitomized this ethos, it was Jack Nicholson. Nicholson adopted a polygonal approach to film-making almost as soon as his acting career began; under the wing of Corman, Nicholson was given the opportunity to direct a few sequences for both The Raven (Roger Corman, 1963) and The Terror (Roger Corman, 1963) (Stapleton 2011). Before writing the script for The Trip, Nicholson also wrote and co-produced Monte Hellman's Flight to Fury (1964), Ride the Whirlwind (1965) and The Shooting (1966), with the last two Nicholson promoted at the Cannes Film Festival to attract international distribution. Experience across a broad array of fields led to the beginnings of Nicholson's role with Raybert when he wrote the company's first feature, Head (Bob Rafelson, 1968) – a kaleidoscopic deconstruction of The Monkees – and stood as production supervisor on Easy Rider, before stepping into the role of George Hanson whose sequences he would edit himself (Kiselyak 2000 [1999]). His participation grew during the BBS period, starring as the lead in Five Easy Pieces; acting in A Safe Place and The King of Marvin Gardens; and directing his debut film Drive, He Said. With Nicholson going on to act in films by 'new' Hollywood icons such as Ashby, Polanski, Forman and Rafelson, Cagin and Dray (1994: 65) argue that Nicholson's post-BBS career 'strongly bears the imprint of this formative period'. However, it would be truer to argue that it was in fact Nicholson's pre-BBS career which serves a more accurate reflection, seeing as it encapsulated an eclectic craftsmanship so fundamental to the running of BBS. Either way, Nicholson's embodiment of this artistic diversity deems him, as the scholars conclude, the 'pivotal BBS figure' (Cagin and Dray 1994: 82).

However, it would certainly be misleading to argue that the production of Easy Rider established a blueprint which adumbrated the film-making conditions of the subsequent BBS films, despite how integral the low-budget biker road-movie was to BBS's contractual deal with Columbia. Since BBS established itself under the financial/distribution wing of the studio, all its subsequent six pictures were emancipated from the only legitimate claim Easy Rider held to the title of an independent production – a film financed and produced outside a major studio. Yet this merely placed Easy Rider within the majority of Hollywood pictures following the de-monopolization of the industry in 1948, when antitrust suits forced the studios to shift their efforts from exhibition and production to distribution. To this effect, by 1960, as Monaco points out, two-thirds of features released in the country were technically 'independent' (Monaco 2001: 24).

Nevertheless, despite the industrial reconfiguration, production of a film remained greatly dependent on the studios' domination over the fields of distribution. As Hugo explains, distribution grew increasingly complex since the mass suburbanization of the middle class after World War II, which decentralized the traditional inner-city motion picture audience demographic (Hugo 1981: 48). With only the studios holding the logistical means of film distribution, 'independent' film-makers were still dependent upon the studios to have their work seen by a mass audience. Indeed, this reality rang true with BBS. Schneider, despite advocating free creative expression, nonetheless imposed a considerable degree of authoritarian mediation to ensure a film's market credibility.

One event which shed light on BBS's astringency concerned the independent film-maker Jim McBride, whose project 'Gone Beaver' was shut down by the company in the early stages of production. Already delayed by legal complications surrounding the immigration of Spanish cinematographer Nester Almendros and British actress Vanessa Redgrave, production of the film eventually collapsed due to McBride's refusal against BBS's 'insistence' on Schneider's brother Harold's active participation as production over-seer (Anon 1972: 30). Dennis Hopper himself felt the brunt of BBS's astringency while trying to find financial backing for his second feature, The Last Movie (1971). Both

Schneider and Blauner rejected Hopper because of a shared lack of faith they felt in his ability to both direct and star in the film, despite the role he played in the company's flush of initial success (Biskind 2007: 125). Subsequently, Hopper was forced to seek a deal with Universal's youth-oriented production unit which granted Hopper final cut as well as a 50 per cent share of the film's gross profits (Winkler 2011: 143), an 'extremity', as Biskind points out, 'from which even BBS shrank' (Biskind 2007: 125)

Indeed, despite his ostensibly anti-interventionist stance on the film-making process, there is evidence that Schneider exerted control over the creative process of the BBS films, something he was able to do through the right to final cut, which was placed in his hands as opposed to the directors of each film. Incidents such as that reported by journalist Grover Lewis (1971) on the set of *The Last Picture Show* unveils the truth behind Schneider's advocacy for creative freedom. When the production was running behind schedule, location manager Frank Marshal testified to how '"Schneider […] begun to act very producer-like and chop out scenes"' (Lewis 1971: 159). Although motivated by the need to keep production moving forward, a scene Schneider made Bogdanovich 'red pencil' involving a gang of boys fornicating with a 'heifer', suggests Schneider's intentions were concerned more with the film's marketability than simply keeping production within schedule (Lewis ibid).

The constant reminder of BBS's dependence on Columbia came about through Schneider's right to final cut. In fact, a crucial factor behind the strong relationship between BBS and Columbia had to do with family relation – Bert Schneider's father Abe was the chairman at the Columbia Pictures board and his brother Stanley was studio president (Cook 2000: 109). There was indeed a contradiction 'at the heart of BBS', as McBride puts it (Biskind 1998: 77). While advocating free artistic expression, and on the other hand intervening in the creative processes of its films, BBS 'walked the line between being a countercultural powerhouse and a conventional production company' (ibid: 77).

The company's lifespan from *Easy Rider*'s release in 1969 to the company's dissolution in 1974 provides a somewhat accurate measurement of the 'new' Hollywood period itself. The condition which BBS was predicated on was from the outset a means of bringing Columbia, and the other studios with their respective sub-divisions, out of economic despair. The films' failure to attract the same box office success that *Easy Rider* had had, essentially meant that BBS became a defunct corporate strategy. Eventually, the six-picture contract was annulled after producer David Begelman's annexation of the studio rid Columbia of the Schneider name, and royalties on BBS's previous films were seized (Cook 2000: 544).

BBS's final picture, the anti-Vietnam War documentary *Hearts and Minds*, managed to find a distributor in Warner Bros. In a befitting display of the contradiction between the Hollywood mainstream and counterculture cinema, the documentary was welcomed by the Academy, winning the Oscar for Best Documentary in 1974. The following year saw the end of the 'new' Hollywood, when the tide of plot-driven franchise films would put the industry back on its feet and transitioning into the blockbuster age.

Although its operation was short-lived, BBS's legacy still continues to glow. In the fundamental role it played in instigating the 'new' Hollywood, BBS was responsible for enabling previously unknown film-makers to produce some of the finest films to come out of Hollywood cinema. Furthermore, in regards to the history of American independent cinema, BBS's legacy rests upon how it provided a model for what is widely recognized today as independent Hollywood cinema: sub-divisions specifically aiming at producing provocative, controversial and challenging films, yet under the financial and distribution wing of major Hollywood conglomerates.

James Vujicic

References

Anon. (1972) 'BBS & Hollywood Unions: Camera Import Nix for "Beaver"', *Variety*, 8 November, p.30.

Biskind, P. (1998) *Easy Riders, Raging Bulls: How the Sex 'n' Drugs 'n' Rock 'n' Roll Generation Saved Hollywood*, London: Bloomsbury.

Cagin, S. and Dray, P. (1984) *Born to be Wild: Hollywood and the Sixties Generation*, Boca Raton, FL: Coyote Books.

Cook, D. (2000) *Lost Illusions: American Cinema in the Shadow of Watergate and Vietnam 1970–1979*, Berkeley: University of California Press.

Hugo, C. (1981) 'American Cinema in the '70s: The Economic Background', *Movie*, 27–28 (Winter/Spring), pp. 43–49.

Kiselyak, C. (2000 [1999]) *Easy Rider: Shaking the Cage* [DVD], USA: Sony Pictures Home Entertainment.

——————— (2011 [2009]) 'Soul Searching in "Five Easy Pieces"', *America Lost and Found: The BBS Story* [DVD], USA: Criterion Collection.

Lewis, G. (1971) 'Bogdanovich's *Last Picture Show*', in P. Travers (ed.), *The Rolling Stone Film Reader: The Best Film Writing from 'Rolling Stone' Magazine*, New York: Pocket Books, pp. 157–69.

Monaco, P. (2001) *The Sixties, 1960–1969: History of the American Cinema*, Berkeley: University of California Press.

Pye, M. and Miles, L. (1999) 'George Lucas', in S. Kline (ed.), *George Lucas Interviews*, Jackson: University Press of Mississippi, pp. 64-86.

Stapleton, A. (2011) *Corman's World: Exploits of a Hollywood Rebel* [DVD], USA: Stick 'N' Stone Production/Anchor Bay Films.

Winkler, P. (2011) *Dennis Hopper: The Wild Ride of a Hollywood Rebel*, London: Robson Press.

INTERVIEW WITH ALEX KENDRICK OF KENDRICK BROTHERS PRODUCTIONS/SHERWOOD PICTURES

From the earliest decades of the film industry, religious individuals and institutions have utilized film as a tool for evangelism and instruction, in addition to providing 'suitable' entertainment that counters Hollywood's values. But the surprise box office success of the apocalyptic thriller *The Omega Code* (Robert Marcarelli, 1999) launched a new wave in popularity of theatrically released Christian films, reaching its apotheosis in 2014 with the financial triumphs of *Heaven Is for Real* (Randall Wallace, $91 million domestic), *God's Not Dead* (Harold Cronk, $60 million) and *Son of God* (Christopher Spencer, $59 million). Armed with greater resources, these films shattered the previous records set by Sherwood Pictures releases *Fireproof* (Alex Kendrick, 2008, $33 million) and *Courageous* (Alex Kendrick, 2011, $34 million).

Alex Kendrick directing *War Room* © 2015 AFFIRM Films, Provident Film, David Whitlow

Working out of Sherwood Baptist Church in Albany, Georgia, Alex and Stephen Kendrick have become the most recognizable film-maker names in the Christian film industry, essentially creating their own brand, which has also made them less reliant on stars than many other Christian films. Their microbudget debut, *Flywheel* (Alex Kendrick, 2003), was made for only $20,000 but sold over a million copies on DVD, while their second film, the American football drama *Facing the Giants* (Alex Kendrick, 2006), was made for only $100,000 but grossed over $10 million at the box office.

In the following interview, Alex discusses their meagre beginnings, rising budgets, influences and inspirations, his collaboration with his brother, and the decision to form Kendrick Brothers Productions in 2013, through which they have released their most recent film, *War Room* (Alex Kendrick, 2015). With a North American gross of over $67 million on a $3 million budget, it has become their most successful film to date, crossing over to additional markets as a result of its primarily African-American focus.

How did Sherwood Pictures get started? What started you and your church to start making films?

I would say that my brother Stephen and I, we grew up making family videos with our home video camera and really had fun developing a knack for telling short stories in three- to five-minute videos. We used to edit between our VCR and our camcorder and would do that for school projects. Instead of live book reports, we would offer to make videos and show them on the VCR and television in our classrooms and in the 1980s – the late 1980s – that was still fairly novel. And we really enjoyed it, and we developed a love for ministry. As we grew and began doing videos for ministry, my older brother Shannon ended up graduating from Georgia Tech and going to work for IBM. Stephen, my younger brother, and I both graduated high school, got our communication degrees from Kennesaw State University in north Georgia, and then both went to seminary and went into ministry and as a part of that continued making videos.

But the older we got, the videos went from just being a means of entertainment or humour to being used as a tool to either disseminate information or to move audiences with a short story, but they were all very short. We wanted to make a full-length feature one day, but did not have the means or the connections to do that. In 1999, I was hired by Sherwood Baptist Church in Albany, Georgia, to be their associate pastor of media. They had a low-power television station, and so they would broadcast their Sunday services, or other events in the community on that channel, so I came down to Albany from Atlanta in 1999 and began overseeing the ministry outreach for their media department for that television channel. Stephen came down two years later, and also was an associate pastor.

In 2002, I read an article by George Barna – he runs the Barna Research Group – and he had done a nationwide survey, and based on his research he came up with the statement that movies, television and the Internet were the three most influential factors in our culture. And you know, I read that and of course everybody I know goes to see movies, watches television and uses the Internet so I agreed with that. It was interesting that in that survey the church and even religious institutions were on the list, but a lot further down the list. You know, in the 1950s and 1960s they were in the top three... I began a dialogue with my pastor about doing a low-budget film for our community, and he was cautious about the idea at first, but he was open to it, and I began praying about writing a low-budget film, a full-length film for the community. I wrote a story called *Flywheel* about a used car salesman, and I began praying, asking God to give me the means to make that film. And he did. I

was honestly surprised when people began giving me money with no strings attached. I raised $20,000 and Stephen helped me make our first movie *Flywheel* with one camera, one microphone, one small soundboard, and one set of lights. It was a very, very small production. All the money went to the equipment.

The movie came out in our one local theatre and it was supposed to last one week. They were actually very reluctant to put it on because they didn't know how well it would do. But since we were a large church, and they thought, well, your church members will come… That particular theatre has sixteen screens and we were their second highest grossing movie, which surprised all of us, including the theatre manager, and he kept extending the stay and we ended up staying six weeks and all the money was returned that was invested in the movie, and so the bigger and more important aspect was we had hundreds of people respond to seeing the film, and so we decided to release it on DVD and it began selling faster than we could make duplicate copies. And I think after about 10,000–20,000 copies sold, we were picked up by Blockbuster and they put a copy in each of their stores nationwide. We were stunned at that. We began getting so many e-mails and letters from people who had seen this very small-budget movie that we realized this was a very viable ministry outreach and so we began praying about a second movie with the hopes it could be better quality and in more theatres, and today that first movie *Flywheel* has now sold a million copies on DVD.

[In] 2004, my brother and I prayed about it and asked God for some ideas because we had never been trained in screenwriting and we began writing the story for our second movie called *Facing the Giants*, and this time we got one high-definition camera and with the volunteer help of our church, we made the movie. So the budget went from $20,000 for *Flywheel* to $100,000 for *Facing the Giants*. We shot it with one high-definition camera, using our local Christian school. Our hope was to get it in theatres. When it was done we showed it to a number of studios. We flew out to California and screened it for 20th Century Fox and for some others. They all seemed impressed that we made a feature film for $100,000, but did not think that it was worth putting in theatres and they gave us a list of reasons that we understood: it did not have any recognizable actors in it; it wasn't a high-dollar movie; and it was obvious that it was a lower-budget film. We were very discouraged, so we began praying again. During that time, we were looking for permission to use certain pieces of music in the film and we contacted a company in Nashville, Tennessee called Provident Music Group. We sent them a DVD. For a while they did not watch it, and we actually forgot we had sent them the DVD since so many weeks had gone by. Eventually when they did watch it, they were surprised and the president of Provident Music Group called us and said that they were interested in sending the movie to their parent company for theatrical distribution and we were very shocked by that. We asked, 'Well, who's your parent company?' He said, 'Sony.' Well, we had approached a number of studios and distributors, but Sony was not one of them. They ended up putting it in 441 theatres… about a tenth the number of screens of a larger movie, but anyway the movie came out, and the expectation was $3–5 million and we were all surprised when it did over $10 million. It then sold 2.5 million DVDs and it's still selling, and so you know that was hard to explain.

And so we began praying, 'Do we continue making movies?' This is obviously reaching an audience that is much broader than we expected. The money that came back from those films, the majority of it did go to the distributor. They by far took the lion's share, but the church did get back a significant amount, certainly more than we invested in it. We're a nonprofit organization and so we said we've got to fund our ministries with it, so that's what we did… New churches, new ministries… We built a sports park for the community that's usable for anyone in our city, with soccer fields and softball fields, volleyball courts and tennis courts, and that's been huge for the city of Albany.

War Room © 2015 AFFIRM Films, Provident Film

We began writing the third movie. We felt like the Lord was prompting us to talk about fighting for your marriage. And so my brother Stephen and I wrote our third script for *Fireproof*. Fireproof was made for a budget of $500,000 and it came out in theatres through Sony's Provident Films. I think they partnered with Samuel Goldwyn who actually booked the theatres, but it was primarily Sony. It came out in 2008 and it grossed over $33 million. And that surprised us! We didn't think it would do that well, but actually it became the number one independent film of 2008. And my brother and I wrote a corresponding book called *The Love Dare*. We really wrote the book after the movie, and it became a *New York Times* best-seller. We would pray, we would obey what we believed God had called us to do; the Lord would send us the people – the actors or whoever – for free; the movie would come out with a ridiculously low budget, and it would do crazy numbers. Sony said, 'We love this, but we can't explain it. Churches aren't supposed to make movies. That shouldn't be working like this. Most people struggle to get their film finished, and then really struggle to make a profit on it and you guys with no film degrees and no prior official education in making films have made three films that have sold millions of DVDs and done really well in theatres. This just doesn't make sense.' Again, we were contacted by – and this is no exaggeration – by thousands upon thousands of couples saying, 'This movie really helped our marriage…'

And then we started praying again and we felt like God said, 'Make a movie about the importance of fatherhood.' So we wrote the movie *Courageous*… It came out in the fall of 2011… and did just shy of $35 million… So again we cannot look at each other and it is hard for us to define why the movies work, why people go to see them. There's no Hollywood actors in these things – Kirk [Cameron] is the closest we've gotten to a recognizable name – but yet people go see them and we have sold a collective total of 9 million DVDs. Even other distributors – we've been contacted by 20th Century Fox, Lionsgate, Film District – they've all said, 'Guys, we don't know why this is working but we'd love to talk to you.' Now at this point, we're still with Sony, so if you were to ask me,

'Why are they working?' This is going to sound silly, but I don't know what else to say other than God is doing something we can't explain.

So we've got four movies. They collectively have done $78 million at the box office. They collectively were made for about $2 million. Nine million DVDs have been sold, *New York Times* best-selling books… and then I think when the *Courageous* DVD came out, it came out of the gate the number one selling DVD in the nation when it premiered… It's hard for us to explain it other than we prayed a lot. We are still learning how to make films. We know that there are weaknesses in our films, but we're still learning how to write scripts, tell stories and produce them… So we credit God, and I know a lot of people that are not in the world of faith, they roll their eyes, and they say, 'What's the real deal?' And we don't really know what to tell them other than we were amateurs, we're still learning, but yeah we're gonna keep going. So that's my long answer, and maybe I've knocked out several of your questions by doing that but that's my long answer.

That was a few of them. So what films and film-makers have influenced you?

Well, I mean, probably several that have inspired a lot of people. We like the cinema style of Spielberg, we love the way he captures expressions and the way he moves the camera. You know I like the way Michael Bay moves it, but I think he moves it too much, almost like the entire movie's a music video. But I do like camera movement, so I probably prefer Spielberg. I like the storytelling ability of Robert Zemeckis. I even go back to Frank Capra. I love the heart in his films. *Mr. Smith Goes to Washington* (1939) and *It's a Wonderful Life* (1946) and some of the ones he did, they have loads of heart.

***Meet John Doe* (1941)?**

Yeah, I mean all of those films he did, those old ones, were fantastic. I like *Sergeant York*, that's from 1942. That's an excellent movie, but yeah we like the classics, we like even the 1980s when, you know, *Chariots of Fire* (Hugh Hudson, 1981) was coming out, some of those are very engaging movies. My kids still watch the classics you know: *The Sound of Music* (Robert Wise, 1965), *Mary Poppins* (Robert Stevenson, 1964), a lot of Disney stuff. Pixar is so good at telling stories you can engage the whole time. But as far as our style, I like *Shadowlands* (Richard Attenborough, 1993) – it's got Anthony Hopkins in it – the CS Lewis story.

One of my favourites.

So yeah, there's a few that have inspired us. You know, even though I know he's really been in trouble for a number of things, the movies that Mel Gibson directed, I thought he did a really good job on… *The Man Without a Face* (1993), *Braveheart* (1995) and *The Passion of the Christ* (2004), and he has proven to be a very effective storyteller, but he does it few and far between, and I know he's had his speed bumps in recent years, but he's been an effective storyteller.

How do you and Stephen collaborate? I know you have different roles in the films – you usually direct, write, produce, edit and play the lead. Stephen writes and produces.

Well, the reason I love working with my brother is we have enough in common where there is some aspect I can do or he could do, but we have enough differences where he has a set of strengths I do not have. If you look at our credits closely, you'll see that early on I wore a lot of hats. I think I had six or seven jobs making *Flywheel*. But originally that

was out of necessity. That's because I just didn't have the help. I had a bunch of church members around me that consisted of farmers and homeschool parents and people like that who had no clue how to make a movie. You know they would do whatever we asked them to do, but there was zero expertise. So *Flywheel*, I wore a lot of hats and Stephen helped me out when he could. By the time we got to *Facing the Giants* we produced together and wrote together. By *Fireproof* I started to gravitate towards directing and editing, and I'm not in *Fireproof* except in the very end where I do a small cameo. *Fireproof* is where we learned Stephen is a better producer than me. So by the time we got to *Courageous*, you don't see me producing anything. So what we do, we develop the story together. We write it together and I direct while Stephen's producing, and that's our strength. And we both do the books together. Now I do enjoy editing. So I worry about writing, directing and editing, Stephen worries about writing, producing, and then Stephen is the main guy that oversees the books… the ministry book and curriculum, because we have curriculum with these films, they're ministry-oriented. We've worked together, you know, since we were kids, and a lot of brothers have friction, and our friction is very rare. We really enjoy working together and hanging out together, so it's been a really good thing.

How do you find time to make feature films while working as full-time ministers?

Well when we started we were definitely full-time ministers and we had to shoot movies on long lunch breaks, evenings and weekends. That didn't leave a lot of family time. By the time the movie *Fireproof* was in production, we had a meeting with our pastor. We said, 'Pastor, we love our jobs at the church, but these movies are developing into

Facing the Giants © 2006 Sherwood Pictures

something that is much bigger and requiring so much time and focus that we have to figure out how not to burn ourselves out trying to be full-time ministers and film-makers.' And so… the church said, 'This is a big enough ministry now and when you guys are not making the films, you're writing and when you're not writing, you're speaking at conferences and seminars and at other churches and sometimes at our church. You guys just focus on those things and let us get somebody to take your office duty during the week,' and so that's what we did. And that was a wonderful arrangement with the church. Today, Stephen and I just worry about the movies, books and speaking. Even though we're still at the church, we're not on salary at the church anymore, but we're still ordained ministers of the church, still on staff. The jobs we used to do in house are now done by other guys that we've also hired.

All four films released so far have been Sherwood Pictures productions. What was behind the decision to form Kendrick Brothers Productions in April 2013?

When we were making the last two films, something consistently began happening. We were approached on a regular basis by these young film students who desperately wanted to learn and get mentored by us. At first we were thinking, we're not far enough along ourselves to turn around and start mentoring, but they kept coming, kept coming,

Fireproof © 2008 Sherwood Pictures

kept coming. What we soon figured out was that there's not a whole lot of places for someone to learn film-making, especially from a ministry standpoint, and get training… They approached us by the hundreds. It was amazing the number of people that would call, e-mail, or come see us at the church. So we said, 'What are we going to do with all these young people who want to help us make films?', because we were saturated with up to 1,700 volunteers from our church. It's not like we're looking for more people to do volunteer jobs. And so that became the first issue. The second thing was that in order to use those 1,700 volunteers at our church, you have to shoot your movies near the church in Albany… We had, after four films, all but exhausted every shootable location in our small city… We're thinking, at some point, are we ever going to shoot anything beyond Albany, Georgia? Well if we do, that raises two big issues: number one, where were we going to do it; and number two, how are we going to take our volunteers with us? Well, that's a big problem, especially if you're going to keep making $500,000–$1 million movies.

So we had a talk with the pastor and we said, 'What do you think if we accomplish two things here? If we let the movie ministry become what it could become if we don't put a lid on it? Which means we don't say every movie has to be shot in our community, and they all have to be done by our volunteers only. Can we include some of these hungry film students that want to learn the craft and are already trying to learn how to be cinematographers and production designers and lighting/audio technicians and all this kind of stuff to do movies? Can we begin looking at training the next generation of film-makers?' And then we began contacting a lot of these universities and they said we'll even give our students course credit to come serve on your film crew for six or eight weeks. They get credit and experience, and you get the help you need… So we're going to shoot in Alabama for a number of reasons… we get tax incentives, we find the location we want to shoot in, we get Christian film students, they get course credit for helping us, they're excited and hungry to help us, and we can make a higher-quality movie, and continue growing our ability, so that's what we're doing, but our home base is still Sherwood.

Even before you formed Kendrick Brothers Productions, the Kendrick Brothers name was a very recognizable brand name and kind of a stamp of quality for your fans. Do you and Stephen consider yourselves Christian film auteurs?

I would never use that term. We're hoping to do what we can to encourage the production value of more films to honour the Lord. We have often said that we consider the current Christian film genre to be in its early stages, much like Christian contemporary music was in the 1980s. It was pretty good but you saw a lot where it lacked. So we're hoping to help the whole Christian film genre improve… I would say today if you look at the Christian contemporary music movement, there is not a whole lot of quality difference from what they're doing from what the world is doing. There's a lot of stuff that's really pretty good out there now, and we've got some excellent singers and musicians and the producers that are doing the albums. It's pretty much the same quality as what we're hearing on the secular radio and so we hope that the quality of the [film] productions get there in the coming years.

You mentioned that most of your cast and crew are all volunteers. Your credits sometimes list dozens or hundreds of people, serving in catering, childcare, even prayer coordinators and assistants. Stephen has said that he sees the team that you have assembled working together with the common goal as a perfect metaphor for the way the church ought to be. Is this emphasis on volunteerism a viable model for independent film-makers working outside of the church-based film movement? Is this something that's possible?

Yeah, what we've learned is when you have a group of people that are passionate about the same cause and are working together in unity you can really accomplish anything. That's true no matter who you are or where your coming together, but you know so far our volunteer teams have been amazingly unified because – and Kirk Cameron said it best when we were shooting *Fireproof* – in the second week of shooting he came to me and he said, 'You know, I finally figured this out.' I said, 'What are you talking about?' And he said, 'In Hollywood, I kept asking myself what's different, and what's missing? When I'm here with you guys it's almost like being at church camp and there happens to be a movie camera.' He said that there's no egos here. You don't have producers in sunglasses walking around with their cellphones shouting at people. He said we don't have the star treatment or the different caste system where you have your low level, you know, crew members and then your mid-level, you know, supporting actors, and your 'A'-list actors and producers – it's kind of a caste system, you know… You know, Kirk said making *Fireproof* was one of his favourite experiences working on a project, and so that said a lot to us, because we didn't know any different. You know my brother and I had never done anything outside of these films. Then of course today we're trying to consult and help a few other people with some smaller projects, but our experience has been very limited, and so it was very encouraging to hear Kirk say those things.

Speaking of Kirk Cameron, he is the only star so far that has appeared in your films. It seems that most faith-based films today that have secured theatrical distribution typically have some big name attached to the film. Do you feel any pressure to secure well-known actors for your films and why do you choose to not go that route?

You know what? One of the blessings of working with Kirk was that he identified with the messages in our films… You know, ministry is our top priority. The business side of it is always secondary. And obviously we hope they do well. We hope they're successful in the box office and on DVD, but for us that's one of the reasons that we haven't tried to chase down big names is that we want the people in our films to be ambassadors for the message of the film… And so you know if we find professional actors that we can trust with that platform we're certainly open to using a name in the film, but I would dare say I don't know that there are very many that would say, 'I'm a Christian and I identify with your faith and the reason you make movies and I'd love to help you'… but if we find people like Kirk that would be faithful with that type of platform, we're certainly open.

Your films feature struggling married couples, whether they have children, like in *Flywheel*, or not, as in *Facing the Giants* and *Fireproof*. You also tackle a myriad of problems: infertility in *Facing the Giants*, Internet pornography addiction in *Fireproof*. How deliberate are you in deciding what issues you want to tackle in your films?

You know what? That comes after that season of prayer… And in those films, those issues came to the surface and we have a desire to deal with common real-life hurdles that most people face, you know: parenting, fatherhood, financial issues, integrity. All those are common issues that most people can relate to and deal with… We are driven to put common realistic issues in our films to hopefully bring some inspiration and hope and increase the faith of the audience by the time they've finished the film.

For *Courageous* you also spent more time with the African American community and also featured a Latino family. Was this a deliberate decision as well? Was that because of any criticism about the three previous films?

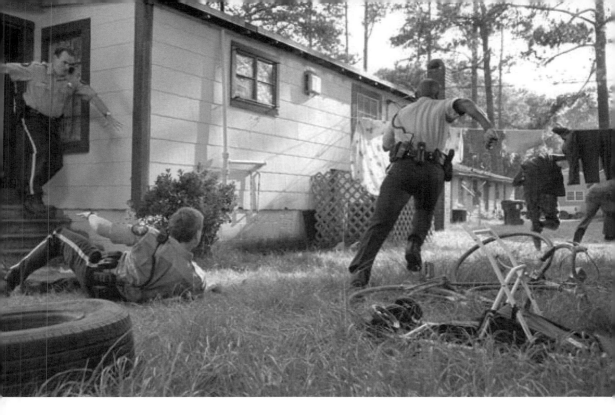

Courageous © 2011 Sherwood Pictures

Any criticism we got was minimal. But you know, when *Courageous* was in the early stages, we talked about what kind of family to portray taking this journey and do we handle it from an African American or a Latino or a Caucasian perspective. Then we thought, why not do all of them? And so we follow these families… And in future movies we plan to continue doing that. We want to tell our stories from a number of vantage points, and maybe from any number of races or perspectives, and so we hope to hit as wide an audience as possible.

You mentioned how your budgets have steadily increased. Do you envision your budget staying on this trajectory or has it plateaued? Has technology helped lower costs in any way for independent makers like yourselves?

You know, technology has made the process more fluid. Shooting a movie on video today is certainly easier than 35mm film. We do believe our budgets will continue to increase, but probably not in huge ways. I don't know that the next film will be more than $2 or $3 million all in, that's everything. But we do want to improve the production quality… So if we have to pull in more professionals to increase the quality or raise the budget by another million, we're certainly open to that.

Courageous © 2011 Sherwood Pictures

I know that several churches have started film ministries, and there has been a few films made by churches: *To Save a Life* (Brian Baugh, 2009), *What If...* (Dallas Jenkins, 2010) and *Grace Card* (David G. Evans, 2010). Have any of these churches, or others, consulted you about how to get these church film ministries launched?

Yes and no. The guy that made *To Save a Life* told us after the fact that he was inspired by what we did, but we did not talk to him before making that film. But the guy that made *Grace Card* – we've had numerous conversations with David Evans, and he's a fantastic guy. He's learning like we are. We think his first effort was more polished than our first efforts, so that's been fantastic. We didn't talk with [Harvest Bible Chapel, makers of *What If?*] much. I think they ventured out and did their own thing. We are aware there's more and more churches and we are approached by a number of them. I would say that's happened a couple dozen times, but some churches move slower than others... We certainly want to share what we know in the hopes that it will help them, you know, get to where we are faster.

Even though you formed your own production company with Kendrick Brothers Productions, do you think the church film movement is still a viable model?

It is. It's starting to morph and evolve a little bit... And the Christian marketplace right now cannot handle twenty movies or really even twelve. They can handle two to three at a time, and everybody buzzes about those two or three, but once you start packing

them in over and over and over, each of them suffers as far as their marketability… I think it's going to still be done. How effective it would be in the future, especially the more movies that are made, that remains to be seen.

You mentioned the Christian music industry earlier, already hinting at some of the parallels. The uninitiated sometimes think of the Christian music industry as monolithic. I think we can identify certain types of Christian artists out there. Some see their ministry as primarily to the faithful, making music to encourage them. Others make music without anything overtly Christian about it per se, but see themselves as making wholesome music for that same audience. Another type of artist, on the other hand, see themselves as Christians making art and that it will make a difference, even if the lyrics lack anything overtly Christian or evangelistic about it. Finally, some see themselves as more evangelistic and seek to reach those in the bars and the clubs rather than those already in the 'born again' crowd. If you were to put your film-making into one of those four paradigms, which would it be and why?

That is a great question and I think it's sad when people's opinions, especially towards Christian films, try to force it into only one category, because we need all of them. I'm very supportive of the movies with subtext. I'm very supportive of the movies that are just out front and bold if they're done well, you know, those can be very cheap. Those can be very cheesy if they're not done well. Our movies tend to be a little bit bolder. You know, we do have a gospel presentation in our films and that's what we want to do. That's our style, so our target audience is first to encourage and inspire the church to keep growing… If the church is not acting like the church, what witness do we have to the world? We don't. It's marginalized and watered down and powerless, so we're reminding the church in our films, in *Facing the Giants* to walk in faith, in *Fireproof* to love like Scripture tells us to love, and in *Courageous* to take the responsibility that God gives us… but we know there's gonna be bleed-over into the general audience, because we've seen it – we've had an untold number of people either share our faith or come to our faith, meeting Jesus Christ as Lord and Savior; that's happened thousands of times and we know we have bleed-over – but our target audience is to continue encouraging, inspiring and helping the church to grow. Some people would call that preaching to the choir, but the choir sometimes needs it… We don't try to make a movie that we think is equal parts for Christians and for non-Christians alike… We make them for Christians first, knowing that there's bleed-over. Now, do we need movies like *The Blind Side* (John Lee Hancock, 2009) for a more secular audience with Christian themes and overtones? Absolutely. We're all for that as well. So, you know, the way I like to look at it is when you go to war…you don't just have the Army over there. You get the Air Force and the Marines and the Army in different tactics and sometimes you know the Navy SEALs and you use a number of tactics to accomplish your mission. And that's the way we feel about Christian films. We need some films that are overt and we need some films that have their message in their subtext. And so we're supportive of all of those.

Zachary Ingle

INTERVIEW WITH CHRIS CHAN LEE

The release of Chris Chan Lee's first feature *Yellow* in 1997 marked a watershed in American independent cinema, with its palpably authentic look at Korean American teenage life through the graduation-night experience of a close-knit group of friends. A guerilla production that was informed by Lee's youth, *Yellow* certainly put the film-maker on the map, but Lee's real triumph has arguably been managing to forge a fully-fledged career in an industry that often relegates writers and directors of ethnic backgrounds to 'one hit wonder' status once their debut features have finished playing the art-house circuit. After shooting television episodes in Singapore, Lee returned to the United States to direct his second feature, the independent neo-noir *Undoing* (2006) starring Sung Kang and Kelly Hu, which utilizes some Los Angeles milieus that are rarely seen in more mainstream genre fare. Most recently, he has served as editor and producer for Dax Phelan's psychological thriller *Jasmine* (2015) in which a once-successful Hong Kong businessman (Jason Tobin) unravels as a result of his wife's murder. This interview covers a range of topics, from Lee's background, to his training, to the logistical challenges of making independent movies.

Chris Chan Lee with Kelly Hu on the set of *Undoing* © 2016 Chris Chan Lee

You grew up in the Mission District of San Francisco. How important in general is the activity of moviegoing in Asian American culture and how did your interest in pursuing a career in film-making take shape in relation to your upbringing?

My sense of moviegoing in Asian American culture is limited to my own experience. When I was growing up, there weren't enough Asian American kids in my environment to have that sense of community. That might be hard to believe, but San Francisco was a different place in the late 1970s when I was in grade school. The only other Korean kids I'd ever see were cousins and other relatives at family get-togethers and church events. I had more of an Asian American experience as an adult after moving to Los Angeles, reconnecting with my identity during college, meeting new friends, and eventually living in Korea town. But now, the moviegoing experience is rapidly changing. There is much more exposure and access to World Cinema. Everyone's attention and interests are scattered across many different mediums and platforms. San Francisco during my youth was much rougher than it is now – there was a lot of violence and petty crime on a daily basis.

As I got a little bit older, our family moved to a house in the suburbs, south of the city. We moved from a mostly Latino and black, working-class community to a majority white, middle-class community of families with parents in professional fields. There were only four or five other Asian kids in my middle school, and we all kind of avoided each other. I'd still drive into the city every Saturday morning to work at my parents' shop near Potrero Hill (and eventually the Mission District), while on weekdays I'd go to school back in the suburbs. In the city some kids referred to me as the guy whose dad owned the store, and in the suburbs we were treated like 'the Chinese people whose dad owns a store'. I didn't really fit or blend in well in either environment. I remember a white kid called me out during lunch break and grandstanded in front of everybody that their dad kicked my relatives' asses back in Korea, ridiculous stuff like that. In high school, I'd hang out with my white friends who were in the cool circles, but I'd also hang out with the nerdy computer science geeks in the computer labs.

At the Safeway, which was where every family in my suburb went to get groceries, I befriended this Indian kid whose parents owned the small liquor store next to the supermarket. We bonded over the fact that both our parents owned shops and could totally relate to how difficult it was to work for your parents in retail. My different circles of friends never wanted to have anything to do with one another, and I was constantly being criticized by one group for associating with another. I did have close friends but overall I was the perpetual outsider in my experience growing up. This led to me always being an observer, and gauging ever-changing social situations, identifying how I felt about myself and other people in these different environments, and really just trying to make sense of the world I was in. I'd say that discomfort and displacement had a big influence on me pursuing the arts and film-making.

You graduated from the University of Southern California in 1993 with a degree in cinema and television production. How well did this degree prepare you for the challenges of working in the film industry, which revolves as much around contacts and the gradual accumulation of credits as it does around an academic qualification?

It could be argued that a formal education in film production is less critical than it would be towards pursuing other fields or professions. The best way to progress as a film-maker is to make films. However, I definitely got a lot out of the USC film school experience. The film school was so hard to get into that I had to actually start attending USC as an undergrad with a general communication arts degree. The plan was to keep applying to the film department, hoping I would finally get accepted. During this time, I volunteered

Undoing production meeting © 2016 Chris Chan Lee

all my free time and weekends to be a production assistant on the films of students who were already in the film programme. I was getting tons of experience in every aspect of production. By the time I reapplied to film school at the end of my sophomore year, I had already been a production manager on a graduate thesis film. By junior year, I was accepted to the USC film school and had already benefitted much from my production experience on student films and relationships with film students.

USC had an amazing critical studies programme that was part of the core production curriculum which gave everyone incredible access and exposure to classic and emerging cinema. I remember watching films from De Sica, Tarkovsky and Herzog for the first time. And we'd watch these movies on actual 35mm prints. Every week at class was an eye-opening experience. There were a few great professors that made one able to appreciate these films. So in addition to the production aspect – where you have film equipment, a workflow imposed by your instructors, and a group of film-makers with similar objectives who also became a pool of volunteers and collaborators – USC also elevated my understanding and appreciation of film as an art form. By the time you are doing your advanced projects, you start seeing more competition – there are fewer projects getting green-lit by professors and fewer slots to be filled for writers, directors and key roles. There are more rules and gatekeepers. Certain ideas and personality styles are favoured over others. Things became more political. I can't think of anybody who enjoyed this during film school, but in hindsight it certainly was a dose of the real world that was to come. There were definitely lots of kids whose parents were already famous producers

or successful studio executives, and they seemed to slide easily from film school to directing a television series or getting a coveted apprentice role with a famous director. But kids who grew up in a convenience store with immigrant parents? Not so many.

Your first feature *Yellow* dealt with a group or Korean American high school youths in Los Angeles on graduation night. Were the characters or situations rooted in any of your own experiences?

During film school, I wrote a feature script called *Mission Street* about a Korean immigrant who tries to open and run a convenience store in San Francisco. It was really a love story, but it also addressed racial tensions that arose out of misunderstandings and cultural divides. I didn't know what I was doing, but I would regularly read the trades like *Variety* and the *Hollywood Reporter* to get a sense of who all the decision makers were and how buzz and attention would be generated for a project. I went to a bookstore in Hollywood and purchased a copy of the *Hollywood Creative Directory* – this was way before IMDbPro and these hand-bound directories were ungodly expensive. But the *Hollywood Creative Directory* had the names, titles and contact info of executives and assistants all across town. I did the next irrational thing, and started mailing my script directly to production executives, studio heads and agents, completely unsolicited. I got some really nice responses, but there was no interest. But then, the LA riots happened. A few days later I got a bunch of phone calls, met with several executives at most of the studios, and landed a literary agent at one of the big three agencies. But a year or so after I graduated, *Mission Street* was still an unproduced script. I went from working on a film every day at film school, to just sitting at home writing and waiting for the phone to ring. I got tired of it. I had to make my own movie or it was never going to happen.

I knew how hard it would be to make a no-budget movie, so I wanted to write a script that I could really identify with that would be worth that journey no matter how long it might take. *Yellow* was intended to be a film that I really wanted to see. The teen movies of the 1980s had a big impact on me, and of course John Hughes comes to mind as a film-maker who defined that era. I had really wanted to see a movie about teens that I could directly identify with, that had Asian kids in it, and that represented different experiences and weren't relegated to being a caricature or sideshow. And of course, I didn't even have that experience of bonding with other Asian Americans during high school; however, I was writing *Yellow* in my twenties when I was living that experience. I had lots of new Asian American friends in LA and there was a tremendous sense of community and belonging. I wanted to infuse that experience into this teen comedy/drama, re-envision the John Hughes-type movie of my youth, and ground it with a main character that worked at his dad's store. That made it personal for me. In my twenties, I realized how mainstream media had contributed to me feeling like an outsider throughout my childhood, and now I actually had the perspective and opportunity to do something about it.

I was interested to read that your manager, Eric Kim, was not just a supporter of *Yellow* but also the first Korean American agent in Hollywood. Do you see Eric and yourself as pioneers in terms of working in the industry and making culturally specific films, or are you more conscious of the general challenges that face anyone who is trying to carve out a career in a very competitive field?

I was dropped by my first agent after about a year. Sometime later, I met Eric through a mutual friend. We instantly connected as two Korean Americans in entertainment, although he was officially in the game and I was just another wanna-be writer/director. He read my script and instantly believed we could find a partner or raise funding and make it happen.

What happened thereafter for a while is a blur – endless meetings, script revisions, the cheapest place in town that week for photocopies, and then the post office. At your first meeting, you're extremely optimistic and you're certain as soon as they read your script and talk to you, it's going to be obvious how great the project is and you'll get financing. A hundred meetings later, your expectations are tempered and maybe even low, but a sense of resolve sets in because you're sticking with it, and you've been living with the project long enough to be able to communicate or discuss it at any level. Around that time is when I met two producing partners, Ted Kim and Taka Arai. They had already read the script before our first meet-and-greet, and after an hour discussion in a tiny coffee shop in Beverly Hills they said, 'Okay.' I can definitely say there was no road map for what we were trying to do in getting *Yellow* made at that time as an American film. But the reason why *Yellow* became a film is because we were able to collect a group of like-minded people who connected with the material and strongly believed the film had to get made. That's pretty much what it takes for anyone, of any colour, to get a film produced.

In 2000, you undertook one year of television directing in Singapore for MediaCorp Studios. This was some time after *Yellow* had not only been well-received on the festival circuit but had also played successfully in niche markets and been sold for international distribution. Did the positive response to *Yellow* not result in offers to direct an immediate follow-up feature, or were you consciously seeking a different professional experience by working outside the United States?

Yellow opened theatrically during a very interesting time. An independent distributor, Phaedra Cinema run by Gregory Hatanaka, released the film in about nine cities across the United States. In Los Angeles, he got us into the art houses like Laemmle and such, but we also got into multiplexes like AMC in Los Angeles, Orange County and San Francisco. I'm just pointing this out because it's become virtually impossible these days for small, truly independent films to have access to those types of screens and audiences. We got lucky. *Yellow* had a five-week run in Los Angeles, which is really good for an independent. It was such an anomaly to have an Asian American film in a theatre. Local communities with high Asian populations literally drove large groups of Asian American students to the theatres in school buses. On a day-to-day basis, the theatrical run of *Yellow* entailed lots of interviews, screening attendances, and if you're the director on a low budget indie, you're also the administrative assistant and courier.

After theatrical, I was accompanying the film on an extended college tour. While living off modest appearance fees, I squeezed in time to write new screenplays. But basically, after making the film and then doing the film festival, theatrical, college circuit, and then home video promotion, I was totally broke from putting my life on hold while tending to the needs of just one movie. I had more substantive meetings with producers and executives, but it wasn't clear what the next project would be. So I kept writing. Then, out of the blue, I was contacted by someone I had met during the festival circuit when I had attended the Singapore International Film Festival with *Yellow*. It turned out she was also a talent scout and producer for MediaCorp Studios, the state-run film and television studio in Singapore. They were looking for directors for their English-language, locally produced programming for Channel 5. So I was deciding between staying in LA, writing while taking odd production jobs, or moving to Singapore with all expenses paid, on salary and directing broadcast television. The best choice seemed pretty clear.

What type of programmes were you directing in Singapore and what did you take away from the experience, personally or professionally?

Undoing © 2006 A Space Between, EK Films, Group Hug Productions

I directed all English-language shows for Channel 5. The first series I was assigned to direct was called *Growing Up* (Channel 5, 1996-2001), which was a beloved one-hour drama period piece about a Singaporean family in the 1970s, in its fifth season. The very first episode I directed turned out to be this big, elaborate mid-season cliffhanger that was based on a real event of the time – a shipyard fire. I remember being on set rehearsing stunts with exploding fire gags thinking, 'This is why they called me in! So complicated! Nobody else wanted to direct this!' That show filmed both in the studio and on location. I remember on my first week in the soundstage, I had designed a scene that had to be shot with one moving camera. There would be no way to utilize all three cameras like they were used to doing. The crew was up in arms about this, as rehearsing a scene with a single moving camera seemed like a huge waste of time. At the outset, I sensed a little bit of tension in my new environment. Who does this new American kid think he is just waltzing in here? I had expected to finally be an Asian amongst Asians in my new home, but ironically I was very much the American in Asia. But like any relationship, we had to start somewhere.

 Production is hard. In the weeks that follow, we went through a lot together, and things were going well. The executives were very happy with what they were getting, and that trickled down to the whole production team. My crews were extremely hard working and fast, and I respected them and did everything I could to facilitate their efficiencies in addition to whatever plans I had. I also went on to direct a half-hour high school comedy called *Moulmein High* (Channel 5, 2001) starring Cynthia Koh. There was much more to

the whole experience, but in a nutshell, things moved very quickly in television. I was directing two or three episodes at a time in order to utilize locations and cast schedules. Approved scripts would be delivered late from the writing staff. There was minimal time for rehearsals. I've always been big on planning but there were plenty of times I had to shoot from the hip – land on location, talk to the actors and production heads, and quickly sketch up a shot list. The experience really helped me to learn how to break down a scene quickly while developing and trusting my instincts.

After returning from Singapore in 2003, you started work on your second feature *Undoing*. The storyline concerns a young man who returns to Los Angeles following a one-year absence due to a tragic incident and this premise suggests that you wanted to address your impression of the city after being away for a similar period of time. Why did you choose to work within the noir genre?

I had a relationship that had a lot of unresolved issues, that despite a difficult break-up, I was attempting to revisit and repair upon return to the United States. I also had a strange case of culture shock. I suddenly couldn't relate to anyone or anything around me. That was surprising, especially since Singapore is such a modern and international society. But I felt more than ever that I was an alien in my own country. I've always loved the noir genre. At the top of my list would be Hitchcock, who I don't think is even regarded as a noir film-maker but certainly many of his films have strong noir characteristics. But the

Undoing © 2006 A Space Between, EK Films, Group Hug Productions

genre's use of archetype, language and visual relationships is a great challenge and fun for any director. At the time, I felt like I had grown up a bit since *Yellow* and I wanted to explore something a little darker, deeper and intuitive. I wanted to do something that was visually sophisticated where the imagery alone evoked emotion.

Undoing had a reported $1 million budget and was shot in 24 days. Did you approach bigger production companies with a view to securing more time and money, or did you always plan to produce the film at this level in order to maintain creative control?

It took a few years to raise the financing, until our lead producer came onboard then things happened in a matter of months. The actual budget was about $300,000. Throughout the development of *Undoing*, the team always wanted to maintain creative control, so that never changed. We all aligned in our passion for independent film. Again, although things moved quickly towards the end, getting to that point required countless meetings, things coming together then falling apart, like most movies!

As the title suggests, Undoing is concerned with regret and attempts to make amends for past mistakes. Within its genre trappings, it's a very thoughtful piece of work that challenges the audience to understand the sometimes contradictory nature of its characters. Did balancing a certain degree of genre expectation with your thematic concerns lead to any tough decisions in the editing room?

I actually always thought that *Undoing* never connected with its intended audience, even though it got a theatrical release, then DVD and digital distribution. Less than 0.1 per cent of produced movies even get that far, so we were lucky enough. But somehow I think the people who became aware of the film from its marketing and publicity, were expecting to see a different movie, like a pure action or crime thriller. While *Undoing* has those elements, it is a quiet film. The most intense moments are expressed under the surface. They are the things that are left unsaid, expressed by silence. This is where I felt the natural union between noir and Asian sensibilities intersected.

Your leading man Sung Kang is credited as a producer on Undoing and served as an associate producer on Justin Lin's breakthrough feature Better Luck Tomorrow (2002). He has a very natural screen presence which won him a lot of fans when he played Han in numerous instalments of the Fast and the Furious franchise (Justin Lin, 2006, 2009, 2011, 2013), but is utilized in a deeper, more ambiguous manner in Undoing. How would you describe your collaboration with Sung?

I first met Sung around 1998, through a mutual Korean American film-maker in Los Angeles who introduced us. The circle was small and tight then. I was impressed and introduced him to a fellow Korean American film-maker Clifford Son in New York who was about to direct his first feature that I was producing. Sung was cast in Cliff's movie and we spent a couple of months shooting around New York City and Jersey. Unfortunately, the film was never completed although it is about 90 per cent shot. However, I've always been impressed with Sung's intelligence and talent, so it's no surprise that he's doing well.

Your leading actress Kelly Hu was probably the most famous addition to the Undoing cast at the time of production, although her most widely seen work, such as The Scorpion King (Chuck Russell, 2002) and X2 (Bryan Singer, 2003), has been largely action-orientated. How did you work with Kelly to realize the character of Vera, whose downtrodden existence is far removed from her usual screen image?

Undoing © 2006 A Space Between, EK Films, Group Hug Productions

I think any fledgling director making an indie movie is easily intimidated by someone like Kelly, who has done blockbuster movies and is a beauty pageant queen. You become sceptical before even meeting the person, as a way to protect yourself or what you are trying to create. But when our team finally met Kelly to discuss the role of Vera and she read a few scenes of the script, she was amazing. One of the best auditions ever.

Undoing makes use of locations in Korea town. How easy was it to secure the use of these locations on a small budget, and what was your experience of shooting in these areas in terms of working on a tight schedule or dealing with local residents or businesses?

The locations were the bane of our existence during production. If you don't have copious funds, it is never easy in LA. You can go to the darkest hole in the wall and mention you want to shoot something, and they'll pull out a location contract.

The scenes shot during the daytime portray the city as being a rather flat, characterless sprawl, but the night-time scenes bristle with neon energy. Were you mainly pursuing a certain genre aesthetic, or was the look of *Undoing* also influenced by your impression of Los Angeles as a transplant from San Francisco?

There's a lot I could say in this regard, but honestly the guiding light was that we worked with what we had. There was definitely stylistic intent to create a sense of isolation in the visuals to reinforce the isolation of being in a big city like Los Angeles, as well as the trajectory of the characters. However, I would say we primarily followed our sensibilities to give focus to what was important in the frame, to create the proper dramatic effect with the lighting or perspective. And we definitely used darkness and black, from a low-budget standpoint, to our advantage and fully embraced it. Our director of photography, John DeFazio, has a restless eye and is easily bored. He would constantly hunt for intensity and interest in any composition.

Undoing was part of the Fast Track programme sponsored by _Film-maker Magazine_ and the IFP Los Angeles Film Festival. The intention of the programme was to mentor the chosen film-makers as they put together the resources required to embark on production. How did _Undoing_ become part of this programme and how did the mentoring process assist or influence your production?

Our producers applied for those programmes. I think, like most projects, we didn't get any direct funds or support from that participation. However, they both immensely helped us and gave the film a lot of momentum. For one, these programmes give you a lot of exposure and also validate your efforts. Even though we didn't get partnership with any of the executives they introduced us to, our mere participation forced us to hone and solidify our goals. Our pitch became razor sharp. It gave us a lot of resolve, and this momentum carried us even after the programmes finished.

You've worked for the American branch of the South Korean media giant CJ Entertainment as an editor, preparing cut-down versions of some of their most successful titles for US remake consideration. Recent years have seen the explosion of Korean culture in worldwide media, whether it's the Gangnan Style phenomenon, the presence of stars such as Lee Byung-hun or Rain in Hollywood action movies, or directors like Park Chan-wook and Kim Jee-woon making films in the United States. Do you think that Korean culture is ensured a permanent place in American media, or is it possibly just a trend, as with the fad for Hong Kong cinema in the late 1990s?

Korean culture and cinema is probably a bit trendy as of now, but even once it settles down a bit, it has left a definite mark and lasting impression. Some of the best film-makers in the world, in my opinion, right now are South Korean auteurs. And for whatever reasons, whatever market conditions or such, the median production value and aesthetic sophistication we're getting out of Korea is just amazing. It will be interesting to see how things develop. I've noticed the projects that I've been working on lately, that have caught my interest, have all had connections to Asia. I'm producing/editing a feature from Hong Kong called _Jasmine_. I'm attached to direct a film with a team out of Korea, and wrote another script recently for a team of producers in Korea and Japan. A lot has changed.

John Berra

Beasts of the Southern Wild © 2012 Cinereach, Court 13 Pictures, Journeyman Pictures

SCORING CINEMA

BEASTS OF THE SOUTHERN WILD

Beasts of the Southern Wild

Studio/Distributor:

Cinereach
Court 13 Pictures
Fox Searchlight
Journeyman Pictures

Director:

Benh Zeitlin

Producers:

Michael Gottwald
Dan Janvey
Josh Penn

Screenwriters:

Lucy Alibar
Benh Zeitlin

Cinematographer:

Ben Richardson

Art Director:

Dawn Masi

Production Designer:

Alex DiGerlando

Composers:

Dan Romer
Benh Zeitlin

Editors:

Crockett Doob
Affonso Gonçalves

Duration:

91 minutes

Cast:

Quvenzhané Wallis
Dwight Henry
Levy Easterly

Year:

2012

Synopsis

Deep within the American state of Louisiana, a young girl named Hushpuppy lives in an impoverished yet vibrant bayou community known as 'The Bathtub'. She lives with her father Wink, whose belligerence and fierce temper belies a loving nature. Despite having been abandoned by her mother, Hushpuppy maintains a wondrous, magical view of the world. Yet The Bathtub (separated from the rest of the world by a levee) is under constant threat of rising water levels and Wink is suffering from a bout of illness. Hushpuppy's world may be about to change forever – and her innermost fears are soon manifested in the form of mythical, child-eating creatures known as 'Aurochs'.

Critique

Beasts of the Southern Wild is distinguished by several remarkable debuts, not least of which are the astonishing performances from Quvenzhané Wallis and Dwight Henry. As the daughter and father eking a meagre existence in America's Deep South, first-time actors Wallis and Henry are incredibly convincing, at times not so much acting as simply existing on camera. A great deal of the film's success is down to the skilled hand of director Benh Zeitlin, who also makes his feature debut. Zeitlin's direction is tactile and sensitive, capturing the watery climate of The Bathtub in exquisite detail from the sizzling pots of gumbo to the makeshift boats that the characters use to get around. Having immersed himself in the culture of the Deep South for several months during pre-production, Zeitlin shot on location outside New Orleans in the town of Montegut, Louisiana, employing local people in many of the scenes. It's therefore little wonder that the movie rings true with near documentary believability. Yet it's also a movie that has a stake in a more fantastical realm, as becomes clear when Hushpuppy imagines the dreaded Aurochs awakening from their frozen slumber and making their way towards The Bathtub.

The narrative's blend of reality and fantasy also plays directly into the construction of the soundtrack composed by Zeitlin and Dan Romer. Zeitlin has in the past scored short films *Death to the Tinman* (2007) and his own short *Glory at Sea* (2008), while Romer is a respected music producer who's worked extensively in the indie and alternative rock scene. *Beasts of the Southern Wild* is the first feature film scored by the two men and the striking, whimsical soundscape plays a critical role in immersing viewers in Hushpuppy's vivid universe. 'The entire score is Hushpuppy's point-of-view, her thoughts,' Zeitlin explained in an interview with the *Hollywood Reporter*. 'We're scoring around these things that she is going to say, to explore Hushpuppy's internal world and her vision of the universe [...] Her thoughts are a combination of the music and words.' (Ellison 2013) The score is composed of several distinct themes, each of which is assigned to a particular character or situation (a device known as a leitmotif).

The theme for Hushpuppy herself, a beguiling and enchanting piece for xylophone, is introduced in the opening track, 'Particles of the Universe (Heartbeats)'. The next theme is the one for the film's bayou locale, first heard in The Bathtub. Tinkling xylophone is gradually replaced by lively, purposeful banjos and fiddles performed by real-life Cajun band the Lost Bayou Ramblers (who appear within the film itself). Gradually, the Ramblers's music merges with The Bathtub theme proper – a triumphant and uplifting piece for brass that celebrates the pluck and tenacity of those living on the fringes of society. Immediately after, the score changes tack once again with evocative, smoky jazz in 'Momma's Song' acting as a musical signifier for Hushpuppy's absentee mother. The conventions of jazz carry a suitably nostalgic and mysterious air, ideal for communicating the young girl's elusive memories of her parent. It also cleverly indicates the boozy environment of the floating bar to which the mother has fled.

In the following tracks, 'I Think I Broke Something' and 'The Smallest Piece', plucked strings are brought in alongside Hushpuppy's xylophone theme to create a sense of prickly anxiety, as the girl begins to worry about her father's health. As Hushpuppy's anxieties begin to take shape, 'End of the World' introduces the theme for the Aurochs. The track begins with a rendition of The Bathtub theme on xylophone but it's slowed down, creating a sense of despondency. The sense of gloominess then increases as percussion and groaning strings further conspire to drain any sense of hope out of the music, conveying Hushpuppy's perception of the creatures as a destructive, all-consuming force.

The tone then shifts back to free-wheeling happiness in the delightful 'Until the Water Goes Down', a wonderfully folksy take on The Bathtub theme with emphasis on skipping strings and banjo. It's back to sadness in 'Mother Nature' as an undulating piano adds more poignancy to the Auroch theme before the rhythmic 'The Survivors' restores a note of optimism. 'Particles of the Universe (Elysian Fields)' complicates Hushpuppy's theme by mixing the xylophone with stark, staccato strings, and the complexities of the adult world impinging on hers for the first time. 'Strong Animals' begins with the Auroch material before a purposeful brass melody rises up in defiance. The downbeat 'The Thing That Made You' merges The Bathtub theme with that of the Aurochs before Hushpuppy finally sees off the 'threat' of the beasts in 'The Confrontation', Zeitlin and Romer deploying the full orchestra to create a sense of noble defiance. The score then reaches a powerful conclusion in the double whammy of 'Death Bed' and 'Once There Was a Hushpuppy', the former a moving piece for solo piano, the latter a joyous six-minute summing-up of all the score's principal ideas. This is where the brass section of the orchestra is properly unleashed, a fitting tribute to Hushpuppy's indomitable spirit.

What the two composers have achieved with the *Beasts of the Southern Wild* soundtrack is nothing short of remarkable, even more so given their relative inexperience in the world of feature film scoring. The music pulls off a difficult balancing act in that it carries a childlike sense of innocence yet never becomes so cloying

or sentimental that the film's realist trappings are undermined. In short, the music captures both the authentic sound of the Deep South and also the narrative's allegorical leanings. Add to this an impeccable sense of structure, with four distinct themes circulating around each other, and it not only works brilliantly well within the film itself; it's also a coherent and appealing listening experience when divorced from the visuals. By merging Cajun instrumentation with the sound of a symphonic orchestra, it's a score that feels both fresh yet comfortingly familiar – a dynamic and arresting work that marks Zeitlin and Romer as film score talents to watch.

Sean Wilson

References

Ellison, Victoria (2013) 'Beasts of the Southern Wild Director and Composer: "We'd Cry Together, Then Write Songs" (Q&A)', *The Hollywood Reporter*, 7 February, http://www.hollywoodreporter.com/race/beasts-southern-wild-director-composer-418007. Accessed 15 February 2016.

DIRECTORS

ALLISON ANDERS
American Women

Partway through Allison Anders's *Things Behind the Sun* (2001), there is a flashback to the gang rape of teenager Sherry (Kim Dickens). The assault is led by the elder brother of Owen (Gabriel Mann), a California rock journalist who in the present-day has travelled to Florida to write a story on Sherry's band. As the adolescent Owen drowns her cries with the music being played through his headphones, the film exits the flashback and returns to Sherry (who is oblivious to the fact that she knew Owen as a child) performing a song about the rape in a club. The camera then repeatedly cuts between Sherry singing onstage and Owen watching in the audience. Occurring in Anders's sixth and probably least celebrated feature, the scene powerfully amalgamates the two complimentary themes which are predominant throughout her richly varied career as a film-maker: the effects of male-dominated culture on the lives of women and the psychologically damaged nature of many of those involved in the music industry.

These themes do not come out of nowhere – by Anders's own admission, there is a strong connection between the narrative content of her films and her tumultuous early life. *Mi Vida Loca* (1993) looks at single mothers in the heavily Latino Echo Park area of Los Angeles and was inspired by the years in which Anders raised her own child in the neighbourhood. The single-parent family struggling to make ends meet in *Gas Food Lodging* (1992), meanwhile, is partly based on her own impoverished, fatherless upbringing in rural Kentucky. The chaotic personal lives of the rock musicians found in *Border Radio* (1987), *Things Behind the Sun*, *Sugar Town* (1999) and *Strutter* (2012) are informed by the experiences of Anders and long-time creative partner Kurt Voss as UCLA students on the fringes of the LA indie and punk scene in the late 1980s.

Any references to the various formative phases of Anders's life found in these films, however, pale in comparison to the level of commitment shown to the biographical in *Things Behind the Sun*, where the sexual assault central to the narrative mirrors Anders's own rape to a chilling level of detail. Not only is the film set in the same Florida town where the well-travelled Anders spent some of her formative years, but the fragmented flashbacks of the assault are shot in the actual house where she was raped as a 12-year-old. On the anniversary of the rape each year, a heavily intoxicated Sherry is guided by her sub-conscience to return to the front lawn of the home and is repeatedly arrested for trespassing. When Sherry discovers that the home was actually the site of the trauma which has defined her entire adult life, she politely visits the new owner and is invited inside. As Sherry enters the parameters of the home, the film transcends from autobiographically informed fiction to become an exercise in catharsis on the part of the film-maker herself.

Women are central to Anders's films, the majority of which are almost exclusively centred on the perspective of female characters. This is not to say that there are no significant male protagonists in her work – on the contrary, the shortcomings of men almost universally create the problems that the heroines face. *Gas Food Lodging* is told from the perspective of Shade (Faruza Balk), with her position as an adolescent girl in the transitory stage between the *naïveté* of childhood and emotional maturity played out through the course of the various

Gas Food Lodging © 1992 Cineville

disappointments and rejections by the men who enter her family's world. Shade witnesses the failed love affairs and inevitable unwanted pregnancy which leads to the psychological decline and eventual exit from the family of her wild-child older sister Trudi (Ione Skye), while her own initial experience with romance and sex is brought to an abrupt halt after she is rejected by a flamboyant local male who is very clearly encoded as gay (to everyone but Shade, that is). The poor economic situation faced by her family is framed as being caused by the desertion of her father from the family, which left her mother Nora (Brooke Adams) to raise two children singlehandedly in a rural trailer park. Despite the wealth of evidence to the contrary, Shade's youthful mind continues to formulate an image of men as being the solution to women's problems. When Shade arranges a blind date for Nora with a man who she spots while unwisely staking out a bar, the bachelor she selects is a former flame of her mother's. After the dinner subsequently results in several hours of stilted conversation, Shade is left frustrated at what she perceives as her mother's fussiness. Although the film ends with Nora in a relationship with a man who her daughter clearly approves of, any sweetness to the narrative's resolution is bitterly counteracted when we also discover that the man who is likely the father of Trudi's baby, a gentle English rock surveyor, died before he could return to her. Despite Shade's youthful immaturity, her fundamental idea about a harmonious life is framed as being correct; men are, in the final reckoning, positioned as both the origin of and only solution to women's problems in the economically fraught world of *Gas Food Lodging*.

The troubles faced by the protagonists of *Mi Vida Loca*, set a world away in the pressure cooker of inner city LA, are identical in their root causes but are expressed in an entirely more solemn fashion than is the case in the more lighthearted *Gas Food Lodging*. The unapologetic machismo of urban Latino gang life is the basis for the action here, with the film's main concern being how such a resolutely male-dominated culture impacts on the development of young women. A love triangle between fledgling gangster Ernesto (Jacob Vargas) and two childhood best friends, Mousie (Seidy Lopez) and Sad Girl (Angel Aviles), is the initial focus of the film. Their relationship turns sour after both give birth to children sired

by Ernesto and they eventually arrange a fight to the death. When the time arrives, both pull their guns but neither Mousie nor Sad Girl can bring themselves to shoot and, in an entirely separate incident, it is instead Ernesto who ends up murdered several blocks away.

Ernesto's death brings the two girls back into an uneasy friendship and, when their older friend Giggles (Marlo Marron) is released from prison, the young Latina community grows closer. With the benefit of age, Giggles is well aware of the destructive nature of male gang culture and tells her younger counterparts, 'we girls need new skills 'cause by the time our boys are 21, they're either in prison, disabled or dead.' She initially sets out to improve herself by searching for legitimate work, but quickly grows frustrated at both her situation and that of Mousie and Sad Girl, who are struggling to raise children as single parents on welfare. When Giggles makes the decision to return to street life, she organizes the girls into a group which mimics the democratic gang model of the men in the neighbourhood and by the end of the film the girls are running their own drug operations and carrying guns. A voice-over by Sad Girl acknowledges the dangers of this, but she rationalizes their actions by claiming that 'by the time my daughter grows up, Echo Park will belong to her and she can be whatever she wants to be.' This speaks to the fundamental contradiction at the heart of *Mi Vida Loca*. The action by the girls to take the power away from the men who caused their various troubles can be seen as a fiercely progressive move which has improved their economic and social positions significantly. However, instead of learning genuinely 'new skills', the advances are achieved by wholly aping the violent male gang culture, a decision which will presumably result in the same death, imprisonment and disability which has afflicted the men of Echo Park. Despite Sad Girl's claims that 'women don't use weapons to prove a point – women use weapons for love', the climax to the film, where a rival female gang member's botched drive-by results in a young child being killed, argues that gang subculture has the same inevitable tragic outcome whether led by either women or men.

Anders's films set in the world of the music industry may on paper seem to be entirely different propositions to *Gas Food Lodging* and *Mi Vida Loca*, but their relocation away from the isolated living environments of trailer parks and urban ghettos does not result in a wildly different thematic emphasis. In these films, men are again the source of the problems faced by the female protagonists. The most extreme example is the chaotic life led by Sherry in *Things Behind the Sun*, where both her alcoholism and promiscuity are framed as manifestations of the trauma from her teenage rape which festers in her psyche. In the black-and-white *Border Radio* – the first of three Los Angeles-based music-industry films in which Anders and Kurt Voss split the director credit – music writer Lu (Luanna Anders, Allison's sister) is left to pick up the pieces when the father of her child, Jeff (Chris D, frontman of LA punk stalwarts the Flesh Eaters), runs away to Mexico in fear of his life after he, band mate Dean (an understated comic turn by John Doe of X) and dilettante young roadie Chris (Chris Shearer) rob a club owner of money which they believe is owed to them. Jeff and Chris are on different sides of the same road; the elder man is a formerly acclaimed independent musician who is rapidly approaching middle-age with little to show for his years of work in the industry, whereas Chris is an independently wealthy hanger-on whose ruthless ambition far outstrips his actual talent. While Jeff behaves erratically as he struggles to come to terms with the end of his career, Chris uses his mentor's absence as an opportunity to replace him, both personally in the life of Lu and their child, and professionally by attempting to form a band using contacts made during his time working for Jeff. When the truth emerges about the robbery, Chris's sociopathy is exposed and Lu, who is framed as being the only rational person in a world of deluded, frail male egos, paves a safe haven for her estranged lover to return to Los Angeles before cutting ties with both men. Lu chooses to raise her child away from the testosterone-fuelled unpredictability of the music industry and, more importantly, away from two men who are both constructed as being entirely out of sync with the realities of 'normal' civilian life.

The incompatibility of music-industry men and an ordered life is a theme again touched upon in *Grace of My Heart* (1996), a relatively high-budget film which represents Anders's closest engagement with the mainstream to date. Heir to a large fortune as the daughter of an influential family, Edna Buxton (Ileana Douglas) defies her controlling mother by attempting to find fame as a singer-songwriter in the culturally and racially charged atmosphere of 1960s America. Small-label boss Joel (John Turturro) recognizes her talent as a performer, but tells her that 'lady singers' don't sell records. Instead, he encourages her to change her name to the more passive sounding Denise Waverly and sets her to work writing songs for his stable of vocal groups. Denise's work inevitably spills over into her personal life as she begins relationships with a series of men who she meets in the music industry. All are ultimately unsuccessful. The social principles of left-wing songwriter Howard (Eric Stoltz) are found to not be precisely reflected in his personal ethics when Denise discovers him in bed with another woman, while she finds out about the end of her affair with John (Bruce Davison) by hearing the married radio DJ announce on air that he is leaving New York for a new market. Denise eventually convinces Joel to let her record a single of her own and the label boss drafts in virtuoso producer Jay (Matt Dillon) to oversee the track. The single flops but Denise and Jay quickly fall in love and are soon married, a relationship which ends after the introspective and manic depressive musician, unhappy at how the recording of his group's new album is progressing, commits suicide. None of the three failed lovers are constructed as bad people per se but all are deeply flawed in various ways. This is a trope which resonates with the majority of the men in Anders's other films; even philandering gangster Ernesto in *Mi Vida Loca* is shown to deeply care about both Mousie and Sad Girl, while the deluded musicians in *Border Radio* and *Sugar Town* are all constructed as fundamentally decent people led astray by ego and ambition. Anders may repeatedly argue that women's problems are caused by the shortcomings of men, but there is a degree of colour and fairness in her portrayals of men which protects her films from charges of misandrism.

In all of her work, Anders demonstrates a particularly developed talent for using music as a powerful supplement to exposition (the use of Honey Cone's 'Girls It Ain't Easy' at the end of *Mi Vida Loca* being a particularly brilliant example of this) but in *Grace of My Heart* the bespoke soundtrack actually equals the dialogue and *mise-en-scène* in its contribution to the basic layout of the narrative. When Denise and English songwriter Cheryl (Patsy Kensit) meet Kelly Porter (Bridget Fonda), a bubble-gum pop act who they have been assigned to write a song for, they quickly realize that she is in a relationship with her female roommate. Rather than discuss the taboo subject, the film simply cuts to Kelly recording the knowingly titled 'My Secret Love' while the songwriters watch on. Similarly, the internal turmoil of Denise caused by her failed love affairs is more often reflected indirectly in her songwriting, rather than in maudlin dialogue and melodramatic confrontation.

Sadly, the impressive formal achievements of the film did not resonate with audiences. After the resounding commercial failure of what was a very ambitious project for a film-maker who had previously been known for somewhat low-fi dramas set in the present day, Anders returned to occasionally making low-budget independent films and began to work in television, where the majority of her work in the past decade has been seen. In *Grace of My Heart*, Denise uses songwriting as an attempt to express a female perspective on relationships and the social issues of 1960s America. The gendered thematic emphasis of the songs penned by Denise mirrors the approach to film-making taken by Anders who, in her seven features to date, has traversed a wide array of American landscapes to tell a range of women's stories. Creating conflicted but strong female characters who attempt to forge their way in male-dominated worlds, her consistently entertaining and vibrant work manages to make poignant feminist statements without resorting to polemics.

Michael Smith

WES ANDERSON
Seriously Quirked

A director always on the point of being so cool as to provoke contempt, Wes Anderson is the most visually distinctive film-maker of his generation. With the exception of his debut feature, *Bottle Rocket* (1996), it would be impossible to watch more than a few moments of any Wes Anderson film without recognizing his signature visual tropes: minutely detailed and baldly artificial sets; slow-motion montages set to 1970s pop music; broadly drawn characters whose clothes and posture tell us everything we need to know about them; and a stable of familiar, famous faces who comprise the select (though still expanding) repertory company at the core of his films. Anderson's second and third films, *Rushmore* (1998) and *The Royal Tenenbaums* (2001), established him as a confident director with a stagey, performative sensibility at odds with both mainstream Hollywood cinema and many of the dominant trends in independent cinema at the time. Yet for many critics, his signature style provokes quick, sometimes irritable dismissal.[1] For the doubters, Anderson is twee and artificial, all quirk and no substance. The director's retro corduroy suits and Hollywood-insider chumminess all contribute to their desire to strip the Hipster emperor of his new clothes and reveal him for the vacant formalist they suspect that he is.

Yet Anderson's oeuvre is more varied and subtle than his detractors would have us believe. Amongst the tics and quirks which make it so identifiably his, there is also a constant drive towards development – whether in the increasing maturity of his themes (if not his characters), seen in *The Life Aquatic with Steve Zissou* (2004) and *The Darjeeling Limited* (2007), or through experimentation with different styles of image-making, such as the plasticine animation in *Fantastic Mr. Fox* (2009), or the detailed miniature models of *The Grand Budapest Hotel* (2014).

Amidst these changes, Anderson's films are united by their carefully constructed, and often self-evidently artificial, *mise-en-scène*. At heart, Anderson is a miniaturist. Born into another place and time, he might have constructed elaborate Victorian dollhouses filled with perfectly scaled accessories, or arcane sixteenth-century glockenspiels, stilted, comical and kinetic. He glories in the moving parts of his adept comic constructions, yet he also takes a perverse joy in each small flaw in the perfect surfaces he creates: Margot Tenenbaum's missing finger; the little boy who interrupts the narrator's pompous recitation at the start of *The Grand Budapest Hotel*; the childish design of the Team Zissou logo. These imperfections become the structuring absences of Anderson's characters, the outward manifestations of their private neuroses. They state, from the outset, the recurring thesis of Anderson's films: nothing is perfect, so you may as well just get on with your life. The absurd importance lavished upon small details is also what has earned Anderson's films their most tenacious label: quirky.

While the term is difficult to define and used by different critics in different ways, Anderson's work lies at the centre of the Venn diagram which unites these; whatever else quirky may refer to, it can always refer to him. Attempting to define the quirky sensibility in contemporary culture, Michael Hirschorn notes the frequent emphasis on the trivial,

The Life Aquatic with Steve Zissou © 2004 American Empirical Pictures,
Life Aquatic Productions, Scott Rudin Productions, Touchstone Pictures

writing that, 'Quirk takes not mattering very seriously' (2007). James MacDowell, who has undertaken the most sustained critical exploration of quirkiness in contemporary cinema (MacDowell 2010), argues that the 'mixture of comic registers [in quirky films] means that we can simultaneously regard a film's fictional world as partly unbelievable, laugh at its flat treatment of melodramatic situations and still be invited to be moved by its characters' misadventures' (MacDowell 2012: 10). The alchemical mixture of the serious and the absurd, of the putatively ironic and the actually melodramatic, is Anderson's tonal signature. Through his artfully arranged tableaux of faintly ridiculous people in mildly comical situations, Anderson reflects our own ridiculousness, and invites us to laugh as much at our own pretensions and anxieties as at those of his characters.

Anderson has also sometimes been characterized as part of the 'smart film' aesthetic (Sconce 2002), in which ironic distance performs an involved dance alongside emotional engagement. In truth, however, there is nothing ironic about Anderson's films – though in their stark self-seriousness, his characters beg to be read ironically. Anderson's characters cling to surfaces because they are terrified of their own depths. Richie Tenenbaum (Luke Wilson) takes up the life of a world-travelling dilettante in fear of his own incestuous desire for his sister Margot (Gwyneth Paltrow); Max Fischer (Jason Schwartzman) busies himself with elaborate theatrical productions and dozens of after-school clubs to conceal his personal and academic failings; Scout Master Ward (Edward Norton) obsesses over the minutiae of scouting procedure to compensate for his crippling insecurity. The fussy, detailed worlds of Anderson's films, which so often irritate his harshest critics, nevertheless emerge organically from the fussy, detailed people who fascinate the director. As Mark Olsen, who sees Anderson as a part of an emerging 'New Sincerity' in American independent cinema, has it:

> Wes Anderson does not view his characters from some distant Olympus of irony. He stands beside them – or rather, just behind them – cheering them on […] In a climate where coolness reigns and nothing matters, the toughest stance to take is one of engagement and empathy. Anderson seems to have accepted the challenge. (Olsen 1999: 12)

What matters, Anderson insists, is the intersection of the personal and the past, and the ways in which nostalgia can come to define us. His films are period pieces – even when they don't claim to be – which evoke memories of times that may never have existed. They are filled with talismanic objects, nearly all of which suggest a kind of old-fashioned, analogue elegance as part of their aesthetic; portable record players, pup tents and monogrammed luggage abound. For his detractors, this is part of Anderson's stylistic emptiness – a default to retro-cool that allows him to define characters through their clothes rather than their personalities. Yet the lingering appeal of the past is central to Anderson's characters – especially in *The Royal Tenenbaums*. For these damaged people, the past is a place where things were better, simpler, or at least, simply allowed. When she learns that her brother has moved back to the parental home, Margot Tenenbaum cries out, 'Why is he allowed to do that?', as if, given the option, she never would have left at all. Wealthy, talented and successful from their youth, the Tenenbaum children have no problems other than the self-inflicted, and yet they are united by their utter inability to deal with life as adults. These characters, stuck in their own whimsical past, provide a genealogy to the pampered, directionless millennials (this writer included) who form Anderson's core audience. They are our fore-brothers and sisters, fumbling out a path through a world where they have everything but mean nothing. And time and again, across all of his films, they create their own meaning through the telling and retelling of their own stories.

The most insistent motif throughout Anderson's films is the use of artificial paratexts which invite us into the world of his stories. *The Royal Tenenbaums* is a library book, hand-stamped out of the collection for our viewing pleasure; the world of Rushmore is introduced by the opening and closing of red-velvet stage curtains which herald the changing of the seasons; *The Grand Budapest Hotel* is bracketed by no less than three framing narratives: the visit to a writer's grave by a contemporary teenager; the writer's own filmed address to camera; and the flashback to the writer being told the story by M Mustafa (F Murray Abraham). These framing narratives prepare us for Anderson's world; sit down, they say, and I will tell you a story. They contain the seeds of Anderson's elaborate *mise-en-scène*, which is always a heightened version of something just recognizable – like a strong memory from childhood, which we are briefly permitted to share with him.

By calling attention to the process of storytelling, Anderson is, of course, also telling us something about stories themselves. His most sustained and consistent treatment of the act of storytelling comes in *The Life Aquatic with Steve Zissou*, a love letter to the world created for Anderson by the real-life popular marine scientist, Jacques Cousteau. We meet Zissou, played by Anderson regular Bill Murray, in the aftermath of a tragedy at sea: his partner has been killed by an elusive marine predator, the Jaguar Shark. Because no one, including Zissou, has ever captured any evidence of this creature, the explorer's already shaky reputation collapses still further, and he sets out on an Ahab-like quest to discover and kill the Jaguar Shark, in the hope of regaining his reputation and getting revenge for his friend. (The invocation of Moby Dick, the greatest American story about stories, calls further attention to Anderson's purpose here.) Though a despicable human being, who mistreats his friends and followers with the kind of casual disdain which would, in a more conventional film, herald a fall, Zissou is also a charismatic dreamer. Indeed, his whole career as a marine biologist seems to have been conjured out of his own imagination, from the clay-mation creatures which populate the oceans and beaches of the world (and which may or may not be visible only to Zissou himself), to his exploration vessel, which we see depicted in cross-section, as if in a glass case in a museum, complete with an observation bubble which he 'thought up in a dream'. Throughout the film people fall in and out of Zissou's spell, sometimes paying a high price for their belief in him. Yet in the final moments, gathered together in the

submersible and on the hunt for the Jaguar Shark, friends, enemies and lovers join with him, staring in wonder as they share his vision.

Perversely, perhaps, in these moments which openly celebrate artifice and illusion, Anderson reveals something like the intellectual core of his films. Good stories, he tells us, are important – not necessarily because of what they are about or what they contain, but because of how they make us feel. This cold director, so often mistaken as a frivolous ironist, is deadly serious about the role that stories play in making our lives worth living. He shares with us fragments of memory and sensation, stitched together into the most elaborate of cinematic creations, and asks only that we marvel along with him. And if we would say of him, as Mustafa says of his hero, M Gustave, that although 'his world had ended long before he even entered it […] he did sustain it with a marvelous grace', then he would find that most satisfactory.

Martin Zeller-Jacques

Note

1. For emblematic examples of Anderson's detractors, see: Smith (2014) and Zacharek (2014).

References

Hirschorn, Michael (2007) 'Quirked Around', *The Atlantic*, September, http://www. theatlantic.com/magazine/archive/2007/09/quirked-around/306119/. Accessed 26 June 2014.

MacDowell, James (2010) 'Notes on Quirky', *Movie: A Journal of Film Criticism*, Issue 1, pp. 1–16.

———— (2012) 'Wes Anderson, Tone and the Quirky Sensibility', *New Review of Film and Television Studies*, 10: 1, pp. 6–27.

Olsen, Mark (1999) 'If I Can Dream: The Everlasting Boyhoods of Wes Anderson', *Film Comment*, 35: 1, pp. 12–17.

Sconce, Jeffrey (2002) 'Irony, Nihilism and the New American Smart Film', *Screen*, 43: 4, pp. 349–69.

Smith, Kyle (2014) 'Grand Budapest Hotel Is a Triumph of Twee', *New York Post*, 4 March, http://nypost.com/2014/03/04/grand-budapest-hotel-is-a-triumph-of-the-twee/. Accessed 26 June 2014.

Zacharek, Stephanie (2014) 'Wes Anderson's "The Grand Budapest Hotel": A Marzipan Monstrosity', *The Village Voice*, 5 February, http://www.villagevoice.com/2014-02-05/film/grand-budapest-hotel-berlinale-review/. Accessed 26 June 2014.

DARREN ARONOFSKY
Sublime Nihilism

The films of Darren Aronofsky are neither cheerful nor optimistic, and yet it would be a mistake to say that they are simply depressing or pessimistic. There is, in fact, a consistently spiritual message in the work of this director that is at the same time horrifying and encouraging. His films all take place within a universe that, because it is far too overwhelming for humans to comprehend, consistently thwarts earthly aspirations. Heroes struggle and vainly strive to find meaning in their lives, only to have their vitality depleted and used up in the process. All the while, indifferent to human exertions, the universe churns on, serving as a backdrop for the unending drama of mortal wretchedness and abjection. Without exception his films are tragedies; but the tragic events depicted are, nevertheless, of a sublime calibre, evoking a sense of awe and wonder in regard to the vast, incongruous divide between the tremendous nature of the cosmos itself, and the feeble attempts by human beings to make sense of their place within the cosmos. In his films, Aronofsky consistently struggles to convey the nature of a fundamental ontological tension between the infinitude of the cosmos, on the one hand, and the fractured, finite experience of individual human lives, on the other.

Over the course of his career, Aronofsky's aesthetic vision has become increasingly polished, and the nihilistically sublime features of his world-view have become progressively more articulate. His first two films, *Pi* (1998) and *Requiem for a Dream* (2000), are both powerful accomplishments, but they lack the clearly cosmic vision of his third film, *The Fountain* (2006). His fourth and fifth films, *The Wrestler* (2008) and *Black Swan* (2010), are companion pieces of a sort that represent differing sides of a similar tragic drama as seen from the perspectives of low art (professional wrestling) and high art (ballet). Among all of Aronofsky's productions, these last two films are his finest, as they avoid many of the blatantly grotesque exaggerations of his previous works while refining his distinctive perspective on the human condition. In these films, the director perfects his message as well as his style.

The cityscapes of New York and its environs play key roles in most of Afonofsky's films. These settings, however, are depicted as neither sleek nor glamorous but dark, run-down, confusing and overwhelming mazes that loop back upon themselves, acting as symbols for the tangled knot of human futility. There is a lot of activity, there is a lot of noise, but there is no sanctuary or happiness in these places. People use one another here – to make money, to get drugs, to gratify sexual desire, to gain power – but never are New York or its environs depicted as safe, happy or comforting places. The streets are endless mazes leading back to squalid and cramped apartments where people live behind locked and bolted doors or, in the case of *The Wrestler*, in a decrepit mobile home. This backdrop is always mysterious, bleak and threatening, setting a tone that primes us to expect the worst for Aronofsky's tragic protagonists.

Yet it is also the case that these cityscapes function as conduits through which the universe, in all of its uncanny mystery, makes its presence felt in the lives of these same

Pi © 1998 Harvest Filmworks, Truth and Soul Pictures, Plantain Films, Protozoa Pictures

characters. While the buzz of activity on New York City streets drones on, or while the mundane routine of daily life in New Jersey plods forward, there is a sense in Aronofsky's work that the real point of it all is somehow buried beneath, and hidden behind, the details. We could be anywhere: New York, New Jersey, the Amazon Jungle or Madrid, Spain. Wherever we are, the universe is working through us, and we can never break free from its grips. Our projects and goals are really not our own, but the workings of a destiny that is beyond comprehension. We are doomed; however, if we abandon ourselves to our doom, we might experience, if only for an instant, an exhilarating, holy fullness that comes from being consumed by the very universe that we struggle to master.

Aronofsky's first major release was *Pi*, in which the main protagonist Max (Sean Gullette) spends much of his time locked away in a cave-like apartment as he endeavours to calculate the mathematical form of the universe. Once he does leave the confines of his apartment, the action becomes infused with paranoia and terror as he is pursued by everyone from government agents to Hasidic Jews determined to get hold of his knowledge. He descends into the subway, travelling through a maze of tubes beneath the City, just another tangle of pathways leading nowhere. This is a place of mystery and danger, yet it is also through the mathematically sublime patterns of this City that the nature of the universe makes itself known to Max. Ultimately, he cannot bear the burden of this knowledge, and so *Pi* ends on a strangely happy note when Max drills a hole in his head to relieve himself of his grand, yet awful insights. The film concludes with

Max sitting in a park, content that he is no longer able to carry out simple mathematical calculations. Ignorance, it seems, is bliss.

There is no such happiness at the conclusion of *Requiem for a Dream*, perhaps the most abject and bleak of Aronofsky's films. All of the main protagonists in this drama are destroyed by their own addictions, being consumed by insanity, dismemberment, imprisonment and sexual degradation. In *Requiem for a Dream*, the rituals of repeated drug use and its effects determine the governing pattern that carries the film along. We see the repeated ingestion of drugs, the repeated dilation of pupils, and the repeated manic behaviour of the addicts, just as in *Pi* we saw the repeated patterns of mathematics. Here, the patterns all lead in the same direction – destruction of individual dignity by insanity, disease and the loss of freedom. Sara Goldfarb (Ellen Burstyn) becomes addicted to diet pills in hope of becoming a contestant on a TV game show. But instead of pop culture fame, she is driven to insanity. Her son, Harry (Jared Leto), becomes addicted to heroin in his quest to become rich as a drug dealer, ultimately suffering the amputation of his arm while his partner-in-crime Tyrone C Love (Marlon Wayans) gets locked in prison. Harry's girlfriend Marion Silver (Jennifer Connelly), meanwhile, descends further and further into sexual depravity as a prostitute. In each instance, the characters ironically fall prey to the very universe that they had hoped to harness for their own purposes, becoming ensnared and consumed by their aspirations, each suffering in a way uniquely suited to the character of his or her own hubris. The strength of this film is found in the nihilistic bleakness through which Aronofsky's message can be heard loud and clear: there are no happy endings. Everyone suffers and dies.

While the unifying theme of bodily finitude and suffering in *Requiem for a Dream* serves as a dim reminder of human connectedness, this message is overshadowed by the unrelenting despair of the film. As if to correct this, Aronofsky's next film, *The Fountain*, re-emphasizes a cosmic perspective on human suffering, becoming more philosophical about our plight as embodied and fragile beings. In *The Fountain*, the story of the transmigration of two souls over the course of hundreds of years serves as a framework within which to illustrate the endlessness of humankind's quest for infinity. Arranged as a triptych, the film's three stories follow the efforts of Tomas/Tommy/Tom (Hugh Jackman) as he, first, as a Spanish Conquistador, searches for the Tree of Life; second, works as a medical researcher to find the cure for cancer; and third, becomes a space traveller who goes to a far off nebula searching for immortality. In each case he is motivated by his love of a woman (Rachel Weisz) who is threatened with death, and in each case his quest results in an ambiguous sort of failure. On the one hand, individual immortality turns out to be impossible. On the other hand, in suffering and dying, it is suggested that humans lose their attachment to the finite, instead to become consumed by, and reintegrated into, the cosmos. Unlike *Pi* or *Requiem for a Dream*, *The Fountain* focuses less on individual misery and degradation and more on the elevation of the spirit when identified as an aspect of the whole universe. In this sense it has a religious message summed up by one of the recurrent lines in the film: 'Death is the road to awe.' It is interesting to observe in this regard that while the majority of the action in *Pi* and *Requiem for a Dream* occurs in the cramped confines of the city, in *The Fountain*, most of the action takes place in wide-open spaces outdoors, beneath the starry skies, or in outer space itself. It is as if Aronfosky has changed his perspective, in this film attempting to make sense of finitude and misery from above, rather than from within the human world.

In *The Wrestler* and *Black Swan*, Aronofsky finally brings together the two perspectives – the individual and cosmic – that he explored separately in his previous films. Originally conceived as two parts of a single story, *The Wrestler* and *Black Swan* both depict individuals who struggle with their own finitude as they aspire towards different kinds of perfection. Emphasizing the loneliness and isolation of the main protagonists, Aronofsky often has the camera follow these characters from behind, superimposing their figures on backgrounds against which they seem to float, uneasy, separate and remote from others.

Throughout both films, imagery familiar from his earlier works is drawn upon to depict the tangled, nihilistic and absurd nature of finite, alienated human existence. In the case of *Black Swan*, apartments with dead-bolted doors and the maze-like streets of New York City and its subway tunnels reappear, evoking feelings of paranoid claustrophobia and serving as symbols for the inner structure of the main character's mind. In the case of *The Wrestler*, the dreariness of working-class New Jersey neighbourhoods, trailer parks, stripclubs and meeting halls serves to emphasize the inescapable reality of decay and decline; images that mirror the situation of the main character who is himself trying to come to terms with his own mortality. And yet in the culminating moments of each film, the isolation of the main characters is overcome as they take a literal 'leap' into the abyss, sacrificing themselves in the completion of their own projects.

In *The Wrestler*, this is the leap taken by Randy 'The Ram' Robinson (Mickey Rourke) as he jumps from the turnbuckle of a wrestling ring, most probably dying from a heart attack in the process. In *Black Swan*, the leap is taken by the ballerina Nina Sayers (Natalie Portman), as she herself dies the death of the Swan Queen. In these leaps, we see a depiction of something like what Søren Kierkegaard describes as the 'leap' of faith, which is a prerequisite for ascension to the religious stage of development (1983: 42). In order to become one with God, the individual has first to abandon attachment to the self and identify with the infinite. In these last two of Aronfsky's films, we see what looks like a prelude to an encounter with the Holy.

Aronofsky is a director who concentrates a stoic yet sympathetic eye on obsessed characters as they confront the inescapable truths of suffering, finitude and death. The sublime and abject coexist in his films as two sides of the same universe. The lowly along with the noble, the rich along with the poor, and the brilliant along with the stupid all struggle and suffer while they try to find their place in a baffling universe that inevitably wears down and crushes everyone. Without exception, the characters in Aronofsky's films strive but never triumph, and inevitably they end up submitting to a destiny they don't understand. Nevertheless, the mystical aspect of Aronofsky's work rescues it from utter hopelessness. It thus seems fitting that the Old Testament has served as inspiration for his latest film, *Noah* (2014).

John Marmysz

References

Kierkegaard, Søren (1983) *Fear and Trembling* (trans. Howard V Hong and Edna H Hong), Princeton, NJ: Princeton University Press.

RALPH BAKSHI
De-Disneying Movie Animation

Ralph Bakshi was born in a Palestinian city that is now part of Israel, but he grew up in Brooklyn and attended what is now called the High School of Art and Design in Manhattan, graduating in 1957 with an award in cartooning. He got a job at Terrytoons Animation Studio in New Rochelle, New York, and worked his way up to animating and directing shows with such characters as Heckle and Jeckle and Mighty Mouse, becoming creative director of the studio before he was 30. He became producer and director of the Paramount Cartoon Studios in 1967, hiring and working with Wally Wood, Jack Davis, Mort Drucker, and other highly talented artists. When the fading theatrical market put Paramount's cartoon department out of business, Bakshi moved to the Al Guest Studios in Toronto, producing and directing episodes of the Spider-Man television series, which marked that character's first appearances outside comic books. Bakshi also started a venture called Ralph's Spot, making commercials and collaborating with Peter Max on TV spots.

Bakshi's first feature film was *Fritz the Cat* (1972), starring the feline protagonist of Robert Crumb's widely read underground comics. The movie did excellent business, thanks to good reviews and the publicity it received as the first animated film ever released with an X rating. The following year brought the semi-autobiographical *Heavy Traffic* (1973) with a young Jewish Italian man navigating through rough Manhattan surroundings. It combined animation with live action, as did Bakshi's next feature, *Coonskin* (1975), in which an African American convict tells updated Uncle Remus stories to another inmate while they bust out of jail.

All of these films contained the kind of rude, crude content that is guaranteed to offend bluenoses and interest groups, and Bakshi sparked more than one moral panic with his early features. He was never shy about defending them, but eventually decided that he had raised enough ruckuses, and in 1976 charted a new course with *Wizards*, a JRR Tolkien-style fantasy with a post-apocalyptic setting. He then embraced Tolkien directly, embarking on an ambitious adaptation of the novelist's three-volume saga *The Lord of the Rings*, originally planned as a two-part film, although only the first instalment was completed. Bakshi shot the entire story in live action and then made his first use of rotoscoping – a method of tracing by hand over photographed images, frame by frame – to turn the footage into an animated movie. It premiered in 1978, followed by the rotoscoped musical *American Pop* (1981), the animation–live action *Hey Good Lookin'* (1982) and the rotoscoped *Fire and Ice* (1983), which used characters created with the pop culture artist Frank Frazetta.

Bakshi returned to New York in the mid-1980s, painting and working on various film and video enterprises. They include *The Butter Battle Book* (1989), a television short made with Dr Seuss; the animation-live action feature *Cool World* (1992), with Brad Pitt and Kim Basinger; the live-action television movie *Cool and the Crazy* (1994), with Jared Leto and Alicia Silverstone; a short-lived animated fantasy series for HBO called *Spicy City* (1997);

Fritz the Cat © 1972 Aurica Finance Company, Black Ink,
Fritz Productions, Steve Krantz Productions

a couple of cartoon shorts for the Hanna-Barbera studio; and a Kickstarter campaign
to raise funds for *The Last Days of Coney Island*, an animated feature which Bakshi
completed in 2015.

Throughout his career, Ralph Bakshi has laboured to make movies as roguish and
outlandish as the (heavy) traffic will bear. Fritz the Cat pushed the pop culture envelope in
Crumb's underground commix, but as a feature film hero he was downright scandalous,
X rating and all. *Heavy Traffic* also received an X, breaking so many traditional rules that
the *Hollywood Reporter* called it 'shocking, outrageous, offensive, sometimes incoherent,
[and] occasionally unintelligent' while also judging it 'an authentic work of art' (qtd in
Cohen 2013: 84). Bakshi stated that *Coonskin* was an 'homage to the black man' (qtd in
Cocks 1973), but this did not impress the Rev Al Sharpton and members of the Congress
for Racial Equality (CORE), who protested a work-in-progress screening at New York's
esteemed Museum of Modern Art and picketed Paramount's headquarters, deeming the
film racist and 'highly objectionable to the Black community' (qtd in Cohen 2013: 86),
according to a statement by the group's Los Angeles chapter.

In addition to offending moralists and minorities, Bakshi had a sideline of mocking
establishment movie-makers who, in his view, put profits and popularity ahead of
freewheeling creativity. His reasons for choosing *Fritz the Cat* as his first feature film hero
surely included that fact that Crumb's freaked-out feline was a ready-made parody of the
lovable critters in countless cartoons from Walt Disney and Warner Bros, not to mention
Terrytoons, where he himself had recently resided. The storytelling jailbird in *Coonskin*
is a Harlem doppelgänger for the Uncle Remus played by James Baskett in the Disney
film *Song of the South* (Wilfred Jackson and Harve Foster, 1946), itself an animation–live
action hybrid regarded by detractors as racist and highly objectionable to the black
community.

The minimal narrative of *Heavy Traffic* parodies the chronicle of family intrigue and betrayal in Francis Ford Coppola's blockbuster *The Godfather* (1972), released a year earlier; and in case story clues do not sufficiently alert spectators to the satirical intent, Bakshi gives his main character the same name – Michael Corleone – as the iconic anti-hero played by Al Pacino in Coppola's picture. More broadly, *Fritz the Cat* is a mordant personification of the 1960s counterculture, and also a canny anticipation of the punk subculture lurking just ahead. He is, you might say, a cross between Krazy Kat, a Katzenjammer Kid, and the most incorrigible stoner you ever knew. A remarkably large audience found him irresistible.

As a decisively daring artist exploring the far boundaries of socially acceptable film, Bakshi was keenly aware that in the 1960s the old obscenity of sexual and scatological expletives had given way to a new obscenity of racial and ethnic slurs. Bakshi used the old and new varieties with equal abandon, enjoying his newfound status an as equal-opportunity provocateur who was as comfortable with 'nigger' and 'kike' as with 'fuck' and 'cunt'. Tossing racial epithets around could be tricky business for a white film-maker, especially in the pre-Quentin Tarantino era, and a first-time viewer of *Coonskin* might think that Bakshi was trying to inoculate himself from charges of racism by starting the movie with a proudly African American actor singing a proudly African American song. The actor is the marvellous Scatman Crothers, who would acquire international fame via Stanley Kubrick's brilliant horror film *The Shining* (1980) five years later, and the song is 'Ahm a Niggerman', a brash title if ever there was one. It begins –

> Ahm a minstrel man,
> Ahm the cleanin' man,
> And ahm the poor man,
> Ahm the shoeshine man,
> Ahm a Niggerman,
> Watch me dance.

– and between verses one hears the refrain, 'Walk on niggers, walk on / Walk on niggers, walk on.' As the closing credits reveal, however, this is not an African American song; in fact, Bakshi himself wrote the lyrics. The expression *politically correct* did not acquire its present-day connotation of *avoiding language or behaviour that any particular group of people might feel is unkind or offensive* until the 1990s, by which time Bakshi was no longer an *enfant terrible* out to shock the galoshes off the bourgeoisie. But if he did run across that term in the 1970s, he evidently thought it did not, should not, and would not apply to him.

He did think that his talents deserved a warmer welcome from a wider public, however, and this is what motivated him to create *Wizards*, his first family-friendly fantasy. Seeing that his notorious urban-themed films were being 'road-blocked' from theatres, and nostalgic for the kind of fantasy drawing he had done as a teenager, he decided to travel that route again and 'prove that Ralph Bakshi wasn't all sex and drugs', as he told the authors of *Unfiltered: The Complete Ralph Bakshi* (Gibson and McDonnell 2008). True to form, though, he again tested the limits of the genre, supercharging the animated sword-and-sorcery story – about an elf named Weehawk and twin wizards named Avatar and Blackwolf, one magical and loving, the other technological and evil – with archival footage showing Adolf Hitler ranting and Nazi troops raging through World War II.

Moving from the PG-rated *Wizards* to his dream project of a large-scale *Lord of the Rings* adaptation was a large but logical step. Bakshi had read the trilogy in 1956, before it was known beyond a coterie of fantasy buffs and Tolkein disciples. By his own account, the movie rights had been held at different times by Kubrick and John

Boorman, both of whom eventually passed on the idea. The process of shooting it live and then rotoscoping the footage was, he believed, analogous to the method of a painter who crafts a three-dimensional model before rendering a complex subject on canvas. In addition to saving time and cutting costs, it would lend a solid, believable grounding to the picture – a key consideration for a film-maker who loved realist painting and counted Norman Rockwell, Howard Pyle and NC Wyeth among his influences at the time. In the movie as it finally developed, multiple looks and styles share the spotlight: Gollum seems to have sprung from Bakshi's unconscious with no intervening stops; the wizards and hobbits are cartoon figures who move and walk like the actors he filmed; and the villains, including the goblinesque orcs, are basically live-action critters whose likenesses have been retooled in the lab until they resemble invaders from an alien world that is not quite real and not quite nightmare.

The results received mixed reviews, exemplified by Vincent Canby's comment in the *New York Times* that the film is 'both numbing and impressive' and 'visually compelling even when murk overtakes the narrative' (Canby 1978). Bakshi was road-blocked from completing the second instalment of the two-part project, but he still harboured plans for other general-audience animations, feeling that *The Lord of the Rings* was no less deeply personal than his previous films. 'So far I've done pictures about who I am,' he told an interviewer. 'Next I'd like to do pictures about who we *all* are' (Sterritt 1979: 13).

Things worked out somewhat differently. *Hey Good Lookin'* is a sweet-and-sour portrait of youth culture in Brooklyn in the 1950s, the place and time of Bakshi's adolescence. He had finished it in 1975, two years before *Wizards* reached the screen, but Warner Bros was understandably skittish in the aftermath of the *Coonskin* brouhaha, and refused to release it unless many major changes were made. Bakshi decided to revise the film on his own terms, which ended up taking seven years. The final cut, containing more animation and less live action than the original version, had a painfully limited release in 1982, on the heels of *American Pop*, a more substantial and rewarding film by any measure. Few observers regard *Hey Good Lookin'* as one of Bakshi's more significant works.

Bakshi's early films, from *Fritz the Cat* through *Coonskin*, were fuelled in large part by his desire to wage war against the Disney version of the world, and especially against the Disneyization of the animation genre. Although he had great respect and admiration for Disney as an artist, he felt that the Disney studio had become a monolithic entity weighing down the animation field with particular approaches to story and style, all grounded in the assumption that cartoons must be squeaky clean, aggressively wholesome, and pitched entirely to families and children. The public had come to perceive these traits as universal norms rather than reflections of a specific social ideology that was legitimate in itself, but highly limiting when held up as law by the culture police.

By the time he started *Wizards*, however, Bakshi believed he had accomplished his self-appointed task of dragging animation into the adult world, and vice versa. This meant he could turn to general-audience material without worrying that he was regressing to the Terrytoons or Warner Bros stages of his life – stages he had thoroughly enjoyed, in any case – and it freed him to explore autobiographical and countercultural material outside the contexts of gross-out comedy and urban angst. He did this most brilliantly in *American Pop*, a superbly designed animation following a series of fathers and sons across several decades with a spot-on balance of edginess and sensitivity. *American Pop* is arguably Bakshi's finest film, and it concludes the major phase of his career, which took on a more palpably commercial texture in 1983 with *Fire and Ice*, the action-adventure fantasy built around characters he created with Frazetta in the latter's only significant movie venture.

Whether or not he creates great movies in years to come, Bakshi has an unshakeable place in animation history – and cinema history – for opening up new horizons at precisely the moment when it was possible to do so and find a receptive audience. The Disney

style would have remained the *only* style for a much longer period if Bakshi had not stepped up to challenge it.

David Sterritt

References

Canby, Vincent (1978) 'Film: *The Lord of the Rings* from Ralph Bakshi', *The New York Times*, 15 November, https://www.nytimes.com/books/01/02/11/specials/tolkien-lordfilm.html. Accessed 4 December 2013.

Cocks, Jay (1973) 'Cinema: Street Sounds', *Time*, 27 August, http://content.time.com/time/magazine/article/0,9171,907790,00.htm. Accessed 4 December 2013.

Cohen, Karl F (2013) *Forbidden Animation: Censored Cartoons and Blacklisted Animators in America*, Jefferson, NC: McFarland.

Gibson, Jon M & McDonnell, Chris (2008) *Unfiltered: The Complete Ralph Bakshi*, New York: Universe.

Sterritt, David (1979) 'Hobbits, Hobbits Everywhere', *The Christian Science Monitor*, 4 January, pp. 12–13.

NOAH BAUMBACH

Presenting Characters that Explore Self-Worth to Become 'Kind of an Asshole'

Since 1995, Noah Baumbach has written and directed seven full-length feature films, and has additionally written, or contributed to, the screenplay of others, including Wes Anderson's *The Life Aquatic with Steve Zissou* (2004) and *Fantastic Mr. Fox* (2009), and the Dreamworks animation *Madagascar 3: Europe's Most Wanted* (2012).

To put Baumach's work into context, his first film, *Kicking and Screaming* (1995) was released one year after Whit Stillman's *Barcelona* (1994). Alongside Stillman's own debut, *Metropolitan* (1990), the films all share the brilliant, talismanic presence of Chris Eigeman, who also stars in Baumbach's *Mr. Jealousy* (1997), and *Highball* (1997). More significantly though, Baumbach's work also feels like a thematic and stylistic continuation of Stillman's early films, where urbanite characters drive the narrative through their conversations, usually concerning high-brow subjects such as philosophy or literature, which in turn heavily reflects upon the dynamics of the social group, and the individual characters' ability or inability to manoeuvre according to their own arbitrary expectations from life. Yet, much like the 'outsider' Tom Townsend in *Metroplitan*, for all of their affectation, Baumbach's middle-class milieu is differently situated from Stillman's upper-class characters.

Baumbach's work is also comparable to the mumblecore film – an American independent sub-genre derived from the influences of Richard Linklater and John Cassavetes, which embraces naturalism, low-budget film-making (often shot in black and white), and conversational characters in the midst of their twenties and thirties, talking about 'life'. Baumbach's films intersect with the mumblecore movement in a number of thematic and stylistic ways, but the most obvious manifestation of this is through *Francis Ha* (2012), which not only resembles the title of mumblecore pioneer Andrew Bujalski's debut film, *Funny Ha Ha* (2002), but is shot in black and white, and features (in addition to being co-written with) mumblecore stalwart, Greta Gerwig, who was also in Baumbach's *Greenberg* (2010).

Even though he shot *Highball* in only six days as an experiment in what he could achieve on a non-existent budget, Baumbach's style is too precisely mapped out to be considered mumblecore; and his films after the TV movie, *Thirty* (2000), starting with *The Life Aquatic with Steve Zissou*, arguably lean towards the 'indiewood' sector, with a number of Wes Anderson collaborations, and having also drawn in Hollywood actors such as Nicole Kidman and Jack Black for *Margot at the Wedding* (2007), and Ben Stiller for *Greenberg*. Yet despite the apparent cultural gap between say, *Madagascar 3: Europe's Most Wanted* and Baumbach's early trilogy, there are a number of definite features that pervade his work.

In *Fantastic Mr. Fox*, the eponymous character is asked by his dejected wife, 'Why'd you have to get us into this [terrible situation]?' to which Mr Fox replies:

Frances Ha (2012) RT Features, Pine District Pictures,
Scott Rudin Productions

> I don't know, but I have a possible theory. I think I have this thing where I need
> everybody to think I'm the greatest – the quote-unquote fantastic Mr Fox – and if
> they aren't completely knocked out, dazzled, and kind of intimidated by me, then I
> don't feel good about myself.

During this confessional moment of self-awareness about his 'wild animal' nature,
Mr Fox is told by Mrs Fox: 'I love you [...] but I shouldn't have married you.' Broadly
speaking, this dynamic, whereby a central character is incredibly self-centred and
exerts a charismatic hold over some, but never all, of the other characters can be found
at the core of every Baumbach film.

In *Highball*, Felix is having a party hosted by the one man in the room that likes him,
but as someone else remarks, 'He doesn't have a personality, but if he did have one
deep down he'd be kind of an asshole.' Felix only becomes socially acceptable once
he has an 'accident' that no one dares mention. In *Greenberg*, Greenberg ironically
tells his friend 'you make people feel sorry for you, when you're really doing it to
protect your own narcissism', despite repeatedly telling people that he is entirely
focused on 'really trying to do nothing for a while'. Furthermore, in *The Squid and
the Whale* (2005), Walt tells his mother, 'you just bailed on Dad because he's not
successful and hasn't got the recognition he deserves,' when it is painfully obvious
from the outside that the relationship dissolved because the father was solipsistic and
insufferably pretentious. Some guidance is offered in *Mr. Jealousy*, when Lester tells
Dashiell, a philandering member of his therapy group, to 'take some responsibility
for yourself, don't blame it on your nature', but this advice can only be extended by
someone who is secretly stalking his girlfriend's ex-boyfriend, Dashiell, to elevate his
own sense of ego.

One way in which Baumbach's characters try to shape their own presentation within the public discourse is through outward demonstrations of their cultural ability. Greenberg was in a band and writes letters, sharing similar talents and frustrations with Malcolm in *Margot at the Wedding*, where 'music's officially a hobby. He's painting now and writing letters to newspapers and magazines'. Zissou makes documentary films that are half-staged but he also insists on using them as therapy for him dealing with his expanding family and the death of Esteban. Frances of *Frances Ha* has difficulty in becoming a professional dancer, but by the close of her narrative arc she is capable of successfully choreographing her life onstage. *Highball* has Don the Magician, and a guest (Peter Bogdanovich) who can only converse through impressions of other people; and even the escaped zoo animals of *Madagascar* discover themselves through developing circus acts. However, the biggest creative 'trade' is that of the writer – whether it is through journalism (*The Life Aquatic with Steve Zissou*, *Fantastic Mr. Fox*) or literature (*Mr. Jealousy*, *The Squid and the Whale*, *Kicking and Screaming*, *Francis Ha*, *Margot at the Wedding*). Part of the reason for this might be that Baumbach's parents are both writers, but writing is also a highly reflective art form, which fits into the social milieu that Baumbach is eager to examine.

In *Margot at the Wedding*, Malcolm tells those around him that when it comes to being famous, 'for me, expectation just turns to disappointment, so ultimately I'd rather not try', which might also explain Greenberg's problems, and why the young men in *Kicking and Screaming* prefer to talk about writing, and wallow in ennui rather than actually doing anything, as they 'need a healthy dose of self esteem'. Most of Baumbach's characters do develop throughout their respective narratives and this is reflected in their professional successes, so for example, Lester in *Mr. Jealousy* manages to turn his life into a successful play (much like Frances with her choreography), and whilst Bernard in *The Squid and the Whale* finds that 'the publishing world isn't receptive always to real literary talent', his wife – who is acting like a more responsible adult – gets published whilst he receives rejection letters for his 'very dense' work.

If the profession of Baumbach's characters is tied in with their feelings of self-worth, then another way in which they persistently position themselves within their worlds is through their relationships with others – to both their families and their friends. Baumbach examines issues of sibling rivalry in films such as *Margot at the Wedding* ('My friend, Blair asked me, "What's it like to have a celebrity as a sister?" I said I've got no problem with celebrity') and his Wes Anderson collaborations (Klaus's rivalry with Ned, and Ash's hatred of Cousin Kristofferson), but the issue of the father figure dominates his work.

At a public book reading in *Margot*, the author is told 'the Father is a loathsome character, yet we also feel a strange sympathy for him', that 'he also silently resents the responsibility of parenthood', and 'I always saw him as someone who so over identifies with everyone around him that he begins to lose all sense of himself'. When Margot, the author, replies, 'I would never have written this portrait were it true,' she is rebuffed with the devastating reply: 'I'm interested in how the Father could be, in fact, a portrait of you.' In the same film, Malcolm, who is about to become a parent, utters: 'I've not had that thing yet where you realize you're not the most important person in the world. I'm anxious for that to happen.' In *Highball*, one character (played by Baumbach) is coerced into revealing that he currently adopts a boy from Venezuela, but the first one he adopted was taken into custody after failing a few payments because it had been 'a tough year', and although Greenberg does not have a son, in one scene he anxiously enquires at a house party: 'Are you kids really different from me?' whilst ignoring his friend's son, Vic, because he is of no direct importance to his own self-esteem.

Unless they are an outsider figure, such as Ned in *The Life Aquatic with Steve Zissou*, the typical Baumbach family unit comprises mainly of people that are unwilling to relinquish their elevated sense of self-importance. Margot is very much like Bernard in *Squid and the Whale* in that they cannot, or do not especially wish to, give up anything of themselves to other people unless they directly benefit, which leads towards antagonistic and barely concealed contempt towards their perpetually disappointing children, as though they are failed extensions of themselves made manifest in miniature and bullyable form. In *The Life Aquatic with Steve Zissou*, fatherhood is one of the driving issues within the film. Zissou does not wish to be a father, so that when his estranged son appears within his narrow vision of the world – one in which Zissou already knew about his son's existence – Zissou refuses to be called 'Dad', preferring to be called something less symbolically loaded or responsible like 'Stevsie'. Yet, unlike Bernard, who it is revealed, 'only wanted joint custody because you pay less child support that way', Zissou's character develops through his experiences, so that by the end of the film, Zissou can hoist his friend's son onto his shoulders and leave his newly garnered award – and the equally symbolic associations of public success – on the floor outside of the theatre, as he walks away.

In addition to the family dynamic within Baumbach's work, there is also the bond of friendship. This relationship is almost always detrimental to any character unless, or until, they are capable of recognizing that it should be fundamentally symbiotic, and not parasitic in its nature. In *Kicking and Screaming*, a character is called a 'foul weather friend' who is 'not interested unless [they are] suffering', which is indicative of how most of the friends treat each other. Furthermore, despite an assertion that 'You guys are all in love with each other', the reality is that 'Affectations' have 'become habits', where 'we stick together out of fear. It's all we know', and these 'pressures to be friends' will result in 'back-stabbing'. This sentiment of mutual stagnation is reiterated in *Mr. Jealousy* where one character laments, 'Friendship based on when you were younger and different people can often be debilitating. I hate seeing men where they get in a situation where they promote each other's insecurities.' These issues of friendship are akin to the problems that arise from family ties in Baumbach's work, as even in *Madagascar 3: Europe's Most Wanted*, the surrogate family of zoo animals get 'stuck in a rut' through failing to develop their introspective adage that 'Circus stick together [*sic*]'. Nevertheless, *Greenberg* and *Fantastic Mr. Fox* are amongst the few characters that demonstrate a final epiphany of selfless friendship, and in *Frances Ha*, the film follows Frances's slow movement away from her best friend, where through cinematic fate, they eventually reunite, but instead of this being a reversion back to their original ways (which is what Frances initially wants), both people mature from their experience and develop in an affirmative direction.

Highball is an interesting relationship experiment whereby the film covers three social events in the same apartment over one year, but across each party there is a component from the other two that has either been removed or altered in some way. The owners, Dianne and Travis, are together in the first and last segment after an unhappy period apart; Miles has a record company job in the first and second parties, but enjoys his record-shop job in the last piece, although his former boss now misses him; Darien has movie stars for girlfriends in the first two events, but then announces he is homosexual; and Felix was insufferable in the first two soirees, but eventually undergoes a radical transformation. In this film, Baumbach plays with combinations and permutations of relationships, and with a wider remit, this essay would have looked at sexual relationships in equal measure; but one of the striking messages across all of Baumbach's work is that development can be

a good thing; it is not always a pleasant experience, and it is never the product of making selfish, easy choices, but it can enable people to understand themselves better, and in turn, this collective maturity can be beneficial to all members of a group, be it familial, through the bracket of friendship, or in a wider cultural way as a social discourse.

Carl Wilson

JOHN CASSAVETES

The Ultimate Hero of American Independent Cinema

For the past decade there have been a number of studies in American independent cinema and despite different approaches to independence their common vantage point is that it is a polyvalent term, and certainly not a fixed one. However, at times one notices that independence is strictly examined in terms of the industrial context, completely disconnected from issues of narrative and thematic experimentation. A closer look at one of the fathers of American independent cinema, that is, John Cassavetes, might make us understand that during the 1960s and 1970s independence from the standardized production process was not simply something that can be explained in political economic terms. It was rather a form of negation, a desire to express non-conformist ideas and to cast a critical eye on aspects of everyday life which are not given sufficient screen time in mainstream cinema.

John Cassavetes remains the ultimate hero of the American independent cinema on account of the fact that he saw cinema strictly as art and not as business. Refusing to compromise, he repeatedly put himself into great debt, or took acting jobs to support his film-making ventures, while later on he founded his own company, Faces Films, to distribute his own films. His first film, *Shadows* (1959), is a landmark of an oppositional narrative on the formal and the thematic level. The film deals with issues of race at a time when the United States had not really come to terms with its institutional and social racism. As Peter Falk rightly points out (Mestdagh 1996), it was a real wonder that, years before Martin Luther King, at a time when black people had to sit in demarcated bus seats in the South, a young man in his early twenties decided to make a film with a strong racial theme. The film's originality relied also on its formal edge. Shot mainly on location in New York, using handheld cameras and direct sound, based upon a concept rather than a script, and with an ensemble cast of student and amateur actors, *Shadows* communicated a sense of originality and rawness that offered a more authentic image of America. The film was partially financed by the audience. As Cassavetes says:

> In February I was going on Jean Shepherd's *Night People* radio show, because he had plugged *Edge of the City*, and I wanted to thank him for it. I told Jean about the piece we had done, and how it could be a good film. I said, 'Wouldn't it be terrific if [ordinary] people could make movies, instead of all these Hollywood big-wigs who are only interested in business and how much the picture was going to gross and everything?' And he asked if I thought I'd be able to raise the money for it. 'If people really want to see a movie about people,'' I answered, 'they should just contribute money.' For a week afterwards, money came in. At the end it totalled $2,500. (Carney 2001: 56)

Cassavetes explains that there was a desire on the part of the people to see real life on the screen and not the stylized reality of Hollywood. While shooting his next film, *Faces*

Shadows © 1959 Lion International

(1968), which was also independently financed, he explained that one of his aims was to show a different America, which was rarely represented in Hollywood (Knapp and Labarthe 1969).

Both films encapsulate his modus operandi throughout his career. He tried to make films which were not polished, nor were they mere reproductions of a fixed script. They were rather based on a concept which he and his team would use to explore and discover things instead of reproducing a coherent dramatic cosmos. Emblematic in this regard, is the scene in which Lelia's (Lelia Goldoni) boyfriend, Tony (Anthony Ray), realizes that the woman he is dating comes from a black background. Within a long shot that alternates between faces and captures different points of view Cassavetes manages to disclose a set of attitudes without relying on dramatic speech but on body language and a performing style, which demanded from the actors to reflect on the roles they performed, and let their own reading of the character influence their acting.

In *Faces* it is the American middle class which is placed under scrutiny, showing people dissatisfied with their marriages, their careers and the roles they have to perform. Trying to rebel against their conformist live styles they end up discovering themselves by spending time with prostitutes and playboys. Again, psychological portrayal is relinquished in favour of a camera-work dedicated to exploring the reality it represents

instead of reproducing rhetorical explanations. Commenting on Cassavetes's modus operandi, Sylvie Pierre and Jean-Louis Comolli synopsized his major innovation:

> Cassavetes and his friends do not use the cinema as a way of reproducing actions, gestures, faces or ideas, but as a way of producing them. We start from scratch, they say: the cinema is the motor, the film is what causes each event to happen and to be remembered. (Pierre and Comolli 1986: 326)

The concept of 'production', which is identified by the French critics as the core characteristic of Cassavetes' work, is at the antipodes of the causal chain of classical Hollywood narrative which is structured upon the principles of narrative continuity and plot development. Cassavetes repeatedly stated that he was not interested in dramatic plot but in characters. But this interest in exploring the characters throughout the shooting process sits uneasily with the well-rounded dramatic hero, whose desires push forward the narrative and his/her actions can be psychologically interpreted. On the contrary, Cassavetes wanted the actor and the camera to reflect while presenting material, so as to lead the narrative and the characters to non-predetermined paths.

 This is the reason why none of his films – with the exception of *A Child is Waiting* (1963) and to a lesser extent the preceding *Too Late Blues* (1961), which were produced by United Artists and Paramount respectively – follow ostensible dramaturgical patterns. *Husbands* (1970) is another important case in point. The film follows the lives of three professional New Yorkers who are shaken when one of their best friends dies of a heart attack. After two days of excessive drinking, they decide to visit London where we follow their encounters with three women. Again the film is based on a visual concept and the characters and the story were the outcome of improvisatory exercises between Cassavetes and the other protagonists, Ben Gazzara and Peter Falk. Considerable screen time is devoted to following the characters' excessive gestures and dialogue, which point to the broader social crises which can account for their impasse. After the completion of the film, Cassavetes, Gazzara and Falk were invited to *The Dick Cavett Show* (ABC, 1968-1974). In an episode that was broadcast on 18 September 1970, Cavett repeatedly tried to find out what the film was about and to his consternation, Cassavetes and his collaborators refused to provide any coherent information. After half an hour of television time, Cassavetes explained that there is no point in talking about plot, since the film aims to explore and discover the characters' reactions to a friend's death, which makes them re-evaluate their own lives.

 In a way, Cassavetes saw the actors as collaborators in the making of a film and, as he refused to offer fixed hermeneutical directions to the audiences and the critics, he did the same with his actors. As he said: 'the picture is what the actors want to bring into it' (Knapp and Labarthe 1969) and this is the main reason why he did not delineate the characters clearly and asked his actors to discard the clichés they employed in traditional narrative films. Gena Rowlands explained that this refusal to offer clear instructions to the actors was a programmatic approach to film-making, which aimed at rendering the actors as collaborators in the making of the film and the production of meaning (Cazenave and Headline 1993). Similarly, Peter Falk pointed out that Cassavetes did not offer clear instructions, because he was afraid that the actors would 'translate it into a cliché' (Knapp and Labarthe 1969). But despite the difficulties and the frustrations triggered by this demanding type of film-making, all the actors he worked with felt that they were respected by the film-maker. As Seymour Cassel phrases it, 'to work with John made you feel that the film was yours' (Knapp and Labarthe 1969).

 Giles Deleuze saw in Cassavetes's work with the actors the emblem of 'the cinema of the body', a type of cinema which reduces the characters to their corporeal attitudes and gestures, and valorizes the film-making process rather than the finished product.

Drawing on Cassavetes' renowned interest in people rather than technical matters, Deleuze explains how the father of American independent cinema was concerned with merging the diegetic with the non-diegetic reality:

> This is what Cassavetes was already saying in *Shadows* and then *Faces*; what constitutes part of the film is interesting oneself in the people more than in the film, in the 'human problems' more than in the 'problems of mise-en-scène', so that the people do not pass over to the side of the camera without the camera having passed over to the side of the people. In *Shadows* it is the two white Negroes who constitute the frontier, and its perpetual crossing in a double reality which is no longer distinguishable from the film. The frontier can be grasped only in flight, when we no longer know where it passes, between the white and the black, but also between the film and the non-film; it is characteristic of film to be always outside its marks, breaking with 'the right distance', always overflowing 'the reserved zone' where we would have liked to hold it in space and time. (Deleuze 1989: 154)

Yet this merging of the reality of the film with the extra-diegetic reality is not to be seen as a matter of technical trickery. It rather synopsizes the film-maker's desire to do away with all stylization, in order to capture real feelings and emotions instead of relying on sentimentalized dramatic tropes that have little connection to real life. This desire to bridge art with life is the quintessence of Cassavetes's cinema and at times this becomes the leitmotif of films, such as *The Killing of a Chinese Bookie* (1976) and *Opening Night* (1977), which thematize the very reality of alternative representational practices. But most importantly, Cassavetes's cinema is a living proof that what constitutes good cinema is above all a good eye for social issues and an interest in people rather than polished *mise-en-scène* and scripts with clear-cut narrative schemas. As he says, 'art films are not necessarily photography. It is feeling. If we can capture a feeling of a people, of a way of life, then we can make a good picture' (Knapp and Labarthe 1969). His oeuvre has influenced a plethora of film-makers in the United States and in Europe, such as Martin Scorsese, Harmony Korine, Jim Jarmusch, Hal Hartley, Lars von Trier, Thomas Vinterberg, Béla Tarr, Yorgos Lanthimos, and many more.

Angelos Koutsourakis

References

Carney, Ray (2001) *Cassavetes on Cassavetes*, London: Faber & Faber.

Cazenave, Dominique & Headline, Doug (1993) *Anything for John*, UK: BFI.

Deleuze, Giles (1989) *Cinema 2: The Time Image* (trans. Hugh Tomlison and Robert Galeta), Minneapolis: University of Minnesota Press.

Knapp, Hubert & Labarthe, André S (1969) *Cinéastes de notre temps: John Cassavetes/ Filmmakers of our Times: John Cassavetes*, France: Office de Radiodiffusion Télévision Française.

Mestdagh, Rudolph (1996) *John Cassavetes: To Risk Everything to Express It All*, Belgium: Amalgam.

Pierre, Sylvie & Comolli, Jean-Louis (1986), 'Two Faces of Faces', in Jim Hillier (ed.), *Cahiers du Cinéma 1960–1968: New Wave, New Cinema, Reevaluating Hollywood*, Cambridge: MA: Harvard University Press, pp. 324–27.

LISA CHOLODENKO
Post-Modern Soap Operas

Lisa Cholodenko made an indelible mark on the independent film world with her feature debut *High Art* (1998). She won the Waldo Salt Screenwriting Award at the Sundance Film Festival that year, as well as an Independent Spirit Award for Best First Feature. Her beguiling romantic drama chronicles the intense relationship that develops between Syd (Radha Mitchell), an assistant editor at a magazine, and her upstairs neighbour, Lucy Berliner (Ally Sheedy), a 'retired' photographer. Sheedy also received awards for her excellent performance.

One of the reasons that *High Art* achieved critical and commercial success was that it was more sophisticated than the scrappy New Queer Cinema films by and about lesbians in the 1990s. Rose Troche's *Go Fish* (1994), Marita Giovanni's *Bar Girls* (1994), Maria Maggenti's *The Incredibly True Adventure of Two Girls in Love* (1995), Cheryl Dunye's *The Watermelon Woman* (1996) and Alex Sichel's *All over Me* (1997) were key American independent lesbian films of the decade. *High Art* ushered in a New Wave of lesbian film-making along with complicated portrayals of queer sexual identity – Kimberly Peirce's *Boys Don't Cry* (1999) and Jamie Babbit's *But I'm a Cheerleader* (1999) among them.

However, Cholodenko does not see herself labelled as a queer film-maker. She said in an interview I did with her for *The Kids Are All Right* (2010), 'I think I'm perceived as someone who is [making] films with lesbian strains in them. [I'm] not pigeonholed as a gay film-maker per se, or a political film-maker, more an independent film-maker'. (Kramer 2010)

Cholodenko established herself with *High Art* after making two short films, *Souvenir* (1994) and *Dinner Party* (1997). A shrewd director, she exhibited a confidence in her work that has become increasingly rare in independent American cinema, as film-makers like Miranda July tend to affect quirkiness to charm viewers in films like *You and Me and Everyone We Know* (2005) and *The Future* (2011). Cholodenko instead creates flawed characters that speak their minds and/or act rashly. Her protagonists make connections with strangers that take them on a path to self-discovery and empowerment; and many of her heroines are united by their quest to find their identity and sense of self through their sexuality. Ultimately, Cholodenko's characters think they have everything under control, only to lose that control with comic and/or dramatic results. As she has acknowledged,

> On some level, if there is anything thematic in [my] films, it is the tension between the two sides of the poles of what it means to be ordered and appropriate and precise and what it means to abandon and see where it lands. (Kramer 2010)

In *High Art* and her subsequent features, Cholodenko has distinguished herself by exhibiting a keen eye for composition – a shot of Syd reading in her bathtub

The Kids are Alright © 2010 Antidote Films,
Focus Features, Mandalay Vision

is especially arty and sexy – and for coaxing strong performances from her actors. Patricia Clarkson stole every scene as Lucy's girlfriend Greta; and the actress's career took off as a result. Cholodenko's character-driven dramas pivot around women facing issues of fidelity and female pleasure, as well as losing, gaining or maintaining control. It is not a coincidence that many of the protagonists in her films often sleep with anger; so frustrated are they with their partners or their conflicts, that they wrestle with their emotions in bed, often the centre of their home.

In addition, the film-maker uses music well in her work. From the atmospheric score by Shudder to Think that provides a haunting quality to *High Art*, and the tune that several characters sing in *Cavedweller* (2004), to the songs by Sparklehorse that form the backbone of *Laurel Canyon* (2002), and the Joni Mitchell song that the characters appreciate in *The Kids Are All Right*, Cholodenko establishes a vibe, a rhythm that reflects the moods and emotions of her characters. Music is also carefully selected and presented in her work; it emphasizes her precision as a film-maker.

High Art mined the sexual and ethical politics of Syd and Lucy who meet when Syd discovers a leak in her bathroom coming from her upstairs neighbour, Lucy's apartment. The women soon form a professional relationship when Syd coordinates a magazine feature on Lucy that could benefit both of their careers. Lucy agrees to participate on the condition that Syd edit the piece. Soon the two women – each are with other partners – enter into a personal affair in addition to their professional one. When Syd enters Lucy's New York bohemian world, it is a lazy, hazy den of iniquity where hangers on snort lines of heroin. Syd is attracted to Lucy's photographs. Lucy admires Syd's ambition, focus and drive. Their friendship morphs into a relationship, which stirs pangs of jealousy from Lucy's girlfriend, Greta (Patricia Clarkson).

When the artist and her editor take a trip upstate, *High Art* captures the flashpoint of the relationship, with intense scenes of Syd and Lucy becoming more intimate. Lucy photographs Syd, and Syd sheds a tear confessing to falling in love with the photographer. Cholodenko's approach to this potentially trite material is savvy. Viewers adopt Syd's innocent, seduced perspective, while also admiring Lucy's ability

to maintain a passive control in her relationships. When Syd is ultimately confronted with her part in Lucy's 'comeback' – being not just the orchestrator, but also the subject – *High Art* provides a truly powerful moment. But Cholodenko shows her mastery as a storyteller by providing another reveal that prompts Syd (and audiences) to recalibrate her experiences.

High Art succeeded because it was not just well made and acted, but because Cholodenko proved herself to be a canny observer of relationships and the power struggles the characters have with themselves and their partners. When Lucy confesses to her mother (Tammy Grimes) that she has a 'drug problem and a love issue' she is being nakedly honest – possibly for the first time in a long while. Likewise, when Syd admits to her boss that she is Lucy's lover, a moment of embarrassment becomes empowering. That Cholodenko captures these moments without making them feel cloying or mawkish is what makes *High Art* such an auspicious feature debut.

Cholodenko further explored the themes of control in her sophomore feature, the warmly received *Laurel Canyon*. The film depicts the upright (read: uptight) Sam (Christian Bale) who takes his girlfriend Alex (Kate Beckinsale) to stay at his mother Jane's (Frances McDormand) home/studio in Laurel Canyon outside Los Angeles. Playing on a favourite theme of a stranger entering an established household – a plotline featured in *High Art*, *Laurel Canyon*, *Cavedweller* and *The Kids Are All Right* – Cholodenko magnifies the ways in which families are shaped, encounter conflict, and find reconciliation.

In my interview with Cholodenko for *The Kids Are All Right*, the writer-director explained why plots about desirable strangers appeal to her. She spoke about juxtaposing what someone projects on another against the attraction they themselves feel:

> You don't really know [someone] when you are interested, or intrigued by them, [versus] when you know someone better, and the intimacies are deeper, and the person is more exposed, the risks are higher. I'm juxtaposing those two conditions against attraction. The underbelly of it all is: What makes an illicit affair charged? What is transgression? What is crossing a boundary? When it is so forbidden, and so taboo, so wrong, does that make something more tempting, and more erotic, or attractive? I am interested in power struggles in intimacy, how people connect and don't connect. Psychosexual states are pretty interesting and complicated. I like poking around in those places – no pun intended. (Kramer 2010)

Cholodenko's investigation of the interrelated issues of love and trust, truth and self-acceptance, resonate as the protagonists of her films come away with a greater sense of self, even if it is sometimes at the expense of someone they love(d).

In *Laurel Canyon*, Sam is protective of Alex, and wary of his mother's lack of boundaries. Alex is finishing her dissertation on genomics while Sam does his residency at a nearby hospital. Once ensconced in the house, however, tension develops not only between mother and son but also between Alex and Sam.

While Cholodenko infuses her film with a loose energy that is ingratiating, a significant plot takes shape when Alex is seduced literally and figuratively by both Jane and her lover Ian (Alessandro Nivola). Alex is pulled into the musician's messy world by her instincts, giving in to her attraction to Ian as well as to Jane. Meanwhile, Sam tries to suppress his own desires for Sara (Natascha McElhone), a resident who drives him to and from the hospital.

How these characters come to expose and express their emotional insecurities is what makes Cholodenko's film so absorbing. *Laurel Canyon* pivots not just on issues of fidelity – a key theme in the director's work – but also on ideas of risk and safety. Alex and Sam have an ordered life, albeit with a few secrets. But their planned futures (both

as professionals and as a couple) are shaken up after being exposed to Jane and Ian and Sara. When their affairs reach a dangerous climax, *Laurel Canyon* investigates the possible repercussions of the characters' bad behaviour. The film is, actually, a comedy of manners, finding dark humour in the way the protagonists reconcile their emotional and physical desires. This theme is at the core of Cholodenko's films. The director's uncanny ability to make the passions she presents tangible and seductive is her strength.

Cholodenko's next project, *Cavedweller*, may be her least known. Airing on the cable American television network, Showtime, this heartfelt adaptation of Dorothy Allison's novel stars Kyra Sedgwick, who produced the film, as Delia Byrd, a singer who returns home to Georgia with her daughter Cissy (Regan Arnold) after her lover Randall (Kevin Bacon) dies. In Georgia, Delia makes a deal to care for Clint (Aidan Quinn), her dying, abusive husband, if she can have custody of their two daughters Amanda (Vanessa Zima) and Dede (April Mullen). Ten years ago, after a violent encounter with Clint, Delia abandoned her daughters and left town with Randall, a musician in a band called Pony Up.

Cavedweller toggles back and forth in time to tell Delia's backstory as she confronts her uncertain future headlong. The film deftly addresses themes of forgiveness and tolerance as Delia tries to do 'what's right', and reunite (with) her family. Cholodenko emphasizes the bond between women as Delia connects with her three very different daughters and gains support from her friends MT (Sherilyn Fenn) and Rosemary (Jill Scott). She also talks with the local Reverend (Dan Lett). These episodes help Delia find value and security as well as her sense of self. Like most of Cholodenko's heroines, Delia is looking to reinvent herself. The film-maker subtly echoes this point as Delia, Cissy and Dede each sing one of Delia's Pony Up songs at different times, illustrating how Delia's imprint is passed along to her children.

The modest scale and cable TV-movie format of *Cavedweller* provide a fine showcase for Sedgwick's flinty performance. Cholodenko adapts well to creating the warm and awkward exchanges between the characters as the story unfolds. Her ability to frame her characters in their environments – a car, a bedroom, a porch or a kitchen table – freights each scene with meaning, showing how well Cholodenko works with the small-screen format. *Cavedweller* builds on her experience of having directed single episodes of the television series *Homicide: Life on the Streets* (NBC, 1993-99), *Six Feet Under* (HBO, 2001-05) and *Push, Nevada* (ABC/CTV Television Network, 2002). She later helmed episodes of *The L Word* (Showtime, 2004-09) and *Hung* (HBO, 2009-11).

Cholodenko received a Best Original Screenplay Oscar nomination (along with her co-writer, Stuart Blumberg) for her next theatrical release, the 'high concept' *The Kids Are All Right*. The film also received a Best Picture Oscar nomination as well as nominations in the Best Actress and Best Supporting Actor categories for Annette Bening and Mark Ruffalo, respectively. *Kids* also won a Golden Globe for Best Motion Picture, Musical or Comedy, and Annette Bening won a Best Actress Golden Globe for her work in the film.

The Kids Are All Right is considered Hollywood's mainstream lesbian film. It concerns a couple – Nic (Bening) and Jules (Julianne Moore) – whose peaceful coexistence is shattered when their 18-year-old daughter Joni (Mia Wasikowska) contacts Paul (Ruffalo), her biological sperm donor father. As Joni and her younger brother Laser (Josh Hutcherson) bond with their 'dad' Paul, and Jules takes a landscaping job for him, Nic becomes jealous, bemoaning that Paul, a stranger, is 'taking over her family'. Nic is particularly sensitive, because she is experiencing anxiety over Joni heading off to college in the fall. Whereas in *Cavedweller*, Delia worries about 'fixing' her family, Nic is questioning whether she has done a good job as a mother.

The Kids Are All Right examines the damaging effects an interloper has on the family with comic and dramatic results. There are broad and farcical moments involving Jules's affair with Paul, but there are also tense scenes of consternation when Paul disrupts the family he 'created' but does not have. Jules's behaviour potentially severs – perhaps irreparably – her relationship with Nic and their kids. Cholodenko remarked about her characters' penchant for bad behaviour: 'I think in terms of a normal sample population of free thinking people, they will be able to identify their own impulses of mistakes and behavior in the film [*Kids*], and this would counter the [other] impulse' (Kramer 2010).

As such, each of the director's films raises a question: would Syd begin an affair with her upstairs neighbour to exploit her talent as a photographer to get ahead at her magazine job? Why would Sam consider an affair with his colleague if he were not having doubts about his relationship with Alex? Why would Alex allow for a threesome to develop with her fiancée's mother and lover? Is Delia doing the 'right thing' moving back to Georgia? And why would Jules sleep (repeatedly) with the sperm donor who fathered the children she raised with her lover? Are these characters simply feeling neglected? Cholodenko answers these concerns by revealing each of her protagonist's psychological state of suffocation. Each woman feels trapped where she should feel supported. They escape their trap by exploring – sexually, but also emotionally – what they can achieve through their own will, which proves to be the unifying theme of the film-maker's work.

In 2014, Cholodenko's miniseries *Olive Kitteridge* aired on HBO after screening at the Venice Film Festival. The four-hour drama was adapted from Elizabeth Strout's Pulitzer Prize-winning novel. Frances McDormand plays the title character, a no-nonsense math teacher in Crosby, Maine, who lives with her pharmacist husband, Henry (Richard Jenkins) and son, Christopher (Devin Druid at 13 years of age, and John Gallagher Jr as an adult). The miniseries chronicles 25 years in the tart-tongued Olive's tough and melancholy life. While some folks she helps appreciate Olive's candour, Christopher is particularly distressed by his mother's brusque nature. Henry mostly tolerates it, once even reproaching her, 'Thank God, I got you to tell me what I'm thinking.' Nevertheless, Olive maintains control, even at the risk of unhappiness. She almost runs away with her colleague Jim (Peter Mullan) and also contemplates suicide.

Olive Kitteridge extends Cholodenko's ability to tell complex, compelling stories about characters stifled by social conventions yearning to break free and be themselves. It will be interesting to see how the film-maker incorporates these same themes in her next production, an NBC miniseries entitled *The Slap* (2014).

Gary M Kramer

References

Kramer, Gary (2010) 'Film Tackles Same-sex Marriage, Meeting the Sperm Donor', *Philadelphia Gay News*, 22 July, http://www.epgn.com/arts-culture/arts/2497-8846151-film-tackles-samesex-marriage-meeting-the-sperm-donor. Accessed 16 July 2015.

LARRY COHEN
Genre Cinema with a Conscience

Between 1972 and 1976, Larry Cohen directed five features. Four of those films are essential viewing for any viewer who wishes to learn not just about the independent film movement of that time, but also to see how the American landscape was rapidly changing. Racial and class divides, philosophical debates about the pros and cons of religion, concerns about how our health is damaged by exposure to pollution, prescription drugs and pesticides are all topics raised in Cohen's films. Where lesser directors have tackled these issues in preachy and stilted manners, Cohen weaves them organically into his pulpy, entertaining stories of gangsters, mutant babies, scheming criminals and aliens masquerading as gods. While this will be a look at a narrow range of Cohen's body of work, any viewer who enjoys these films would do well to seek out Cohen's pictures beyond those discussed here.

Bone (1972), Cohen's debut feature, is the story of Bill (Andrew Duggan) and Bernadette (Joyce Van Patten), a white Beverly Hills couple who are taken captive by an unnamed African American criminal (Yaphet Kotto). In what would become a sure sign of a Larry Cohen film, Bone constantly upends audience expectations. By the end of the first act, it has been revealed that the couple is in serious debt and that Bill has a secret bank account under only his name. The film continues to turn down surprising corridors as Bernadette seduces the criminal, allying herself with him, and Bill is released to close out his bank account but spends his time wandering around Beverly Hills, slowly losing his mind.

Bone is a film light of step, skipping from thriller to dark comedy to surreal nightmare and back again before a brutal climax and powerful resolution. While the surface plot is entertaining and Cohen's treatment of what could have been tasteless material is memorable, it is what lies beneath the surface that gives the film staying power. The film takes aim at racial and class divides and the preconceived notions that people have about life on 'the other side'. Cohen then turns from twisting the stereotypes the characters have about each other to making the audience confront their own expectations about the characters. The most striking way this is done is by revealing the seemingly victimized Bernadette to be the most cold-blooded among the unlikable trio.

The film thankfully avoids political correctness. While many of Bill and Bernadette's incorrect assumptions about the criminal are based on his race, he is still a potentially violent intruder who has taken them hostage. In a disturbing scene, he even tries to rape Bernadette. The criminal, in turn, assumes that because Bill and Bernadette are white and seemingly rich they are probably guilty of something and deserve to be robbed. Considering Bill is hiding money from Bernadette and how quickly Bernadette turns on her husband, he is shown to be correct. As Cohen explains,

> I think the film really does address the racial issue in America as well as anything that's ever been made on the subject. It also deals with white fantasies. For

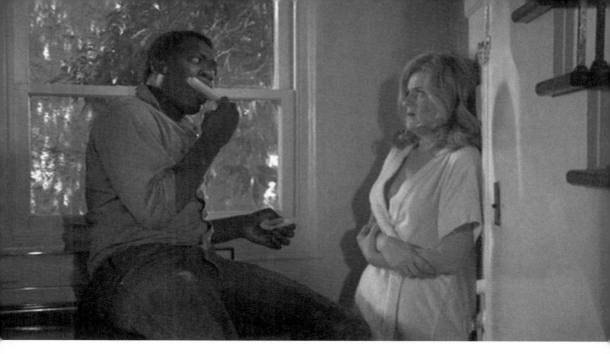

Bone © 1972 Jack H. Harris Enterprises,
Larco Productions

example, Yaphet Kotto never identifies himself as 'Bone'. Joyce Van Patten
names him that. In the script, she says, 'Oh Bone! You're just the way I imagined
you'd be.' He could be something she conjured up. Her version of a black man.
(Williams 1997: 303)

Cohen continued his look at racial divisions in America, expanding his explorations to
consider the connection between race, poverty and crime with *Black Caesar* (1973).
Although marketed as a 'blaxploitation' film, it is rooted in the classic Warner Bros.
gangster films from the 1930s that made stars of James Cagney, Edward G Robinson
and Humphrey Bogart. Even its title takes direct inspiration from Robinson's *Little
Caesar* (1931). The film is a traditional morality play: Tommy Gibbs (Fred Williamson),
a poor African American kid, rises from working as a bagman for the Italian mob
to running his own empire in New York's Harlem neighbourhood before greed and
arrogance leads to his downfall.

 What sets *Black Caesar* apart from the glut of other blaxploitation films of the period
is that Tommy's misdeeds are never brushed aside as justifiable reactions to racism.
As a kid, Cohen seems to argue, Tommy tried to get by any way he could, held down
in a life of crime by racist cops and city officials. But once he has money and power,
Tommy becomes a monster driven by the demons in his past. He kills friends who
get in his way, beats and rapes his wife, and has no one left to turn to as his criminal
empire falls apart. While Williamson is charismatic in the role, there is nothing to like
nor admire about Tommy. He brings his misfortunes on himself, which flies in the
face of what happens in many blaxploitation films, giving the film a moral point and
continuing Cohen's habit of subverting genre tropes.

It's Alive (1974) is Cohen's breakthrough film. With a plot that revolves around a mutated killer baby, it could have been a trashy exploitation picture, but Cohen again subverted genre expectations to great effect. Frank (John P Ryan) and Lenore Davis (Sharon Farrell) seem to live a charmed life. They have a nice home. Frank is a successful public relations executive. They have a polite son (Daniel Holzman) and another baby on the way. But when the baby is born, he can barely be recognized as human. He has fangs and claws and a large, misshapen head. He immediately kills the medical staff in the delivery room but leaves Lenore alive. After escaping from the hospital, he leads the police on a city-wide manhunt; killing anyone he feels to be threatening. Unfortunately, the baby views almost everyone beyond Frank and Lenore to be a potential threat.

Using this lurid setup as way to hook the audience, Cohen shifts focus away from the killer baby and onto Frank. What initially seems like a graphic horror film becomes a character study of a man under extraordinary stress. Unable to deal with fathering a killer, Frank ignores the needs of his increasingly unstable wife and becomes single-minded in his quest to help find and kill the baby. Brought to life by Ryan's career-best performance, Frank is possibly Cohen's greatest creation. He is the embodiment of changing American masculinity in the 1970s. Frank is college-educated, holds a white-collar job, and has no problem openly displaying his love for his wife and son. These traits run counter to what used to be considered a 'real man'. When his tragic second child is born a killer, Frank finds himself under siege from the media and the police. His response is to try and be the 'tough' alpha-male he is not. He closes off from his wife, carries a gun, and becomes desperate to be the person to kill the baby. He professes to anyone who asks that he does not believe the baby to be human and that it should be put down like an animal. In one scene, Frank makes the apt analogy that he is like Dr Frankenstein because most people believe the monster is Frankenstein, not the Doctor. He bristles at the media description of the child as 'the Davis baby' because people will view him as monstrous as well. Still, Frank's pain and shock become more understandable as the film progresses. He may not be a sympathetic character but he remains relatable due to the impressive shading Cohen provides and Ryan's devastating performance.

Sprinkled throughout the film are theories that the baby is a genetic mutation that is the result of humans evolving to live in a hostile world. Cohen makes the most of this idea, pointing out the pollution clouding the sky, the heavy use of pesticides, the numerous prescription drugs that can lead to unexpected side effects (which provides a clever subplot about doctors being too cosy with a corrupt pharmaceutical industry), and the chemicals used to 'clean' drinking water. *It's Alive* was the first of Cohen's films to seamlessly mix his ability to write three-dimensional characters with his pulpy plots and social commentary. Surprisingly, considering the film could be viewed as a bait-and-switch for those looking for a graphic horror film about a mutated killer baby, it was a huge hit. The same cannot be said for his follow-up film.

God Told Me To (1976) is a daring amalgam of surreal horror, science fiction and police procedural. It is also a blatant questioning of blind faith that does not flinch when looking at the dark side of being a true believer.

Peter Nicholas (Tony Lo Bianco) is a New York City police detective and a devout Catholic. His religious beliefs lead to intense guilt over his failed marriage and relationship with his new girlfriend Casey (Deborah Raffin). Investigating a string of random murders where the killer always claims, 'God told me to,' Peter finds his faith shaken. When he winds up on the trail of a mysterious figure who met with all the killers before they committed their crimes, he slowly begins to believe he is tracking not a man but something not of this world. It is when the film questions if the mystery figure is an alien or a god that the film found controversy and Cohen found his destiny as a true auteur.

Like *It's Alive*, *Gold Told Me To* uses its genre setup to bring in the audience before delivering a character study of a man trying to be something he is not. At every turn of the film, Peter tries to ignore the mounting issues that are holding him back from being with Casey, but the past will not let him go. It is not until he faces up to his childhood as an orphan, his religious faith that no longer fulfils him, and what happened to destroy his marriage, that he is able to confront the mystery man behind the killings. 'How it impacts his wife, his girlfriend and his brother are all dealt with as if they were really happening, not in some silly, nonsensical way with the use of CGI,' Cohen asserts, placing the need for believable characters above all else. 'The people are real people and the situations are real, even if they may be fantastic' (Foster 2012).

God Told Me To was a commercial failure. At one point, the distributor changed the title to *Demon* in an effort to ride the coattails of films like *The Exorcist* (William Friedkin, 1973) and *The Omen* (Richard Donner, 1976). The film even played in different cities at the same time under different titles, potentially confusing audiences that might have been looking for it under the wrong title. It also suffered from boycotts by religious organizations angered at the parallels drawn in the film between the mysterious figure and Jesus Christ. Despite its financial failure, it has been recognized in the years since as one of Cohen's most accomplished works and its influence can be seen on films and television series as diverse as *E.T. the Extra-Terrestrial* (Steven Spielberg, 1982) to *The X-Files* (FOX, 1993–2002).

For these four films, working outside the studio system allowed Cohen the freedom to work his own way and he relished his outsider status as a subversive genre director:

> That's the essence of outlaw film-making: not asking permission. In every art form – writing, composing, painting – you go to work when it pleases you. Only in movies or theatre do you need approval of dozens of others. I've tried to avoid playing by those rules. (Williams 1997: 360)

Matt Wedge

References

Foster, Simon (2012) 'Larry Cohen: Interview', *Special Broadcasting Service*, 31 October, http://www.sbs.com.au/films/movie-news/898637/larry-cohen-interview. Accessed 20 November 2013.

Williams, Tony (1997) *Larry Cohen: The Radical Allegories of an Independent Film-maker*, Jefferson, NC: McFarland & Co.

SOFIA COPPOLA
Fame and Self-Reference

Since her Academy Award-winning original screenplay for *Lost in Translation* (2003), and continuing in *Somewhere* (2010) and *The Bling Ring* (2013), Sofia Coppola has generated a complex, nuanced and penetrating depiction of fame – often representing a form of alternate consciousness both for those who have it and for those who, as it were, witness it, admire it, or want it for themselves. Celebrity in her rendering is a kind of atmosphere that transforms a person's individual presence in the world – sets them up, sets them apart. Often the phenomenon is uniformly confounding, and creates astonishing fields of distortion – including isolation, vacancy, alienation and asymmetries of power and influence – both in the celebrity and those who view or relate to the celebrity. When filmed by Coppola, or better, brought to life through her filmic representations, yet another valence of distance (and distortion) is conjured: here, the celebrity daughter of legendary director/father, Francis Ford, contributes not just an illustrious pedigree to film-making, but a decided interest in the very act of displaying actors (and their characters – in both senses) for our consideration. With a family tree full of accomplished and acclaimed stars including Nicolas Cage (né Coppola), Talia Shire, Jason Schwartzman, brother Roman Coppola (with whom she now runs the production company American Zoetrope, inherited from their father) and mother Eleanor Coppola, among others, we should not be surprised that Coppola has herself become an adept reader and savvy interpreter of celebrity.[1]

Coppola offers us portraits of people – often depictions of celebrities – in the midst of experiencing existential dissipation. Historically, the condition is regularly figured on film as an effect – usually a sentimental or melodramatic effect – such as when a person suffers neglect, poverty, injustice, illness, insufficient educational support, lack of good judgement, or is brought to premature death. These are films about how life is wasted, or wastes away, often tragically so – and they leave us thinking or believing things would have been better if the conditions were more propitious – if the characters were wealthier, better raised or protected, more educated, better looking and generally more well-connected. But Coppola returns to the phenomenon of human dissipation under different lights to explore it under inverse conditions: in the midst of lives of luxury and fame and grandeur. Whether in *Lost in Translation*, *Somewhere*, *Marie Antoinette* (2006) or *The Bling Ring*, we are presented with intelligent, beautiful, privileged people who are often disoriented, at a loss, set adrift, trying to assess the state of their lives, which seem somehow beyond their control – despite what we commonly regard as considerable and conspicuous advantages.

A cynical reading of Coppola's films (especially those made in the decade between 2003 and 2013) might contend that her work is as vapid and self-satisfied as the characters she sometimes features. Such a hasty summary misses

The Bling Ring © 2013 American Zoetrope, NALA Films, TOBIS Film, Tohokushinsha Film Corporation (TFC)

the existential panic that lies at the heart of her depictions of lives lived without apparent want, in the midst of radical luxury and unchecked licence. These are, it turns out, deeply yearning souls, capable of their own profound insights about the human condition as such (not just the condition of humans with wealth and fame) – and it is precisely because we, as viewers, are not distracted by the obvious and literal elements of impoverishment and loss that we can see and appreciate the abiding human drama that haunts *any* conscious being. Moreover, since wealth is rarer than poverty, since fame anoints many fewer than the untold masses of obscured lives, we can marvel at the paradoxes and puzzles of suffering that haunt and harangue the otherwise favoured and fortunate ones. Perhaps Coppola aims to artfully announce that money and acclaim, notoriety and visibility do little for – and perhaps make harder – the abiding questions that cling to each human life: How shall I live? What is the purpose of my brief existence? Instead of dismissing Coppola's characters as unworthy of having problems, or undeserving of our attention in their suffering of those dilemmas and trials, we might consider that it is because we are witness to their lives of splendour and opportunity, of comfort and leisure that we have a chance to recognize the way human dissipation does not forgive or forget anyone.

Coppola recognizes the vaunted, confounding illusion that animates our love of celebrities, including the sheer fact of fame. Celebrities *feel* like intimates – they live on screens in our homes and in our pockets, and lie staring up at us from magazines on the floor of our bathrooms; we speak of actors and the characters they play as if they were cherished family members or dear friends. But to them, to the celebrities we reference and judge? We are just a foreign mass of unknown, undifferentiated humanity. How can the asymmetry of this relationship function except as a fantasia

and a hallucination? Coppola, perhaps to the highest and most accomplished degree among her immediate film-making contemporaries, gives us a glimpse of this strange, disorienting, uneven interaction; and she often does so with empathy and generosity for the lot of the celebrity, including a willingness to consider how the distortions make him or her less glamorous and more isolated. She couples her portraits of celebrity life with an informed awareness of the dreams and desires of the anonymous people who love the stars, regularly depicting a sentiment we find accurately drawn, though from a very different era, in Ralph Waldo Emerson: 'What you are stands over you the while, and thunders so that I cannot hear what you say to the contrary' (1903: 96). Giving expression to the conflict between being and seeming, between essence and appearance, between authenticity and affect, perfectly suits Coppola as a subtle but unflinching analyst of late-capitalist consumer culture.

Coppola's languid visual style – from the microphone boom dropped into the frame in *Lost in Translation* to the circling Ferrari at the opening of *Somewhere* – is meant to show us that imperfection crowds these lives under observation, and that they too are defined by repetition (in a Kierkegaardian sense of shaving off 'the beard of all my ludicrousness' every morning), varieties of boredom and restless seeking (though, as it is for all of us, always in circles). Even if one drives a Ferrari, the track goes around – another eternal return of the same; indeed, the car-in-motion is a leitmotif of Coppola's work, showing up at some point in all of her films except, of course, the period work *Marie Antoinette*. The circling, the repetitions, the self-reflections in the midst of Coppola's rendering of celebrity calls to mind the ancient Egyptian figure of the ouroboros – the serpent or dragon that eats its own tail. Celebrity, then, is not linear (even as we invoke the trajectory of a 'rising star'), and not earned as a reward (even as the year is punctuated by the industry's expansive capacity to celebrate its own achievements), but is instead a special kind of self-reflexive and self-referential form of life. Coppola clearly intends to admit and articulate this reading of celebrity – there is even a song named 'Ouroboros' on *The Bling Ring* soundtrack, and that film also finely reflects the 'meta' nature of celebrity – the kind of phenomenon that constantly calls itself into question even as it undergoes itself as an experience.

Coppola's work from the last decade (2003–13) – a bona fide cycle of films in its own right – does not morally or legally vindicate the acts and opinions of its characters so much as substantiate their world as an aesthetic or somatic fact. In *Lost in Translation*, there is the joy of drinking whiskey invoked by Bob Harris (Bill Murray) while filming a commercial in Tokyo – 'For relaxing times, make it Suntory time' – and then, by contrast, Harris's apathetic whiskey drinking at the hotel bar. These are co-extensive celebrity realities – both of them intimately part of Harris's fame. Meanwhile, the rich Valley kids who want to be Hollywood stars not by, say, acting in films but merely by partying together, or even more superficially, simply wearing the stars' clothes they steal, end up having 'real' Hollywood stars (Emma Watson, et al.) pretend to be them in *The Bling Ring*, and docufiction footage of the actors blended with unexpected, oddly authorizing, self-aware cameos by Lindsay Lohan and Paris Hilton (real-life victims of the Valley kids' exploits). And so, the kid-criminals live the same tabloid life as the stars they follow; and the stars get DUIs and steal things just like the kids – another circle. In this constant movement of reference and self-reference, the difference between fame and infamy becomes blurred. The evolving content of celebrity is increasingly diluted until its only condition is the dubious achievement of simply being known by others. At the very cutting-edge of fame-worshipping teens, we catch a glimpse of those old-fashioned questions posed in the gospel of Matthew: 'For what is a man profited, if he shall gain the whole

world, and lose his own soul? or what shall a man give in exchange for his soul?'
What does the state of celebrity give to a star? Being known by others leaves no
assurance that one will be known to oneself.

A common attribute of all Coppola's feature films is an abiding interest in the
lives of young women. A first glimpse of this enduring attention occurs in her
directorial short *Lick the Star* (1998), which centres on a group of four high school
girls who plot to slowly poison the boys. Peter Bogdanovich plays the principal, and
the black-and-white film marks the beginning of her multi-film collaboration with
cinematographer Lance Acord, with whom she later worked on *Lost in Translation*
and *Marie Antoinette*.[2] The following year, in her critically acclaimed first feature
The Virgin Suicides (1999), her insight into teen life – call it the wretchedness
of late adolescence – is given over to the histrionics of broad allegory. The
true illuminations of the film are in its details (often shot in close-up by Edward
Lachman) – in the gestures, looks, smiles, hands and the occasionally penetrating
voice-over (written by Coppola based on Jeffrey Eugenides's novel of the same
name) imbued with nostalgia and awe; compare the richness and revelation of the
details with the caricature of a monstrous matriarch (played by Kathleen Turner),
who is portrayed as controlling, paranoid and emotionally distant, and thus remains
but a proxy for this terror – a continual parody of being the *cause* of the family's
first child suicide. Yet the mortifying seriousness of teenagers killing themselves –
and the adult responses to those suicidal acts – is too arch and macabre to
enjoy. That aspect of the story plays in the mode of a dark-comedy public service
announcement. Like many who die young, the mystery of the Lisbon girls, hangs
on their radical, irrevocable decisions. But then as suicide, as such, so often lacks
context or justification, it presents but an open space for our impositions, as the
narrator (voiced by Giovanni Ribisi) says at the end: we are meant to realize that
into that formlessness and void of meaning – and especially when reflecting on the
significance of legends (another kind of fame) – we fill in our own readings.

Increasingly, Coppola's early interest in the lives of young women has expanded
to include youth culture more generally and its particular struggle with the variously
hypnotizing, disarming and destructive forces of 'lifestyle envy' (Rothkopf 2013a).
It is fitting, then, that Coppola should choose and be compelled by the young – as
if that period of life were a muse to her thinking – since the young still possess
the pathos, hope and delusion that there are easy ways to achieve more reality,
more clarity, and more intensity from life. Adulthood, she often suggests, involves
compromises, disappointments and the steady dismantling of youth's early claims
to the world, and expectations from it; consequently, her films – despite a regular
focus on the young – summon the curiosity of adults who may have lost touch
with their own adolescent yearnings and precociousness. Under a certain light,
those youthful beliefs can be taken as a form of faith in one's creative power,
personal worth and the value of hyper-individuation – though all this is so often
condescendingly read by adults as instances of braggadocio and *naïveté*, or worse,
dismissed as evidence of low self-esteem.

Coppola has been celebrated as 'a neorealist of hyper-materialist life' (Jones
2013) but what that concatenation should suggest is that she couples careful, artful
observation with a lack of moralizing judgement. Her work is regularly described
as 'deadpan'[3] and this epithet is helpful and accurate insofar as it hews close to
the definition of the term – 'marked by or accomplished with a careful pretense of
seriousness or calm detachment; impassive; displaying no emotional or personal
involvement'.[4] While Robert Altman presents celebrity and show business in a
spirit of self-distanced satire, overlapping exposé, and even atmospheric farce
(inchoately in *Nashville* [1975] and then prominently in the mid-1990s suite *The*

Player [1992], *Short Cuts* [1993] and *Prêt-à-Porter* [1994]), and Steven Soderbergh gravitates towards a jazz-inflected throwback to the warm shimmer of fame's allure, all the while burnishing the surface to expose its brittle ironies (especially in *Full Frontal* [2002] and the *Ocean's* series [2001, 2004, 2007]), Coppola waits: she holds her shots, creates space for unexpected glimpses of vulnerability, and perhaps most worthy of note and admiration, she manages to have the extended gaze not turn into a gawk or a smug chastisement. After we have been granted entrance into these rarefied lives, we should not – Coppola gently, knowingly shows us – feel confirmed in their degeneracy but rather humbled by their fragility and exposure.

Somewhere and *The Bling Ring* reflect a particularly ripe culmination of forces between Coppola and her chief collaborators Harris Savides (who was cinematographer on both films), and long-time production designer, Anne Ross. Savides died suddenly during production on *The Bling Ring* – replaced by Chris Blauvelt, who served as cinematographer to Mike Mills on *Beginners* (2010), and who worked alongside Savides on David Fincher's *Zodiac* (2007) and *The Game* (1997) – but his and Ross's influence on Coppola's capacity to find and feature the details of these lives (their oblique dimensions, their unexpected revelations of genuine emotion) should be emphasized. While Savides tracks his subjects, the work never feels predatory (like straight documentary or handheld reality television); and while Ross stocks the sets with tactical expertise, they never feel stilted, stylized or beyond their relationship to characters' lives (as we regularly see, for example, in Wes Anderson's work). Consequent to Savides's and Ross's work, Coppola has provided the conditions for her actors to explore the moral, emotional and existential gradations of their characters. Perhaps this is why Coppola has been singled out for her 'talent for making art out of the vapid' (Wheat 2013).

From Scarlett Johansson's Monica Vitti-like character in *Lost in Translation* – one of the 'beautifully lost women in cinema' (Rothkopf 2013b) – to Kirsten Dunst's Marie Antoinette in the eponymous film; to Elle Fanning's child of celebrity in *Somewhere*; to Emma Watson's aspirational-in-the-midst-of-privilege Nicki in *The Bling Ring*; Coppola's heroines are anything but vapid, dull, tedious, insipid, flat or otherwise without a spirit of liveliness. These women, and the many women who surround them (and sometimes the men too), are seekers. Having so much, they want more from life, which often summons them to transgressions – whether it means visiting a Buddhist temple, walking away from an idling Ferrari, or wearing Paris Hilton's pumps. AO Scott has picked up on these elements, for example, in *The Bling Ring*, which is populated by people who are, among other things, 'acting in the grip of a genuine aesthetic compulsion, feeding an appetite for beauty and intensity that is hardly theirs alone' (Scott 2013). That the characters find themselves in exceptional circumstances does not mean that they express an exceptional desire; a viewer, at least one who shares such an aesthetic compulsion, will merely recognize something of himself or herself in the wish that being seen or admired by another person can achieve a satisfying compensation for one's own incompleteness. Coppola's treatment of this shared compulsion, Scott continues, results in a film that 'occupies a vertiginous middle ground between banality and transcendence, and its refusal to commit to one or the other is both a mark of integrity and a source of frustration' (Scott 2013). The frustration is misplaced – or rather, to be marked as a sign of accomplishment – since it is precisely in the tense middle ground where viewers can perceive the ethical and emotional stakes of Coppola's work – in this film and elsewhere in her oeuvre. Frustration, as Adam Phillips has shown, is a sophisticated way of saying one does not get what one wants; when reality outstrips desire, we are all assured of frustration – hence the potential universality of *human* frustration (Phillips 2013: 1–33). After Freud,

Phillips contends, 'it is only in states of frustration that we can begin to imagine – to elaborate, to envision – our desire' (Phillips 2013: xx). Therefore, were a film thoroughly banal, it would be easily dismissible; and if it were exclusively transcendent, it would remain beyond reproach. In the middle ground we are frustrated, and thus involved and implicated – gripped.

David Denby has also recognized in Coppola's latest work an intermediary space, though he sees her achievement as an indication of societal defeat: 'The progression [from rock 'n' roll groupies to the bling ring] marks a cultural decline, I suppose, from eros to fetishism' (Denby 2013). Sustaining his apprehensiveness regarding the ethical troughs of contemporary culture, Denby concludes: 'Like so many films about Los Angeles, *The Bling Ring*, is caught between rapture and despair, between the glittering views from the Hollywood Hills and a sense that all moral distinctions have slid away in the canyons' (ibid). Denby is not exultant about Coppola's contribution, saying instead that 'what she offers the audience […] is sly bemusement laced with complicity' (ibid). This seems both ungenerous and misattributed, since Coppola began her life on the shoulders of her father at Cannes; it is therefore both an ineluctable fact of her personal history and a perfectly justifiable preoccupation to repeatedly – even compulsively – examine the relationship between fame and identity, and study the effects of celebrity on individual authenticity. Coppola's work is a creative, constructive response to the frustration of not getting what she wants, namely, perfectly assured responses to the nature of life in the spotlight – or conclusive refutations of enticements offered in the shadows.

David LaRocca

References

Denby, David (2013) 'Rob Jobs', *The New Yorker*, 10 June, http://www.newyorker.com/magazine/2013/06/10/rob-jobs. Accessed 24 August 2015.

Emerson, Ralph Waldo (1903) 'Social Aims', *The Complete Works of Ralph Waldo Emerson*, Concord Edition, Boston: Houghton, Mifflin and Company.

Jones, Kent (2013) 'The Bling Ring', *Film Comment*, May/June, http://www.filmcomment.com/article/review-the-bling-ring-sofia-coppola/. Accessed 24 August 2015.

Phillips, Adam (2013) 'On Frustration', *Missing Out: In Praise of the Unlived Life*, New York: Farrar, Straus, and Giroux.

Rothkopf, Joshua (2013a) 'The Bling Ring: Movie Review' *Time Out: New York*, 11 June, http://www.timeout.com/us/film/the-bling-ring-movie-review. Accessed 24 February 2016.

———— (2013b) 'Three Takes on L'Avventura', *Time Out: New York*, 8 July, http://www.timeout.com/newyork/film/three-takes-on-lavventura. Accessed 24 February 2016.

Scott, AO (2013) 'Twinkly Totems of Fame, Theirs for the Taking: A 'Bling Ring', Lusting After Celebrity Trinkets', *The New York Times*, 13 June, http://www.nytimes.com/2013/06/14/movies/a-bling-ring-lusting-after-celebrity-trinkets.html. Accessed 24 August 2015.

Wheat, Alynda (2013) 'The Bling Ring', *People*, 14 June, http://www.people.com/people/article/0,,20708410,00.html. Accessed 24 February 2016.

Notes

1. Coppola published a photo book, *SC 2003: Some Pictures from This Past Year* (Magazine House Co, Ltd, 2003), with an afterword by Takashi Homma, which she annotates by saying, 'These are photos of friends and family and things I liked in 2003.' For more on Coppola and Homma, see my 'Cresting: A Series of Remarks on Takashi Homma's New Waves', in *New Waves 2000–2013* (Longhouse Projects, 2013).
2. See Derek Hill, *Charlie Kaufman and Hollywood's Merry Band of Pranksters, Fabulists and Dreamers* (Harpenden: Kamera, 2008), p. 123.
3. Coppola's work is referred to as 'deadpan' by Zach Baron, 'Stealing Fame', *The New York Times* (9 June 2013), p. 14; and cited elsewhere in this essay, by Kent Jones (2013, *Film Comment*) and David Denby (2013, *The New Yorker*).
4. http://dictionary.reference.com/. Accessed 24 August 2015.

JONATHAN DEMME
American Humanist

Jonathan Demme's 40-year career is as artistically adventurous in its scope and variety as that of any other commercial film-maker of his time. His work ranges from exploitation to Oscar bait, from inventive remakes of enshrined classics to low-key documentary portraits of martyrs, survivors and a US president. His music and performance films are widely acclaimed, and his colourful, chaotic ensemble pieces and dramatic comedies about dreamers and principled outcasts established his cinematic voice as one of the most original, appealing and iconoclastic of the American post-studio era. But despite his longevity and success, Demme is not a household name. His restless genre hopping and indifference to conventional Hollywood career paths (as well as to stock stories and characters) have ensured his relative obscurity along with his continuing vitality.

As adaptable as his sensibilities may be, Demme's body of work is the product of a unique and coherent vision. He is American film's great modern humanist, to whom true communication, no matter how apparent the distance between people, is always not just possible but immediately available through common languages – laughter, sex, music, fear, justice. He regards his fictional characters and real-life subjects with fantastic curiosity, empathy and clarity, and conveys their stories in ways that legitimately work toward heightening his audiences' compassion for their fellow people, as great humanist art must. In Demme's world, everyone is interesting and everyone, as the great French humanist put it, has their reasons.

Like more than a few other notable American film-makers of the last half-century, Demme cut his teeth on Roger Corman productions, first writing, then directing cheap, quick genre pieces with a fair amount of creative freedom within clearly prescribed formulas. He directed three engaging and entertaining pictures for Corman – *Caged Heat* (1974), *Crazy Mama* (1975) and *Fighting Mad* (1976) – which all hint, sometimes strongly, at the talent that would become obvious in the next phase of his career.

Citizen's Band (1977), Demme's first picture outside Corman's stable, was also his first truly excellent one. With casual intimacy, the film traces the stories of the inhabitants of a small town who are connected by their interactions on the CB radio airwaves. It plays a bit like *Nashville* (1975) without Robert Altman's stinging irony or condescension – Demme's warmth and generosity towards his characters are fully in evidence. He has said that his next film, *Last Embrace* (1979), was rushed into production by United Artists before the script was ready (Clarens 1980: 10). The result is a mixed bag: an overtly Hitchcockian mystery/thriller with a fascinating if disjointed plot and many delightful moments. But in the end, *Last Embrace* is not focused enough to be really satisfying.

Something Wild © 1986 Orion Pictures,
Religiosa Primitiva

Melvin and Howard (1980) suffers from no such deficiencies – it's a masterpiece, perhaps the purest expression of Demme's essential goodwill. The story – loosely based on that of Melvin Dummar, an ambitious but hapless everyman who claimed to have been given Howard Hughes's handwritten will, which named him the beneficiary of $156 million – could have been a cynical study of tawdry American hucksterism. In the hands of Demme and screenwriter Bo Goldman, however, it is exactly the opposite: a deeply optimistic and empathetic celebration of dreamers like Melvin who remain unburdened by their accumulated failures and disillusionments. Demme, at his best, is able to bring his rebellious, resilient, openhearted characters face-to-face with the frightening uncertainty and savagery at the heart of the American Dream, and find something in the experience that makes them all the more poignantly fulfilled, if not utterly transformed.

Citizen's Band and *Melvin and Howard* are early peaks in Demme's long prime period. More triumphs were soon to come, but only after another lesson, this one unwillingly learned. After *Who Am I This Time* (1982), an entry in the PBS American Playhouse series based on a Kurt Vonnegut story and starring Susan Sarandon and Christopher Walken, he received his first big-budget assignment: a World War II homefront drama starring Goldie Hawn as a GI's wife who goes to work in an aircraft plant and finds herself reinvented by her new independence and friendships. Unfortunately, *Swing Shift* (1984) became a notorious example of what can happen to a director's vision when it is subsumed by the ego of a producer and/or star. In this case, Hawn was unhappy with Demme's cut of the film, which he had crafted as an ensemble piece that he saw as a tribute to the women who had kept American factories running while most of the nation's men were at war. The central relationship in Demme's version was between Hawn's

character, Kay, and her free-spirited neighbour, Hazel (Christine Lahti); Hawn felt that the film should be a love story between Kay and Lucky (Kurt Russell), a 4-F musician who works with the women at the plant.

According to Demme's and other accounts, Hawn prevailed upon the producers to have large sections of the film rewritten, reshot and re-edited under her supervision, against Demme's strong objections. Accounts of the differences between Hawn's version of *Swing Shift* and Demme's suggest that the original cut was a far superior film to the one that was released, and a major entry in Demme's body of work (Bliss and Banks 1996: 48–58). But that version of the film, once circulated as a VHS bootleg, is now all but lost. As released and currently available, *Swing Shift* is a disjointed failure that offers only tantalizing glimpses of its director's intended product. Perhaps, one day, some miracle of archiving and restoration will allow a wide audience finally to see what Demme intended with the film that ought to have been his breakthrough.

Yet though 1984 may be the year of Demme's most frustrating professional experience, it also marked his entry into what would be the most important and enduring phase of his career. *Stop Making Sense* (1984), his modestly well-crafted yet thrilling concert film featuring the New York art-rock band Talking Heads, brought performance films of brilliantly idiosyncratic artists into his repertoire. Demme's subsequent eagerness to place eclectic, culturally diverse pop music prominently in the soundtracks of his fiction features would give him new and versatile tools for emphasis, counterpoint and subtle commentary on the action, adding to his already uncannily expressive *mise-en-scène*.

Demme's next feature, *Something Wild* (1986), is one of the best American films of the 1980s. In its progress from New Wave screwball to hyper-realistic crime melodrama to postmodern fable, *Something Wild* exemplifies both Demme's style and his ethos. Its main characters, Lulu (or Audrey – Melanie Griffith), Charlie (Jeff Daniels) and Ray (Ray Liotta), function equally as malleable archetypes and urgently believable characters within the diverse, multilayered, vividly drawn America that Demme builds around them. Charlie and Audrey, at first wayward souls tagging along together for desperate, impromptu kicks, are reinvented as surely as Melvin, Kay or the protagonists of Demme's next two films – unformed and rehardened under Ray's furious heat.

Something Wild is propelled by music. A permanent tonal shift aided by a masterful sequence of songs played by The Feelies during the scenes at Audrey's high school reunion, when the three main characters first converge, is breathtaking for its economy and precision as well as its dramatic thrill – an announcement of Demme's readiness to direct with a new level of intensity. But the film's most remarkable qualities are his refusal to regard any character or situation as simple, minor or disposable, and to find harmony in the chaotic world he depicts. Everywhere, often unexpectedly, savage violence is counterbalanced by simple kindness; rage is met with resignation; lust is tinged with pathos; and lies angle for truth. Like all American road movies, *Something Wild* is a search for the hearts of the nation and its people, and Demme's sensitivity and insistent faith in humanity are powerful means towards such discoveries. He finds them intricately speckled in black and white.

Married to the Mob (1988) makes for a wonderful companion piece to *Something Wild*, even if its funky, colourful, urban/suburban milieu is more tinged with comedy and kitsch than that of the earlier film. While *Married to the Mob*'s characterizations are often cartoonish, the central characters – FBI man Mike (Matthew Modine); mob boss Tony (Dean Stockwell); and especially Angela (Michelle Pfeiffer) – are in the end given far more dramatic weight

than the film's comic overtones would suggest. Pfeiffer, in particular, puts everything she has into her performance as a mafia widow who is pursued by her late husband's boss (and killer), but finds romance with the G-man on her tail instead. She and Demme are able to infuse Angela and Mike's relationship with a tenderness and emotional resonance that give the movie far more depth and complexity than expected from such a light, albeit dangerous, romantic farce. As in *Something Wild*, Demme seems almost to be inventing his own genre. He effortlessly and joyfully exploits, subverts and explodes every Hollywood convention in sight, and comes up with a nimbly musical pastiche that is entirely original. The two films' endings rhyme beautifully – down to Sister Carol East's credits-launching direct address of the camera in both – with the couples reunited after being tested by violence and deceit but finally transformed by love. And while the earlier film stands as Demme's best, *Married to the Mob* remains a uniquely enjoyable piece of work by a director in effortless control of a fully developed personal style.

With *The Silence of the Lambs* (1991), Demme is still operating at the peak of his abilities. It swept the Academy Awards and became a cultural phenomenon, largely on the strength of Anthony Hopkins's bravura portrayal of the debonair, savage Dr Hannibal 'The Cannibal' Lecter. But the film – Demme's first from an adapted screenplay – represents a departure from the thrilling originality of its two predecessors. It has important points in common with them, chiefly its central theme of personal growth and transformation (which is assigned a very literal dark side here), and its determined female protagonist. FBI Agent Clarice Starling (Jodie Foster) is an immensely sympathetic character, and Demme's adherence to her point of view as a feminine interloper in a world simmering with male hostility and lust is what gives the film its fevered heart.

But *The Silence of the Lambs*, unlike any previous film of Demme's, maintains a practically uninterrupted mood of dreadful seriousness from start to finish, even considering Hopkins's over-the-top, devilish charm. It's marvellously effective, but because there's so little humour, there's little room for the deft, unexpected poignancy for which Demme has such a rare gift. The grace notes and delicately observed moments of human interaction – of which, to be clear, there are plenty – land with unaccustomed heaviness in the dour atmosphere. *The Silence of the Lambs* is a truly great film, but for those who deeply value its director's exquisite ability to vary cinematic tones with freewheeling aplomb without compromising the dramatic integrity of his characters or material, it is naggingly disappointing.

Unfortunately, Demme's next feature would not return him to the course he'd begun to chart with *Something Wild* and *Married to the Mob*, nor would any of his subsequent ones. *Philadelphia* (1993), despite unassailable intentions and many briefly rewarding moments, suffers from a maudlin earnestness that is even farther removed from Demme's usual mode than the ghastliness of *The Silence of the Lambs* – a deficiency made glaring by Howard Shore's blatant, syrupy score, which does far more harm than Bruce Springsteen's lovely 'Streets of Philadelphia' (which underlays the wonderful opening credits sequence) can hope to mitigate. Perhaps this is a harsh assessment of the first major American film to deal directly with AIDS and its physical and societal ravages, which certainly, on balance, accomplished a great public good. But *Philadelphia* falls far short of the standards Demme had set with his previous work.

Beloved (1998), though, is marvellous – a riveting film from start to finish, elevated by uniformly excellent performances and rich, impeccably detailed production design. Demme's approach to the material (Toni Morrison's Pulitzer-winning 1987 novel) is modest by his earlier standards, but little more so than

with *The Silence of the Lambs*. If, a decade after *Married to the Mob*, Demme had not quite made good on the enormous promise of his urgently inventive, vibrant work of the 1980s, he had also built a formidable set of film-making skills, augmented, as ever, by an abiding devotion to his characters and their stories.

Demme's next two features were remakes of early-1960s films that had acquired new, passionate followings decades after original release: *The Truth About Charlie* (2002, after Stanley Donen's 1963 Hitchcock-lite *Charade*) and *The Manchurian Candidate* (2004, after John Frankenheimer's eponymous 1962 Cold War-paranoia thriller). While both are easily forgotten given that context, neither should be disdained. Both are excellently done: skilful, creative reimaginings of their source materials, and *The Truth About Charlie* is especially charming for its open homage to the French New Wave and Truffaut in particular – not to mention Demme's expert deployment of the magnetic Thandie Newton, bravely and ably standing in for Audrey Hepburn.

Although this account of Demme's career is focused on his fiction films, it is important to note his increasing focus on documentaries, especially in recent years. These include *Swimming to Cambodia* (1987), his seminal filmed monologue by Spalding Gray; *The Agronomist* (2003), a tribute to the Haitian radio journalist and political provocateur Jean Dominique; *Jimmy Carter: Man from Plains* (2007), which chronicles the former president's tumultuous media tour following the publication of his book *Palestine: Peace Not Apartheid*; *I'm Carolyn Parker* (2011), a portrait of a civil rights activist and Hurricane Katrina survivor; and no fewer than four performance films with Neil Young. This body of work, with its emphasis on music, indomitable personalities and individual struggles against injustice, should be sufficient to dispel the notion that Demme's film-making has become less personal in the later stages of his career.

Any appearance of such a trend is also belied by his most recent fiction feature, *Rachel Getting Married* (2008). An intimate ensemble drama, the film finds Demme working from an original screenplay for the first time since *Philadelphia*. Jenny Lumet's script, while occasionally overwrought, provides Demme with a milieu that ideally suits his disposition, with its ethnically and socially diverse cast of characters gathered for a ceremonious weekend in a devoutly musical household. Kym (a deeply committed Anne Hathaway) is a thorny central character, a challenging entry in Demme's gallery of charismatic iconoclasts. Furloughed from rehab for her sister's wedding, Kym is an obviously compromised figure who constantly provokes those around her because of her horror and guilt over an unspeakable family tragedy.

Yet Demme fills the majority of scenes with a lively, natural energy that effectively balances the overhanging despair, and finds hope for redemption in the galvanizing powers of music and celebration. He fills the film with diegetic performances by typically varied sources – including previous collaborators Young (whose 'Unknown Legend' is movingly sung by TV on the Radio's Tunde Adebimpe, playing the groom), Robyn Hitchcock and Sister Carol East – and honest, unprejudiced interactions among people who would have never met except for the occasion at hand. *Rachel Getting Married* doesn't quite qualify as a return to Demme's prime form of the 1980s, but it is his warmest feature film in many years, and inspires optimism for his future work.

Demme has several intriguing projects either completed or planned, but even if he never released another film his career would already have been exceptional. Great art can't help but make the world a better place, and great humanist art like Demme's does so on an added, concrete level. If he is not the

American Renoir (there isn't one), it is at least certain that his films – wherever they have broken through, as he has always strived for them to do – have enlightened our cinema and ourselves, whether we know it or not.

Dave Marr

References

Bliss, Michael & Banks, Christina (1996) *What Goes Around Comes Around: The Films of Jonathan Demme*, Carbondale & Edwardsville: Southern Illinois University Press.

Clarens, Carlos (1980) 'Demme Monde', in Robert E Kapsis (ed.), *Jonathan Demme: Interviews*, Oxford: University of Mississippi Press.

BRIAN DE PALMA
Perversions and Assassinations

Once the most controversial film director in the English-speaking world, Brian De Palma remains as contradictory as he is polarizing. His early infamy as an irresponsible agitator for left-wing violence (after the 1970 revolutionary comedy *Hi, Mom!*) was surpassed in the early 1980s by his reputation as a misogynist and a thief of Alfred Hitchcock's masterpieces following the 1980 sex thriller *Dressed to Kill* (1980), which relocates *Psycho* (Alfred Hitchcock, 1960) into upper-middle-class New York City, and the provocative mystery *Body Double* (1984), which scrambles all of Hitchcock's canonical narratives into a sublimely irrational murder mystery set against the backdrop of Hollywood marginalia. After an extended run of big-budget, putatively 'mainstream' entertainments – *Scarface* (1983), *The Untouchables* (1987), *Carlito's Way* (1993), *Mission: Impossible* (1995), *Mission to Mars* (1999) – the left-wing-agitator label came back around with the 2007 release of *Redacted*, an ultra-Brechtian digital document set during the western occupation of Iraq. For cinephiles around the world, De Palma is a consummate technician, the creator of some of the most inventive and memorable passages in all of cinema (think of the chainsaw scene in *Scarface*, the 'Be Black, Baby!' sequence in *Hi, Mom!*, the climactic slaughter on prom night in *Carrie* [1976], the museum chase in *Dressed to Kill*, the staircase shootout in *The Untouchables*, the 'backstory shot' in *Raising Cain* [1992], the theft at CIA headquarters in *Mission: Impossible*). He is also noted for his exaggerated, operatic sensibility and for his black, borderline-suicidal, sense of humour.

Born in 1940 to a highly educated and professional but severely dysfunctional upper-middle-class family in Newark, New Jersey (and relocating almost immediately to Philadelphia), De Palma grew up in an atmosphere of mistrust, paranoia and surveillance – the same themes that might be said to define his work as a film-maker. Like other American film-makers of his generation, he grew up in the ideologically two-faced 1950s and became an adult during the turbulence of the 1960s; De Palma spent that decade in New York City, first as a student at Columbia and then as a Village resident. His student film *Woton's Wake* (1962) caught the attention of Pauline Kael, who sat on the jury that awarded it the Rosenthal Award for student film. De Palma made short documentaries for such disparate clients as the Museum of Modern Art and the NAACP; as a graduate student at Sarah Lawrence University, he co-directed *The Wedding Party* (1965, released 1969), a gentle comedy that is most notable for introducing Robert De Niro to the screen.

Beginning with his ultra-cheap second feature, the avant-garde 'Hitchcock-does-Rashomon' exercise *Murder à la Mod* (1967), De Palma demonstrated a willingness – perhaps even a drive – to experiment with structure and form, as well as the realization that social life after *Psycho*, at least in the United States, would forever be marked by the death of Marion Crane. In the Vietnam-era features *Greetings* (1968) and *Hi, Mom!*, De Palma coupled the Godardian and *cinéma-vérité* models with a distinctly East Coast disaffection. *Greetings*, the first film to receive the 'X' rating, cleared $1 million at the box office, predating the blowout success of *Easy Rider* (1969) with the ephemeral 'youth

Dionysus in '69 © 1970 Sigma III

audience' by a year; its sequel, *Hi, Mom!*, brought the failed draft-dodger protagonist of *Greetings*, played by De Niro, into the world of guerilla theatre and from there, inevitably, into domestic terrorism. (*Hi, Mom!*, unlike *Greetings*, was not a hit, perhaps because it opened within days of the accidental explosion that killed the core members of the Weather Underground Organization, a clandestine revolutionary group aiming to overthrow the United States government.) Between these two films, De Palma directed *Dionysus in '69*, an entirely split-screen documentary record of an avant-garde performance by Richard Schechner's Performance Group.

In 1970, De Palma relocated to Los Angeles. Warner Bros was impressed by the success of *Greetings* and, after the success of *Easy Rider*, was anxious to tap into the new and unknown 'youth market'. The result of this dalliance with the Hollywood machine was disaster: De Palma was fired from the rat-race comedy *Get to Know Your Rabbit* (1970, released 1972) at the urging of the film's star, Tom Smothers. Betrayed both by his allies within the system and by the system itself, De Palma apparently spent years in a brooding depression before re-emerging with *Sisters* (1973), a wild and viciously comic parody of/homage to/thesis statement about *Psycho*, in which Hitchcock's original narrative is recast in despairing and implicitly political terms: the Marion Crane character is now an upwardly mobile black man (dispatched by a psychotic female killer with a cake-smeared kitchen knife), while the Lila Crane character has become a crusading feminist reporter.

Phantom of the Paradise (1974) is a gleefully perverse horror musical about a disfigured artist's revenge against the system that betrayed him – a system represented by a Faustian rock mogul, Swan, who has signed a deal with Satan himself. Despite strong performances (especially by William Finley as the disfigured artist and Paul Williams as the rock mogul) and a host of memorable songs (by Williams), *Phantom of the Paradise* was not a box office success. After his next film, the Paul Schrader-scripted *Obsession* (1976), a gauzy, portentous homage to *Vertigo* (1958), De Palma delivered the epochal *Carrie*, a breakaway success that, along with *Jaws* (1975), redefined the borders between

horror and comedy. Both Piper Laurie and Sissy Spacek, as the tortured mother and daughter at the centre of a small-town psychosexual inferno, won Oscar nominations; De Palma, for the first time, won real mainstream respect. De Palma closed out the 1970s with *The Fury* (1978), a big-budget psychokinetic thriller featuring Kirk Douglas and John Cassavetes, and *Home Movies* (1979), a micro-budget Oedipal comedy about a severely troubled family uncomfortably like De Palma's own.

De Palma entered his most infamous period in 1980 with *Dressed to Kill*, an ambitious attempt to transpose the basic narrative structure of *Psycho* into the chic milieu of the white urban bourgeoisie. The subject of intense vitriol from some critics and scholars (who were alarmed by De Palma's successful attempt to do 'Hitchcock' better than Hitchcock himself did 'Hitchcock') and the object of boycotts by feminist activists in the United States and the United Kingdom, *Dressed to Kill* was De Palma's biggest hit yet. De Palma leveraged this financial success to direct *Blow Out* (1981), a tricky allegory about a film sound engineer (played by John Travolta) who witnesses a political assassination and then attempts to save the life of another witness (Nancy Allen, then De Palma's wife). Recuperated as a masterpiece in the thirty years since its decisive box office failure, *Blow Out* now seems like De Palma's definitive statement about the uneasy – and literally deadly – relationship between political rhetoric, film spectatorship and sexual violence.

With *Scarface*, an explosive remake of the 1932 Howard Hawks/Ben Hecht classic, De Palma cemented his reputation as a cinematic brute. Al Pacino, delivering the first of the self-parodically oversized lead performances that would typify the rest of his career, plays a Cuban refugee who takes over Miami's drug trade. Working from a script by Oliver Stone, De Palma here indulged in a spectacularly violent and over-decorated style that most anglophone critics found repellent. However, *Scarface* gradually found its audience amongst minority communities all over the globe, and by the turn of the century had become one of the most influential films of all time. De Palma followed *Scarface* with *Body Double*, a brilliantly self-reflexive – and fascinatingly spiteful – Hitchcock pastiche that, as De Palma affirmed in interviews, was made precisely to provoke outrage from the groups (film scholars and feminists) that found *Dressed to Kill* so upsetting. The most experimental gesture in all of De Palma's cinema may be the intrusion of a music video (for the Frankie Goes to Hollywood blowjob anthem 'Relax'), a moment that, in a Godard-meets-Jerry-Lewis way, rudely turns the diegesis inside-out. Another definitive box office failure, *Body Double* was followed by *Wise Guys* (1986), a stumbling Mafia farce that probably represents De Palma's least enjoyable work.

In 1987, De Palma struck gold with his adaptation of the Al Capone-centred television show, *The Untouchables*. Directing around the bland figure of Kevin Costner (as the morally upright Federal marshal Eliot Ness), De Palma pulled a gallery of memorable performances from the supporting cast, especially the Oscar-winning turn by Sean Connery as a too-seasoned Chicago cop. The film's clean, monumental style, coupled with a David Mamet script and a classic score by Ennio Morricone, propelled the film to international box office success. De Palma, as he had with *Dressed to Kill*, leveraged the success of *The Untouchables* to make *Casualties of War* (1989), a long-gestating Vietnam War project based on the 1969 book by Daniel Lang. Unlike the other Vietnam films then in circulation – such as *Apocalypse Now* (1979) and *Platoon* (1986) – *Casualties of War* avoided battle scenes and military heroics in favour of a disturbingly intimate true-crime tale of a group of infantrymen who kidnap, rape and kill a peasant girl. Despite strong performances by leads Michael J Fox and Sean Penn, *Casualties of War* was another in De Palma's string of post-1980 box office failures, doubtlessly due to its agonized tone and downbeat conclusion.

In 1990, De Palma's career nearly came to an ignominious end with the full-scale artistic and financial disaster of *The Bonfire of the Vanities*, a woebegone adaptation

of Tom Wolfe's scandalous novel about the racial and economic tensions of Reagan-era New York City. (It has been said, not without reason, that the best thing about *The Bonfire of the Vanities* is the 1991 tell-all book about its production, Julie Salomon's *The Devil's Candy: The Anatomy of a Hollywood Fiasco*.) Working from a pitiable script by Michael Cristofer, paradoxically hampered by a nearly unlimited budget, and saddled with the worst casting of his career, De Palma – for once, without intending to do so – delivered a completely unlikable and nearly indefensible film. De Palma sprung back the following year with the small-scale but joyfully inventive thriller *Raising Cain*, featuring the great John Lithgow in several roles. Featuring some of the most exhilarating – and some of the funniest – image-making of his career, *Cain* marked De Palma's return to Hitchcock-pastiche territory. The next year, De Palma directed *Carlito's Way*, a second collaboration with Al Pacino (again cast as a Latino gangster caught between the drug trade and the American justice system). *Carlito's Way* proved to be only a modest box office success; however, for its unexpectedly lyrical passages, its haunted lead performance and the diabolically sustained action sequence at its conclusion, it was later named the best film of the 1990s by *Cahiers du Cinéma*.

With *Mission: Impossible*, the first film in the Tom Cruise espionage franchise, De Palma had his biggest box office success. Despite rumours of on-set friction with his star, De Palma pulled out all the proverbial stops and managed to deliver an enormously-scaled and muscular action flick that was also slippery, deceptive and formally adventurous. As he had done before, De Palma used this success to secure a large budget for a more personal project: *Snake Eyes* (1998), a conspiracy thriller starring Nicolas Cage in full-on bipolar performance mode as a corrupt Atlantic City cop who stumbles into a political assassination. Displeased by the reactions of test audiences, Paramount Pictures cut the film (by as much as half an hour, according to some sources) and forced De Palma to reshoot the ending. The result was another resounding box office failure. De Palma followed this with *Mission to Mars*, an atypically optimistic space-travel/alien-encounter film that, again, failed at the box office.

After *Mission to Mars*, exhausted by his years in the American film industry, De Palma uprooted to France. There, he directed *Femme Fatale* (2002), a dazzlingly youthful return to the thriller genre. With its outrageous opening sequence set at the Cannes Film Festival – beginning with *Double Indemnity* (1944) playing on a hotel-room television, proceeding through a lesbian encounter in a bathroom stall, and culminating in a jewel heist – *Femme Fatale* repositioned De Palma as an art film director (of the playful, Raoul Ruiz variety). Next, De Palma attempted his first full-on film noir, an adaptation of James Ellroy's *The Black Dahlia* (2006). Shot in Eastern Europe (for the tax breaks and cheap labour) but convincingly set in 1940s Los Angeles, the film did not find a large audience. Then, in 2007, De Palma delivered his biggest surprise – the mini-budgeted Iraq war drama *Redacted*, based (like *Casualties of War*) on a true story about American troops raping and murdering a local girl. Shot on digital video (a first for the director), *Redacted* signalled the unexpected return of the angry, politicized De Palma, whose view of the occupation of Iraq earned him accusations of treason from the American right wing. It also won De Palma his only major festival prize, the Silver Lion at the Venice Film Festival. As of this writing, De Palma's latest film is *Passion* (2012), a tantalizingly bifurcated adaptation of the Alain Corneau thriller *Crime D'Amour* (2010).

Broadly speaking, De Palma's career is typified by the tension between his artistic ambitions and his relationship to the economic realities of film-making. De Palma has made no secret of his distaste, even contempt, for the American studio model that has elevated apolitical technicians like Spielberg and Lucas to Olympian grandeur. And yet, since he prefers to work on a large scale, De Palma has tried to operate 'within the system', balancing personal films like *Home Movies* or *Casualties of War* with frankly mercenary jobs like *Mission: Impossible* or *The Bonfire of the Vanities*. If this balancing

act has not always been successful, it is perhaps because of his willingness to take dangerous risks. In this regard, however, one should also note his extraordinary resilience; he has continued working through circumstances that would have felled many a director. Unlike, say, Robert Altman or Martin Scorsese, De Palma's legacy is very much up for grabs. Despite the extraordinary notoriety he once enjoyed, his masterpieces are still emerging from the shadows.

Chris Dumas

SAMUEL FULLER
Brutally Sentimental

Twelve years old and little Sammy Fuller was already the toughest kid on the block, working as a copy-boy in the rough and tumble of a New York City newsroom. By 17, he was a crime reporter with the *Evening Graphic*, churning out stories of corruption and vice for the eager eyes of Joe Public. He wrote novels and screenplays and made it in the movies, but not soon enough or big enough to go to war as anything other than an ordinary doggy. Fighting his way across Africa and Europe, the former crime reporter got the chance to cover the biggest crime in history, and brought home some of the first footage of the Falkenau concentration camp. Back in the United States, he put it all on paper, and then onscreen, writing, directing and often producing some of the toughest, most personal films ever to come out of Hollywood. In movies like *The Steel Helmet* (1951), *Underworld USA* (1961), *Shock Corridor* (1963) and *White Dog* (1982), he broke taboos and challenged the sensibilities of mainstream America. You couldn't accuse him of having good taste, or tact, but then, he didn't care about those things. Sam Fuller only cared about the story.

At times, the much-rehearsed legend of Sam Fuller, as repeated by his many admirers as well as by the man himself, feels like something he would have written. Fuller's myth is the myth of America itself – not in the rarefied form in which it comes down to us in the classical western, but complete with all the contradictions of a country at odds with itself. His films are the product of an idiosyncratic, personal philosophy formed on the streets and in the trenches. Fuller is the immigrant kid made good; the perpetual underdog; the arch individualist; the man of the people.

Opinions about Samuel Fuller are as varied and contradictory as his movies. To many critics of his time, he was a vulgarian; to the film-makers of the French New Wave, he showed the expressive potential of genre cinema. Directors as varied as Martin Scorcese, Wim Wenders, Tim Robbins and Quentin Tarantino all claim him as an influence. He has been called a fascist and a populist, a thug and a savant, a pure product of the Hollywood system and the ultimate independent iconoclast. Whatever the contradictions, running through every account of Fuller is the sense of a tough, uncompromising film-maker, intent on telling his stories his way. Yet few critics have remarked upon the streak of innocence, even of sentimentality, which lies just beneath the streetwise bravado of both the man and his films, and which ultimately makes them unique.

Perhaps because his sensibility is so palpably at odds with that of mainstream Hollywood, the label which has most persistently stuck to Fuller is that of a 'cinematic primitive'. Coined by Luc Moullet (1985), and solidified by Andrew Sarris (1996: 94), this estimation of Fuller's place in relation to the more universally respected American auteurs like Ford, Hitchcock and Welles, has remained the official critical line on Fuller for decades. Peter Stanfield observes that critics calling Fuller a primitive were celebrating the fact that he seemed 'to exist outside of the corrupting influence of commercial imperatives and bourgeois mores'. But, Stanfield continues, 'Positioning [Fuller] as a primitive also meant

Credit: *The Steel Helmet* © 1951
Deputy Corporation.

that Fuller's work had to be explained; he could not be relied upon to comment authoritatively on his own work: that function needed a trained and insightful critic' (2011: 115).

This colonization of the 'primitive' Fuller by self-appointed cinephiles reaches its most obnoxious peak in Jean Luc Godard's *Pierrot Le Fou* (1965), in which Fuller makes a cameo at a party full of the vacuous rich. Asked by the film's protagonist to define the cinema, Fuller responds, 'A film is like a battleground. It's Love. Hate. Action. Violence. Death. In one word, Emotions.' His words translated by a bored-looking woman, Fuller looks stiff and uncomfortable throughout the exchange, and even if the speech sums up something of his attitude towards what matters in a story, its inclusion in a film as arch and inessential as this one makes it ring false.

The problem with viewing Fuller as a primitive, ultimately, is that it encourages us to view him as simplistic, when in fact he was anything but. As Lisa Dombrowski writes, 'The longstanding association of the primitive with the instinctual [...] can unfairly characterize artists who produce primitive work as acting without conscious thought or training' (2008: 7–8).

Fuller's films, however, are marked by their self-consciousness and their artful use of cinematic technique. His reliance upon long takes and dramatic compositions is remarkable, especially when examined alongside other makers of 'B'-movies and programmers. Nor is Fuller's world-view simplistic or primitive. Rather, as Stanfield argues, 'Fuller revelled in the ambiguity and contradiction he found in the everyday' (2011: 166). This contradiction lies at the heart of many of Fuller's best films. His insistence upon the importance of personal honour and individual action in the face of an uncaring world makes Fuller a sentimentalist, even by the standards of Hollywood. However, his sentimentality is not comfortable or reassuring; however honest, or true to themselves, or even heroic his characters may be, it is the rare Fuller film where this makes their fate any less grim.

The director's uniquely brutal sentimentality is at its most visible in his war films, which somehow celebrate the ordinary fighting man as a romantic, noble figure, while still taking pains to depict both the horrible violence and the monotony of war. Though his action occurs in harsh, unforgiving landscapes, Fuller's films argue for the importance of sentiment in the face of hardship. Perhaps because they are most closely informed by his own experiences, Fuller's films about the US infantry feel like the truest expression of his personal aesthetic, and none more so than *The Steel Helmet*.

An accomplished and uncompromising 'B'-movie, *The Steel Helmet* was a genuine hit, making Fuller's reputation and helping him to move from the Poverty Row Lippert

Studios to 20th Century Fox. This Korean War story revolves around the hard-bitten veteran, Sargeant Zack (Gene Evans), lost behind enemy lines in the middle of the war. Initially portrayed as a gruff, unsentimental survivor, Zack forms unlikely friendships with a South Korean boy, Short Round (William Chun), and a black army medic, Thompson (James Edwards). In Fuller's depiction of this messy war, chains of command are stretched to breaking point and with his company slaughtered, Zack is a free agent, who only agrees to aid a lost squad of infantrymen in exchange for the box of cigars that one of them carries in his pack. Like most of Fuller's war films, *The Steel Helmet* plays out as a picaresque, with Zack and the hapless squad faltering from one danger to another on their trek to the safety of a Buddhist temple. Encounters with snipers or booby-traps punctuate long periods of monotony or boredom, and the claustrophobia of the soundstage stands in effectively for the narrow field of vision of jungle-bound soldiers. Fuller's war is never grand or heroic, and from the ground-eye view of his ordinary foot-soldiers, the only thing apparently at stake is their own lives.

Also typical of Fuller's oeuvre is the squad's racial and social diversity. In addition to Thompson and Short Round, the company includes a mute, a former conscientious objector, a green lieutenant and a Japanese American veteran. Yet Fuller is not content merely to use these men as a synecdoche of melting-pot America, as so many other platoon films have done. Rather, he uses each of these characters in a developing discourse about duty and honour – what a man must do and what a man deserves. Every character gets a moment in which to articulate his world-view (and, ultimately, to come around to Fuller's), but the didactic elements of the film reach their peak as the squad watch over a captured North Korean Major. Hoping to exploit their fear and uncertainty in order to escape, the Major (Harold Fong) taunts both the African American Thompson and the Japanese American Tanaka (Richard Loo) by reminding them of their status as second-class citizens back home in America. Thompson is stoic: 'A hundred years ago I couldn't even ride a bus. At least now I can sit in the back. Maybe in fifty years I'll sit in the middle. Someday even up front. There's some things you just can't rush, buster.' Tanaka is less assured when reminded of the internment of Japanese Americans during World War II, admitting, 'You rang the bell that time.' But he goes on to justify himself, arguing, 'I'm an American. And if we get pushed around back home, well, that's our business.'

The highly personal brand of patriotism Fuller displays here is typical of him, if unusual for the time. Lee Server reminds us that, 'At the time of *The Steel Helmet*, with blacklisting rampant in Hollywood and the country actually at war, Fuller gave evidence of a brave and potentially suicidal iconoclasm by giving his commie major such powerful anti-American ammunition' (1994: 65). Yet however critical Fuller or his characters might be of the actions of America or Americans, their loyalty to the country is instinctive and unswerving, the produce of sentiment rather than reason.

The same dynamic, of personal sentiment triumphing over evidence and experience, is at work in the film's central conflict. Throughout the film, Zack repeatedly clashes with the semi-competent Lieutenant Driscoll (Steve Brodie). Zack is the uncompromising voice of bitter experience, looting corpses for their bullets and boots, while Brodie, apparently more humane, clings to ordinary decency. Their first disagreement comes when the squad stumbles upon a dead GI and Brodie wants someone to retrieve the soldier's tags. Zack objects that 'a dead man's nothing but a corpse. No one cares who he is now', but Brodie still gives the order, with the result that his soldier is killed by booby traps around the body. Unfazed, Zack chastises the Lieutenant and rummages through the dead man's pack for cigars. Fuller only sets Zack up as the bitter voice of utility in order to undo him. It is Zack who allows Short Round to tag along on his journey, and who finds himself softened by the child's good-natured loyalty. It is Zack who, after Short Round is killed by a North Korean sniper,

murders a captive in cold blood. It is Zack whose mind snaps during the final assault on the temple, causing him to drop his weapon and stagger aimlessly through the rest of the battle. And it is Zack who is given the last word in the film, as he honours the dead Lt Driscoll by placing his own helmet upon the officer's grave in a mute gesture of acceptance.

What matters in Fuller's war films, and indeed, in almost all of his films, is not the effect of what a man does – the world inhabited by Fuller's characters is too grim and unbalanced for them to imagine that they are in control. Soldiers live and die without meaning, except the meaning they create for themselves through their friendship, their loyalty and their unquestioning patriotism. In the final moments of *The Steel Helmet*, the four shell-shocked survivors of the squad are ordered to move out and continue marching. As they trudge out of shot a caption on the screen reads: 'There is no end to this story.' In the world according to Sam Fuller, meaning occurs only where we make it, and there are no real endings, for there is always another story.

Martin Zeller-Jacques

References

Dombrowski, Lisa (2008) *The Films of Samuel Fuller: If You Die, I'll Kill You!*, Middletown, CT: Wesleyan University Press.

Moullet, Luc (1985) 'Sam Fuller: In Marlowe's Footsteps', in Jim Hillier (ed.), *Cahiers du Cinéma: The 1950s – Neo-Realism, Hollywood, New Wave*, London: Routledge.

Sarris, Andrew (1996) *The American Cinema: Directors and Directions 1929–1968*, New York: DaCapo Press.

Server, Lee (1994) *Sam Fuller: Film Is a Battleground*, Jefferson, NC: McFarland and Co.

Stanfield, Peter (2011) *Maximum Movies – Pulp Fictions: Film Culture and the World of Samuel Fuller, Mickey Spillane, and Jim Thompson*, New Brunswick, NJ: Rutgers University Press.

DAVID GORDON GREEN

Gettin' Around, Walkin' Around, Lookin' at Stuff

For much of the 2000s, following his debut, *George Washington* (2000), David Gordon Green's singular career was defined by a series of thematic and visual tropes which synopsized the key elements of his widely admired authorial signature. With varying degrees of emphasis, these came to include: Green's reverential debt to the 1970s Hollywood Renaissance (particularly the work of Terrence Malick); his emotively impressionistic depictions of impoverished communities in unfashionable regions of the American South; a talent for evocative visual poetry and languid, meandering storylines; an emphasis on mood and tone, foregrounding emotional ambience over narrative economy and psychological transparency; and his fondness for thematic ambiguity, temporal dissonance and tactile philosophical abstraction.

On the release of *Joe* (2013), however, critical discussions of Green's work almost uniformly emphasized the supposedly schizophrenic disjunction between his 'distinctive' indie output and his mid-career move into 'anonymous' mainstream film-making, a trajectory that Peter Bradshaw dubbed 'the weirdest auteur detour in modern movie history' (2014: 20). Indeed, many admirers were taken aback by the yawning tonal and aesthetic gulf between the sublime elliptical poetry of *George Washington* and *Undertow* (2004) and the bawdy scatological humour of *Pineapple Express* (2008), *Your Highness* (2011) and HBO's lewd-'n'-crude *Eastbound and Down* (2009–2013). Somewhat predictably, this discursive frame valorizes Green's indie output as typifying the vitality, intelligence and authenticity of leftfield film-making while his commercial movies are almost uniformly interpreted as evidence of the ongoing creative bankruptcy of mainstream Hollywood cinema.

This polarized view of Green's output – and the ease with which he has managed to successfully oscillate between both poles – is symptomatic of certain enduring critical anxieties; namely, whether 'independence' remains (1) an ideologically clear designation for work that genuinely exists outside the mainstream, or (2) simply a niche marketing term. The cultural logic at work here is sometimes self-defeating. For example, when Green followed his $25 million Jonah Hill star vehicle *The Sitter* (2011) with the low-budget *Prince Avalanche* (2013), the latter was automatically hailed as a triumphant return to his indie roots. This was to overlook the fact that the $30 million gross of *The Sitter* made it the director's second most lucrative film to date after *Pineapple Express*, while *Prince Avalanche* recouped less than half of its comparatively miniscule $725,000 budget. Box office receipts are no marker of quality, of course, but this disparity is indicative of the restrictive bind Green has found himself caught in. Yet Green refuses to be pigeonholed as the earnest cine-poet so beloved by critics and rarely shies away from declaring his populist tastes. 'As a filmgoer, I like all types of movies,' he remarked with matter-of-fact defiance after the release of shambolic stoner adventure *Pineapple Express*. 'As a film-maker, I want to make all types of movies' (Fetters 2008).

A native Arkansan, Green attended film school in North Carolina where he befriended what would become his regular team of creative personnel, including cinematographer Tim Orr, musician David Wingo, production designer Richard A Wright and actors Paul Schneider and Danny McBride. Green's ongoing commitment to close-knit collaboration

Prince Avalanche © 2013 Dogfish Pictures, Muskat Filmed Properties, Rough House Pictures

and general disdain for the monomaniacal precepts of the auteur theory was vindicated when the beatific *George Washington* became the most acclaimed American independent debut since Quentin Tarantino's trend-setting *Reservoir Dogs* (1992). Costing just $42,000, it is difficult to shake off the feeling that the euphoric critical reception to *George Washington* was due in no small part to the film's bucolic indifference to notions of 'cool' or 'irony' that had dominated the independent scene since the early 1990s.

Shot entirely on location in the town of Winston-Salem, NC, *George Washington* is a visually rich, lyrical and narratively disconnected tale built around the tragic fall-out among a group of adolescent friends following the romantic break-up of Buddy (Curtis Cotton III) and Nasia (Candace Evanofski). Using a largely non-professional cast, it offers a surreal, entrancing collage of a decaying wasteland where, according to Green, 'man met nature and nature kicked his ass' (Ducker 2006). The film is given the loosest of structure by Nasia's woozy, dreamlike voice-over, deliberately invoking *Days of Heaven* (Terrence Malick, 1978) in both its torpor and observational vagueness. 'They used to get around, walkin' around, lookin' at stuff,' Nasia drawls as her friends amble aimlessly through the decrepit town. 'They used to try to find clues to all the mysteries and mistakes God had made.' If Green's own comments on his film-making style are sometimes direct to the point of banality – 'continuity has never been my speciality' (Ducker 2006) – his debut is as sublime and preternaturally assured as Malick's *Badlands* (1973). By turns sad, tender and funny, *George Washington* is a quietly mesmerizing late-summer hymn to the quotidian and the infinite, all steeped in dreamy, magic-hour gauze. 'Sometimes I smile and laugh when I think of all the great things you're gonna do,' Nasia coos hesitantly to the eponymous man-child (Donald Holden). 'I hope you live forever.'

Just as *George Washington* foreshadows the soon-to-be-fashionable 'rough South' aesthetic of *Winter's Bone* (2010), *Beasts of the Southern Wild* (Benh Zeitlin, 2012) and *Mud* (Jeff Nichols, 2013), so too does *All the Real Girls* (2003) prefigure indie cinema's growing interest in challenging popular culture's traditional conception of romantic love. Less abstract than Green's debut, *All the Real Girls* nevertheless successfully imported many of its distinguishing hallmarks, not least its ethereal cinematography, lilting ambient score and subdued air of wistful existentialism. Green's emergent signature was also evident in its elliptical storytelling and love of sleepy Americana. Rusty railway tracks

vanish into the horizon; buildings and machines are engulfed by moss and foliage; and a two-legged dog ambles eccentrically across the frame. *All the Real Girls* is an emotively bittersweet tapestry with a simple premise: Paul (Paul Schneider), a notorious womanizer and small town ne'er do well, falls for Noel (Zooey Deschanel), his best friend's virginal sister. As the offensively smug *Garden State* (Zach Braff, 2004) and obnoxiously affluent *Like Crazy* (Drake Doremus, 2011) both demonstrate, emotionally realistic stories about twentysomething romantic angst are not the easiest hand to play. Yet Green's take on the subject manages to imbue its clichéd premise with affecting, dreamily solipsistic vigour.

All the Real Girls is also a document of a dimly remembered time before Deschanel lapsed into doe-eyed self-caricature. In-keeping with cinematographer Tim Orr's expressive manifestation of the characters' heightened emotional states, Deschanel appears more intangibly beautiful here than at any point in her career. Noel is no prettified abstraction, however; Deschanel's nuanced performance structures the film's understated critique of Paul's self-serving romantic fetishism. *All the Real Girls* begins with an unbroken four-minute take of the couple murmuring hesitant sweet nothings; it ends with a wistful shot of the river that flows unhurriedly through the town. Reflecting the autumnal hues which dominate the film's palette, the final image offers a quietly transcendent answer to Noel and Paul's lovestruck insularity. Green's sleight of hand signals that the end of their relationship is both profound ('the saddest thing in the world') and ephemeral, a fleetingly painful moment of human intensity amidst the quietly indifferent rhythms of the natural world.

Green's subsequent film *Undertow* is arguably his most off-kilter and unsettling feature to date. 'Sometimes it's the strange moments that stick with you,' mumbles John (Dermot Mulroney), an all-too appropriate observation given the film's uncanny qualities. Adolescent desire is reimagined in *Undertow* as if filtered through the Surrealist Manifesto. 'Let me see your knife,' demands Lila (Kristen Stewart) of her boyfriend. 'Can I carve my name in your face?' A plank of wood nailed to his foot, Chris (Jamie Bell) hops agonizingly through a meadow like the unwitting survivor of a botched crucifixion. Sickly younger sibling Tim (Devon Alan) is bookish and guileless, experiencing the material world with the tactile inquisitiveness of an animal. This meandering film becomes increasingly picaresque as the brothers are pursued across rural Georgia by their murderous uncle Deel (Josh Lucas). Beautiful and strange, a feral siren (Shiri Appleby) listlessly elucidates the sad truth behind the film's enigmatic title. There are obvious nods to *Night of the Hunter* (Charles Laughton, 1955) and *Rebel Without a Cause* (Nicholas Ray, 1955), while the discordant 'happy ending' in which the brothers are reunited with benevolent grandparents has an air of Brechtian unreality that is pure David Lynch.

If Green is sometimes guilty of wearing his influences a little too readily on his sleeve, his reference points are rarely less than impeccable. Co-produced by Malick and hauntingly scored by Philip Glass, *Undertow* is teeming with signifiers of Green's favourite period of American cinema. His ostentatious use of zooms, freeze frames and slow motion recall *The Wild Bunch* (Sam Peckinpah, 1969) and *Butch Cassidy and the Sundance Kid* (George Roy Hill, 1969), while the impoverished *mise-en-scène* and earthy colour palette signal the influence of Robert Altman circa *Thieves Like Us* (1974). Yet despite the abundance of allusions, *Undertow* nevertheless feels like it exists entirely within its own unique time and space. 'We should disappear,' suggests Chris in the film's opening scene. 'Go some place where we can see everything.' Characters in Green's films invariably struggle with language in their attempt to verbalize the incommunicable. Through its downtrodden fairy-tale structure, however, *Undertow* encompasses the longing for re-enchantment found in his most affecting work. The film's deeply ambiguous conclusion reaches out towards the spiritual in an apparently Godless world. 'I used to get confused where things begin and where they end,' Tim murmurs to himself. 'Sometimes I wonder if I'm superstitious. Do I believe in broken mirrors and demons and curses? Sometimes…'

Snow Angels (2007) retained Green's trademark emotional sophistication but noticeably muted the stylistic self-consciousness of his previous features. Filmed in Nova Scotia, the fourth and final of his self-defined 'crybaby movies' (Odam 2013) has more than a little of Atom Egoyan's *The Sweet Hereafter* (1997) in its snowbound melancholy and depiction of a small community in the aftermath of tragedy. It is also a powerful exploration of dysfunctional masculinity and how poverty and class struggles fuel not only individual depression but also the related disintegration of familial relationships. Largely told in extended flashback, *Snow Angels* begins with a school band playing Peter Gabriel's 'Sledgehammer', a famously phallocentric and innuendo-laden paean to heterosexual desire. 'Do you have a sledgehammer in your heart?' enquires the school instructor as gunshots signifying the murder of Annie (Kate Beckinsale) by her estranged alcoholic husband Glenn (Sam Rockwell) ring out in the distance. The film is marked out by impressively naturalistic performances and an uncompromising approach to its bleak subject matter. An elegiac montage scored by Green's regular musical collaborators Explosions in the Sky seems to offset the air of fatalism, suggesting the possibility of community regeneration and renewal. Yet the film's coda constitutes a quietly devastating reiteration of the enduring stillness of grief.

Despite widespread critical acclaim, Green was frustrated that his indie features consistently struggled to reach beyond a niche audience.

> I remember thinking I can't keep doing this. I need to exercise something else […] I want to make a movie in Los Angeles that's funny and makes people laugh. I want to make something that's commercial and people are excited to buy tickets to. (Brown 2013)

With individual budgets ranging between $25–$50 million and featuring multiplex-friendly stars like Natalie Portman, James Franco and Seth Rogen, Green's trio of mainstream comedies were certainly far removed from the material with which he had made his name. However, if the bland and catastrophically unfunny *The Sitter* remains the director's only complete creative failure, both *Pineapple Express* and *Your Highness* are hugely enjoyable, showcasing Green's versatility, his love of the action and fantasy genres, and his uniquely enthusiastic willingness to visualize a Minotaur's penis. Indeed, the critical insistence upon his 'auteur detour' overlooks a gleefully consistent scatological streak that has been evident in Green's work since *George Washington*. Moreover, to varying degrees all three of Green's studio comedies perpetuated his career-long exploration of American male identity, thematic terrain explored in more detail in his two subsequent films.

Based on a little-known Icelandic comedy, *Prince Avalanche* was a low-budget road movie providing another useful bridge between Green's mainstream comedies and his independent output. While Alvin (Paul Rudd) and his younger work colleague Lance (Emile Hirsch) are the classic mismatched couple of buddy movie convention, the film's affective force lies in its deceptively complex emotional undercurrents rather than its amiable surface humour. Set in a fire-ravaged Texas national park in the late 1980s, the two men offer contrasting archetypes of American masculinity: Alvin the quiet, solitary outdoorsman; Lance the horny, overbearing frat-boy. Both characters hold each other in broad contempt until their growing conflict eventually strips away their absurd gendered posturing, unveiling Alvin's underlying sadness and Lance's emotional sensitivity. An eccentric elderly truck driver (Lance LeGault) offers a further dead-end paradigm of stilted manhood explored with greater force in *Joe*: weather-ravaged, hard-drinking, crudely misogynist. The men's emotional repression is thrown into sharp relief during a poignant sequence when Alvin encounters a mournful old woman trying to salvage what remains of her ruined home. 'Sometimes I feel like I'm digging through my own ashes,' she states plaintively. The opening titles explain that four people died during the fires, leaving the sparsely populated landscape of *Prince Avalanche* more than amenable to a supernatural interpretation.

The final moments of *Prince Avalanche* segue neatly into *Joe*'s tree-clad topography, as dungaree-clad workers are filmed toiling amidst blackened forest. Like *Prince Avalanche*, *Joe* is ambivalent in its representation of masculinity, swaying uncertainly between a reverential mythopoeticism (particularly regarding physical labour) and a pessimistic view of American manhood as violently atavistic. *Joe* is a neo-western whose symbiotic relationship with *Prince Avalanche* is mapped across the films' respective landscapes: '*Avalanche* is the re-birth of the forest, and *Joe* is the genocide of the forest,' notes Green (Dowd 2013). *Joe* also offers a similarly masculine triptych. Gary (Tye Sheridan) is a half-formed young man offered two bleakly Oedipal role models: his father, Wade (Gary Poulter), a violent, alcohol-ravaged tyrant who prostitutes his young daughter to fund his drinking; and the volatile Joe (Nicolas Cage), a younger version of Wade barely kept in check by his maxim that 'what keeps me alive is restraint'. *Joe* marries the violent southern gothic vibe of *Undertow* with an acute emphasis on social deprivation. Green has sometimes been accused of aestheticizing poverty with his visually sumptuous depictions of socio-economic hardship. Like *Snow Angels*, however, *Joe* is acutely political in the way that it pinpoints the social continuum between poverty, violence and self-destructive masculinity. 'These men who bust their asses work like dogs,' rants Joe. 'And I believe in them, but every day they hurt. They get old, they peel back […] There's no frontier anymore.' Given that the majority of the film's cast are homeless people and local day labourers, Joe's diatribe is given particular resonance in the wake of 2008's catastrophic economic meltdown.

The savagely inevitable bloodletting in *Joe*'s final scenes feels like an ugly but necessary purge: not just of brutish versions of masculinity, but of an older generation forcibly removed to allow the new to grow. 'Nobody wants these trees,' explains Joe, when Gary asks why they cull the gnarled woodland. 'They're no good for anything'. In turn, it is tempting to understand *Manglehorn*'s (2014) low-budget study of an elderly, emotionally withdrawn locksmith (Al Pacino) as the third part of a loose masculinity-in-crisis trilogy. From the outset, Green has fervently located hope in the young and their embodiment of futurity. 'The grown-ups in my town, they were never kids like me and my friends,' sighs Nasia in *George Washington*. 'They had worked in wars and built machines. It was hard for them to find their peace. When I look at my friends, I know there's goodness.'

Martin Fradley

References

Bradshaw, Peter (2014) 'Joe', *The Guardian* (*G2*), 25 July, p. 20.

Brown, Emma (2013) 'The Return of David Gordon Green', *Interview Magazine*, http://www.interviewmagazine.com/film/david-gordon-green-prince-avalanche/. Accessed 29 July 2014.

Dowd, AA (2013) 'David Gordon Green on "Prince Avalanche" and its Nicolas Cage companion piece', *AV Club*, 15 August, http://www.avclub.com/article/david-gordon-green-on-iprince-avalanche-iand-its-n-101620. Accessed 21 June 2014.

Ducker, George (2006) 'David Gordon Green', *The Believer*, August, http://www.believermag.com/issues/200611/?read=interview_green. Accessed 17 July 2014.

Fetters, Sarah Michelle (2008) 'Pictures in the Snow: Talking About Angels, "Pineapple Express" and Emotional Truths with David Gordon Green', *Moviefreak.com*, 21 March, http://www.moviefreak.com/artman/publish/interviews_davidgordongreen.shtml. Accessed 1 July 2014.

Odam, Matthew (2013) 'David Gordon Green Continues to Defy Expectations', *Austin360*, 3 March, http://www.austin360.com/news/entertainment/movies/david-gordon-green-continues-to-defy-expectations/nWgpQ/. Accessed 14 July 2015.

TODD HAYNES
With the Love of the Lens

Todd Haynes is that rare phenomenon – an academic's film-maker. There are film-makers' film-makers, of course, in the same sense as there are writers' writers and artists' artists. These are film-makers admired by their peers. The critics' darling is another well-known example: a director praised by the cultural opinion makers. But the academics' film-maker is something else: it is a director prized by academics. It is certainly rarer than the other two, although not so uncommon as to be unique. There are numerous examples: Douglas Sirk, Nicholas Ray, Rainer Werner Fassbinder, Chantal Akerman, Maya Deren. It is not an exclusive epithet: an academics' film-maker could just as well be a film-makers' director or critics' darling – indeed, they often are. But the criteria tend to be different. Whereas film-makers admire other film-makers for their unparalleled skilfulness and originality in employing the medium's possibilities, and critics may applaud directors for the power of their expression, academics tend to appreciate them for their engagement with scholarly discourses: cinema history, film philosophy, debates in *mise-en-scène*, the voyeur, fetishism, consumer society, postmodernism.

Scholarly praise for Haynes is often expressed in similar terms. Film scholar James Morrison has argued that though Haynes's 'films are not themselves, in any ordinary sense, works of theory […] one of their most notable features is their explicit relation to the body of knowledge that has accumulated under that banner for several decades' (2007: 132). Mary Desjardins (2004), for instance, admires Haynes's studied analysis of celebrity culture in the short film *Superstar: The Karen Carpenter Story* (1987), while amongst others Chad Bennet (2010) is appreciative of *Velvet Goldmine*'s (1998) critical engagement with queer theory. Perhaps unsurprisingly, most praise is reserved, however, for Haynes's acknowledgement of debates in cinema studies. Some of the most influential scholars in the history of film studies have celebrated both *SAFE* (1995) and *Far from Heaven* (2002) for their appropriation of academic writing about psychoanalysis, *mise-en-scène* criticism, melodrama, Fassbinder and Sirk – among them Laura Mulvey, Richard Dyer, Mary Ann Doane and Lynne Joyrich.

This is not to suggest that Todd Haynes does not deserve the attention. Many critics, too, consider him one of the most accomplished film-makers of his generation. I would like to say here that I am also a fan, that in fact *Far from Heaven* ranks among my favourite films of all time, but that would not much help matters, given that I am an academic as well – and that part of my love for the film stems from how it adopts Mulvey's writing on Sirk to revisit the 1950s melodrama. But it is important to understand from the outset the terms of the debate: Haynes is not necessarily appreciated because he is an accomplished film-maker (which he, to be sure, most definitely is), but because he is an accomplished film-maker within a discourse set by academics: a discourse which expects film-makers to be political, self-conscious, cinephile and, perhaps above all, appreciative of academia's engagement with cinema. I am always taken by how much better the film goes down in third year classes than with the freshers; it's an acquired taste, one taught, I suppose, at universities, by teachers like myself.

I'm Not There © 2007 Endgame Entertainment, Killer Films, John Goldwyn Productions, John Wells Productions, The Weinstein Company

By most accounts, the love affair between Haynes and academia began sometime in the early 1980s, when he studied semiotics at Brown University. It is here, presumably, that he picked up a love for the theories of amongst others the faculty members Kaja Silverman and Laura Mulvey (Davis 2008: 12). His understanding of the nature of the sign – arbitrary and relational yet perceived as necessary and intrinsic – informed some of his earliest short films, not least *Superstar: The Karen Carpenter Story*. In this film, which was long unavailable for viewing due to a court mandate on behalf of the Carpenter family but at the time of writing can be found on various online streaming sites, Haynes manipulates the sign of 1970s singer Karen Carpenter by portraying her as a Barbie doll with anorexia, deconstructing at once the plasticity of pop culture; the simulacral, commoditized and above all unattainable imagery of women in mass media; and the prejudiced discourses around the causes and effects of Carpenter's terrible disease. The power of the film resides in its chronology: at first, seeing Karen Carpenter, the frigid and plastic embodiment of Nixon's silent majority, as a lifeless Barbie doll provokes laughter; yet as the disease takes a hold of her body, the stiffness of the doll figure becomes a harrowing metaphor for the rigidity of the disease's mould.

The films with which Haynes made a name for himself both within and outside of academia, *Poison* (1991) and *Velvet Goldmine*, deconstruct the signs of gender and sexuality. Their approach, in both cases though more explicitly in *Poison*, is to interrogate our understanding of discourses of masculinity and femininity, heteronormativity and homosexuality, through appropriation of theories on queer, ranging from the writings of Genet to those of Judith Butler, Julia Kristeva and Jacques Lacan. Thus in *Poison* – a majestic tapestry weaving together the story of a boy who kills his father for reasons unbeknownst to the narrator (the mockumentary 'Hero'); the story of a man imprisoned with the man he (sexually) abused as a child at reform school (the coming-of-age story 'Homo'); and the story of a scientist who isolates and ingests the human sex-drive, becoming the 'Leper Sex Killer' (the aptly named 'Horror') – the classical Hollywood representation of identity as fixed is problematized in favour of a genre-dependent portrayal of gender and sexuality that is more flexible, the unambiguous interrogated by the ambiguous, being by becoming – or to continue the metaphor, the thread, single and linear, by the threading, multiplicitous and multimodal.

The film that sealed Haynes's special relationship with academics, or at least this academic, was his 2002 masterpiece *Far from Heaven*. A pastiche technicoloured

melodrama about a 1950s middle-class suburban housewife who befriends her African American gardener after her husband comes out as gay, the film is, as Susan Willis has remarked,

> as much an homage to film theory, and in particular to feminist film theory, as it is to Douglas Sirk. It reads the 1950s melodrama (and beyond it, the 1950s in popular memory) through the lens of 1980s and 1990s feminist film theory. (Willis 2003: 134)

As is well documented, Sirk's films allow for multiple readings. Initially, they were seen as ideologically complicit 'weepies', in which female hardships were eventually softened by the smooth, strong arms of men, private passions sublimated by patriarchal society. Yet in the late 1970s feminist film critics like Mulvey, Tania Modleski and Richard Dyer began watching these films again to come to another conclusion: whilst the plot suggested a happy ending, the *mise-en-scène* implied the improbability or even impossibility of such a happy ending. Thus in *All that Heaven Allows* (Douglas Sirk, 1956), the blueprint for *Far from Heaven*, the reunion of lovers Carrie (Jane Wyman) and Ron (Rock Hudson) is undercut by an imagery of motherly care (Carrie has exchanged her sexy red dress for a grey suit), sterility (Ron's earthy greens and browns have been traded for a hospitalized blue), passivity (Ron is unconscious after an accident) and ridicule (a deer walks into the picture, making a mockery out of the movie's social realism). Far from ideologically complicit, this film criticized 1950s gender and class inequality.

Haynes re-envisions 1950s melodrama 'through the lens' of such observations, making explicit the critiques latent in the original. In *Far from Heaven*, Cathy's (Julianne Moore) friendship with her black gardener Raymond (Dennis Haysbert) finally fails under pressure of their peers. In addition to the Sirkian strategies of colour-coding, double-framing, mirroring and the use of symbols, Haynes frequently focuses his camera on people looking: a reporter looks on as Cathy greets Raymond in the garden, Cathy's neighbours watch her as she meets him at an art show, men stare at Cathy's husband Frank (Dennis Quaid) as he enters a gay bar. Though Haynes uses this technique in many of his films, it here takes on extra significance given that Fassbinder employs it in his brilliant adaptation of *All That Heaven Allows*, *Ali: Fear Eats the Soul* (1974), a film which shifts the focus from gender to ethnicity. By viewing Sirk not only through the lens of academia but also through the eyes of Fassbinder, Haynes adds historical weight and gravitas to the peer pressure that brings his protagonists to their knees.

Haynes's films are often discussed in terms of postmodernism, if not because of his educational background in semiotics then, presumably, because of his affinity with tropes like pastiche and eclecticism. It is certainly true that Haynes has consistently adopted many of the stylistic strategies and critical tactics associated with postmodernism, ranging from the aforementioned pastiche and eclecticism to parody, reflexive irony, unreliable narration and the deconstruction of point of view and the subject, most notably in Haynes's last film to date, the not altogether successful biopic *I'm Not There* (2007). As the era of postmodernism recedes into the past at ever quickening rates, however, it is time to reconsider these assumptions. The use of strategies connoted with the postmodern does not necessarily a postmodern film make, as more recently film-makers like Wes Anderson and Spike Jonze and television programmes like *Mad Men* (AMC, 2007–2015), *Community* (NBC, 2009–2014; Yahoo! Screen, 2015) and Haynes's own HBO miniseries *Mildred Pierce* (HBO, 2011) have demonstrated.

In postmodernism, as Fredric Jameson (1984) noted, techniques like eclecticism and reflexive irony are frequently employed to rid experiences of expression, depth and affect. Haynes, on the contrary, uses these tactics precisely to draw intimations of depth out: the post-irony of his storytelling, the anguish stemming from discourses of race and gender, the tragedy of prejudices around AIDS, the dehumanizing effects of

heteronormativity, the possibility of love. In *Far from Heaven*, Haynes references Sirk and Fassbinder not only to deconstruct the conventions of melodrama, but to add depth to the feelings they provoke: the colour-coding brings with it a history of oppression and inequality, the focus on people looking invokes intertextual memories of peer pressure, conformation, isolation and perhaps most of all alienation. As Mary Ann Doane evocatively puts: 'Haynes's cinema demonstrates not so much that the image resides within a genre, but that the generic invades the image, reducing its singularity, making it available for recognition' (2004: 12–13).

Haynes has been rightly praised for his contributions to queer cinema and discussions about identity and sexuality more broadly. But it is here, perhaps, that one of Haynes's other utmost important contributions to the history of cinema lies. Haynes demonstrates that films can be clever and naive at the same time; he shows that they can be ironic and sincere, critical and moving, referential without being unoriginal. Indeed, *Far from Heaven* is so moving precisely because it deconstructs the representational modes of earlier traditions. As again Doane writes: 'Nietzsche's oxymoron – the pathos of distance – seems strikingly appropriate for Haynes's cinema, which not only reconciles these two effects but reveals them as mutually sustaining' (2004: 14). In this sense, Haynes's films anticipated from the start the post-postmodern or metamodern sensibility that would come to dominate popular culture from the mid-2000s, one that received its most well-known expression in aptly named movements like 'The New Sincerity' and 'Quirky'. Haynes may be an academic's film-maker, but his influence reaches far beyond the university.

Timotheus Vermeulen

References

Bennett, Chad (2010) 'Flaming the Fans: Shame and the Aesthetics of Queer Fandom in Todd Haynes's Velvet Goldmine', Cinema Journal, 49: 2, pp. 17-39.

Davis, Glyn (2008) *Superstar: The Karen Carpenter Story*, London: Wallflower.

Desjardins, Mary (2004) 'The Incredible Shrinking Star: Todd Haynes and the Case History of Karen Carpenter', *Camera Obscura*, 19: 3, pp. 22–55.

Doane, Mary Ann (2004) 'Pathos and Pathology: The Cinema of Todd Haynes', *Camera Obscura*, 19: 3, pp. 1–21.

Jameson, Fredric (1984) 'Postmodernism, or the Cultural Logic of Late Capitalism', *New Left Review*, 146 (July–August), pp. 53–92.

Morrison, James (2007) 'Todd Haynes in Theory and Practice', in James Morrison (ed.), *The Cinema of Todd Haynes: All that Heaven Allows*, London: Wallflower Press.

Willis, Susan (2003) 'The Politics of Disappointment: Todd Haynes Rewrites Douglas Sirk', *Camera Obscura*, 18: 3, pp. 130–75.

NICOLE HOLOFCENER

The Radicalism of Emotional Authenticity

Nicole Holofcener's films tackle themes that are rarely addressed with any depth or sensitivity in American cinema. *Please Give* (2010) explores social class division, white privilege, liberal guilt, female friendship, dying in an apartment alone, the awkwardness of breast exams, and the scarring emotional trauma of chronic adolescent acne. Mainstream films are generally too escapist and hyper-masculine to go near these themes. Holofcener's works are also defined by their fully realized characters and sophisticated narratives, including *Walking and Talking* (1996), *Lovely and Amazing* (2001), *Friends with Money* (2006) and *Enough Said* (2013). While one might wish that more American film-makers would embrace an equally true-to-life approach to constructing cinematic stories, Holofcener's commitment to realistic dramedy and emotional authenticity remains rare and subversive.

Snappy dialogue and urban coastal settings earmark her oeuvre as being part of the same American independent film tradition as Woody Allen, Whit Stillman, Noah Baumbach and Lena Dunham, though she is arguably more charitable in her depictions of human frailty and folly – and less relentlessly snarky – than her peers. She herself cites as inspirations *The Heartbreak Kid* (Elaine May, 1972) and *Starting Over* (Alan J. Pakula, 1979), as well as Allen's films (though his influence on her is often overstated because her stepfather, Charles Joffe, was his producer). However, it would be most appropriate to compare her work to the films of Mike Leigh and Yasujiro Ozu. The three auteurs craft comic-realist ensemble pieces that respect all the characters – even the antagonists and the comic relief figures – not merely the protagonist as viewer/auteur surrogate.

Holofcener's ensemble piece *Friends with Money*, for example, is about three wealthy couples and their single friend, Olivia (Jennifer Aniston), who has fallen on hard financial times and become a housekeeper. Olivia's acquaintances gossip about her ceaselessly, certain they know how she should be living without having the slightest idea what it is like to *be* her. Meanwhile, Olivia tries to retain her affection for her longtime companions while harbouring increasingly-hard-to-conceal envy over their settled domestic lives and financial stability. If this film were an over-the-top, Hollywood farce, Olivia would be like Kristen Wiig's aimless, zany heroine from *Bridesmaids* (Paul Feig, 2011); predictably, the stuck-up married friends would be one-dimensionally snooty and their marriages would fall to pieces during the climax, just as Olivia discovers true romance with a dashing beau. And yet, *Friends with Money* defies all dramatic expectations, challenging audiences to be more careful observers of film storytelling – and of real life – by presenting a series of credible characters living everyday lives in a recognizable setting.

Each of the marriages Holofcener examines in *Friends with Money* has a noticeable fault line. Depressed, irrational Jane (Frances McDormand) is prone to disproportionate outbursts of rage over small social slights and the thoughtlessness of strangers. Jane confesses that her short fuse is a manifestation of her preoccupation with aging and an awareness of her own mortality. Viewers may be inclined not to believe her assertion and embrace, instead, her friend Christine's theory that Jane is angry because her husband Aaron may be a closeted gay

Enough Said © 2013 Fox Searchlight Pictures, Likely Story

man. In a mainstream film, Christine would be right, because a secretly gay husband who is 'outed' at the most dramatic, inopportune time would make a 'sidesplitting' and tragic centrepiece for the movie. On the other hand, Holofcener suggests that the braver, more human thing for Christine to do would be to actually believe a woman when she reveals the source of her pain, and not cavalierly assume she is lying to herself or others. Audience members are advised to take note of this moral as well.

But is Jane's husband a closeted gay man? Aaron (Simon McBurney) is fit, well-dressed, works in fashion, and has impeccable taste. He also has some moderately effeminate mannerisms that encourage two other gay characters in the film to assume he is gay, too, and flirt with him. For his part, Aaron seems surprised and confused by the advances of gay men. He is also visibly hurt when his wife expresses dissatisfaction with her life that suggests she does not value their marriage. Careful viewers may wonder, as the film progresses, whether Aaron is really gay, or whether Christine wants her friends' marriage to be a sham so that she would not be the only one in her social circle to have picked the wrong mate.

Since the movie never provides a definitive answer to the question of Aaron's sexuality, many viewers have asked Holofcener to fill them in on the 'solution' to the 'mystery'. They tend to be disappointed to discover that there isn't one. 'I kind of felt like it was none of my business,' Holofcener revealed.

> I swear. I'm not trying to be clever by not deciding. I just didn't decide... if he is gay, then he's also a great husband and a lovely person and he loves his wife. And if he's not, then, you know, he just has a really strong sense of style, and that's not such a bad thing. (Holofcener 2006)

Aaron's ambiguous sexuality is not the central concern of the film. Instead, *Friends with Money* is about the tendency of the characters to dish dirt, obsess over material things, lack true compassion, and fail to demonstrate self-awareness. While Aaron is the kindest character in the film, he is not above gossiping with his wife and Christine about their married friends, Franny (Joan Cusack) and Matt (Greg Germann), who appear to be perfectly happy, in large

part because they are wealthy, in good physical shape, have regular sex, and hire servants to clean the house and help them raise their children. Since most generic film narrative models would insist that 'perfect' couples hide dark secrets, viewers might expect this marriage to be the one that explodes spectacularly in the final reel. Meanwhile, Christine's (Catherine Keener) marriage to David (Jason Isaacs) is in the most obvious trouble throughout the film, so viewers used to careworn film tropes would expect a dramatic reversal at the last minute, in which the couple has a teary reconciliation. And yet, at the end of the film, the happily married Franny and Matt remain happily married and the unhappily married David and Christine divorce. The storylines unfold realistically. There are no last-minute surprises. Ironically, the fact that there are no surprises for any of these couples at the end of the film is quite surprising.

On the other hand, Holofcener does offer a 'happy ending' to Olivia, with a bittersweet twist. When Olivia quits her job as a travelling maid, one of her former clients asks her on a date. The portly, slovenly, cheap, unambitious and socially awkward man has a degree of unlikely charm that appeals to Olivia. After their first date, he reveals that he is living off an inherited family fortune and that he wants to continue their relationship. His money is clearly an incentive to accept his offer, but Olivia believes they may make a good couple because they are both emotionally damaged people who can understand and forgive one another's flaws. The film fades out after she makes this charged statement; the final image is her wistful, enigmatic expression. The ending Holofcener has written here seems to raise questions about the potential future of this relationship without letting the audience off the hook by providing any likely answers.

Like *Friends with Money*, Holofcener's other films present equally morally ambiguous characters and scenarios. In *Walking and Talking*, a neurotic twentysomething's (Keener) fears that she will never see her recently engaged best friend (Anne Heche) again after the wedding are compounded by the discovery that her cat is dying. Meanwhile, her ex-boyfriend is now so addicted to pornography – and so embittered by his father's descent into Alzheimer's disease – that she finds it unlikely that they will ever get back together again, even after she has made an effort to keep him in her life.

A study of female body-image issues and sibling rivalry, *Lovely and Amazing* shows how three emotionally troubled sisters can begin to overcome their difficulties with one another by forgiving themselves and their mother for not being perfect women with perfect bodies, perfect marriages and perfect careers. The film nails men to the wall for utterly failing to empathize with what they perceive to be 'trivial women's problems'; notably, the criticism of insensitive males is too apt and the men too believably portrayed for viewers to dismiss Holofcener's critique as overstated.

In *Please Give*, the impending death of a poor, cantankerous old lady inspires her antisocial granddaughters (Rebecca Hall and Amanda Peet) and wealthy neighbours (Catherine Keener and Oliver Platt) to confront their own aging, as well as the pointlessness and beauty of life. The central thematic moment in the film occurs when several characters take time out from their hectic city lives to go to rural New York to enjoy the stunning beauty of autumn leaves on trees before they wither and fall. The old lady, who is with them, refuses to look at the view, and wallows in her own misery.

Even Holofcener's most 'conventional' film is still an emotionally turbulent, absorbing viewing experience. *Enough Said* is about a jaded divorcee (Julia Louis-Dreyfus) who is so afraid of getting burned a second time by a man that she seeks out information on her new boyfriend's character flaws from his ex-wife (Keener) to protect herself from becoming too invested in the romance. Her self-destructiveness is painful to watch, as is her increasingly harsh treatment of her teddy bear of a boyfriend (James Gandolfini), who is mystified about the cause of their relationship's unexpected tailspin.

Virtually all of Holofcener's characters are at least neurotic, if not deeply flawed, so they have the potential to get on a viewer's nerves. Consequently, actors occasionally ask her to rewrite key dialogue or allow them to soften their character's rough edges with a charismatic performance so that they don't risk their bankability as stars by playing a heel. Holofcener understands these impulses, but resists them. She defends the characters as written to the actors, hoping that they

and the audience will share her affection for her creations, warts and all. As she says, 'I love and respect this character who is having a hard time being nice right now' (Holzman and Schiff 2008). In the real world, a lot of us have a hard time being nice, and hope that we may be loved and respected despite our toddler-like behaviour. We do not always extend the same courtesy to other people and see beyond their problematic actions.

Admittedly, Holofcener writes and directs her films with an awareness of the marketing concerns of her financers, who nudge her towards casting famous, glamorous actors and constructing more gimmicky plots that assume a less intellectual audience. 'I'm a sellout,' Holofcener joked in an interview, noting that the only way she could make exactly the movies she wanted to make, without compromise, would be to go to England, 'be Mike Leigh, and make two cents' (Holzman and Schiff 2008). However, many of Holofcener's biggest supporters praise her for how 'uncommercial' her work is – and for giving women's voices and lives more of a presence in American film – without lingering on the marketing-motivated compromises she has made with her films during production.

Many of Holofcener's longtime fans have assumed that the well-constructed illusion of reality in her films is a direct result of them being autobiographical. This assumption is understandable, primarily because Catherine Keener bears a slight resemblance to the director and appears in all of her films, playing what seem to be a series of thinly disguised Holofcener stand-ins, in the way Jean-Pierre Léaud played Antoine Dionel five times as François Truffaut's fictionalized self. After all, Keener plays an artist whose work is underappreciated and hard to market in *Lovely and Amazing*, and her complaints sound like they come straight from Holofcener. It also seems clear that the extended family depicted in *Lovely and Amazing* is modelled on Holofcener's. It is. And it isn't. Generally, audiences assume too much when they are certain of a one-to-one correlation between, for example, the mother in the film, who has had liposuction and who is a character in a movie, and Holofcener's real mother, who has not had liposuction and is a living, breathing human being (Holzman and Schiff 2008).

Is there a better way of understanding these movies than to obsess over how best to judge the moral worth of her characters or to conclusively determine where the auteur's real life ends and her art begins? Perhaps some clues may be found in her intuitive and organic writing process, which results in dialogue so crisp that it sounds improvised instead of scripted. Like Flannery O'Connor, Holofcener begins with a character or a basic scenario inspired by her experiences or by people she has encountered in her day-to-day life, but she has no idea what the overall plot is or how the story is going to end. Her narratives unfold organically as she writes them; they aren't dragged towards a predetermined conclusion. While she risks not knowing how to end her stories, she usually solves the problem with rewrites and meditation.

Holofcener gives her characters and stories autonomy. She gives them room to breathe and be themselves. She does not stand in judgement of her creations nor pin a trite moral in a bow to her endings. As one might expect, she wishes that viewers of her films would afford her creations the same respect. The humanism underpinning Holofcener's films is part of what makes them great art, but it also helps educate filmgoers how to be better movie audiences. Finally, her films point to ways in which we may all become kinder to ourselves and to others, and more receptive to the mystery of real life in all its comedy, tragedy and beautiful pointlessness.

Marc DiPaolo

References

Holofcener, Nicole & Berman, Anthony (2006) 'Audio Commentary', *Friends with Money* [DVD], Culver City, CA: Sony Pictures Classics.
Holzman, Winnie & Schiff, Robin (2008) *Anatomy of a Script 3 – Nicole Holofcener* [DVD], Los Angeles, CA: Writers Guild Foundation.

TOBE HOOPER
One Hit Wonder?

Tobe Hooper has never been able to recapture the quality, energy or imagination shown in his low-budget, gruesome masterpiece, *The Texas Chain Saw Massacre* (1974). This film, which is now regarded as a classic of the horror genre and is regularly voted one of the greatest horror films of all time, has even been given a place in the permanent archive of the NYC Museum of Modern Art. It set the benchmark by which all other horror films would be measured post-1974.

Hooper made a rod for his own back however, albeit unwittingly, as most critics are quick to point out that none of his other films live up to the standard set by *The Texas Chain Saw Massacre*. Although he has continued to make films and to work in television, his career (certainly in artistic terms) effectively went into decline after this early highpoint. On the face of it then, Hooper never made another good film and certainly not a great one. The evidence seems damning if we consider such films as *Lifeforce* (1985), *Invaders from Mars* (1986), *Spontaneous Combustion* (1990), *The Mangler* (1995) and *Toolbox Murders* (2004) – some of which are downright preposterous, and none of which come close to the nightmarish tone and visceral power of *The Texas Chain Saw Massacre*.

However, to suggest that Hooper never made anything of merit again is an unfair claim. *Death Trap* (1977), *The Funhouse* (1981) and *The Texas Chainsaw Massacre Part 2* (1986), all show varying degrees of imagination and a flair for the cinematic medium, as well as providing textual detail which provokes analysis. Arguably, these three examples show that Hooper is more than just a one-trick pony. However, it is somewhat frustrating and ironic that, rather than developing his craft and directorial potential gradually with each successive film – like, for example, David Cronenberg – he peaked, creatively, with only his second feature. It seems as if the bulk of his creativity was released due to the wholly independent and rather unorthodox conditions under which *The Texas Chain Saw Massacre* was made, and those conditions could not be repeated. Nonetheless, Hooper's third feature, *Death Trap* certainly feels like it was made in a similar manner due to its grimy look, bizarre storyline and weird atmosphere.[1] This is perhaps unsurprising as some of the key personnel also worked on Hooper's masterpiece – Kim Henkel adapted the story for the screen (he previously co-wrote *The Texas Chain Saw Massacre* with Hooper); Wayne Bell collaborated with Hooper on the music score again; and Marilyn Burns (who played long-suffering Sally Hardesty) was cast in the role of Faye.

Death Trap appears to be set in rural Texas or Louisiana, although it was shot entirely on sets (Thrower 2008: 440). The plot revolves around Judd (Neville Brand), the deranged owner of the run-down Starlight Hotel. He keeps a pet crocodile in the swamp outside, kills any passing trade with a huge scythe or pitchfork, and feeds the bodies to it. There is little more to the plot, but this is in keeping with the pared-down style of *The Texas Chain Saw Massacre*. In this respect, and others, *Death Trap* can certainly be regarded as a companion piece. *Death Trap* is also populated by strange characters, it features gruesome deaths, and it has an unhinged tone and unsettling atmosphere. Similarly, it features an extremely

The Funhouse © 1981 Mace Neufeld Productions,
Universal Pictures

offbeat music score by Hooper and Bell – consisting of a tinkling dulcimer, crashing
percussion, clanging sounds and electronic drones, bleeps and screeches (Thrower
2008: 442) – which is supplemented with incessant diegetic country music on the radio.
As Stephen Thrower notes, 'the audio field buzzes and clamors with atonal sounds
and clashing musical styles' (2008: 440). It can also be argued that the rest of the cast,
alongside Marilyn Burns, could have appeared as characters in *Chain Saw*. Roy (William
Finley), Miss Hattie, the brothel madam (Carolyn Jones) and Buck (a young Robert
Englund), in particular, would not have been out of place in that scenario. However, it is
Brand who could easily have been a member of the cannibal family, especially as he plays
the role of Judd like an amalgamation of Leatherface, the Hitchhiker and the Cook – a
similarity also noted by Thrower (2008: 440).

 Death Trap may not feature the same remarkable creativity or relentless nightmarish
quality as *The Texas Chain Saw Massacre*, but Hooper's follow-up film is in many respects
just as unique. It looks and feels like a live-action version of an EC horror comic – Brand's
permanently crazed expression and wild hair, the weird setting and lurid use of colour
(predominantly blue, red and green) are all reminiscent of the distinctive drawing style
found in them. EC horror comics often presented grim tales in a blackly humorous
manner, as well as placing great emphasis on blood and gore, and this aspect is also
manifested in *Death Trap*.[2] Some examples of this black humour include Judd wildly
tossing a yapping pet poodle to the crocodile; Roy crawling around a hotel bedroom
barking like a dog at Faye; and Judd's over-anxious state when people keep turning up
unexpectedly at the hotel (one of the similarities with Leatherface). Into this mix add a
screaming child with a leg brace who is trapped under the crawlspace by Judd and the
crocodile; gruesome murders; another lengthy chase through the woods (reminiscent
of Leatherface's pursuit of Sally); and a reworking of Sally's torture by the Cook, as Faye
is wrapped in a shower curtain and beaten by Judd. The end result is unlike anything
else. As Thrower states, 'there are passages in the film that border on hysteria, and they
demonstrate the director's continued ability, not lost after *Chain Saw* as detractors claim,
to summon an authentic reek of displacement and mental collapse' (2008: 440).

 During the denouement, after Judd dispatches his final victim, he is eaten by his own
crocodile in a further nod to the EC comic tradition of payback for misdeeds. Notably,

despite the gruesome proceedings and disturbing tone, yet again the main female characters survive, and in this case there is an almost upbeat resolution rather than the nihilistic bleakness of *The Texas Chain Saw Massacre*. *Death Trap* is certainly a flawed film, and it was plagued by production problems and studio interference. However, the film also has its merits, if, as Thrower points out, 'it nevertheless feels like the work of the man who made *The Texas Chain Saw Massacre*, and not the guy who made *Poltergeist* (1982)' (2008: 441).

Hooper's next feature was *The Funhouse*. The film tapped into the current trend for slasher movies, but significantly did not simply regurgitate their formulaic traits. Set in the disquieting milieu of the travelling carnival, the plot features four teenagers who decide to spend the night in the funhouse without realizing that there is a homicidal monster in residence. Hooper avoided gore and instead played with his horror reference points, including tropes he instigated himself in *The Texas Chain Saw Massacre* – not least, the now clichéd 'crazy' character who warns the teens of trouble ahead. The opening credits set up the creepy 'carny' atmosphere which leads into a sequence full of intertextual references to other horror movies. We see a bedroom filled with classic horror iconography – fake spiders and bats, masks, a ventriloquist dummy head, sharp objects, film posters and figurines. A gloved hand appears and chooses a mask and a knife, recreating the famous extended POV camera sequence which opens *Halloween* (John Carpenter, 1978) – even to the extent of a POV through the mask eyeholes. Hooper intercuts shots of a young woman, Amy (Elizabeth Berridge), going for a shower. Here, he references the lead-up to and eventual demise of Marion Crane (Janet Leigh) in *Psycho* (Alfred Hitchcock, 1960). The masked figure appears behind the shower curtain, pulls it back and proceeds to slash. As Amy screams, the music screeches in Bernard Herrmann fashion and then a twist occurs. Amy grabs at the arm and pulls off the mask. The knife is a fake and the attacker is revealed to be her horror-mad brother, Joey (Shawn Carson), playing a prank. This intertextual play is significant because Hooper not only references and pastiches a range of classic horror films, but he is also clearly self-aware enough to recognize that *The Texas Chain Saw Massacre*, his own innovative film, forms a bridging point between *Psycho* and *Halloween* in terms of some of the key conventions to be found in slasher movies. Apart from the obvious slasher tropes, he focuses the camera on a Frankenstein's monster mask in Joey's bedroom, which becomes a key motif as the film progresses.

Like *Death Trap*, this film is not without flaws; for example, the pacing seems rather slow at times. Similarly, it has also been consigned to the bargain bin along with Hooper's genuine disasters and, aside from a brief spell on the so-called 'video-nasties' list (along with *Death Trap*), the film never really achieved the notoriety or the retrospective acclaim bestowed upon *The Texas Chain Saw Massacre*.[3]

However, *The Funhouse* does feature some genuinely creepy and unsettling moments, as well as having an overall tone which shifts between humour and menace reminiscent of Hooper's masterpiece. These are not the only similarities: the cleft-headed monster (Wayne Doba) hides his deformity beneath a Frankenstein's monster mask (shades of Leatherface, and a sly nod by Hooper as if to say that what lies beneath the mask is more frightening than old-school horror); grotesque characters such as the fortune teller, Madame Zena (Sylvia Miles), populate the film; Amy is pursued and trapped by the monster until she defeats him; and, again, country music features on the radio. Notably, the 'carny barker' (Kevin Conway), who is revealed to be the father of the monster, defends his own violent actions, insisting, 'I'm just protecting my family.' There is a definite parallelling of the 'normal' teens here with the dysfunctional, monstrous family in *The Funhouse*, which is a theme already taken to extremes in *The Texas Chain Saw Massacre*. This reveals a continuing artistic sensibility as Hooper reworks and extends his own themes, as well as revisiting key narrative and stylistic moments from

The Texas Chain Saw Massacre and *Death Trap*. There is also a recurring trope of 'the Final Girl' in all three of these films, albeit manifested in different ways, which Hooper returns to more prominently in *The Texas Chainsaw Massacre 2* (1986).[4]

The Texas Chainsaw Massacre 2 is a further example of Hooper's perceived loss of talent. Rarely championed by anyone, this film has been written off by most critics and fans alike. However, there is more to the film than meets the eye. Hooper continues to make the most of intertextual referencing (usually for humorous purposes) and takes the gore to extremes as if to poke fun at those critics who castigated him for the supposed high levels of it in the first film. This sequel, far from being a disaster, functions as a satire of rampant 1980s consumerism and as a self-referential musing on his masterpiece. It features yuppies being violently dispatched by Leatherface; an amusement park (Texas Battle Land) run by the cannibal family; the changing landscape of rural Texas; a new member of the family, Chop-Top (Bill Moseley), a Vietnam veteran; and a heroine called Stretch (Caroline Williams), who could be regarded as the ultimate 'Final Girl' due to her strength, resourcefulness and decisive victory over the monster. She completely reverses the hysteria of Sally Hardesty and even recreates Leatherface's famous chainsaw 'dance' at the end – another tongue-in-cheek self-reference by Hooper.

In the final analysis, Hooper's work post-*The Texas Chain Saw Massacre* is not a complete failure. Although he has suffered from working within the studio system rather than remaining independent – which appears to have sublimated his true creativity – the films discussed here show that he has, at times, retained the individuality and imagination that created *The Texas Chain Saw Massacre*.

Shelley O'Brien

Reference

Thrower, Stephen (2008) *Nightmare USA: The Untold Story of the Exploitation Independents*, Godalming: FAB Press.

Notes

1. *Death Trap* is also known as *Eaten Alive*, *Horror Hotel* and *Starlight Slaughter*.
2. Notably, unlike *The Texas Chain Saw Massacre*, *Death Trap* features some extremely gory deaths.
3. 'Video nasty' was a colloquial term coined in the United Kingdom in 1982 which originally applied to certain films distributed on video cassette that were fiercely criticized for their violent content by the press, media commentators and various religious organizations.
4. For a discussion of the 'Final Girl', see Carol J Clover, *Men, Women and Chain Saws: Gender in the Modern Horror Film* (Princeton, NJ: Princeton University Press, 1992).

DENNIS HOPPER
A Hollywood Incoherent

The onscreen legacy of Dennis Hopper is often overshadowed by his legacy off it – with his debauched lifestyle as a result of a heavy alcohol and drug dependency, Hopper is widely thought of as one of Hollywood's great hell-raisers with his overriding screen image doing little to dissuade this verdict. With over 200 credited acting roles, it is no surprise that Hopper's career behind the camera is a legacy that often falls short, along with his output as a photographer and a painter.

Indeed, during the late 1980s to the early 1990s, within the eye of a productive storm which saw Hopper navigating between Hollywood mainstream, independent and television productions, Hopper directed four Hollywood genre pictures featuring well-known stars – *Colors* (1988) with Sean Penn and Robert Duvall; *Catchfire* (1990) with Jodie Foster; *The Hot Spot* (1990) with Don Johnson; and *Chasers* (1994) with Tom Berenger. These films are merely referenced here to clarify their stark contrasts to the three films that preceded them in Hopper's directorial cannon: *Easy Rider* (1969), *The Last Movie* (1971) and *Out of the Blue* (1980). Together, these films testify to Hopper's legacy as an important figure in the history of American independent cinema, as it exists as an ideological construct within the corporate parameters of conglomerate-dominated Hollywood. Specifically, through the production of these films Hopper unwittingly exposed some of the ironies underlying a period in Hollywood history that popularized the notion of an auteur-led cinema, most commonly known as the 'new' Hollywood.

After being practically blacklisted from the studio system after a dispute with Henry Hathaway on the set of *From Hell to Texas* (Henry Hathaway, 1958), Hopper had spent much of the 1960s finding acting work within the domains of low-budget independent film-making. It was his work on two films produced by American International Pictures (AIP) – *The Glory Stompers* (Anthony M. Lanza, 1967) and *The Trip* (Roger Corman, 1967) – that would prove monumental in Hopper landing his directorial debut. Playing the lead as motorcycle gang leader Chino in *Stompers* and granted the opportunity to direct a drug sequence in *The Trip*, Hopper stood as the ideal man to direct a biker film that actor Peter Fonda had envisioned while out promoting *The Wild Angels* (Roger Corman, 1966). Fonda's project would tell the story of two bikers who ride across the country on motorcycles bought from selling hard-drugs, only to be mercilessly gunned down by rednecks. The project was titled 'The Loners', but after Fonda and Hopper drafted a script with author Terry Southern, the title was changed to *Easy Rider*.

Standing in as *Easy Rider*'s producer, Fonda's efforts to reach a financial agreement with AIP had fallen through as a result of its co-founder Samuel Arkoff's distrust towards Hopper's perilous reputation. Instead, Fonda found his financier with Bert Schneider and Bob Rafelson at Raybert Productions, the company credited for founding the British/American pop group The Monkees. Partly due to his father Abe being the president of the studio, as well as the huge amount of profits The Monkees' songs earned for the studio through record and television sales (Taylor 1976: 202), Schneider was able to secure a production budget of $360,000 for *Easy Rider* (Kiselyak 1999) – at the time considered the de facto sum for the cost of a biker movie – as well as a distribution deal from Columbia.

Out of the Blue © 1980 Robson Street

Production began in February 1968, and although its early stages proved problematic due to Hopper's reportedly despotic and disorderly directing style, Schneider was content on allowing Hopper to continue to direct the film as he wished, and in his capacity as executive producer, forbade intervention from anyone as well as himself.

After production wrapped, Hopper spent almost a year editing the raw footage down to a four-and-a-half-hour cut. Concerned over the inauspicious marketability of the film, Schneider, Rafelson, editor Donn Cambern, Jack Nicholson and film-maker Henry Jaglom re-edited the film down to its more digestible 95-minute duration while Hopper was away shooting a small role in *True Grit* (Henry Hathaway, 1969). On his return, Hopper responded unfavourably to the cut, believing Raybert had 'ruined my film' (Winkler 2011: 122–23). However, with *Easy Rider*'s fate resting on the distribution power of Columbia, Hopper had no choice but to comply with Raybert's edit.

Easy Rider went on to win the Prix de la Premiere Oeuvre at Cannes and take in $19 million at the domestic box office, making it the third-highest grossing film of 1969 (Berra 2008: 39). This success would initiate an industrial reconfiguration amongst the Hollywood conglomerates: with Hopper having practically been granted carte blanche during the film's production, *Easy Rider*'s success fostered the illusion of an auteur-led cinema. In a euphoric turn, the studios aimed to recreate, in varying ways, the nonchalant film-making conditions that *Easy Rider* was produced under by establishing sub-divisions whereby the studios would finance and distribute films that catered primarily to younger audiences. However, the realities surrounding *Easy Rider*'s postproduction revealed the industrial exegesis surrounding the production of a studio-released Hollywood picture.

If Hopper can be held responsible for creating the false belief of a marketable 'independent' auteur cinema with *Easy Rider*, it was his second feature, the appropriately titled *The Last Movie*, that disillusioned the studios on the fallacy. A project Hopper had conceived of before *Easy Rider*, *The Last Movie* was financed by Universal as part of a collective of films produced by the studio's sub-division headed by producer Ned Tanen. Universal agreed to finance Hopper with a 1-million-dollar budget, distribution, a weekly salary of $500, 50 per cent of the film's gross profits, as well as granting Hopper the right to final cut (Winkler 2011: 143).

It was this final liberty which proved just how far gone the studios were on the euphoria unleashed by the 'independent' spirit of *Easy Rider*. Shot on location in Peru, it was not

the drug-fuelled production which posed the greatest burden for the studio, but rather the film's postproduction stages where the studio–director relationship deteriorated. Undertaking the task of compressing 48 hours of raw footage into a releasable viable form at his home in Taos, New Mexico, Hopper missed several deadlines to provide a cut for the producers at Universal (Winkler 2011: 152). In addition, with riches earned from *Easy Rider* still coming in, Hopper's drug and alcohol intake intensified, causing the editing premises to become the grounds for debauchery of a scale so legendary that LM Kit Carson and Lawrence Schiller made a documentary about it – *The American Dreamer* (1971). Unable to complete a cut, Chilean film-maker Alejandro Jodorowsky produced his own cut within two days, which Hopper brought to Universal only to be turned down as a result of the acrimonious relationship with Universal (Love 2008). Eventually, after eighteen months of editing, Hopper finally produced a 108-minute cut which he brought to the Venice Film Festival on 29 August 1971 to be screened out of competition (Winkler 2011: 174).

The Last Movie centres on Kansas (Hopper), a Hollywood stuntman working on a production of a western filmed in a small village on the mountains of Peru. When production ends and the crew return to Hollywood, Kansas decides to stick around with his native girlfriend (Stella Garcia). During a drunken conversation with friend Neville (Don Gordon), the two embark on a get-rich-quick scheme to extract gold from an undiscovered mine. Another subplot surrounds Kansas's efforts to organize an orgy during a night out drinking with other gringos. When Kansas and Neville's plan fails, Kansas returns to the village, where upon his arrival he is held captive by the natives, and forced to take part in a re-enactment of the violence they witnessed during the Hollywood film's production. With scenes from one subplot randomly interspersed with another, spontaneous jump-cuts, insertion of a 'scene missing' intertitle replacing an entire scene, and a Brechtian-esque climax where Kansas, beaten to the point of death, jumps up onto his feet as Hopper standing amongst the film's crew, the film proved too inaccessible for critics and audiences. After a short term in theatres Universal withdrew and shelved the film, ending Hopper's short-lived Hollywood majesty.

With the industry getting back onto its feet with blockbusters from the mid-1970s, studios were far less inclined to finance film-makers to embark on their idiosyncratic countercultural pictures that made nothing in return. Throughout the rest of the decade Hopper exclusively kept to acting in predominantly idiosyncratic roles in and outside the United States. It was not until the start of the following decade when Hopper finally directed his next picture, this time the low-budget Canadian production *Out of the Blue*.

The project originally began as a television film titled 'The Case of Cindy Barnes' directed by Leonard Yakir, with filming taking place in and around Vancouver. It focused on Cebe (Linda Manz), a rebellious teenager so tormented by her parents' depraved lifestyles that she is eventually driven to murder her father, Don. Initially cast to play the role of Don, Hopper eventually replaced Yakir after executive producer Paul Lewis, who was also the production manager on *Easy Rider* and the producer for *The Last Movie*, started to lose faith in his initial director two weeks into production (Hunter 1999: 92). Displeased with the screenplay, Hopper immediately began to purge characters, or recast Canadian actors with Americans ones more familiar to him, such as Don Gordon, who took over the role of Don's best friend Charlie. Cautious not to fall out of the government tax shelter, however, Hopper retained Canadian actor Raymond Burr in the production but depreciated his role from the film's narrator to Cebe's councellor Dr Brean with a mere two-scene presence. In addition, Hopper included found music from friend Neil Young, whose song 'Hey Hey, My My', a testament to the death of rock 'n' roll from the rise of punk, provides a leitmotif for Cebe's idealization of the Sex Pistols as well as providing the film's title: 'Out of the blue and into the black' (Winkler 2011: 221).

With regards to its stylistic composition, *Out of the Blue* remains striking for its use of

plan-sequence shots, something Hopper admitted he had 'never tried before' (Petley and Walsh 1982: 22). Although both *Easy Rider* and *The Last Movie* each contain one clear use of the long take, none match the intricate staging of characters within their respective *mise-en-scène* that the device provokes in *Out of the Blue*. In addition, being a character-driven plot concerning controversial socio-economical themes such as domestic violence, poverty, drugs and adolescent angst, one could suggest Hopper's preference for the long take would be to direct emphasis towards the working-class interiors as well as draw attention to intense character performances. On the other hand, another explanation points towards Hopper's anxiety caused by the experiences *Easy Rider* faced regarding the possibility of any outside tampering with the narrative. With regards to the long takes, Hopper explained, 'I wasn't sure that the film wouldn't be chopped up by other people, so I didn't want to give them any options' (Herring 1983: 222).

Hopper managed to shoot the footage under a five-and-a-half week shooting schedule and edited the film in six. His most spontaneous production, *Out of the Blue* nevertheless remains his greatest directorial accomplishment. With its character-driven plot, *cinéma-vérité* style, and nihilistically tragic finale ending with Cebe killing both her parents and herself, Hopper's third feature helped carry the spirit of the 'New Hollywood' out of the 1970s and into the 1980s – a decade where the demand for plot-driven, big-budget blockbusters reached its zenith. Premiering at Cannes, *Out of the Blue* was denied any national association with Canada and instead was submitted as 'A Dennis Hopper Film'. It was as not released in the United States until 1982 and not distributed in Canada until 1983. Despite positive critical reception and a radio spot by Jack Nicholson heralding the film as 'a masterpiece', *Out of the Blue* did little to revitalize Hopper's reputation as a director in the eyes of the general public (Winkler 2011: 222–23).

However, Hopper would eventually capitalize on his idiosyncrasy to rejuvenate his career, at least in front of the camera, beginning with his Golden Globe-nominated performance in David Lynch's mesmerizing *Blue Velvet* (1986), which instigated a newfound typecasting as caricatured antagonists in blockbusters like *Speed* (Jan de Bont,1994) and *Waterworld* (Kevin Reynolds, 1995).

James Vujicic

References

Berra, John (2008) *Declarations of Independence: American Cinema and the Partiality of Independent Production*, Bristol: Intellect.

Herring, Henry D (1983) 'Out of the Dream and into the Nightmare: Dennis Hopper's Apocalyptic Vision of America', *Journal of Popular Film and Television*, 10: 4, pp. 144–54.

Hopper, Dennis (2002) Director's commentary, *Out of the Blue* [DVD], UK: Sanctuary.

Hunter, Jack (1999) *Dennis Hopper Movie Top Ten*, London: Creation Books.

Kiselyak, Charles (1999) *Easy Rider: Shaking the Cage*, UK: Sony Pictures Home Entertainment.

Love, Damien (2008) 'The Mole Man: Going Underground with Alejandro Jodorowsky', *Bright Lights Film Journal*, 31 July, http://brightlightsfilm.com/61/61jodorowskyiv.php#.Ur2rb_RdWCc. Accessed 5 July 2013.

Petley, J., & Peter Walsh, (1982) 'Dennis Hopper: How Far to The Last Movie?', *Monthly Film Bulletin*, October, pp. 221-22.

Taylor, John Russell (1976) 'Staying Vulnerable: An Interview with Bob Rafelson', *Sight & Sound*, 45: 4, pp. 203–4.

Winkler, Peter L (2011) *Dennis Hopper: The Wild Ride of a Hollywood Rebel*, London: Robson Press.

JIM JARMUSCH
The Decline of American Civilization

In a 2005 article for the *New York Times*, Lynn Hirschberg hailed Jim Jarmusch as 'the last major truly independent film director in America'. Given the abundance of independent features being produced in the United States in the mid-2000s, and today, this is a somewhat hyperbolic claim. Still, Hirschberg certainly has a point, not only with regards to Jarmusch's steadfast approach to making films – eleven features from *Permanent Vacation* (1980) to *Only Lovers Left Alive* (2014), all made outside the Hollywood studio system with no in-between 'money jobs' via commercials or episodic television – but also his continued examination of the erosion of the American cultural landscape from an outsider perspective, as embodied by characters who are immigrants, tourists, criminals or exist at the lowest rung on the social-economic ladder.[1]

Although his first commercially released feature, *Stranger Than Paradise* (1984), is rightly seen as a watershed moment in American independent cinema, it is actually hard to see the film's influence in the sector today, or even in the wake of its initial run. Spike Lee and Kevin Smith have declared that it was *Stranger Than Paradise* that inspired them to embark on their respective debut features, *She's Gotta Have It* (1986) and *Clerks* (1994), but Jarmusch's breakthrough work essentially served as a rough production and marketing model that could be readily appropriated by enterprising fledgling film-makers operating with limited budgets. His unhurried style, with long, static takes that fix characters in environments to which they do not belong, is now seen less in American independent cinema than it is in such foreign works as Diego Lerman's *Suddenly* (2002) and Hiroshi Watanabe's *Soshite dorobune wa yuku/And the Mud Ship Sails Away…* (2013), which have appropriated Jarmusch's preference for stark black-and-white images, measured pacing, ironic take on road movie iconography, and deadpan approach to non-conformist experience.

With the possible exception of *Broken Flowers* (2005), which grossed $13 million at the US box office at a time when its leading man (Bill Murray) was in the midst of a critical renaissance, Jarmusch has never found the kind of crossover success that most independent film-makers achieve at some point in their career, when their sensibility briefly aligns with mainstream taste, nor has he gone looking for such acceptance. As JD LaFrance (2003) has argued, 'The style of Jarmusch's films are more in touch with European sensibilities than American and it is this aesthetic that prevents them from really breaking through into North American mainstream culture.' Yet the low-to-modest financial returns for the director's films in the domestic market have less to do with his lack of salesmanship or his specific mode of storytelling (minimalist, sometimes elliptical narratives that revolve around character and space) than it does with a sustained critique of America's corrosive value system. Delivered from a studied distance that many of the director's ardent admirers – whether arthouse patrons or professional critics – had taken to be a cool signature or bohemian posture rather than a discreet means of expressing discontent, Jarmusch's seemingly slight vignettes are actually highly critical of dominant, even oppressive, social-economic power structures. Mark Peranson insists that gradual

Dead Man © 1995 12 Gauge Productions, JVC Entertainment Networks, Newmarket Capital Group, Pandora Filmproduktion

realization of Jarmusch's stance towards the United States led to his fall from critical grace in the mid-1990s:

> Furthermore, most critics who were the first to hail Jarmusch failed to realize that, in fact, in 1984 they were actually watching art films that attacked the myths of prosperity of Reagan's America, and general ideas of ethnocentricism. They were being confronted by their own narrow-mindedness; when this became clear, they unsurprisingly backed off. (Peranson 2002: 179)

Peranson's overview of Jarmusch coincided with a lull in the director's career following the muted critical response afforded to *Dead Man* (1995) and *Ghost Dog: Way of the Samurai* (1999), although he would subsequently rebound with his long-gestating anthology *Coffee and Cigarettes* (2003) and *Broken Flowers*. Indeed, the neo-western *Dead Man* is, alongside his quasi-thriller *The Limits of Control* (2009), Jarmusch's most explicitly political film and, consequently, one of his most divisive. Beautifully shot in black-and-white by the great Robby Müller, and accompanied by a discordant guitar score by Neil Young that becomes a trance-like drone in the final third, this is perhaps the film that encapsulates the director's fascination with foreign and ethnic cultures while simultaneously serving as his definite statement on the fundamental flaws of the American dream.

The titular 'dead man' is William Blake (Johnny Depp), an accountant from Cleveland, who travels west by rail to take a position at a metal works in a town called Machine. Upon arrival, Blake is informed by Dickerson (Robert Mitchum), the proprietor of the works, that the position has already been filled: finding solace in a bottle of whiskey, Blake encounters former prostitute Thiel (Mili Avital) and ends up in bed with her, only

to be interrupted by her lover Charlie (Gabriel Byrne), who also happens to be Dickerson's son. Charlie murders Thiel, and wounds Blake, but the accountant fires back with Thiel's pistol and kills Charlie with a shot to the neck. After making an amusingly inept getaway by falling out of the window and riding away on Charlie's horse, Blake awakens in the woods to find Nobody (Gary Farmer), a Native American outcast, trying to remove the bullet that is lodged close to his heart. Nobody points out that, because the bullet cannot be removed, Blake is already a 'dead man', as the wound will eventually prove to be fatal. The two men become riding companions, with Blake making peace with his situation and accepting his unlikely outlaw status.

Jarmusch reflexively adopts the genre of the western to comment on the state of contemporary America via the roots of its industrialization, and its often intertwined obsessions of violence, fame and money. Violence is widely accepted as a method of defence, retaliation and business practice, with such acts invariably executed in a clumsy manner that further strips away the romanticism that is associated with the film's genre history. 'Why do you have this?' Blake asks Thiel after discovering that she has a gun beside her bed. 'Cause this is America,' is her matter-of-fact reply. Nobody will later refer to bullets as 'the white man's metal', alluding to how the land is being taken by its native inhabitants through a combination of technical advancement and remorseless violence. Most of the white characters here are opportunistic hired killers, or want to attach themselves to the 'celebrity' of the outlaw that Blake unwittingly becomes, while Dickerson demands revenge for the murder of his son, but actually seems more concerned about the return of his horse. It is never specified what product(s) his ironworks produces, but it is fair to assume that the manufacturing of guns has played a significant role in the construction of his empire. Peranson notes that, although this is the first western to be shot in black and white since John Ford's *The Man Who Shot Liberty Valance* (1962), 'the landscape, though evocatively photographed, can only be described as ugly' (2002: 182). Machine is a nightmarish melting pot of environmental pollution and moral corruption, which is appropriately located at 'the end of the line'. Jarmusch finds some beauty in the terrain that Blake and Nobody traverse, but 'civilization' is depicted as a dehumanizing capitalist pit that runs on pure greed and will continue to ruthlessly encroach on the land of Nobody's people.[2]

The inherent problems that Jarmusch observes in *Dead Man* lead to the erosion that he illustrates in his contemporary works, which are often located in cities that are falling into a social-economic tailspin as his characters drift around districts in dire need of a paint job. The cities of New York, Memphis and Detroit, which feature in *Stranger Than Paradise*, *Mystery Train* (1989) and *Only Lovers Left Alive* respectively, serve to link such faltering urban landscapes to the decline or outright failure of cultural movements, particularly music, as they have been coopted by the mainstream, or simply sputtered out. *Stranger Than Paradise* arrived at the end of the punk era and New York as seen here is not a vibrant cultural melting pot with chance encounters awaiting at every corner; instead, it is an unwelcoming place trapped in a perpetual winter. Work-shy immigrant Willie (John Lurie) sticks to his usual haunts and, on the rare occasion that he ventures further afield, receives a curt refusal when asking for directions. If this New York is a city where a revolution never quite happened, then Memphis as seen through Jarmusch's lens is a kingdom that has fallen, leaving only the exploitation of its popular myths – Elvis Presley and the history of Sun Records – to support a stagnant economy. Meanwhile, Detroit is a bankrupt city where people go to hide, such as vampire and progressive musician Adam (Tom Hiddlestone), who lives in a neighbourhood where most of the houses are derelict as a means of keep a low profile while bemoaning the lack of appreciation for true artistry in the YouTube era.

Jarmusch makes films that are concerned with time and place, but he rarely tells stories from the perspectives of the lifelong neighbourhood dwellers whose personal histories would be intertwined with that of their districts. Instead, his characters are outsiders or even tourists, people who are passing through certain cities with a modicum of expectation, only to be decidedly nonplussed by what they see and experience. Suárez asserts that 'Jarmusch's minimalist style, sympathy towards outsiders, ferocious wit, and rejection of pretension recalls some of the best qualities of punk, as do his characters' blankness and inexpressiveness' (2007: 20). *Mystery Train* is an anthology piece with the third story featuring local characters, but the preceding entries revolve around the activities of visitors to Memphis. In the first story, young Japanese tourists Mitsuko (Youki Kudoh) and Jun (Masatoshi Nagase) spend some time in the city as part of their tour of the United States, lured by their respective devotions to Elvis Presely and Carl Perkins; in the second, Italian widow, Luisa (Nicoletta Braschi), is stranded while escorting her husband's coffin back home and, while eating at a diner, is almost scammed by a con artist who uses a tall tale about meeting Elvis as a means of asking her for money. These vignettes are filled with slow tracking shots of the visitors walking around Memphis, often passing derelict buildings or businesses with fading facades, as it becomes apparent that the desperate peddling of the city's iconography is the only economic hand that it has left to play. His approach to Detroit in *Only Lovers Left Alive* is similar. Adam is joined in Detroit by his soulmate Eve (Tilda Swinton), who now resides in Tangiers. They take a night-time drive through the city's suburbs that takes in the house where Jack White grew up, but this once densely populated area now constitutes a post-recession 'ghost town'.

In comparison, culture abounds in Jarmusch's Europe-set works, whether in the flavourful, even soulful characters of his city-hopping anthology *Night on Earth* (1991), or the vivid art, architecture and music that is seen and heard throughout his oblique hit-man yarn *The Limits of Control* which takes place in Spain. In the latter, an unnamed professional assassin (Isaach de Bankolé) repeatedly visits the national art museum in Madrid to appreciate its stimulating collection, but wandering through every respectfully preserved courtyard, street or hallway is as much of an enriching experience. When the assassin does come into contact with America – in the form of his target, the head of a capitalist organization (Bill Murray) – it is by accessing a remote underground headquarters that has been equipped with a near-absurd level of security in order to prevent infiltration by anyone who disagrees with its way of doing business. As a coldly inhuman space, this headquarters provides a stark contrast to the vibrant landscapes of Madrid and Seville, and is just as much of a 'machine' as the frontier town of *Dead Man*.

It's debatable as to whether Jarmusch's anti-establishment rhetoric has cost him an audience in his home country, as the niche box office success of *Stranger Than Paradise* and his marvellous prison escape jaunt *Down by Law* (1986) would be considered marginal in today's independent landscape, where such films need to challenge the grosses of studio releases in order to be considered breakouts. Nonetheless, it's the consistency and gradual politicization of this anti-industrial ideology that continues to make Jarmusch one of the most incisive commentators on the corrosive side effects of American capitalism, even when his points are dispensed in a characteristically deadpan manner.

John Berra

References

Hirschberg, Lynn (2005) 'The Last of the Indies', *The New York Times*, 31 July, http://www.nytimes.com/2005/07/31/magazine/the-last-of-the-indies.html?_r=0. Accessed 20 August 2015.

LaFrance, JD (2003) 'Jim Jarmusch', *Senses of Cinema*, 5 October, http://sensesofcinema.com/2003/great-directors/jarmusch/. Accessed 20 August 2015.

Peranson, Mark (2002) 'Stranger than Fiction: The Rise and Fall of Jim Jarmusch', in Yvonne Tasker (ed.), *Fifty Contemporary Film-makers*, London & New York: Routledge, pp. 177–86.

Suárez, Juan Antonio (2007) *Jim Jarmusch*, Urbana & Chicago: University of Illinois Press.

Notes

1. Jarmusch's experience with Hollywood is limited to *Dead Man*, which was distributed by Miramax, and *Broken Flowers* and *The Limits of Control*, which were distributed by Focus Features. These films were made independently and then sold for distribution on the condition that they would not be re-edited prior to release.
2. *Ghost Dog: Way of the Samurai* credits Gary Farmer as playing a character named 'Nobody', the same name as his character in *Dead Man*. After he is confronted by some mob hit-men on his roof, Nobody repeats one of his lines from the earlier film – 'Stupid fucking white man!'

RIAN JOHNSON

A Storyteller's Storyteller Telling Stories

After half a dozen years of trying to put together a deal, writer-director Rian Johnson finally made *Brick* (2005) – from a script written directly after graduating from the University of Southern California School for Cinematic Arts – with $500,000 raised from family and friends. Shot in his hometown of San Clemente, including extensive sequences in his old school, it was picked up at the Sundance Film Festival, where it won the Special Jury Prize for Originality of Vision, and went on to gross almost $4 million. It is a high school film noir that sidles up to the edge of David Lynch territory, but avoids foregrounded self-reflexivity. Johnson understands that knowing a genre is different from being knowing about it: his *Evil Demon Golfball from Hell!!!* (1996), a short absurdist noir reworking of Poe's 'The Tell-Tale Heart' (1843), tells its story completely straight; whereas his teenage effort *Ninja Ko, The Origami Master* (c.1990) is a jokey homage to badly dubbed martial arts movies; and *Escargots* (2006), a short made with Joseph Gordon-Levitt and Noah Segan directly after *Brick*, is a *nouvelle vague* mash-note/pastiche.

Brick follows the former strategy, never once winking at the audience even as it evokes character types familiar from, among others, *The Maltese Falcon* (John Huston, 1941). Laura (Nora Zehetner) is a teenage femme fatale, as calculating as Brigid O'Shaugnessy (Mary Astor). Dode (Segan) is, like Wilmer Cook (Elisha Cook Jr), a sap in love with the wrong girl who fatally misses the point. Grotesque criminal mastermind the Pin (Lukas Haas) is, like Kasper Gutman (Sydney Greenstreet), not as in control of his minions, allies and schemes as he thinks. Assistant Vice-Principal Trueman (Richard Roundtree) is the equivalent of Lieutenant Dundy (Barton MacLane), allowing the investigator-hero enough elbowroom to solve the case or rope by which to hang himself. And Brendan (Gordon-Levitt) is that investigator, a scruffy, beat-down loner with a dubious past, still in love with an ex-girlfriend who fell in with the wrong crowd and got herself murdered. He is as jaded as Sam Spade or Philip Marlowe, but similarly ethical. He has Jim Rockford's smart mouth and tendency to take a beating, but also his occasional capacity to dish it out.

Brendan always seems to be hunched over with his hands in his jacket pockets, closed off from the world that has betrayed him. Indeed, Emily (Emilie De Ravin) dumped him, even after he ratted out his dealer-partner Jerr to protect her, because she could not cope with his disconnectedness. In most scenes, he is alone or interacts – in the most instrumentalist of ways – with just one other character. Blandly generic architecture makes schools indistinguishable from grocery stores. Parking lots and the spaces behind buildings achieve the same kind of non-identity as the blank, cartoon-like backdrops against which Brendan is often positioned. He frequently appears with corridor-like shapes stretching out behind him to some distant vanishing point, or framed against deserted spaces or empty skies, or heading into a barren, uninhabited depth of field. The void is always there, waiting for him.

Inspired by *A Clockwork Orange* (Stanley Kubrick, 1971), *Glengarry Glen Ross* (James Foley, 1992) and especially *Miller's Crossing* (1990) – the Coen brothers' mashup of

Looper © 2012 DMG Entertainment, Endgame Entertainment

Dashiell Hammett's *Red Harvest* (1929) and *The Glass Key* (1931), to which Johnson's short *The Psychology of Dream Analysis* (2002) alludes – *Brick*'s dialogue is peculiarly idiomatic, a hardboiled high school patois, rich in archaic terms, alternative colloquialisms and archly overachieving vocabularies. Delivered with a deadpan clip and with the conviction that it is completely normal for these people to talk this way, it never pauses to check whether the audience is keeping up. The maze-like plot works in a similar way. While Brendan does seem to solve the mystery and coordinate appropriate punishments for the guilty, even he himself is not entirely sure he has got it right. This undermining of certainty and closure is only appropriate for the debut feature of a director who favours narrative complexity as a means of probing the extent to which humans can exercise control over their circumstances and experience, whether by setting plots in motion or reframing the terms of the narratives in which they find themselves.

The Brothers Bloom (2008) is about orphaned Stephen (Mark Ruffalo) and Bloom (Adrien Brody) who, on their passage through a long succession of foster homes, discover the art of the confidence trick. At the wrap party for an epic sting (featuring cameos by *Brick*'s Zehetner, Segan and Gordon-Levitt), Stephen is depressed, not for the first time, by the realization that nothing in his life is ever real and he never gets to be himself. He quits the hustle, unaware that for decades Stephen has built his elaborate shell games, full of 'thematic arcs' and 'embedded symbolism', out of love for his younger brother – to keep Bloom close, and to enable him to be more than his shy self. So Stephen concocts what he promises will be their last boiler-room scam. In order to separate eccentric Penelope (Rachel Weisz) from several of her many millions of dollars (or perhaps it is really to help Bloom find true love at last), Stephen needs Bloom's flimflam skills. A series of baits-and-switches ensues, practised on both characters and audience.

In addition to these imbricated narratives and the competing realities they imply, the film several times addresses the importance of storytelling. Among Penelope's many

hobbies is pinhole photography, and she prefers the distortion created by taking a picture with a melon because the view it presents of the object is a story rather than a mere likeness. She survived her upbringing – misdiagnosed as allergic to everything, she was raised in isolation – by creating an alternative narrative in which she was not a tragic victim but a woman who could find beauty in anything. (Bloom meanwhile is concerned that she is a character in one of Stephen's cons.) She survives being the brothers' mark by changing how the story would normally end, becoming instead their accomplice – only then a legendary Bunco artist from the brothers' past takes over the narrative, or perhaps does not, but then unequivocally does, and it falls to Penelope and Bloom to embark on a new story, to build a new world.

This charming, quirky caper's mildly unreal setting owes something to *How to Steal a Million* (William Wyler, 1966), *Harold and Maude* (Hal Ashby, 1971) and *Hudson Hawk* (Michael Lehmann, 1991), and character names suggest a debt to James Joyce. The Bernardo Bertolucci-inspired visuals by Johnson's regular cinematographer, Steve Yedlin, include a nocturnal beach setup modelled directly on a scene from *The Conformist* (Bernardo Bertolucci, 1970), while portions of the soundtrack, by Johnson's cousin and regular composer, Nathan Johnson, are directly influenced by Nino Rota's score for Fellini's *8½* (1963) – a film about the personal and technical struggles of creation in a world where reality is unstable and meaning is unclear. Shot on location in Montenegro, Serbia, Romania and the Czech Republic for $20 million, *The Brothers Bloom* struggled to find an audience, grossing only $5.5 million worldwide. Ironically, Johnson turned to the very genre with which Fellini's Guido (Marcello Mastroianni) struggles for his $30 million-budgeted follow-up, *Looper* (2012), and met with much greater success. Shot in Louisiana and Shanghai, its stars, high-concept, more disciplined quirkiness and almost Spielbergian concern with father–son relationships and with single mothers somehow managing to make ends meet, proved much easier to market. It grossed almost $180 million worldwide.

In Kansas, 2044, thirty years before the invention of time travel, Joe (Gordon-Levitt) executes the people who crime bosses send back from the future when they need to dispose of someone without leaving a trace. Like all such 'loopers', one day he will have to 'close his loop', that is, execute his future self and go into retirement until the day he is sent back in time to be executed by his younger self. But in 2074, a new crimelord, the Rainmaker, is accelerating the rate at which loops are being closed. Old Joe (Bruce Willis) comes back, evades young Joe, and sets out to locate and kill three children, one of whom will grow up to be the Rainmaker. Young Joe must kill old Joe, and ultimately protect the infant Rainmaker, while avoiding his boss, Abe (Jeff Daniels), and his Gat Men, especially Kid Blue (Segan), a klutzy rival who yearns for Abe's approval, all of whom are all also hunting old Joe.

This setup is indebted to Shakespeare's *Macbeth* (1611), *La jetée* (Chris Marker, 1962), *The Terminator* (James Cameron, 1984) and *Twelve Monkeys* (Terry Gilliam, 1995) – by coincidence the assistant cameraman in Shanghai was John Connor, and inevitably, Johnson was later considered a potential director for the recent *Terminator* reboot. The science fiction/film noir combination prompted *Blade Runner* (Ridley Scott, 1982) comparisons, but the urban settings are more akin to Jean-Pierre Melville or Michael Mann. The scene in which the two Joes meet in a diner recalls the one in *Heat* (Michael Mann, 1995) when Hanna (Al Pacino) and McCauley (Robert De Niro) meet, with a little bit of Han Solo (Harrison Ford) and Greedo (Paul Blake) thrown in for good measure. The Bruce Willis-like prosthetic nose worn by Gordon-Levitt is such an astonishingly good make-up effect that many dealt with its uncanny affect by labelling it unconvincing. Such commentary distracted from Gordon-Levitt's remarkable performance, which captures Willis's voice, mannerisms and tics, and even sneaks in a sly concern about male pattern baldness, but is not an imitation. This creative anticipation of the older character that

Willis plays is most evident in the scenes the two stars share. The diner scene also sets up the central conflict, in which several possible futures compete to become the actual future. Young Joe thinks old Joe should just do what old men do – die – and leave him to live the life old Joe has already lived. Old Joe wants to change the past so as to alter the future – to prevent the death of his wife when the Rainmaker's Gat Men came for him. Young Joe offers to just walk away should he ever meet old Joe's future-wife.

Shortly after this most science-fictional of conversations, the film unexpectedly swerves into territory closer to 'It's a Good Life' (James Sheldon, 1961), the *Twilight Zone* (CBS, 1959–64) episode about a boy with psychic powers, and to Katsuhiro Otomo's manga *Domu* (1980–81). It is also shot more like a western, with allusions to *My Darling Clementine* (John Ford, 1946), *Shane* (George Stevens, 1953) and *The Searchers* (John Ford, 1956), and plentiful spaghetti western imagery, such as rapid tracking alongside young Joe as he flees through a cane field, and widescreen close-ups of his eyes. In this half of the film, young Joe changes, realizes he must thwart old Joe so that the child can grow up without the traumatic experience that will lead him to become the Rainmaker.

Johnson's handling of such narrative complexity is pitch-perfect, as is demonstrated by a sequence that draws upon audiences' intertextual knowledge to make the conflict between competing narratives/futures more suspenseful. Old Joe, hiding out in a sewer, groans in pain as he senses young Joe's contemporaneous experience overwriting – forcing out – his own memories. We cut to a shot we have already seen from young Joe's viewpoint: having scared off a vagrant threatening Sara (Emily Blunt), young Joe, suffering from dehydration and drug withdrawal, collapses on her porch, and we see – and now see again – Sara standing over him. Old Joe opens his pocket watch – the same one that the young Joe carries – to look at the photo of his future wife it contains. (The film repeatedly contrasts signifiers of linear determinism, such as watches and clocks, with signifiers of chaotic, nonlinear determinism, such as cigarette smoke and cream swirling in coffee.) Old Joe urges himself to remember the first time he saw his future wife so as to conserve that future. Cut to Sara clicking her fingers in front of young Joe's face. 'No,' says old Joe, 'the first time I saw her face.' Cut twice to Sara slapping young Joe. Old Joe repeats over and again, 'the first time I saw her face,' until he remembers the day, more than two decades in the future, when he first encountered the woman who will save his life and marry him. As he stares at the picture in the watch, audience familiarity with *Back to the Future* (Robert Zemeckis, 1985) or, perhaps, *Hot Tub Time Machine* (Steve Pink, 2010) builds suspense. The photograph does not fade. Old Joe's future is, for now, secure.

It is no surprise to discover that *Annie Hall* (1977) had an immense impact on Johnson, but thirty years later the postmodern metafictional strategies that Woody Allen practised are rather shopworn and tiresome. Johnson's stories about storytellers and the stories they tell turn instead upon the capacity of crime and science fiction genres to incorporate epistemological and ontological concerns into the worlds they create – and the stories they tell.

Mark Bould

SPIKE JONZE

Examining the Collective Work Behind the Indie Brand Name

Inscribed beneath the film title on the promotional materials of *Being John Malkovich* (1999) are the words 'A Film Directed by Spike Jonze'. One of the central philosophical 'jokes' of the film is that one man can not maintain control of, and be entirely responsible for, the distribution and public comprehension of his own 'brand'; yet ironically, the advert generates a commodified aura of authority around the first-time director.

The commercial context of this attempt to anchor meaning can be traced across Jonze's films. In the posters for *Adaptation* (2002), Jonze's name is prominently placed in close proximity to that of the screenwriter, Charlie Kaufman, reinforcing their well-documented collaborative process. After a fallow period of film-making, in attempting to lend promotional weight to Tarsem Singh's *The Fall* (2006), the early advertising half-heartedly misspelled: 'David Fincher & Spike Jones Presents', and following such a difficult and lengthy development process for *Where the Wild Things Are* (2009), Jonze's name is conspicuously relegated to the fine print at the bottom of the poster. Nevertheless, the considerable critical and modest commercial success of Jonze's fourth film, *Her* (2013), has dramatically elevated the director's name to a genre modifier. With a special emphasis on auteur ownership, *Her* is prominently advertised as: 'A Spike Jonze Love Story'.

Prompted by the thematic content of *Being John Malkovich* and its unknown director, *New York Magazine* published a biographical feature entitled 'Spike Jonze Unmasked' (1999), in which journalist Ethan Smith implored: 'Will the real Jonze please stand up?' The article states that 'Jonze is a pseudonym used by Adam Spiegel', from his high school days working at the Rockville BMX store, Maryland. Subsequently, the Jonze name became 'an entire persona' that was adopted by Spiegel. Spiegel may have created 'Jonze' outside of Hollywood, but in looking for the 'real Jonze', the article also feeds into this evolving public discourse, incorrectly asserting that Jonze is 'heir to the $3-billion-a-year Spiegel catalogue business'. The Internet is now littered with numerous biographies on Jonze that erroneously reiterate this factoid (for example, see O'Hagen 2003).

Jonze's early work in the late 1980s, and throughout most of the 1990s, helped to pioneer fanzines and subcultural magazines (*Freestylin'*, *BMX Action*, *Homeboy*, *Dirt* and *Grand Royal*). In the retrospective documentary, *Joe Kid on a Stingray* (2005), this contribution is said to have significantly helped define Generation X. Jonze's photographic work for *TransWorld Skateboarding* magazine demonstrated that he operated with an extremely dynamic style;[1] but it is his no-budget skateboarding videos that show Jonze's talent for comically playing with genre and elevating the final product in the process. For example, *Goldfish* (1993) features a scene that would find a fuller form in the Jonze-directed music video, 'Sabotage' (Beastie Boys,

I'm Here © 2010 Absolut Vodka

1994), playing out like a knowing homage to 1970s action-cop movies. In *Las Nueve Vidas de Paco* (1995), the skaters are presented in a series of shorts with a sepia cowboy movie setting, and in *Mouse* (1997), Jonze presents pro-skater, Erik Koston as Charlie Chaplin.

Jonze unwittingly used these cinematic tropes to help hone his craft on a micro-budget prior to becoming a feature film director. However, post-*Being John Malkovich*, Jonze shot the introduction to the skate video, *Fully Flared* (2007), which featured grossly exaggerated slow motion, explosions, flames and impossible stunts. Jonze was taking his style to its logical conclusion, but numerous reviews accused him of being a commercial 'sell out'. Nevertheless, on the Crailtap blog, which is affiliated to Jonze's own skateboarding company, Girl Skateboards, there are constant teasing references to Jonze's desire to 'keep it real' and remain authentic; and they frequently present embarrassing or comical photographs and videos, almost in an attempt to prove that Jonze does not follow the Hollywood director stereotype.[2]

Assembling a 'real Jonze' from media information alone is impossible. When Spike Jonze married Sofia Coppola in 1999, the *Vogue US* photo-shoot left Jonze out of every picture but one, where his head is almost entirely obscured by his more fashionable and famous bride.[3] For his cover shoot of *The Face* magazine in January 2000, Jonze was literally presented as an unfinished 'connect the dots' sketch. When Sofia Coppola later released *Lost in Translation* (2003), several commentators, picking up on Coppola's recent divorce from Jonze in the same year, stated that the character of John (Giovanni Ribisi), a career-driven photographer, was based on her ex-husband, despite having no tangible evidence and Coppola insisting that this wasn't the case.[4]

A more measured way in which one may come to know a director is through their own voice, and the DVD release for *Being John Malkovich* features the bonus clip: 'An Interview with Director Spike Jonze.' In *Being John Malkovich*, there is the entirely fictional and satirically overblown 'American Arts & Culture Presents John Horatio Malkovich: Dance of Despair and Disillusionment', in which Malkovich pretentiously

states: 'There is truth, and there are lies, and art always tells the truth. Even when it's lying.' In Jonze's similar companion video to his own 'art', the director is driving a car whilst being asked a series of questions about his debut film and its meaning. Jonze nervously fumbles and stutters through some of the answers, which matches several descriptions of Jonze in real interviews. But then, under pressure to provide answers about directorial intent, Jonze abruptly pulls over the car to vomit in the road. The video appears to be real, but given the context – juxtaposed against Malkovich playing Malkovich – the evasive, unpretentious Jonze on display is just one more cleverly reflexive public construction.

Spike Jonze's acting work has also seen him star in the Sundance festival short, *Pig!* (Francine McDougall, 1996), and appear as cameo/supporting characters in acclaimed films such as *Mi Vida Loca* (Allison Anders,1993), *The Game* (David Fincher, 1997), *Three Kings* (David O Russell, 1999) and *Moneyball* (Bennett Miller, 2011). Jonze also features in Martin Scorsese's *The Wolf of Wall Street* (2013), because of an opportunity that arose from sharing the same casting director as his own film, *Her*; confusingly however, Jonze is also credited with providing a voice for a character in *Her*, but under his real name, Adam Spiegel. Jonze's minor quirky roles are significant because they reveal something about his playful nature. For example, Spike Jonze was an executive producer of the MTV reality show, *Jackass* (2000–02), and shared producer and writing credits for *Jackass Presents: Bad Grandpa* (Jeff Tremaine, 2013), but the 'Bad Grandpa' idea itself originated from *Jackass* sketches where Jonze would dress up as an elderly gentleman with his co-stars and perform outrageous acts in front of an unsuspecting public. Furthermore, Jonze also performed in the self-directed 'Praise You' (Fatboy Slim, 1999) music video as Richard Coufey, leader of the (non-existent) Torrance Community Dance Group. The video is shot in a documentary style, which gave rise to the notion that Coufey was real. However, Jonze did not attempt to correct anyone's misconceptions; rather, when he collected his prize for Best Directed Video at the MTV Video Music Awards, he appeared in character as Coufey – which then became the highlight of his mock-documentary short *Torrance Rises* (1999).

In 2004, Jonze masterminded an even more elaborate promotional campaign for Volvo, called *The Mystery of Dalarö*. It is a mockumentary by the fictional 'renowned Venezuelan documentary director, Carlos Soto' about a real place in Sweden where 32 people in the small town suddenly bought a new Volvo s40 from the same dealership on the same day. In a further twist to the campaign, the fake director later released another short film on his own (fictional) webpage in which he 'proves' that the families and experts that testified were part of an elaborate ruse perpetrated by Volvo, which unwittingly included himself.[5]

Jonze is no stranger to the commercial aspects of his reflexive antics. In addition to numerous advertisements for clients such as Ikea, Levi's, Sprite, Nike and Adidas – not forgetting *I'm Here* (2010), the 29-minute short film about a robot that falls in love, essentially as an arthouse, promotional vehicle for Absolut Vodka – Jonze has directed over fifty music videos (at a prodigious rate between 1993 and 2002), launching and relaunching the careers of numerous bands and musicians with his own interpretative take on their style. He has placed Björk in the hyperreal 'It's Oh So Quiet' (1995) video, where the film alternates between a faded grey 'reality' and a fantastically Technicolor 'Musical' world. In 'Buddy Holly' (1994) the band, Weezer, were superimposed into an episode of *Happy Days* (ABC, 1974-1984) replete with disco dancing Fonz. Jonze has even managed to cast Christopher Walken – an actor synonymous with psychologically dark and disturbed characters – in 'Weapon of Choice' (Fatboy Slim, 2001), which has him tap-dance in a hotel lobby before he floats into a wire-worked world of dreamlike implausibility.

In what feels as though it should have come from a classic Jonze hoax, in 2001, *Variety* reported that Jonze and a number of other American directors were called upon by the Pentagon to help develop possible scenarios of terrorist actions against America, post 9/11 (Bart 2001); yet it's worth noting that not all of Jonze's patrons have embraced his ability to blur the line between fiction and reality. His advert for Gap, called *Pardon Our Dust* (2005), was not shown due to it featuring a rapidly escalating scene in which a Gap store was beautifully demolished by rampaging shoppers, and Gap could not condone such behaviour in real life.

Jonze also has a vested interest in actual documentaries that examine 'outsiders', having produced *Murderball* (Henry Alex Rubin and Dana Adam Shapiro, 2005), which follows the US full-contact rugby team as they prepare for the 2004 Paralympics in Athens, and *Heavy Metal in Baghdad* (Eddy Moretti and Suroosh Alvi, 2007), which follows a band's attempt to perform a live gig in a country where their form of music is banned. Jonze has shot anonymous concert footage for *Free Tibet* (Sarah Pirozek, 1998), and interviews for the DVD releases of *Lost in Translation* and *Three Kings*. However, his two most substantial directorial offerings are *Amarillo by Morning* (1998), which is a modern bullriding documentary that focuses on a small group of aspirational suburban teens as they train to become cowboys – with fascinating parallels to Jonze's own subcultural background, and an unaired promotional campaign video at home with Al Gore and his family in the run-up to the 2000 US presidential election.

Despite having a successful day job involving an American Vice President, Spike Jonze is one of the self-styled 'Beautiful Losers'. In 2004, Aaron Rose (owner of the infamous Alleged Gallery, 1992–2002) and Christian Strike curated the 'Beautiful Losers: Contemporary Art and Street Culture' exhibition. As it had been in previous shows, Jonze's photography work was considered alongside material by indie film-makers Mike Mills, Harmony Korine, Larry Clark, and several other 'street' artists, some of whom Jonze had collaborated with on earlier projects, such as Mark Gonzales in the short, *How They Get There* (1997). The thematic umbrella for all of these artists is that they were influenced by the prevailing underground youth subcultures of the early 1990s with their multidisciplinary DIY ethic. Reflecting on this 'historic event', in the prologue to the exhibition catalogue, Rose and Strike state that 'the independent spirit of these artists has remained steadfast' (Rose and Strike 2005: 19), yet in the closing acknowledgments, it is revealed that the exhibition was sponsored by corporate behemoth, Nike (2005: 256).

A previous exhibition from 2003, called 'Sponsorship: The Fine Art of Corporate Sponsorship/The Corporate Sponsorship of Fine Art', explored these potentially problematic issues of 'co-branding', 'corporate collaboration versus commission' and the 'two-way patronage' paradigm, where in return for financially supporting indie artists, companies such as Nike and Levi's get 'the street/art/subculture credibility that builds their brands' (McGinness 2005: 13). This dynamic can be seen in much of Jonze's advertising and promo work. However, in a parallel act of industrial and cultural synchronicity, contemporary areas of the burgeoning indiewood sector within the American film industry operated on similar principles. Hollywood studios created boutique divisions, or worked with independent arthouse companies, to promote and package indie brands; and as distinctions and definitions were increasingly blurred, the same issues of 'art versus commerce' were considered.

Being John Malkovich was made on a budget of $13 million (miniscule by Hollywood studio standards, but not quite DIY) and was nominated for three Academy Awards; but it was also responsible for the Independent Spirit Awards creating the entirely new category of 'Best First Feature – Over $500,000' in 2000, which it went on to win. Furthermore, it was produced by Gramercy Pictures, which was a 'mini-major' offshoot from Universal Pictures, and was distributed by USA Films (which Universal Pictures

also later acquired). However, *Being John Malkovich* was also produced by Single Cell Pictures, a company owned by Michael Stipe, lead singer of the band, R.E.M., and Propaganda Films, a company that specialized in making highly successful 'cool' music videos and promos (such as those by Jonze). Propaganda Films also produced the distinctive 'indiewood' films of David Fincher and Mark Romanek, in addition to the more Hollywood spectacular end of the 'MTV' spectrum, with directors such as Michael Bay and Zach Snyder.

Whether he is one of James Mottram's 'Mavericks [that] took back Hollywood' (2006), thereby heralding a triumphant return of the auteurist New Hollywood directorial style, or one of Sharon Waxman's 'Rebels on the Backlot' – one of 'six maverick directors' who had 'conquered the Hollywood studio system' (2005) with his reflexive, 'hip' sensibilities, it is through examining this commercial and cultural juncture that one can most fully understand how and why Jonze segued into the indiewood sector so successfully and remained there, and it is through examining his 'other' work, that one can most fully appreciate what 'A Film Directed by Spike Jonze' means, and then immediately question it.

Carl Wilson

References

Bart, Peter (2001) 'Pentagon Calls for Rewrites on War Script', *Variety*, 14 October, http://variety.com/2001/voices/columns/pentagon-calls-for-rewrites-on-war-script-1117854200/. Accessed 20 July 2014.

McGinness, Ryan (2005) *Sponsorship: The Fine Art of Corporate Sponsorship/The Corporate Sponsorship of Fine Art*, Corte Madera: Gingko Press.

Mottram, James (2006) *The Sundance Kids: How the Mavericks Took Back Hollywood*, New York: Faber and Faber.

O'Hagen, Sean (2003) 'Who's the Proper Charlie?', *The Guardian*, 8 February, http://www.theguardian.com/film/2003/feb/09/features.review. Accessed 20 July 2015.

Rose, Aaron & Strike, Christian (2005) *Beautiful Losers: Contemporary Art and Street Culture*, New York: Iconoclast.

Smith, Ethan (1999), 'Spike Jonze Unmasked', *New York Magazine*, 18 October, http://nymag.com/nymetro/movies/features/1267/. Accessed 20 July 2015.

Waxman, Sharon (2005) *Rebels on the Backlot: Six Maverick Directors and How They Conquered the Hollywood Studio System*, New York: HarperCollins.

Notes

1. Such as pages 34–36 of *Transworld Skateboarding*, February 1990, where Jonze uses a fisheye lens on Greg Jackson, and motion-blurred shallow focus shots of Steve Keller.
2. The Crailblog can be found at: http://crailtap.com/blog/. Accessed 20 July 2015.
3. Part of the 'talking fashion' section of *Vogue US*, September 1999.
4. Sara Maria Vizcarrondo takes this idea even further in her short article 'His and Hers: Jonze and Coppola', http://www.fandor.com/keyframe/an-apology-i-presume. Accessed 20 July 2015.
5. Although it appears to no longer be active, the fictional director's real webpage was available during the promotional campaign at: http://www.carlossoto.com. Accessed 20 July 2015.

RICHARD KELLY
Wibbly-Wobbly, Timey-Wimey Cinema

In the rebooted BBC science fiction series *Doctor Who* (2005–), there is a talismanic line spoken by the Doctor (David Tennant) – 'wibbly-wobbly, timey-wimey'. This serves as a pithy summary of the work of Richard Kelly, a film-maker acutely concerned with time and its potential for complex narratives. Cinema itself is the capture and manipulation of time, and this concern runs throughout Kelly's limited, variable but very distinctive oeuvre.

Kelly was born in Newport News, Virginia, in 1975, where his father worked for NASA on the Mars Viking Lander project, a background that Kelly drew on for his third feature *The Box* (2009), in which Arthur Lewis (James Marsden) works on the same project. Kelly studied at the University of Southern California in the School of Cinema-Television, where he made two short films: *The Goodbye Place* (1996) and *Visceral Matter* (1997). He graduated in 1997 and then spent several years trying to get funding to produce his first screenplay, *Donnie Darko*. He met actor Jason Schwartzman and organized a production deal with Drew Barrymore's production company, Flower Films – Barrymore herself would appear in the film as inspirational though frustrated teacher Karen Pomeroy. In order to direct the film, Kelly had to keep the budget under $5 million. The film premiered at the Sundance Film Festival in January 2001 and, according to Kelly, would have premiered on the Starz network had it not been picked up by Newmarket Films for theatrical distribution (Churner 2004). Newmarket insisted Kelly re-edit the film, and he states that the subsequent Director's Cut, released on DVD in 2004, is closer to the original screening at Sundance (Churner 2004). The film's theatrical release, however, was overshadowed by the terrorist attacks of September 11, 2001, and it only received a limited US release in October of that year, possibly because of its plot device of a jet engine falling onto a house. International release was also slow – the film did not reach UK cinemas until late 2002. However, *Donnie Darko* did attain success on DVD, received largely positive reviews and became a cult favourite.[1]

Kelly followed this limited success by writing the screenplay for *Domino* (2005), directed by Tony Scott, and then writing and directing *Southland Tales*. This bizarre film received a critical mauling when it premiered at the Cannes Film Festival, and was recut and released in 2007 to a further critical drubbing and disastrous box office results.[2] Kelly's next project, *The Box*, was released in 2009 and, while not as ridiculed as *Southland Tales*, still failed to capture the adoration of *Donnie Darko*.

Were it not for the cult status of *Donnie Darko*, Kelly would be an unremarkable director with little critical attention paid to him. Yet in his limited output recurring tropes, themes and features do appear, including the aforementioned concern with time and isolated protagonists who are confused by their surroundings. In *Donnie Darko*, the eponymous Donnie (Jake Gyllenhaal) is not only a teenager with 'emotional problems' but experiences visions of a giant, malevolent rabbit named Frank that warns him about the apocalypse, visions that he only shares with his therapist, Dr Thurman (Katherine Ross). In *Southland Tales*, Boxer Santaros (Dwayne Johnson) loses sight of whether he is an actor researching a

Southland Tales © 2006 Darko Entertainment, Destination Films, Universal Pictures

role for a film or actually the character *in* the film, while Roland Taverner/Ronald Taverner (Seann William Scott) knows that he has an important role to play in the events occurring around him, but has no idea what that role is. In *The Box*, Arthur and Norma Lewis (Cameron Diaz) do not understand why Arlington Steward (Frank Langella) has selected them for a mysterious experiment, how it could possibly work nor the increasingly strange events that they encounter.

In all three films, the characters' confusion is mirrored in the viewer, as a complete explanation is never offered. Did Donnie actually see the future and travel back in time in order to change it, or view the events of a parallel universe that he travelled into in order to rectify it? Or was it all a dream or hallucination? Is Steward an agent of extra-terrestrial intelligence or an emissary from the afterlife? And how much do NASA and the US government really know about his mission? How does the new energy source of Fluid Karma influence the rotation of the Earth, causing rifts to appear in space and time so that one person is two and two people are one and they must not touch each other because that will cause the end of the world? Kelly's films frustrate in their refusal to provide resolution, sometimes coming across as tedious, incoherent pretention, in the case of *Southland Tales*, or as beautifully beguiling and profoundly moving, in the case of *Donnie Darko*.

The weaknesses of all three films are most apparent in their exposition, which require voice-over or prolonged monologues, or even ancillary material, to explain what is actually going on. These inadequate explanations undermine the power of the unfolding drama, Kelly at his best in the realms of ambiguity and uncertainty. This is apparent from the two releases of *Donnie Darko*, as the Director's Cut provides explanations through *The Philosophy of Time Travel*, a book within the film's universe that Donnie reads and the viewer can as well, with text from the book viewed as a DVD extra. The film itself is, seemingly, inadequate at fully expressing its themes and concerns, paratextual materials like this expanding the fictional universe. Similarly, the extras on the Region 1 DVD of *Southland Tales* include a featurette about the film's federal agency, USIdent TV: *Surveilling The Southland*, and a short animated film, *This Is the Way the World Ends*, a line taken from the film's voice-over spoken by Private Pilot Abilene (Justin Timberlake). The DVD of *The Box* includes 'Prequel Music Videos', shot in the style of 1970s amateur films, which show work at NASA, including the lightning strike that 'killed' Steward. These videos similarly expand the fictional world of the film in order to provide further context

and clarification of the events in the narrative. It is questionable, however, whether this clarification adds to or detracts from the films' own drama, as Kelly's great strength as a film-maker is his use of ambiguity. His work is most interesting and compelling when the viewer shares in the confusion of the characters and like them puzzles over the events of the narrative, never truly understanding what has taken place.

Central to this ambiguity is Kelly's exploration of time. *Southland Tales* and *Donnie Darko* both feature the possibility of time travel and, in the former, encountering earlier versions of one's self. The latter not only features the in-text book mentioned above, but also represents timelines through the visual device of 'chest-spears', fluidic tentacles that project from people and express their futures, similar to the water tentacle in *The Abyss* (James Cameron, 1989). While time travel is not a conceit of *The Box*, that film is concerned with notions of otherworldly existence beyond our current comprehension. In one scene, Arthur encounters three gateways of a shimmering, fluidic substance, reminiscent of the spears of *Donnie Darko* and the Fluid Karma of *Southland Tales*. Indeed, all three films feature portals of some sort, as Boxer in *Southland Tales* travels through one, resulting in his amnesia, while Frank (James Duval) shows Donnie a portal that leads him to burn down the house of Jim Cunningham (Patrick Swayze). Fittingly, this portal appears on a cinema screen while Donnie and his girlfriend Gretchen Ross (Jena Malone) watch *The Evil Dead* (Sam Raimi, 1981), and much of *Southland Tales*'s mystery involves events from a screenplay bleeding into real life, as well as explicit references to such films as *Kiss Me Deadly* (Robert Aldrich, 1955) and *Brazil* (Terry Gilliam, 1985). *The Box*, again, differs from the other films through a lack of cinematic references within its diegesis, but its premise and tone is reminiscent of *The Twilight Zone* (1959–64), which also featured an episode based upon the Richard Matheson short story 'Button, Button' (1970), which is itself reminiscent of the short story 'The Monkey's Paw' (1910) by WW Jacobs. Through its resemblance to *The Twilight Zone* and other earlier science fiction, fantasy and horror texts, such as *The Outer Limits* (ABC, 1963–65) and *The X-Files* (FOX, 1993–2002), *The Box* emerges as an homage to this type of fantastical story.

The Box also illustrates Kelly's careful attention to period detail. Set in 1976, the time of Kelly's early childhood, Kelly's regular production designer Alex Hammond meticulously reconstructs a 1970s setting for *The Box*'s macabre tale, much like the 1980s setting of *Donnie Darko*. The production design of *Southland Tales*'s future setting is also intricate, including an intertextual reference to *Donnie Darko* as the image of Frank the menacing rabbit appears as graffiti. Each film is very specific in its setting, supertext or voice-over informing the viewer that *Donne Darko* is in '1988', *Southland Tales* is in '2008', *The Box* is in '1976'. Yet the films' ambiguous treatment of temporality problematizes this certainty, the 'wibbly-wobbly, timey-wimey' conceit at odds with the specificity of the production design.

While the three films certainly differ and share only some commonalities, there is a further consistent theme that offers an overall through-line: responsibility. Gretchen mentions to Donnie that his name makes him sound like a superhero, to which he responds: 'How do you know I'm not?' In the vein of Spider-Man's mantra (taken from Voltaire): 'With great power, comes great responsibility,' Donnie uses his power to see through time to take responsibility for stopping Frank, which he believes only he can do. When Gretchen is killed by Frank's car, Donnie (possibly) uses the car to go back in time to die, so that Gretchen will never meet him and therefore not be killed. Roland/Ronald in *Southland Tales* literally hold(s) the fate of the world in his/their hands, and take(s) responsibility for destroying it by shaking hands, because he/they is/are not a 'punk'. Arthur and Norma are offered $1 million dollars in exchange for another's life, and while they accept the proposal, they are subsequently given another choice that requires them to take direct responsibility for their son's future. While Norma and Arthur clearly learn a

(very painful) lesson, the film ends with the Box being given to another couple. Will they make the same choice, or achieve the greater humanity Steward seemingly searches for more easily? We do not know, and are left to consider what we would do.

This is a question asked in all of Kelly's films. If we could improve the present by changing the past, even if it meant our death, would we? If offered a fortune in exchange for someone's life, that crucially *we do not know*, would we? Like other film-makers, including James Cameron, Terry Gilliam and, more recently, Duncan Jones, Kelly uses the fantastical genres of science fiction, fantasy and horror to pose philosophical questions about time, responsibility, identity and humanity. Yet whereas the other film-makers mentioned above often use straightforward stories and visual methods to express their themes, Kelly veers more towards narrative complexity and expository dialogue in his films, ancillary material and even interviews. His visual sensibility is competent and, sometimes, striking, as is his use of music such as in an early sequence in *Donnie Darko* that introduces the viewer to the school that the young characters attend, where a smooth panning shot presents various students to the sound of Tears for Fears' 'Head over Heels'. Overall, Kelly's greatest talent may be as a writer rather than director, a great creator of imaginative concepts that are expressed somewhat ponderously through verbal means. This is most apparent in *Southland Tales*, which is paced very poorly, and is also evident in *The Box* when multiple characters receive explanations about the strange events taking place. In *Donnie Darko*, his first and most accomplished work, Kelly does more with less, using elements of science fiction, fantasy and horror to deliver a beguiling and compelling feature that deserves mention alongside *Eraserhead* (David Lynch, 1977), *Reservoir Dogs* (Quentin Tarantino, 1992) and *Moon* (Duncan Jones, 2009) as among the most impressive and distinctive debuts of any film-maker.

At the time of writing, Kelly has been attached to various other projects, including true crime tale *Amicus* that may star Nicolas Cage (Sneider 2012). Whether this project or indeed something else will emerge remains to be seen, as will the answer to whether or not Kelly will ever recapture the promise shown in his remarkable debut.

Vincent M Gaine

References

Churner, Leah (2004) 'An Interview with Richard Kelly, director of *Donnie Darko*', *Hybrid Magazine*, August, http://www.hybridmagazine.com/films/0804/richard-kelly-interview.shtml. Accessed 19 December 2013.

Jacobs, WW (1910) *The Monkey's Paw: A Story in Three Scenes*, London: Samuel French.

Matheson, Richard (1970) 'Button, Button', *Playboy*, June.

Sneider, Jeff (2012) 'Kelly, Cage Team for True Crime Tale', *Variety*, 26 September, http://variety.com/2012/film/news/kelly-cage-team-for-true-crime-tale-1118059915/. Accessed 18 December 2013.

Notes

1. See 'The 50 Greatest Independent Films', *Empire Online*, http://www.empireonline.com/features/50greatestindependent/2.asp#50independent; '*Donnie Darko*' [Rotten Tomatoes], http://www.rottentomatoes.com/m/donnie_darko/. Accessed 14 December 2013.
2. See '*Southland Tales*' [Rotten Tomatoes], http://www.rottentomatoes.com/m/southland_tales/; '*Southland Tales*' [Box Office Mojo], http://www.boxofficemojo.com/movies/?id=southlandtales.htm. Accessed 17 December 2013.

ZALMAN KING

Venus Rising or the Virgin and the Bad Boy

According to the film critic Molly Haskell, 'For a woman [...] there is nothing more erotic than being understood' (1990: 100). For Zalman King, making women be understood within the context of the erotic served as the thematic foundation of his entire career – a foundation that King developed and refined in a series of early film and premium cable productions dating from 1986 to 1995. So successful were these early productions at cementing King's reputation as 'the high priest of erotic film-making' that during the making of *Eyes Wide Shut* (1999), Stanley Kubrick reportedly called on King 'to learn how to shoot eroticism' (Sinha-Roy 2012). It was a reputation that led both King's early commercial success and his checkered second act.

Before commencing his career behind the camera, King earned his credibility in front of it, starting with a gig on an episode of *The Alfred Hitchcock Hour* (CBS, 1962-65) in 1964. From there he found work in film and television, most notably in *The Young Lawyers* (ABC, 1969–71), *Some Call It Loving* (James B Harris, 1973), *Trip with the Teacher* (Earl Barton, 1975), *The Passover Plot* (Hugh J Schonfield, 1976), *Blue Sunshine* (Jeff Lieberman, 1978) and *Galaxy of Terror* (Bruce D Clark, 1981). King acted right up until one of his first stints as a producer on *Endangered Species* (Alan Rudolph, 1982), which would shortly thereafter be followed by the initiation of King's brand with *9½ Weeks* (Adrian Lyne, 1986).

Although the film wound up directed by Adrian Lyne (a kindred spirit if there ever was one) the script was penned by King, with assistance from his wife, Patricia Louisianna Knop, plus a third screenwriter. It should be noted that King participated in a screenwriting capacity on nearly every production of his in the 1986 to 1995 period, aside from *Siesta* (Mary Lambert, 1987), *Boca* (Walter Avancini & Zalman King, 1994) – where he was involved as co-director and executive producer, respectively – and the last film in this time frame, *Delta of Venus* (1995), which he directed and Knop helped author instead; Knop also wrote *Siesta* while King executive produced. This is noted to demonstrate the extent to which King exercised firm, creative agency over all the projects he was involved in. Nearly all of the King productions, save for three films to varying degrees, during the 1986 to 1995 period, show a definite, conscious effort on King's part to fashion himself into a recognizable brand. The three odd films from this period, for the sake of clarity, are his 1988 debut, *Wildfire* (barely recognizable as a King film), *Boca* (more noted as a thriller than an erotic romance and he only co-directed) and *Siesta* (King trademarks are present but it's more of an experimental thriller, which he only produced).

With that noted it can be safely said that most King productions share a common, basic narrative and thematic framework. From movie to movie, relatively few dramatic adjustments are made to the narrative framework in question, excepting *Wild Orchid 2: Two Shades of Blue* (1991), which this essay will come to later. Every King production is carried by a female that one could define as at least figuratively virginal who achieves a profound self-discovery and liberation through sex and sensuality. The catalyst is a man, either an adventurous blue-collar bad boy, as in *Two Moon Junction* (1986) and *Red Shoe*

Two Moon Junction © 1998 DDM Film Corporation,
Lorimar Motion Pictures, Planet Productions

Diaries (Showtime, 1992–99), or the more gentlemanly bad boy seen in *9½ Weeks*, *Wild Orchid* (1989) and *Delta of Venus*. The young woman then finds herself in and through highly emotional copulations – perhaps exclusively or mostly with the male catalyst – often in environments that could be termed exotic, bohemian or even carnivalesque. Throughout the story, she finds herself consensually, if somewhat reluctantly, made more present in her own body, more conscious of her identity and the world at large through her sexual relationship or relations in some cases. Beyond this, the end goal for the young woman is to either escape her middle-class existence, and/or to domesticate her free-spirited male object, ultimately. The sexual awakenings are depicted by making use of graphic techniques, though, not exactly and exclusively in the carnal sense. In fact, one suspects that today's younger audiences might find King's use of nudity to be fairly tame. By 'graphic', one is referring to the framing, editing rhythms, decor, costuming, and the lighting and colour scheme – King is a highly subjective, spectacle-driven yet mostly tasteful visual stylist.

9½ Weeks, while not strictly King's if one defines authorship through the role of director, can be rightfully considered in an aesthetic and thematic sense his first Kingsian movie, mostly. A variant on the King male prototype is here established by John (Mickey Rourke) who, though financially successful and obviously polished, nonetheless exudes a slightly unwholesome, blue-collar vibe through his speech and physicality in contrast to King's virginal female prototype assumed by Elizabeth (Kim Basinger), with the actress quite Marilyn Monroe-like in her ability to be sexy but not dirty. Introducing the template for Kingsian erotica, the film evidences a low-intercourse, high-atmosphere scene ratio, eschewing thrusts and genitalia and instead relying more on looks, touches, soft lighting, romantic words and gestures, foreplay, and so forth. What is perhaps the most famous scene in the film – the food scene – is simply Elizabeth blindfolded, experiencing different tastes, leaving a lot to the prurient imagination. For King, the erotic is just as much the anticipation of the sexual act if not more so. King also establishes in this film his use of

the exotic other, presenting a 1980s New York City overrun with oddballs, sex workers, foreign street musicians, hoods, artists, and so forth. This is New York City as ballyhooed by conservative parents. Still, Lyne leaves his mark by placing these elements in the periphery and filming them in a more restrained and casual fashion. But most importantly, King establishes the point of view he'd commit to throughout the 1986 to 1995 period; namely, the female's. Every beat in the story takes place from Elizabeth's point of view.

If the male and female prototypes weren't firmly and obviously established in 9½ Weeks, then they're writ-large in his second film as director, Two Moon Junction. Both Sherilyn Fenn's Southern belle April, outfitted almost exclusively in virginal white, and Richard Tyson's often-shirtless and Fabio-esque carnival worker Perry, evoke nothing more or less than the star-crossed couples seen on the covers of romance paperbacks. The story, about a girl from polite society who is engaged to be married and is then swept away by a drifter employed by the carnival passing through town, is King's purest take on the girl getting mixed up with the guy from the wrong side of town. In this, King's actual directorial debut (Wildfire notwithstanding), the relative understatement of Lyne's visual style is replaced by King's more visceral, footloose and fancy-free approach. Dolly-ins, handheld shots, slow motion, glowing soft-focus, extreme close-ups and angular shots cover King's vision of gorgeous flesh and a vestigial American South awash in virginal white where aristocrats, truckers and carnies compete for screen time.

King would continue with his affinity for the visually carnivalesque by setting his next film, Wild Orchid, in the home of carnival – Rio de Janeiro. King takes Brazil's designation as a rainbow nation literally by conjuring an over-stimulated visual scheme to complement the overheated natives; its Brazil as imagined by a frightened Midwestern tourist before arrival, which the central character, lawyer Emily Rees (Carré Otis), essentially is, so perhaps it's just being impossibly subjective. Rourke is back, here playing deviant millionaire James Wheeler but essentially delivering an unintentionally parodic take on his character from 9½ Weeks. As a matter of fact, it might not be unfair to say that, BDSM content excluded, Wild Orchid is a remake of 9½ Weeks, but this time with a happy ending as the virgin domesticates the distant and controlling bad boy. As such, it's unfortunate that its in-name-only sequel, Wild Orchid 2: Two Shades of Blue, has to live in its predecessor's infamous shadow, for it's easily King's finest work as a director. Wild Orchid 2: Two Shades of Blue is also the one film out of King's early efforts where the pivotal sexual awakening, though it does empower the female lead, also wounds and numbs her (she is forced to work in an upscale bordello or face certain poverty). It's the one film from King's early filmography where sex isn't so much liberating as restricting. Consequently, though the sex, and the film overall, is often delicately and elegantly shot, it carries an especially ambiguous gravitas. It's a tone that recalls somewhat the second half of 9½ Weeks and looks forward to the film that would lead to King's successful first attempt at cable programming.

Red Shoe Diaries sees King managing to synthesize the visual flourishes from earlier in his filmography with the classy and classical restraint demonstrated in Wild Orchid 2: Two Shades of Blue. The film melds the story of the (figuratively) virginal, middle-class girl, here Alex (Brigitte Bak), getting involved with the hot, blue-collar, bad boy type seen in Two Moon Junction, but it complicates things by making the boyfriend she's cheating on, Jake (David Duchovny), equally appealing, if not more appealing, muddling audience sympathies. However, the most notable shift in the King formula is having the female lead commit guilt-laden suicide half-way into the film, making Jake the audience surrogate, though the character's introspective and sensitive nature hew closer to the King heroine archetype than his male one. Another device that King introduces in the film and that he would use throughout the run of his Showtime television series Red Shoe Diaries is the use of voice-over.

Extensive use of voice-over also features in the last film of the 1986 to 1995 period, *Delta of Venus*, to the point where the result is a bit redundant; an audiobook set to lush, period scenes. The film, continuing in the mould of synthesized classical and modernist touches from King's previous two works, is loosely based on the work of Anaïs Nin; a seemingly ideal and fitting source for King. In this, King's most ambitious attempt at high-brow respectability, the traditional male catalyst is noticeably gone for much of the film, inspiring the woman to action only from afar and unbeknownst to her (he hires her under a secret identity to pen erotic stories for him). And while Paris-based writer Elena (Audie England) is incited by her connection to mystery man Lawrence Walters (Costas Mandylor), it isn't a lust-filled connection. Her journey is driven by her desire to grow creatively. Yet it is arguable that this is the one time in King's works from this period where the female goes through her sexual journey because of – and for – herself.

Discussing his approach to building his brand, King explains:

> I learned from *9½ Weeks* and *Wild Orchid* and *Two Moon Junction* that you can say, 'From the creators of this and that,' but what you really need to do to cement an audience is to have a franchise. I'm using my name, but it could be yours or anybody else's; the point is that you need to have a title or something with continuity, so people can say, 'Oh, it's these same people who were responsible for those other films.' The reason that's important is that then you can build a core audience that knows that the name Zalman King or *Red Shoe Diaries* guarantees certain things [...] So in terms of our business plan, in terms of making films efficiently, a consistent name identifies the individual films with a genre, and the audience will come see those films. (McDonagh 1995: 66–67)

King accomplished the approach in question – perhaps too well. A mid-career shift into a film involving extreme sports as its subject, *In God's Hands* (1998) was followed by a show on primetime NBC called *Wind on Water* (1998) that had nothing to do with the stories of sexual awakening he was known for. It was cancelled after two episodes. King's attempt at rebranding himself failed. The 'high priest of erotic film-making' found himself restricted by the image he'd cultivated in his early career. In an age of easy access to sexual images thanks to the Internet (King owes half of his career arguably to the rise of premium cable) his brand of romantic erotica found itself with more competition. Thereafter followed two more attempts, again on the Showtime network: the ludicrous *ChromiumBlue.com* (2002) and *Body Language* (2010), which was basically a poor man's *Red Shoe Diaries*. King's narrative features following *In God's Hands* don't fare much better. A short reality series called *Forty Deuce* (2005) on Bravo is a noticeably bright spot in his second act, as are two documentary titles, *Dance with the Devil* (2006) and *Crazy Again* (2006), which hinted at a potential third act as a skilled documentary film-maker.

Carlos Segura

References

Haskell, Molly (1990) *Love and Other Infectious Diseases: A Memoir*, Lincoln, NE: iuniverse.

McDonagh, Maitland (1995) *Film-making on the Fringe: The Good, the Bad and the Deviant Directors*, New York: Citadel Press.

Sinha-Roy, Piya (2012) 'Erotica Director Zalman King Dies from Cancer', *Reuters*, 3 February, http://www.reuters.com/article/2012/02/03/us-zalmanking-dead-idUSTRE81223120120203. Accessed 18 July 2015.

WILLIAM KLEIN
Iconoclasm, Antagonism and Protest

This essay analyses the experimental films produced by the American-born, Paris-based artist William Klein. Best known for his raw and cutting edge photographs from the 1950s and 1960s, Klein's work as a film-maker tends to be overlooked in popular discourse. Although Klein has made a number of films throughout his illustrious career, the essay is specifically concerned with three case studies, which, in combination, reveal Klein's highly unusual approach as a film-maker. The aim of the essay is to bring Klein's artistic legacy into context and deconstruct his methods as an artist with special reference to the cinematic.

An understanding of Klein's work as film-maker can only be facilitated through an understanding of his cross-cultural personal background. Born in 1928 in New York into a Jewish family whose business collapsed through speculation on Wall Street, Klein finished high school early and started a course in sociology at the City College of New York at the age of 14. At the age of 18, Klein joined the US Army as radio operator for two years and was initially stationed in Germany and later on in France in the immediate aftermath of World War II. Supported by a GI Bill educational assistance programme provided by the US Army, in 1948 Klein enrolled at the renowned Sorbonne University in Paris to study painting. In contrast to the highly regimented chain of command structure in the military, at the Sorbonne Klein was actively encouraged to revolt against authority and reject bourgeois values.

In 1954 the renowned art director of *Vogue*, Alexander Liberman, invited the 26-year-old expatriate artist to return to New York in order to take up a position as a graphic design assistant at the magazine. In spite of his initial training as well as success as a painter, at this stage in his career Klein had already shifted towards other media, which included sculpture and photography. Although he never took up a specific job with *Vogue*, Klein received portrait assignments from the magazine while Liberman convinced *Vogue*'s publisher Condé Nast to financially cover his photographic excursions in New York. *Vogue* were shocked by Klein's work as it deemed his photographs to be a crude and aggressive representation of the city. Finding an American book publisher for the photographs became an impossible task.

In 1956 Klein returned to Paris where a small publisher, Éditions du Seuil, which specialized in travel books, agreed to publish the work under the intriguing title *Life is Good and Good for You in New York* (1958). The book quickly revealed Klein's signature style as a photographer: many images were rough, blurry, out-of-focus or taken at an unusual angle. Printed grainy and with a strong contrast, the black-and-white photographs were a bold statement that totally went against perceived traditions of photography. Influenced by his studies at the Sorbonne, where he was actively encouraged to break the rules, Klein thus established himself as an iconoclastic artist whose work could be seen to critique photographic realism or a photographic 'truth'. Filled with visual puns and witty depictions of the everyday, Klein's photographs were received to wide critical acclaim in the artistic communities of Paris as they clearly suggested an entirely new way of using the camera.

Mr. Freedom (1969) Films du Rond-Point, O.P.E.R.A.

Commonly referred to as New York in short, the book is considered Klein's magnus opus and is regarded today as one of the landmarks in the history of photography.

Remarkably, the book would not have seen the light of day if it were not for the insistence of one of Éditions du Seuil's renegade employees – none other than the renowned film essayist Chris Marker, who threatened to quit his job if Éditions du Seuil did not go ahead with publishing Klein's provocative New York photographs. At this point in time, Marker had already made a number of films and was associated with, what would become to be known as, the Left Bank Film Movement. While Marker championed Klein's provocative and highly unusual approach to photography, Marker's friend, the film director Alain Resnais, specifically encouraged Klein to venture into film as the next logical step in his career.

While Klein's parents' business collapsed during the Great Depression, his extended family mostly consisted of wealthy and well-connected lawyers. One of his uncles in fact represented, amongst others, Charlie Chaplin and his struggling film studio United Artists. Despite these family connections leading to the upper echelons of Hollywood, Klein's idea for a short film which captures the lights of Broadway at night was turned down by United Artists. While the proposed film failed to gain backing in the United States, Klein found support from the producer of independent cinema Anatole Dauman of Argos Films. At this stage in his career a clear pattern began to emerge: on one hand Klein was consistently turned away or discouraged in the United States, while in contrast to that, in France he was warmly welcomed and actively promoted as an artist. Since the film was granted support by the French government, which requires a quota of French citizens working on the film, Chris Marker and Alain Resnais were assigned roles as technical assistants. Under the title *Broadway by Light* (1958), this was Klein's first exploration in film.

Broadway by Light is a ten-minute montage that captures the city lights on New York's Broadway. Shot in colour and predominantly with a long lens, Klein did not concentrate as much on the meaning of the individual words or signs illuminated by the lights, but rather, he focused on the lights as a visual spectacle punctuating the nocturnal urban landscape. This emphasis on a spectacle is further emphasized by the long lens which tends to deconstruct the city and thus also questions the very existence of the lights: in most cases these are advertising signs such as for Pepsi Cola or other well-known American brands. The film also includes brief moments where workers can be seen to fix the light bulbs or rearrange the lettering on a theatre advertising board. The workers look like puppets on a string as their bodies become mere silhouettes against the bright lights of Broadway. To this end, the film actually depicts a dehumanized proto-landscape: the lack of human interaction is also emphasized in the way the film was made which optically emphasizes the distance between the camera and the subject matter as well as the highly controlled position of the camera. The film can be read as a commentary on the allure of capitalism, advertising and indeed also the visual appeal of the cinematic apparatus, as Klein clearly indulges in the high quality of colour reproduction. The lack of human interaction, social life and the sheer dominance of advertising in the film anticipates Guy Debord's Marxist theories explored in his classic book *The Society of the Spectacle* (1967) – published nearly ten years after Klein's film was made. *Broadway by Light* thus appears to foreshadow with startling accuracy Debord's observation that commodity images produce 'waves of enthusiasm for a given product' and that this enthusiasm bears similarities to the role of religions in the past.

With regard to both content and methodology, *Broadway by Light* constitutes a visual antithesis to the rugged black-and-white photographs popularized in Klein's New York book. It is quite clear that with this film Klein seeks to reinvent himself, and by doing so, he avoids any easy categorizations as an artist. He is neither entirely photographer nor film-maker in the same way that he is neither fully American nor a foreigner to America. Despite the ambiguity of Klein's first exploration in film, it is difficult to ignore the subtle critique against the dominance of advertising, the allure of images and the seductive powers of capitalism in his country of birth. Here, Klein develops a critical eye on his own cultural background which is promoted by the fact that he is increasingly becoming an outsider to this very environment.

Klein's first feature film, *What to Do with Polly Maggoo* (1966), is a satirical and surreal depiction of the fashion industry. The film was inspired by Klein's own forays in fashion photography as well as his enduring relationship with *Vogue* and its art director Alexander Liberman. The film is also deeply self-referential in that it essentially focuses on a film crew attempting to produce a TV programme on a young American model called Polly Maggoo. The TV programme footage – or the film within the film – consistently overlaps with other visual elements which include extensive montages, still photographs, philosophical monologues, the countdown from the film leader cutting into sequences, footage of Paris crowds apparently unaware of the camera, as well as several instances where Polly is filmed as she is being photographed in a fashion shoot. Right from the start the film appears critical of the fashion world as Polly Maggoo responds to the TV crew:

> You want to know who I am? I sometimes wonder myself. People take my picture. People take my picture every day, so my picture's been taken millions of times. And every time they take my picture, there's a little less of me left.

Klein's film does not paint a very sympathetic picture of people in the fashion industry who come across as greedy, pretentious, superficial and even slightly mad. Inasmuch as the film appears to ridicule the excesses of fashion, it also highlights the poor treatment

of women. As the French word for model, 'mannequin', suggests, Polly as well as other women are consistently objectified, pushed around like props, ridiculed and laughed at. Despite the beauty and glamour captured in this film, the fashion industry comes across as ugly and revolting towards the end. Considering that Klein, for many years, profited from commissions by *Vogue* and the generous support of Condé Nast, *What to Do with Polly Maggoo* is a deeply provocative film in that it derides and ridicules the very people who have promoted Klein in the past. Here too, Klein essentially stepped outside of his comfort zone and produced a film that looks at his own circumstances like an outsider gazing into a mad microcosm.

Apart from the critique against fashion, commodity fetishism and hedonistic capitalism, on a more subtle level the film also captures political and ideological tensions prevalent at the time. Brief references to phone conversations to Brazzaville, Congo and Dallas, Texas – the former was engulfed in a Cold War proxy battle and the latter the city where JFK was assassinated in 1963 – point to a global political order that was in crisis. Similarly, the dissatisfaction of workers in the TV station directly referred to in the film, as well as tense exchanges captured on the streets of Paris about the evils of capital, allude to an economic order that was on the brink of collapse. Polly Maggoo also includes footage of student protests: some of which are staged for the film though some of them apparently also take place on the streets of Paris at the time of filming. All these elements subtly creeping into the film provide a political subtext, which alludes to the growing radicalization of the youth in the late 1960s in France.

Led by Chris Marker, in 1967 Klein was part of a group of renowned film directors, which included Alain Resnais and Jean-Luc Godard who collaborated on the anti-war film *Far from Vietnam*. The project was initially proposed to Marker by a radical student organization who wanted to attract more participants to their agitprop meetings through a politically charged cinema. Yet even though the film was excitedly received by a lot of press, Klein described his disappointment that not many people actually came to see it. In his effort to create a greater social and political impact through cinema, Klein conceived of *Mr. Freedom* (1969) – a live-action satirical take on the clash between capitalism and communism filmed in the over-the-top visual style of a comic strip. The garish colours, exaggerated costumes and surreal script stand in complete contrast to *Far from Vietnam* and other political cinema also known as Third Cinema. Satire does not disguise, however, a very serious ideological clash that is explored in *Mr. Freedom*.

At the beginning of the film, Mr Freedom is briefed by Dr Freedom that the world is essentially divided into one side that is right and another side that is wrong. Wrong is red and right – as Dr Freedom explains – is red, white and blue. It is Mr Freedom's job to convert the red parts so that other parts that are 'maybes' will also turn red, white and blue. Dr Freedom sends Mr Freedom to France, which is about to be invaded by reds to the dismay of America. It is Mr Freedom's job to stop the tide of red in France. This overarching narrative, explored through Dadaistic means in the film, not only references Cold War anxieties and the reductive dichotomization of the world into good and bad, it also highlights the increased might of French students and workers rattling the state apparatus. To that end, Klein's film is supremely in touch with its time as it depicts Mr Freedom struggling to cope with the rise of anti-capitalist sentiment in France.

It is important to consider *Mr. Freedom* in a historical context: filming began in early 1968 when, at the same time, the student revolt and general strikes picked up in momentum on the streets of France and indeed across many urban centres around the world. Not only does Klein allude to precisely these ideological struggles within the film: the film actually appears to participate in these very struggles in a number of poignant scenes. For instance, Mr Freedom's attempt to create fear in the French people is dramatically explored through a mad frenzy in which several cast members of the film burst out onto a crowded street in Paris and create utter mayhem to the detriment of

an elderly woman and shocked onlookers. The frenzy, which includes illustrious figures such as Serge Gainsbourg cast for the film, appears so spontaneous and improvised that it verges on a performance art piece that is as much captured by Klein's camera as it is observed by a baffled crowd. Other scenes include Mr Freedom dressed as a CIA-type spy, increasingly recognizing that he is fighting a losing battle against the tide of anti-capitalist sentiment, as he observes mass demonstrations which were actually taking place on the streets of Paris. By merging documentary film and public performance art into narrative cinema, Klein reveals himself as an experimental artist who continuously pushes against the assumed boundaries between fiction and reality.

The true accomplishment of *Mr. Freedom* can be found in the provocative plot that ridicules American policy to the point at which it becomes grotesque, and in the cinematic tools with which it communicates this plot to the viewer. In fact, by incorporating the exaggerated satirical figure Mr Freedom, Klein cunningly references an all-American action hero as a metaphor for economic, militaristic as well as cultural imperialism. Unsurprisingly, the film was banned in the United States for a number of years, while in France the release of the film was delayed for several months. *Mr. Freedom* is a deeply political film – even a visual form of protest – that did not merely represent an intense ideological struggle, but it actually participated in the very social forces that transformed French society through the uprising in May 1968.

William Klein is what you might call an idiosyncratic artist whose works often appear to contradict each other. On one hand he is an outsider, both in America as well as in France, looking at cultural phenomena from the sidelines. Yet on the other hand Klein is also an insider, right at the centre of artistic and intellectual communities, rubbing shoulders with key figures in the cultural establishment. Similarly, on one hand he benefits from personal connections such as to the fashion industry, yet on the other hand he also appears to antagonize and strain these connections through his artworks. This level of antagonism and provocation can be observed, most vividly, against his very own cultural background. It is quite possible that Klein's provocative stance against his country of birth was one of the very reasons he became such a celebrated figure in France.

It must not be overlooked that Klein's work – and here I particularly refer to the three films analysed above – had a distinct political agenda. While this agenda might have been quite subtle in *Broadway by Light* in 1958, by the time Klein made *Mr. Freedom* a decade later, this agenda could not have been clearer. Looking at these films in chronological order, the viewer experiences the maturing of an artist whose voice metaphorically becomes louder and more convincing. Klein's films allude to an artist who evidently enjoys exploring the boundaries of cinema, moving beyond the photographic or the documentary, into the realm of the surreal.

Marco Bohr

SPIKE LEE
Politics on Film

Spike Lee is a highly significant director in American cinema both because of his stylish innovation and the frequently confrontational content of his work. He is unafraid of controversy and uses both his celebrity position and his film output to make explicitly critical statements about social and cinematic attitudes towards race, class and crime. The director, who dismisses films like *Mississippi Burning* (Alan Parker, 1988), *Amistad* (Steve Spielberg, 1997) and *Remember the Titans* (Boaz Yakin, 2000) as '"spurious" histories' (Fuchs 2002: viii), and who criticizes Quentin Tarantino for his use of 'the n-word' (Miller 2012), is a deeply political film-maker, whose stories and directorial style are shot through with serious themes.

The man nicknamed 'Spike' by his mother was born Shelton Jackson Lee in Atlanta, Georgia, the son of a teacher of arts and black literature and a jazz musician and composer. The family moved to Brooklyn, New York when he was a child and he attended John Dewey High School. Lee went to university at Morehouse College and also took film courses at Clark Atlanta University, graduating with a BA in Mass Communication from Morehouse. It was during his student years that he made his first film, *Last Hustle in Brooklyn* (1979). After his BA, Lee undertook a Master of Fine Arts in Film & Television at New York University's Tisch School of the Arts. At Tisch, Lee demonstrated his interest in the cinematic depiction of black American history, using scenes from DW Griffith's *The Birth of a Nation* (1915) in his short film, *The Answer* (1980), about a young black film-maker tasked with remaking the notorious classic (Crowdus and Georgakas 2002: 202–3). Lee's subsequent film, *Joe's Bed-Stuy Barbershop: We Cut Heads* (1983), won a student Academy Award.

Following graduation from Tisch, Lee scraped together the budget for his first film by writing to friends and relatives as well as collecting bottles and cans for cash (Younge 2013). From these endeavours, Lee assembled a budget of $175,000 for the comedy *She's Gotta Have It* (1986), which earned $7 million at the US box office. This success led to him being hired to direct the Columbia picture, *School Daze* (1988), that went on to earn over $14 million at the box office from a budget of $6.5 million. After this dual success, Lee wrote, produced and directed *Do the Right Thing* (1989), which was a major critical and commercial success that earned Lee an Oscar nomination for Best Original Screenplay. The positive reception extended to the US Library of Congress selecting the film for preservation in the National Film Registry in 1999.

Subsequent to the acclaim that greeted *Do the Right Thing*, Lee became a highly prolific film-maker, releasing sometimes more than one film a year, including the award-baiting biopic *Malcolm X* (1992), the grim crime drama *Clockers* (1995), the documentaries *4 Little Girls* (1997) and *The Original Kings of Comedy* (2000), as well as the heist thriller *Inside Man* (2006) and *Oldboy* (2013), a remake of Park

She's Gotta Have It © 1986 40 Acres & A Mule Filmworks

Chan-wook's film of the same name. He also branched into television, including the HBO two-part documentary *When the Levees Broke: A Requiem in Four Acts* (2006), about the impact of Hurricane Katrina on New Orleans, as well as a follow-up, *If God Is Willing and da Creek Don't Rise* (2010).

Across his oeuvre, Lee continually engages with political themes including race, crime and poverty, sometimes subtly and other times overtly. *Do the Right Thing* depicts simmering racial tensions on a blisteringly hot day in Brooklyn, eventually erupting into violence that leads to a young black man's death at the hands of the police. *Do the Right Thing* also features Lee's motif of characters delivering lines direct to camera, a trope repeated in such later films as *Bamboozled* (2000) and *25th Hour* (2002). *Malcolm X* is an explicit condemnation of racism, and its title sequence encapsulates Lee's interest in combining documented history with cinematic artifice. Malcolm (Denzel Washington) delivers a speech in voice-over, with an image of the American flag intercut with footage of the Rodney King beating that took place in Los Angeles in 1991. As the sequence progresses the flag catches fire, and the camcorder footage slows down as Malcolm states that black Americans have neither seen nor experienced democracy. The flag is reduced to a large X that retains the stars and stripes, signifying that the story of Malcolm X is the story of America, a story of violence and oppression.

Released in the aftermath of King's beating and the Los Angeles riots, *Malcolm X* stands as an angry statement about the African American experience. George Holliday's camcorder footage of King was an accidental insight into the American establishment's treatment of black people, and Lee's intercutting of this footage with the visual effect of the flag implicates the whole of America in the continuance of racism. Malcolm's speech over the titles 'charge[s] the white man with being the greatest murderer on earth [...]

the greatest kidnapper on earth […] We don't see any American Dream. We've experienced only the American Nightmare!' Lest the audience be complacent about the film being historical, the recent footage emphasizes that the American Nightmare is ongoing.

The camcorder footage of King is reminiscent of Oliver Stone's use of Abraham Zapruder's film of the assassination of John F Kennedy in *JFK* (1991). Like Stone, Lee uses a range of different film types, creating different visual aesthetics within individual films. News footage appears in *Malcolm X* as well as *Summer of Sam* (1999) and *25th Hour*. Lee even raids his own back catalogue for *Bamboozled*, which takes its title from a scene in *Malcolm X* that Lee uses in his later film, while TV executive Thomas Dunwitty (Michael Rapaport) says at one point, 'I don't give a goddamn what that prick Spike Lee says!' Lee's postmodern satire about a modern minstrel show filled with racist caricatures that become hugely successful features multiple clips of African Americans in film and television, emphasizing the power of fictional representation in shaping and reinforcing socio-historical attitudes. Furthermore, the majority of *Bamboozled* was shot on mini digital video, apart from the dance sequences of its performer Mantan (Savion Glover), which were shot on 16mm film. This different aesthetic emphasizes the mutability of the medium used for images and representations. The digital sequences make use of low-angled shots as well as tracking shots without clear emphasis in the frame, creating an amateur-like aesthetic. This aesthetic gives the film the appearance of a fly-on-the-wall documentary at a TV studio, whereas the 16mm film sequences add to the sense of spectacle around Mantan's dancing, a spectacle of racist stereotyping made stronger by the specific medium of its presentation.

Different aesthetics run through Lee's work even when the political content is implicit. The opening scene of *25th Hour*, as well as a surreal monologue by protagonist Monty Brogan (Edward Norton), is presented in grainy, oversaturated footage that contrasts with the visual texture of the rest of the film. The effect is to highlight the integration of truth and artifice – Monty's monologue highlights a (long) list of social and racial tensions that plague America while the overexposed image emphasizes the presentation. *25th Hour* is also notable for its post-9/11 anxiety – pre-production was underway at the time of the 2001 attacks and Lee opted to integrate the aftermath into the film (LaSalle 2006). The result is a series of haunting images including a title sequence featuring the Tower Light Memorial, in which powerful lights create towers of illumination in the void left by the World Trade Center (Municipal Art Society of New York n.d.). Subsequent scenes overlook Ground Zero while characters describe life in New York after 9/11, the cumulative effect an expression of disorientation and confusion. Monty is about to go to prison for seven years but his friends are also unsure how to live in a New York so profoundly damaged. The film's embrace of this uncertainty is typical of Lee's engagement with the ineffable, turning his camera on difficult issues in an unflinching but still entertaining way.

Despite their interest in tension and violence, Lee's films are not without warmth, especially in relation to New York City. *Do the Right Thing* and *25th Hour* are detailed portrayals of community, as is *Summer of Sam*. Despite being set during the murderous rampage of 'Son of Sam' David Berkowitz in the summer of 1977, Lee's interest is not in Berkowitz's murders but the relationships within a small community in the Throgs Neck section of the Bronx. The backdrop of a serial killer adds to domestic and social tensions in Throgs Neck, eventually culminating in mob violence much like in *Do the Right Thing*. Lee's fictional story against a historical backdrop demonstrates again his integration of reality and artifice, which are highlighted through the use of different film types. Scenes featuring Berkowitz (Michael Badalucco) receiving instructions from his dog have the grainy, overexposed quality that Lee uses

elsewhere, unlike those featuring the inhabitants of Throgs Neck. The overexposure heightens the surreal nature of the Berkowitz sequences in contrast to the relative normalcy of Throgs Neck. Like other Lee films, there is direct address to camera, this time by a narrator figure that bookends the film, describing New York as the city he loves and hates in equal measure.

Affection for New York runs throughout much of Lee's oeuvre as well, even when community is not a central theme. *Inside Man* and *Oldboy* carry less of the director's signature than his earlier work, but nonetheless both make extensive use of New York locations. *Inside Man* features different film types as well as references to post-9/11 tensions, the film attempting to blend Lee's sociopolitical interests with the generic demands of a heist thriller. *Inside Man* is more deceitful than much of Lee's work – rather than being a straightforward heist thriller or tale of social tensions, it is ultimately a con movie: the confidence trick pulled the audience as well as Detective Keith Frazier (Denzel Washington). Despite, or perhaps because of this, *Inside Man* remains, perhaps also because of its major stars (Washington along with Clive Owen and Jodie Foster), the highest-grossing film of Lee's career, taking over $184 million worldwide. By contrast, *Oldboy* was a flop, perhaps because of unfavourable comparisons with the South Korean original. *Oldboy* also differs from much of Lee's work in its fantastical stylistics, the past and present of protagonist Joe Doucett (Josh Brolin) sometimes appearing in the same shot, such as when the window of a hotel room shows events that take place elsewhere. *Oldboy* is a curiously anonymous film, which is likely due to the film's producers editing it to a shorter version (Fretts 2013). Lee's films normally feature the credit 'A Spike Lee Joint', but *Oldboy* is only credited as 'A Spike Lee Film' (Khatchatourian 2013).

Whereas some of Lee's recent films have lacked a strong political element, this element can be found in his television work, especially his documentary, *When the Levees Broke: A Requiem in Four Acts*, which uses news footage and interviews to create a comprehensive impression of the complexities of New Orleans's experience of Katrina. The political issues associated with the federal government's response to Katrina are implied through these experiences. While this could appear to be a straightforward documentation of events as they occurred, the director's hand is readily apparent, carefully editing material to cumulatively create a sense of injustice and outrage in the viewer. Similar responses are obviously invited by *Bamboozled* and *Do the Right Thing*, among others. Consistently across Lee's oeuvre, reality and artifice are integrated in a way that illustrates the political potential of cinema. Film-making edits material for public consumption in much the same way as political propaganda, like election campaigns and public appearances. Lee's use of different film types and his combination of documented and fictional material continually demonstrates the intrinsic manipulation of image and sound for political means, making him as important a political film-maker as he is a representative for African American cinema.

Vincent M Gaine

References

Crowdus, Gary & Georgakas, Dan (2002) 'Thinking About the Power of Images: An Interview with Spike Lee', in Cynthia Fuchs (ed.), *Spike Lee: Interviews*, Jackson: University Press of Mississippi, pp. 202–18.

Fretts, Bruce (2013) 'Elizabeth Olsen Is Creeped Out by Her Own Movie, Spike Lee's remake of the Korean thriller "Oldboy"', *New York Daily News*, 24 November, http://www.nydailynews.com/entertainment/tv-movies/elizabeth-olsen-creeped-movie-article-1.1524059. Accessed 27 August 2014.

Fuchs, Cynthia (2002) 'Introduction', in Cynthia Fuchs (ed.), *Spike Lee: Interviews*, Jackson: University Press of Mississippi, pp. vii-xv.

Khatchatourian, Maane (2013) 'Box Office: Spike Lee's "Oldboy" a Thanksgiving Disaster', *Variety*, 29 November, http://variety.com/2013/film/news/spike-lees-oldboy-looking-like-a-big-fat-turkey-at-thanksgiving-b-o-1200892692/. Accessed 27 August 2014.

LaSalle, Mike (2006) '9/11: Five Years Later/Spike Lee's "25th Hour"', *SFGate*, 10 September, http://www.sfgate.com/cgi-bin/article.cgi?f=/c/a/2006/09/10/PKGPMKU4661.DTL. Accessed 26 August 2014.

Miller, Tim (2012) 'Quentin Tarantino Accused of 'Blaxploitation' by Spike Lee… Again', *The Independent*, 26 December, http://www.independent.co.uk/news/world/americas/quentin-tarantino-accused-of-blaxploitation-by-spike-lee-again-8431183.html. Accessed 27 August 2014.

Municipal Art Society of New York (n.d.) 'Tribute in Light', http://www.mas.org/programs/tributeinlight/. Accessed 27 August 2014.

Younge, Gary (2013) 'Spike Lee on *Oldboy*, America's violent history and the fine art of mouthing off', *The Guardian*, 1 December, http://www.theguardian.com/film/2013/dec/01/spike-lee-oldboy-interview-director. Accessed 26 August 2014.

HERSCHELL GORDON LEWIS
The Gore Auteur

It is fair to say that the term 'auteur' has become almost redundant due to its overuse, mainly because it has become common practice in certain film magazines and other media to label almost any director an auteur, who has made more than two films and which feature repeated traits. Despite the concept of authorship itself being regarded by many film scholars as having little currency any more, and the term 'auteur' seemingly rendered almost useless critically, it still has some value when attempting to reappraise the work of certain film-makers. One such candidate overdue for reappraisal is Herschell Gordon Lewis.

Lewis, who had a dual career as both English professor and running an ad agency, began his film-making career in 1960 with *The Prime Time* and made a series of cheap, so-called 'nudie cuties' in order to cash in on current trends (Curry 1999: 13). He continued in this vein, making low-budget, independent, exploitation pieces covering a range of genres until his last film of this era in 1972.[1] However, the films he is most associated with are his series of six gore-heavy horrors – *Blood Feast* (1963), *Two Thousand Maniacs* (1964), *Color Me Blood Red* (1965), *The Gruesome Twosome* (1967), *The Wizard of Gore* (1970) and *The Gore Gore Girls* (1972). These films earned him the label 'the godfather of gore' and have usually been regarded as exploitative trash with no redeeming features (Lewis and Rausch 2012).

Nonetheless, over time, *Blood Feast* has carved out a place in cinema history – being noted as the first of its kind and therefore having some merit – and so Lewis can lay claim to being a pioneer of sorts. However, despite more interest in his films in recent years – most likely due to their wider availability on DVD – there has been little attempt to consider his work critically or to interrogate whether it is the case that all his gore films have to offer is gruesome imagery and cheap thrills. It can be argued that there is indeed more to Lewis's splatter creations than meets the eye and it can also be demonstrated that he is a genuine auteur by examining these films in more detail.

The first thing to note about Lewis is that he had a hands-on approach to film-making born out of necessity. The extremely low budgets he worked with meant that paying a large crew would have been impossible, and therefore Lewis would often perform a variety of roles – director (on every film), cinematographer, writer, composer, special effects technician and producer. This in itself shows a level of control over the film-making process, which is uncommon, even in low-budget productions. Lewis also often employed some of the same cast and crew from film to film. Alongside these elements of continuity, there is also further robust evidence to support a case for authorship and to give some credit where it is overdue.[2]

Stylistically the gore sextet is linked in numerous ways, and these recurring stylistic elements give a visual coherence and unity to the films, which shows that Lewis certainly did have an authorial stamp. It was *Blood Feast* that established most of the key traits to be found in the gore sextet. Shot on Eastmancolor film stock, *Blood Feast* features a lack of camera movement, jerky zoom shots, expanded time, a focus on bright primary colours (especially the heavily saturated red of Eastmancolor), melodramatic or overly wooden

Blood Feast © 1963 Friedman-Lewis Productions.

performances, sound recorded at source, distinctive music scoring, no real attempt at creating suspense and, most significantly, the extremely gruesome special effects set-pieces. *Blood Feast* also bears more than a passing resemblance to early silent cinema and Grand Guignol theatre, both of which relied heavily on spectacle, and this is also evident in the rest of the films.

The link to Grand Guignol is manifest in the staging of many of his gore set-pieces, especially the type of atrocities being committed; for example, eye trauma appears with great regularity, limbs are hacked off, and faces fried. Lewis takes it a step further, however, adding in disembowelment, brains and tongues ripped out, flayed skin, and a seemingly endless imagination regarding the weapons used for the destruction of the body, as well as filming the detail in lingering close-up. Notably, despite the excesses of these set-pieces, they are done with such over-the-top gusto and a sense of tongue being placed firmly in cheek, that it is hard to feel offended. And, just as French audiences had flocked to see Grand Guignol onstage, American drive-in audiences queued to see *Blood Feast*.

The plot of *Blood Feast* revolves around the gruesome killings of young women by Fuad Ramses (Mal Arnold) in preparation for an Ancient Egyptian 'blood feast'. Imagine the ghastly thrill of a film which does not even bother with establishing time, place or character, but simply starts with the sound of a determined ostinato drum beat as a maniac approaches a woman in a bath, gouges out her eye and then hacks off her leg leaving a gory mess! Only then do the credits roll (in blood-red typeface) as Lewis's strangely melancholic music plays over an image of a sphinx. As the story proceeds, the music often replaces dialogue. Indeed, the use of organ and piano is extremely reminiscent of silent cinema, not just in terms of telling the tale but also in the articulation of these particular instruments. Another aspect of the film which brings to mind silent cinema and Grand Guignol is the acting. Mal Arnold's performance

is one of the highlights, as he so knowingly over-acts the role of Ramses. Whenever he appears he stares wildly, gleefully rubs his hands together (like a silent movie villain), creeps around slowly, and delivers his lines in an exaggerated and comical manner reminiscent of Tod Slaughter in his silent cinema-inspired 1930s melodramas. This is in wild contrast to Connie Mason who plays wealthy, and supposedly cultured, Suzette Freemont. Mason's performance is so expressionless and wooden that it is difficult to consider it acting, but it somehow serves to heighten the effect of Mal Arnold's excesses. This ensures that none of the proceedings, despite their gruesomeness, can be taken very seriously.

By the film's end there have been five extremely gory deaths, little advancement of the narrative and absolutely no attempt at character development. Although this undoubtedly signifies a piece of film-making which can be regarded as poor quality, it also reveals something about Lewis's distinctive aesthetic. He was not attempting to make great art, he was attempting to make money and yet, in the process, he was creating work which was unlike that of anyone else. This was confirmed with his second gore film, *Two Thousand Maniacs*, which had the highest budget of the sextet. The entire production is more professional, apart from the 'anti-acting' technique of Connie Mason again (playing Terry Adams). The continued use of Eastmancolor gives the film a polished look which seems at odds with the content (as it did in *Blood Feast*). It even has a theme song, 'The South's Gonna Rise Again', and proper end credits. There is also a good deal of humour present in the film and a return of the 'mickey-mousing' silent cinema-style organ when an extended chase occurs.

The plot revolves around a ghostly Southern town called Pleasant Valley which was wiped out during the Civil War. It reappears a hundred years later for the townspeople to get revenge. They capture a group of 'Yankee' tourists and proceed to mutilate and kill all but two of them in typically grotesque ways. Notably in this film, Lewis makes greater use of camera movement and angles of shot, matches on action and fades, as well as experimenting with unusual camera positioning. In the barrel roll scene, for example, a character is pushed inside a beer barrel and nails are hammered into it before it is rolled downhill. The camera is actually placed inside the barrel and reproduces the nauseating tumbling sensation experienced by the victim. The increased budget gave Lewis greater freedom to experiment it seems. The film features all of the main Lewis traits as described previously but, unusually, it is almost thirty minutes before any blood is spilled. The first set-piece, however, is typically gruesome as a female victim has her thumb amputated convincingly in close-up and is then finished off with an axe. Henceforth, Lewis's earlier restraint is put to one side and three further victims are messily dispatched before the film ends.

Lewis's third gore film, *Color Me Blood Red*, tells the tale of an artist called Adam Sorg (Gordon Oas-Heim as Don Joseph) who resorts to killing young women for their blood in order to obtain just the right shade of red for his paintings. As made explicit by the title, and as usual with Lewis, the predominant colour is bright Eastmancolor red. In this film it appears everywhere – on paintings, leotards, sweaters and swimsuits, as well as in the bloodthirsty set pieces featuring disembowelment and, of course, eyeball trauma! Music often functions as a narrating device again and wild, jazzy, up-tempo scoring is used to move scenes along. The scoring in Lewis's films has been overlooked and yet it is a key feature in his work. It not only underscores the action (in sometimes bizarre ways) but it creates an energy that is not often found in very low-budget material. This jazz-based scoring would dominate Lewis's next three films, ensuring a high level of stylistic continuity alongside the other recurring traits so apparent in his work.

The final films in the sextet, *The Gruesome Twosome*, *The Wizard of Gore* and *The Gore Gore Girls*, cement Lewis's position as 'the godfather of gore'. They take the Grand Guignol elements to extremes, outdoing even *Blood Feast* in their gruesome detail. The deaths are inventive to say the least – scalpings, decapitation with electric carving knife, chainsaw deaths, disembowelment by punch press, heads smashed in, eyes pulled out

and fondled, buttocks beaten to a pulp and covered in salt, heads deep fried, faces ironed, and nipples cut off which then squirt milk and chocolate milk! This may sound revolting and in bad taste but, notably, Lewis's last two films become increasingly self-aware and he seems to be broadly winking at the audience. In *The Wizard of Gore*, for example, the eponymous Montag the Magician (Ray Sager) melodramatically states that 'torture and terror have always fascinated mankind' and proceeds to muse on the death and nastiness seen in films and on television. Undoubtedly, Lewis is articulating a point about his own work while at the same time encouraging the audience to see it as just an illusion like the ones which Montag creates. Furthermore, in *The Gore Gore Girls*, at the end of the film the protagonist Abraham Gentry (Frank Kress) looks direct to camera and says to the audience 'You've seen enough' and draws down a shade. This is a deliberate, even Brechtian, engagement with the audience by Lewis and a comment on their fascination with gruesome spectacle.

Lewis, then, was a pioneer and he paved the way for increasingly gory horror films. However, he can also be legitimately regarded as an auteur, as not only do his films have clear stylistic continuity, they also have recurrent themes. He situated his horrors firmly in the realms of middle-class contemporary America, allowing him to poke fun at teen culture, family relationships, snobbery and ineffectual policing. In some respects, Lewis's films can even be regarded as a more extreme form of Sirkian melodrama. He certainly had no problem systematically 'dismembering' the mores of conservative US society.

Shelley O'Brien

References

Curry, Christopher Wayne (1999) *A Taste of Blood: The Films of Herschell Gordon Lewis*, London: Creation Books.

Lewis, Herschell Gordon & Rausch, AJ (2012) *The Godfather of Gore Speaks*, USA: BearManor Media.

Notes

1. In 2002, Lewis made a comeback of sorts with *Blood Feast 2: All U Can Eat*, his first film in thirty years. This was followed in 2009 by *The Uh! Oh! Show*, which concerned a television game show where the contestants are dismembered for every wrong answer.
2. For example, similar cases have been made for the work of Russ Meyer and Andy Milligan.

TERRENCE MALICK
Days of Wonder

There are always birds and often birdcages; sometimes empty. There are houses, with windows and doorways open to the world outside where the skies are big. A doorway stands alone in the desert. A river runs through every film, kids play on the shore, soldiers run into the sea, the tide comes in on the lovers and we dive into water as if it were the portal to another happier dimension. And there's weather, the rosy-fingered dawn or crepuscular dusk, the sunlight suddenly gracing the grassy hill. There is a fire: a house, a crop or a village goes up in flames, silently or to the accompaniment of children singing. There is violence, murder and war. His camera is at once inquisitive, searching, or meandering, glancing. And then there are the voices. The self-fabulating solo voice, richly accented ruminations, stories, whispered prayers, questions, imprecations, epiphanies, the building chorus, the internal monologue of an entire Company.

From his celebrated debut *Badlands* (1973) to his recent burst of creative energy peaking with the Palme d'Or triumph of *Tree of Life* (2011), Terrence Malick has had a massive influence on American film-making. His films have been quoted, referenced and to some extent remade – see Tony Scott's swooning *True Romance* (1993) – and in the process have created a visual vocabulary and aural soundscape that now leaks into the work of other directors, as well as advertising. Car and beer commercials strive for a Malickian embracing of universal experience as much as fledgling independent directors (Andrew Dominik and David Lowery), or even superhero films – the trailer for *Man of Steel* (Zack Snyder, 2013) was lauded as Malickian on first sighting (Gilchrist 2012). The whispered voice-over, the magic hour photography with a cannily chosen piece of contemporary music, the attention to the precisely captured fabric of life, the humourlessness, the solemn striving for some religious/philosophical answer and the prodigious capacity of his female characters to dance, has also left the director open to parody and, especially with his divisive last three films *Tree of Life*, *To the Wonder* (2012) and *Knight of Cups* (2015), increasingly loud protestations of imperial nudity. And yet Malick still stands – no longer as enigmatically beyond reproach as he once was despite his continued refusal to play the media game – but still there, along with Woody Allen, as one of the few American auteur film-makers to have come of age in the *decade mirabilis* of 1970s Hollywood and survived through to the new millennium.

And yet Malick's debut seems like a modest beginning. The true crime/lovers-on-the-run plot reads on paper as a low-budget update of *Bonnie and Clyde* (1967), directed by Arthur Penn, who also receives an acknowledgement in the credits having stood as an early mentor to Malick. In Martin Sheen and Sissy Spacek, Malick's two leads were practically unknown – and became the first in an impressive cadre of acting talent to owe their breakthrough to the director. Based on the true story of the Charles Starkweather murder case, Malick privileges the dreamy point of view of Holly (Spacek), a teenaged girl who meets and begins a tentative romance with Kit (Sheen). When Holly's father tries to quash the relationship, Kit murders him and the pair hit the road.

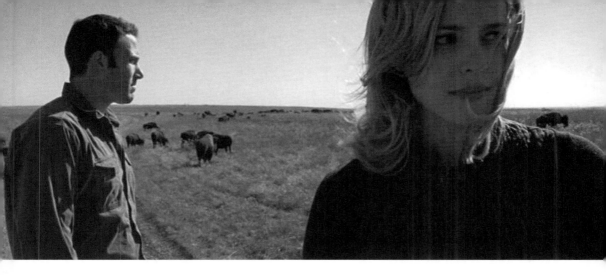

To the Wonder © 2012 Brothers K Productions,
Redbud Pictures

Despite Holly's insistence on narrating the film as if it were a teen romance, the young lovers defy their generic stereotypes. They are not particularly interested in sex – 'I don't see what all the fuss was about,' says Holly after losing her virginity and refusing Kit's bizarre suggestion (one of many) that they crush their hands with a rock to make the moment more memorable. The violence as well is childlike in both its cruelty and its absence of affect or glamour. 'Found a toaster,' Kit mentions, returning from the cellar where he's just stowed the freshly murdered corpse of Holly's father. Such is the bored acceptance of violence that never has a killing spree been less spree-like. Rather than a fast and furious pursuit, Holly and Kit dawdle, get distracted and go through the motions. Kit's name suggests a young man making himself up as he goes along. He poses and mumbles, seeking to impress an indifferent world with his callow James Dean impersonation and fakes his signature, to what end is unclear even to him. Holly and Kit make camp, play house and dress up, but are soon fecklessly bored, even with each other by the end.

Coming four years later, *Days of Heaven* (1978) was also a story of two star-crossed lovers caught in a particular moment of American history: this time the year is 1916. Fleeing once more a violent crime – possibly a murder – Bill (Richard Gere) and Abby (Brooke Adams), along with her young sister Linda (Linda Manz), head for the Texas pan handle where they work as farm hands on a wealthy estate. Claiming to be brother and sister to avoid gossip, Bill sees an opportunity to escape their precarious hand-to-mouth existence when he discovers that the farmer (Sam Shepherd), on whose land they work, and who has fallen for Abby, is terminally ill.

The story is looser. Unconstrained by a pulpy origin, it strives for something more elemental, biblical even, with its plague of locusts, hell fire and sense of original sin. If *Badlands* was poetic prose, then *Days of Heaven* was out-and-out poetry. The music in *Badlands* had often been an ironic commentary – the Nazi's official composer Carl Orff's songbook for children investing scenes of fire and destruction with a sense of giddy play. Here, the visuals, photographed by Néstor Almendros, and the music, scored by Ennio Morricone substantially redeploying the seventh movement from Camille Saint-Saëns's *Carnival of the Animals* (1886), 'Aquarium', work together.

Days of Heaven is rooted in dirt, poverty and desperation, but it aspires to the cleansing touch of a beautiful but indifferent nature. The cleansing river to which the lovers take as an escape route becomes Bill's death mask as he falls into it. It is also grounded by Linda Manz's left-field voice-over, which rather than narrating creates a word picture to rival the cinematography: 'Weren't no bad in him. Give him a flower, he'd keep it forever.'

Badlands and *Days of Heaven* established the essentials of what would remain Malickian to this day: the extensive magic-hour photography; the surprising, original and highly effective musical choices; the narration which voiced the movie more than the dialogue, but which also told its own story; and the sense of something profound happening further away than the story itself. *Days of Heaven* also marks the beginning of a Malick legend: the difficult production, the throwing out of the script, and the protracted editing process that took two full years and during which Malick somehow burrowed into the miles of footage and found the film. The legend would receive further gloss, embroidery and exaggeration due to Malick's subsequent disappearance: a twenty-year absence during which the myth would grow of the artist who the studios could not handle, the philosopher and the closest thing Hollywood ever came to having a poet.

The silence was broken with what at first glance seemed an odd choice – a big-budget war film with a massive and star-studded ensemble – *The Thin Red Line* (1998). However, it soon became apparent that Malick had carried on almost exactly where he had left off twenty years earlier. Again, he is a chronicler of American history through a Brueghelian attention to the stories of the bystanders, the attendants and the marginalized. Narratively, the film is a straightforward retelling of James Jones's other World War II novel, following the battles and losses of the men of C Company from boat to Hill 201 and back again.[1] Yet, in stark contrast to the other big World War II film released in the same period, Steven Spielberg's *Saving Private Ryan* (1998), Malick's film is uninterested in hymning the virtues of the 'good war' and the 'Greatest Generation'. The Homeric military ideal is a form of psychosis, an atavistic grapple that is savage and unadorned with politics or an ethos. Beneath the bravado, the bravery and cowardice, there is a constant questioning not only of war itself but of our wider place in the world, the universe even. The intimate self-mythologizing of his first two films is replaced with a choral internal monologue of the entire platoon, from Colonel Tall's fears to Pvt Dolls's reaction to killing his first man: 'killed a man, worst thing you can do. Worse than rape. And no one can touch me for it.'

The choral effect often means that no voice is identified. 'Maybe all men are part of one big soul,' a voice wonders, quoting Steinbeck's Tom Joad, but despite the merging voices one character peers out from the film as the first unabashedly Malickian hero. Whereas the lovers of *Badlands* and *Days of Heaven* are almost unwitting in their actions, victims of circumstance and their own drives and – in the case of Kit – psychosis, gaining no deeper insight, Pvt Witt (Jim Caviezel) is the projection of the director's gaze, capable of awe, tearing up at natural beauty and feeling things through and through. He seems to hear the music on the soundtrack. A spiritual being, though one engaged in the world – he wants to fight – he is also selfless in his devotion to the company and his sacrifice is Christ-like: Jim Caviezel would go on to play Jesus in Mel Gibson's *The Passion of the Christ* (2004). The worldly and cynical Sgt Welsh (Sean Penn) stands as a materialist foil to Witt's Midwest invocation of the 'Glory', but by the film's end he is a survivor who can only bear witness to loss. His sense of defeat and entrapment is almost total, quoting Stephen Crane's *Red Badge of Courage* (1895): 'We're in a box, a moving box.'

The Thin Red Line also manages to continue Malick's tendency to split critics, even occasionally split critique – *The Guardian*'s Jonathan Romney (1999) expressed his own ambiguous reaction by giving the film five question marks instead of five stars. A fair expectation would have been for Malick to return to Paris and whatever pursuits had preoccupied him for his twenty-year absence. However, his next film *The New World* (2005) carried Malick's interest in American history back to the Birth of the Nation. The Malickian hero is once more present but is now a heroine, in the unnamed Pocahontas role (Q'orianka Kilcher) and in effect the original mother of America. She will act as the ambassador between the New and the Old World and her intercession saves the struggling Jamestown colonialists, while her relationships with, first, Captain John Smith (Colin Farrell), the soldier, frontiersman and explorer – and romantic hero – and subsequently with the pragmatic farmer, tobacco planter and proto-capitalist John Rolfe (Christian Bale), almost represent in microcosm a process of settlement. These relationships, though loving, effectively civilize and destroy her, but not before making her the first American celebrity in her visit to the English court and her royal audience with King James (Jonathan Pryce). Dressed in European clothes and walking around the topiary and lawns of England, the playful free spirit we witness at the beginning will, like Witt, only rediscover her true freedom following her premature death.

From an eclectic history of America spanning the first settlers through World War II to the nascent youth culture of the 1950s, Malick has progressed to a Walt Whitman-esque Song of Himself, within which is incorporated the ambitious inquiries into our place in the Universe. *The Tree of Life* is a portrait of the artist as a small man, playing out on a cosmic scale. Following the premature death of a sibling, elder brother Jack (Sean Penn) spends the anniversary of his brother's death recalling the time spent with his siblings in one particular childhood home; his difficult relationship with his martinet father (Brad Pitt); and his worship of his idealized mother (Jessica Chastain). Framing this intensely realized recollection is nothing less than a biography of the universe, seen through a mix of astrophysics and scriptural allusion. There is a heartfelt yearning for consolation and meaning, but the film lapses into prayer card/New Age cliché on occasion. Dialogue is almost entirely absent, with adult Jack being a wordless echo of Sgt Welsh's desperate sense of entrapment.

To the Wonder is the sonata to *The Tree of Life*'s symphonic ambition. Once more plumbing his own private life for material, the film tells the 'story' of Neil (Ben Affleck) and Marina (Olga Kurylenko), from their European romance – typified by a visit to Saint Michel (the Wonder of the title) – through to their American dissolution and separation. In a follow-on from *The New World*, America is now a polluted, urbanized and alienated society where a priest (Javier Bardem), who has lost his faith, tries to ignore the demands of his poor parishioners, and where the dancing is now done by the disappointed French ballet dancer rather than the mother of the nation, to the obvious disapproval of Neil. The sonata is in the key of water, the tide comes in, the river runs and water goes down the drain. It is unique in Malick's filmography in not having a fire. The couple are not beset by the major problems of Kit and Holly or Bill and Abby. Rather their disintegration is ordinary and domestic, made up of dissatisfaction, incomprehension and petty jealousies. The film is at once discomfortingly intimate and yet at the same time the dialogue is almost entirely removed from the world. Nobody talks, except to themselves. Poised on the edge of indifference, *To the Wonder* is Malick's smallest film to date and the one which has met – so far – with the harshest critical response.

At the time of writing, there are three new Malick projects awaiting imminent release: a documentary, *Voyage of Time*; a new dramatic feature *Knight of Cups*

(2015); as well as an as-yet untitled feature, which are all slated for release in the next few years. And so his six-film filmography could swell in a relatively short space of time to nine and his reputation could easily progress in another direction. From the talented burnout to one of the most prominent American arthouse-directors, this maverick visionary might only just be hitting his stride.

John Bleasdale

References

Gilchrist, Todd (2012) 'Man of Steel Teasers Turn Zack Snyder into Terrence Malick', The Hollywood Reporter, 21 July, http://www.hollywoodreporter.com/heat-vision/man-steel-teasers-zack-snyder-superman-terrence-malick-352769. Accessed 20 July 2015.

Romney, Jonathan (1999) 'The Thin Red Line: Review', The Guardian, 26 February, http://film.theguardian.com/News_Story/Critic_Review/Guardian/0,,31612,00.html. Accessed 20 July 2015.

Note

1. *From Here to Eternity* (1951) was James Jones's debut novel; it was filmed by Fred Zinneman in 1953 with Montgomery Clift and Burt Lancaster in the lead roles.

DAVID MAMET

Profanity, Flimflam and the Power of What Happens Next

David Mamet was born in Chicago, where he grew up in an educated household – his parents were a schoolteacher and a labour attorney – in a Jewish neighbourhood. He attended public schools and the independent Francis W Parker School, and he did some acting, playing a soda-fountain clerk on a Chicago television show geared towards Jewish teens and working for the theatre programme at Hull House, a highly respected community centre. These activities ended when his parents divorced and he moved to a suburb with his mother. He went to Goddard College in Plainfield, Vermont, studying theatre and literature; his contemporaries there included the actors William H Macy and Jonathan Katz, who would later appear in his movies. Mamet also trained at the Neighborhood Playhouse School of Theater, a well-regarded institution in New York, where he spent his junior year.

He graduated from Goddard in 1969 with hopes of acting professionally but no clear plan for getting a foothold in the profession. After serving in the merchant marine and working at various short-term jobs – maintenance worker, taxi driver, real estate salesperson, and the like – he moved to Montreal and joined a McGill University theatre company. Then he landed an instructor position at Marlboro College in Vermont, where he taught in the drama department and discovered his vocation as a playwright. After a short time he was at Goddard again, now as an artist in residence and founder of the St Nicholas Theater Company, which performed the plays that he was busily writing. He subsequently took the plays and the company to Chicago, where he taught at the University of Chicago and the Pontiac State Prison while refining his writing skills.

Mamet's first important play was the semi-autobiographical *Lakeboat*, which draws on his merchant-marine experiences; it was written and staged at Goddard in 1970 and professionally produced ten years later. He earned greater acclaim for *The Duck Variations*, a 1972 play in which two old men have a meandering conversation about ducks, nature and the meaning of life. *Sexual Perversity in Chicago* won Chicago's esteemed Joseph Jefferson Award for best new play of 1974, and a larger breakthrough happened when *American Buffalo* arrived on Broadway in 1977, winning the New York Drama Critics Circle Award for best play of the season with its tightly coiled account of three men planning a petty theft. Other theatrical milestones include *Glengarry Glen Ross*, which garnered the Pulitzer Prize for Drama in 1984 by depicting four businessmen scrambling for a living in the real estate trade, and *Oleanna*, a 1992 play about conflict between a bitter professor and a feminist student. The latter production opened Off-Broadway in New York after debuting as the first offering of Mamet's own Back Bay Theater Company in Cambridge, Massachusetts.

Mamet's movie career grew directly from his work in the theatre. He earned his first movie credits by writing the screenplays for Bob Rafelson's *The Postman Always Rings Twice* (1981) and Sidney Lumet's *The Verdict* (1982). His first film as both writer

House of Games © 1987 Filmhaus, Orion Pictures

and director, the aptly titled *House of Games* (1987), taps into his fascination with social and personal deception. Similar concerns fuel his comedy-drama *Things Change* (1988), co-written by Shel Silverstein, and his police thriller *Homicide* (1991). Mamet subsequently directed a movie version of *Oleanna* and wrote screen adaptations of *Glengarry Glen Ross* (1992; directed by James Foley), *American Buffalo* (1996; directed by Michael Corrente) and his 1982 play *Edmond* (2005; directed by Stuart Gordon), in which he probes American anxieties about race, sexuality and violence. Barry Levinson's *Wag the Dog* (1997), adapted by Mamet and Hilary Henkin from a novel by Larry Beinhart, is a classic satire of political double-dealing in the media.

In the new millennium, Mamet underwent a political conversion, proclaiming his new positions in a 2008 essay for the *Village Voice* titled 'Why I Am No Longer a "Brain-Dead Liberal"'. There he embraced a familiar list of conservative staples: rejecting gun control and government intervention, for instance, while hailing corporate benevolence and military power. His screen work since then includes the CBS television series *The Unit* (2006–09); the television movie *Phil Spector* (2013); and several comedy shorts. Mamet has also written numerous books on subjects ranging from anti-Semitism to the art of movie directing.

Mamet's movies and plays are immediately recognizable by the presence of two trademarks. One is the massive quantity of indecorous, profane and all-around dirty language that his characters typically employ. While this would make for triteness and monotony in less dexterous hands, Mamet is a virtuoso of the cussword; a case in point is *Glengarry Glen Ross*, where he serves up 'fuck' and its variations almost incessantly yet still manages to electrify the listener with a precisely timed, viciously spoken '*Fuck you!*' at the climax.

His other trademark is the remarkably consistent style he imposes on the lines that he writes and on the actors who speak them. Sometimes called Mametspeak, his dialogue is clipped, direct, and so rhythmic that it might have been rehearsed with a metronome,

which it sometimes was in his early years as a director. To avoid glib emotion and facile psychology in his writing, he places emphasis on key words and phrases by means of repetition rather than change of volume or tone of voice. With minor adjustment the same devices can convey uncertainty or hesitation, especially when combined with gaps, ellipses or sentences broken into fragments. A brief speech in *The Spanish Prisoner* (1997), spoken by an FBI agent, illustrates the technique's effectiveness for stressing an essential aspect of a feeling or idea:

> It's an interesting setup, Mr Ross. It is the oldest confidence game on the books. The Spanish Prisoner. 'S how far back it goes, the Glory Days of Spain. Fellow says, him and his sister, wealthy refugees, left a fortune in the Home Country. He got out, girl and the money stuck in Spain. Here is her most beautiful portrait. And he needs money to get her and the fortune out. Man who supplies the money gets the fortune and the girl. Oldest con in the world. Intelligent people – play on their vanity and greed... interesting twist.

Fragments abound. The words 'money' and 'fortune' appear three times each, while 'oldest confidence game' and 'oldest con' bracket the speech, appearing near the beginning and the end. In addition, the staccato cadences of the phrases underscore the authority of an expert who can provide useful information with a no-nonsense punch.

Not found in this speech, or in scores of speeches like it, is what Mamet would call 'inflected' language. Mamet has a passionate preference for 'uninflected' dialogue and images. 'You always want to tell the story... through a juxtaposition of images that are basically uninflected' (Mamet 1991: 2), he writes in his 1991 book *On Directing Film*, where he argues further that the step-by-step progression of a 'story' is the only thing that matters to an audience. 'Interest in a film comes from this,' he declares: 'the desire to find out what happens next' (Mamet 1991: 63). Period. Later he defines 'the essential nature of acting in film' by asserting that like a good story, a good performance must be 'created by the juxtaposition of simple, for the most part uninflected shots, and simple, uninflected physical actions', always done 'as simply and *as unemotionally* as possible' (Mamet 1991: 75, 76, original emphasis). Although he rarely indicates just what he means by 'uninflected', Mamet sometimes uses Soviet montage theory to support his insistence that 'the best image' is always a straightforward shot of a single object (Mamet 1991: 8). The director who forsakes this narrow path is indulging the 'Cult of Self', defined as 'the cult of how interesting you and your consciousness are' (Mamet 1991: 106), which is the last thing an audience will find compelling. Good actors will 'not *emote*, not *discover*, but do what they're getting paid to do, which is to perform, as simply as possible, exactly the thing they rehearsed' (Mamet 1991: 71, original emphasis). As for dialogue, its purpose 'is not to carry information about the "character." The only reason people speak is to get what they want' (Mamet 1991: 71).

In some respects, Mamet's fervour for the uninflected presents a refreshing alternative to both the fussiness of bad art cinema and the messiness of bad commercial cinema. In other respects, though, his unwavering insistence on the simple and straightforward reflects a strangely cramped view of directing, writing and acting. Is it mere curiosity about what happens next that has made Stanley Kubrick's *2001: A Space Odyssey* (1968) or Robert Altman's *Nashville* (1975) or Terrence Malick's *The Thin Red Line* (1998) into modern classics? If plot curiosity is essential to audience involvement, why do we watch our favourite movies many times, finding new pleasures even though we know what happens next? In good Shakespeare films, does the dialogue refrain from informing us about the characters, and do they speak only to get what they want? Do the compelling actors influenced by Method practices – Marlon Brando, Marilyn Monroe, Robert De Niro, Meryl Streep – work their magic by refusing to discover or emote?

Mamet's view is also profoundly conservative. He disparages 'modern art' in *On Directing Film*, and he has special scorn for 'performance art', which he always puts in scare quotes and likens to the 'neurosis […] of a disordered mind' (Mamet 1991: 61). Performance art is Mamet's term for any work that does not build sufficient curiosity about what happens next; to compensate for this shortfall, the artist resorts to excess, stunts and distractions, becoming steadily more bizarre or 'outré' and ultimately leading the culture as a whole 'to degenerate into depravity, which is what we have now' (Mamet 1991: 63). These are unexpected notions from a writer whose flamboyantly crude language and narrative hocus-pocus have themselves brought accusations of decadence, excess and self-indulgence. The influential *New York Magazine* critic John Simon, for instance, doubted that even the scabrous characters of *Glengarry Glen Ross* would use such a 'mangled and mephitic' vocabulary; then he disparaged the play as 'mud wrestling' and questioned the values of 'a theater – of a culture – that considers this stuff high art' (Simon 2005).

Mamet's tendentious stances notwithstanding, his theories have proved reasonably expedient in his own films. One reason for this is the skilful handling of his clipped-off dialogue by actors – most notably Macy, Joe Mantegna, Ricky Jay and Rebecca Pidgeon – who share his wavelength, work with him repeatedly, and thoroughly understand his techniques. A more important reason is that Mamet often strays pretty far from his own rules. In his theoretical writing, examples of the uninflected shot tend to be prosaic: a teacup, a spoon, a door, two guys walking down the street, one starts talking to the other… In his movies, however, they can be rich with atmosphere; see for instance his shots of the Las Vegas hotel suite and the mansion of the godfather (Robert Prosky) in *Things Change*; shots of Mantegna brooding over a crime scene or a figurine showcase in *Homicide*; or shots of the lavish, lonely dinner party presided over by the mayor (Charles Durning) in *State and Main* (2000). Then too, the expressive faces of Mamet's actors bring layers of psychological interest that are far from uninflected. Macy, Mantegna and Pidgeon are gifted minimalists, able to convey more with a cocked eyebrow or faint smile than some Hollywood stars can communicate with their entire bodies.

The steadiness of Mamet's favoured acting style is matched by the steadiness of his main philosophical theme: a conviction that human interactions of all kinds, from business and education to friendship and love, amount to unpredictable gambles that always have elements of trickery and flimflam about them. His debut movie, *House of Games*, presents one of the clearest statements of this idea, examining it from multiple angles via plot machinations involving con artists, a psychiatrist and a suitcase of money belonging to the mob. The theme returns in *Things Change*, about a gentle Italian immigrant (Don Ameche) who agrees to sign a false confession for a fee; and it takes on added intellectual heft in *Homicide*, which begins as a detective story about a Jewish cop (Mantegna) investigating the murder of a Jewish woman and becomes a reflection on religion, ethnicity and loyalty when he comes upon organized anti-Semites and ardent Zionists whose intrigues pose a challenge to his dormant Jewish consciousness. Mamet's own religious sensibilities find their first full expression in *Homicide*, and it is arguably his most fully realized film. His subsequent films prepared directly for the screen, such as *The Spanish Prisoner* and *State and Main*, are comparatively lightweight affairs, although some pictures that seem at first to be acts of commerce – the martial arts drama *Redbelt* (2008), for instance, and the true-crime television movie *Phil Spector* – offer considerable rewards.

It is ironic that Mamet the energetic film-maker and prize-winning playwright has found only limited success in transferring his stage works to the screen. *American Buffalo* had a vibrant Broadway production starring Robert Duvall, Kenneth McMillan and John Savage, yet the movie version directed by Corrente is unmemorable despite

having Dustin Hoffman, Dennis Franz and Sean Nelson in the cast. *Glengarry Glen Ross* also excelled on Broadway, with Mantegna, Robert Prosky and JT Walsh among the players, but the combined talents of Al Pacino, Jack Lemmon, Alec Baldwin, Alan Arkin, Ed Harris, Kevin Spacey and Jonathan Pryce fail to lift Foley's film version to similar heights. Mamet himself directed Macy and Debra Eisenstadt in the screen version of *Oleanna*, which was riveting in its initial Off-Broadway run; again the movie was a disappointment, lacking the stage production's meticulous balance between characters afflicted with diametrically opposed forms of ideological obtuseness. The bright exception to this pattern is Gordon's low-budget version of *Edmond*, which arrived onscreen with a splendid cast including Macy, Pidgeon, Mantegna and Julia Stiles, who make up in dramatic passion what the production lacks in polish and finesse.

One hopes that Mamet will be able to align his playwriting and film-making skills more productively as the late phase of his career unfolds.

David Sterritt

References

Mamet, David (1991) *On Directing Film*, New York: Penguin.
————— (2008) 'Why I Am No Longer a Brain-Dead Liberal: An Election-Season Essay', *The Village Voice*, 11 March, http://www.villagevoice.com/news/david-mamet-why-i-am-no-longer-a-brain-dead-liberal-6429407. Accessed 15 December 2013.
Simon, John (2005) 'A Bad Business', *New York Magazine*, 16 May, http://nymag.com/nymetro/arts/theater/reviews/11920/. Accessed 15 December 2013.

JOHN CAMERON MITCHELL
In Search for Catharsis and Comfort

John Cameron Mitchell adapted, directed and starred in *Hedwig and the Angry Inch* (2001), his first film, which derives from the 1998 rock musical of the same title. The musical's book was by Mitchell, and the music and lyrics by Stephen Trask. Both the musical and the film have garnered cult followings. The musical won a *Village Voice* Obie Award and the Outer Critics Circle Award for Best Off-Broadway Musical. Its recent Broadway revival (2014) won Tony Awards for Best Revival of a Musical, Best Lead Actor in a Musical for Neil Patrick Harris, and Best Featured Actress in a musical for Lena Hall, who plays Hedwig's husband Yitzhak. *Hedwig and the Angry Itch* was one of the first musicals to be shot in the Canadian city of Toronto, and it speaks to the city's wide-ranging filmic personas (Ue 2014: 7). Through musical numbers and monologues, Hedwig, an East German transgendered singer, charts her life story: Hedwig undergoes a sex change to marry an American GI and, together, they move away from East Berlin. The soldier leaves Hedwig, who subsequently forms a rock band and meets and falls in love with Tommy Speck (Michael Pitt), whom she gives the stage name Tommy Gnosis, the surname of which is the common Greek noun for 'knowledge'. Tommy abandons Hedwig to become a successful rock star using songs written by the two of them when they were together, and Hedwig follows Tommy's tour around the country.

Internationally acclaimed, the film was recognized with a Golden Globe nomination for Mitchell's leading-role performance, and it won Best Film (Teddy Award) at the Berlin International Film Festival and the 2001 Sundance Audience Award (Audience). Some of the musical's numbers, including 'The Origin of Love', are widely performed today. But more importantly, the film introduced us to Mitchell: his sensitivity to visual style; his deft handling of metanarratives (the film repeatedly calls attention to its own construction and numerous subplots are suggested and introduced throughout); his interest in human psychology alongside broader social issues (Germany's history is an informing presence); and his concern over gender and sexuality.

Shortbus (2006), Mitchell's second film, was also written and directed by him, but it was developed with the film's actors through improvisation workshops. An audition website attracted hundreds of tape submissions, from which the film's actors were cast and with whom the characters were developed. The film premiered at the 2006 Cannes Film Festival and producers Howard Gertler and Tim Perell received a 2007 Independent Spirit Award. Set in Mitchell's home, New York, a year after 9/11, *Shortbus* weaves together the stories of a sex therapist (Sook-Yin Lee) (or couples counsellor, as she prefers to be called), who cannot have orgasm; a couple (PJ Deboy and Paul Dawson), who want to open up their relationship, and their stalker (Peter Stickles); a dominatrix (Lindsay Beamish), who wants real human interaction; and many others. The film's concerns, the breadth of its colour scheme and its treatment of sexuality – here, real sex is explicitly featured – are very much in keeping with *Hedwig*'s, but the subtext is the sense of alienation that comes with living in a postmodern city, something with which the film's viewers may well relate. As Jim Emerson puts it,

Rabbit Hole © 2010 Blossom Films, Lionsgate,
OddLot Entertainment

Shortbus is full of wounded, fractured people trying to shove themselves back together. Just as the genitally stunted Hedwig personified sex as the Great Divide, the new Berlin Wall that was also a bridge ('Without me right in the middle, babe, you would be nothing at all'), the characters in *Shortbus* focus on sex as a way of getting through to each other, and getting in touch with themselves. It's a gleefully randy romantic roundelay, in the tradition of Max Ophuls' serially sexual French comedy *La Ronde* (1950). Polymorphously pornographic, sure; but it doesn't feel the slightest bit obscene. And that's a neat trick. (Emerson 2006)

New York, we are repeatedly told in the film, is too expensive to live in, and the city is shown to us through an animation sequence created by John Blair. This richly detailed virtual city approximates a hand-painted model. Crucially, the close proximity of the city's inhabitants offers no guarantee that they are able to connect: Jamie and James, partners for five years, have grown emotionally distanced, with the latter contemplating suicide. The reasons for this are never fully explained. If the salon in *Shortbus* provides these disparate characters with a space for personal, artistic and sexual expression, then the film, as a whole, similarly operates as a carnival wherein these energies are celebrated.

In *Hedwig and the Angry Itch* and in *Shortbus*, Mitchell and DeMarco are arguably experimental in their use of colour, but in their most recent film, *Rabbit Hole* (2010), by contrast, we find a quieter colour scheme and a realistic tone. *Rabbit Hole* is an adaptation of David Lindsay-Abaire's Pulitzer Prize-winning 2006 play. The New York production won a Tony Award for Best Performance by a Leading Actress in a Play for Cynthia Nixon and nominations for Tyne Daly (Featured Actress), Daniel Sullivan (Direction) and John Lee Beatty (Scenic Design). From this material, Mitchell crafted what, he hoped, 'could be the Ordinary People of our generation that people look to for comfort' (Harris 2011). The film premiered at the 2010 Toronto International Film Festival, where it received a standing ovation and international recognition for Mitchell

and leading actress Nicole Kidman: Mitchell received an Independent Spirit Award nomination, while Kidman, who co-produced the film, received Academy Award, Golden Globe and Screen Actors Guild nominations for her performance as Becca.

The film opens with establishing shots of an upscale suburban community on a beautiful spring day, wherein we find Becca (Kidman) gardening. The camera lingers on and provides us with different clues (e.g. an empty doghouse), before revealing, through delayed decoding, that Becca and her husband Howie (Aaron Eckhart) are grieving over the death of their 4-year-old son Danny (Phoenix List) after he chased their dog into the street and was hit by a car. The film shows Becca and Howie and their different ways of finding comfort. While Becca removes traces of Danny and finds solace in conversing with Jason (Miles Teller), the teenage driver of the car, Howie tries to cling on to the few reminders that they have of their son. And whereas Becca wants to sell their house, Howie hopes to protect the memories that they shared. As with *Hedwig and the Angry Itch* and *Shortbus*, *Rabbit Hole* is rich in subplots and in Mitchell's figuring of minor characters. Some of these embedded narratives include Becca discovering how her work life was replaced by her family; Becca's mother Nat (Dianne Wiest) grieving her son, who died of a drug overdose; and Becca's sister Izzy (Tammy Blanchard), who is pregnant.

Rabbit Hole is not melodramatic despite its potential to be so. It is restrained but characteristically Mitchell, with its effective blending of drama and comedy, and its keen attention to detail. In an interview with Chad Jones, Lindsay-Abaire remembers seeing the film at the Toronto premiere:

> The play works because there's a lot of comedy, and that gives the characters the breathing room they need to go on this journey. For the film, we cut so much that worked in the play that I worried we had cut all the laughs. But there were all these other laughs I didn't know were there. (Jones 2011)

The film was shot with a RED Digital Camera, which enabled Mitchell to home in on the actors and their consistently strong performances and to translate, visually, the complexity of Lindsay-Abaire's words. We find evidence of this in Nat's different treatment of her daughters Becca and Izzy, much of which is expressed non-verbally: Nat's awkwardness around the former is matched by her more vocal disapproval of the latter. *Rabbit Hole* ends optimistically, and it leaves open the possibility that Becca and Howie can start afresh. Lindsay-Abaire concludes his screenplay, based on his original play, as follows:

> Becca looks to Howie. They both look a bit scared. She reaches over and takes his hand… for the first time in a very long time. It's a simple gesture – not of resolution – but of possibility. Howie holds on tight. And we… (Lindsay-Abaire n.d.: 96)

As private as grief is, Mitchell shows that it is universal. Despite Becca's protestations about a comparison between Danny and her brother, because Danny was chasing their dog and her brother had overdosed, Nat's feelings are neither less sincere nor less strong than Becca's. The film, thus, shows how the characters – and we, as the film's viewers – are bonded through tragedy. It is universal in its resonance, and this is very much in keeping with Mitchell's oeuvre. We might not identify with Becca or Nat, but Mitchell's works are filled with complex characters who are scarred, disconnected and vulnerable, and who work out their personal frustrations, whether sexual, cultural or social, through these films.

Tom Ue

Referenes

Emerson, Jim (2006) 'Shortbus', RogerEbert.com, 19 October, http://www.rogerebert.
com/reviews/shortbus-2006. Accessed 11 August 2014.

Harris, Brandon (2011) 'John Cameron Mitchell, "Rabbit Hole"', Film-maker, 22
February, http://film-makermagazine.com/16843-john-cameron-mitchell-rabbit-
hole/#.U-bbwlYQ7wl. Accessed 10 August 2014.

Jones, Chad (2011) '"Rabbit Hole" Pleases Writer David Lindsay-Abaire', Times Union,
10 March, http://www.timesunion.com/entertainment/article/Rabbit-Hole-pleases-
writer-David-Lindsay-Abaire-1059137.php. Accessed 10 August 2014.

Lindsay-Abaire, David (n.d.) Rabbit Hole, unpublished.

Ue, Tom (2014) World Film Locations: Toronto, Bristol: Intellect.

ERROL MORRIS
Re-Enactment and Re-Conception

As a film director, Errol Morris has an illustrious origin story: Werner Herzog baited him with a promise to 'eat my shoe' if Morris would finish his first documentary feature. After Morris completed *Gates of Heaven* (1978), Herzog – a man of his word – literalized the figure of speech and in the process became the subject of a short film by Les Blank, *Werner Herzog Eats His Shoe* (1980), in which he said: 'It should be an encouragement for all of you who want to make films, and who are just scared to start, and who haven't got the guts, so you can follow a good example' – namely, Morris. Herzog clearly recognized something distinctive in Morris's approach to film-making – worth the challenge to Morris and worth the risk of ingesting leathery soup – and in the many films Morris has made since then, and the accomplished after effects of that bet, Morris has created works full of care, facility and insight. A significant part of Morris's conceptual innovations for documentary film-making begins and resides in his approach to the craft itself.

One of the most innovative aspects of his material engagement with film-making – one that has become instantly recognizable as Morris's quintessentially 'direct-to-lens style' – is known as the Interrotron.[1] Any viewer of television or documentary interviewers will be familiar with the customary framing of the subject (close-up, head off-centre, background softly lit and out-of-focus, eyes looking *past* the lens to the presumed interviewer, etc. think *60 Minutes*).[2] Morris created a camera/mirror/teleprompter/lens configuration that welcomes the gaze of the interviewee (who sees the live image of the director) *without* the intimidation of an aggressively pointed camera lens, thereby making it possible to capture a person, as it were, face-to-face with the (eventual) viewer, in a position and posture of tremendous urgency and intimacy. As the viewer faces the screen head-on, so the subject of Morris's documentaries looks back across the axis of the screen towards the viewer; it is an arresting orientation for all involved, at once vulnerable and aggressive. Far from a movie-making gimmick or a stylistic tick, the Interrotron goes to the very heart of Morris's achievements as a storyteller: with his physical redistribution of the camera's mirrors and lenses, he has created an arrangement of visual axes that shifts the emotional and moral stakes of the encounter between the viewer and viewed. The continuity of the two is intensively enhanced even before the first word is spoken – and often the silences are the most revealing and confounding. So when the regularly curious, troubling or mysterious story does unfold, the viewer is already caught up in the relationship instantiated from the first frame.

Another inventive aspect of Morris's art comes from a different kind of physical transformation of filmed reality: the re-enactment. Like Herzog and Jeff Wall, Morris is an unusually gifted prose stylist with a deep knowledge of the history of ideas and art (at one point he was a doctoral student in philosophy), and possesses an acute mind for observation and critical thought. So as with Herzog and Wall, it is often productive and illuminating, and also rewarding, to allow the artist to speak for himself. In an essay on re-enactment, Morris (2008) concisely articulates the moral and aesthetic stakes for the re-

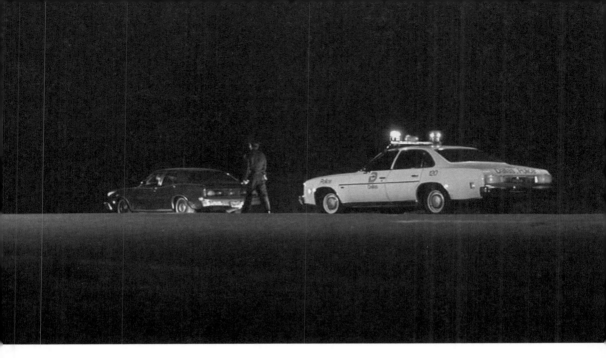

The Thin Blue Line © 1988 American Playhouse, Channel 4 Television Corporation, Third Floor Productions

creation of filmed action. He begins by relating an odd question posed by a journalist about his film *The Thin Blue Line* (1988): 'So, how is it that you managed to be on the roadway that night?' The events of the film occurred in 1976. The journalist, for some reason, assumed that Morris just happened to be on the dark highway that night a decade earlier with a film crew and cameras rolling. Morris assures us: 'I wasn't there' (Morris 2008). But the journalist's uninformed conjecture coupled with Morris's expert re-enactments draw us into questions about how documentaries about the past can (or should) be made. Morris asks and answers: 'How do you represent [past events] in a movie? How do you evaluate the nature of competing and conflicting evidence? It is through reconstructing the past with re-enactments'. Morris continues:

> Memory is an elastic affair. We remember selectively, just as we *perceive* selectively. We have to go back over perceived and remembered events, in order to figure out what happened, what *really* happened. My re-enactments focus our attention on some specific detail or object that helps us look beyond the surface of images to something hidden, something deeper – something that better captures what really happened. (Morris ibid)

In *The Thin Blue Line*, one example of such a detail is the slow-motion milkshake-in-midair. Morris again, asks and answers:

> Why care about the milkshake? Why does the milkshake matter? Because we assemble our picture of reality from details. [...] I re-enact this detail in my film. The milkshake-toss *for me* is emblematic of the discrepancies between Turko's [a police officer's] account and what really happened. As such, the spilled milkshake is a clue and stands at the beginning of a chain of inferences. (Morris ibid)

For Morris, 'the milkshake is a metonym for the many problems with [the police officer's] account' (ibid).

Morris was incredulous that anyone, perhaps especially a journalist, could have *believed* that he was at the scene of the crime (ahead of its occurrence) with camera's rolling. And yet, as Morris says,

> people believe some pretty amazing things, and it made me think: is it a legitimate question? How do we know what is real and what is re-enacted in a photograph? What is real and what is a simulacrum? It's a question about images. How do we know what is happening for the first time and what is a re-enactment of an event? In a *photograph* or in a *movie*? How do we know it hasn't been doctored or altered to deceive us about the 'reality' we imagine we are observing? (Morris ibid)

So though *Morris* knows he was not aiming to deceive his audience – attempting to trick them into believing that he just happened to be on site when the crime occurred – it did in fact happen. But as viewers, we are in a position to potentially always believe or disbelieve the assertorical content of the images we encounter. Morris's recurrent use of re-enactment stands as a reminder – often a provocative one – that we ought to be more vigilant about the nature of what we see and what we think about what we see. Morris's technique of re-enactment, then, does not simply provide visual content for phenomena that were unfilmed at the time of their occurrence (a common problem for any documentary aiming to present a filmed account of past events). Rather, Morris's re-enactments instead provide the conditions for viewers to re-conceive the meaning of those events. Re-seeing events enables a literalized *re*-vision – a revised perception of the past that may culminate in the change of a present-day belief.

If the Interrotron gives us a view that seems full of privileged intimacy with the speaking subject, the presence and prevalence of re-enactment in Morris work – from the acclaimed *The Thin Blue Line* through to *The Unknown Known* (2013) – re-invigorates any theoretical concern with the very nature of documentary as a site for the representation of truth. Morris, more than most of his film-making contemporaries (perhaps with the notable exceptions of Herzog and Abbas Kiarostami), engages the nature of truth in both his films and in his voluminous writing about representation. Of central relevance to this point, consult Morris's deft, highly inflected remarks on photographic representation in his book *Believing Is Seeing: Observations on the Mysteries of Photography* (2011), in which he explores the nature and truth of images, and relates brilliant meta-critical commentary on the kind of work he undertakes in his own films – especially the nature of truth in filmic representation. To be sure, Morris's lucid prose and philosophical precision enrich our understanding of the conceptual/schematic/scopic approaches we might adopt for a definition of the documentary form, and in so doing, further complicate (and often defer) any settled opinion about the kind of truth re-enactment makes possible.

Film critic, aesthetic theorist and philosopher, Noël Carroll describes Morris's work as 'aestheticization in documentary', since Morris appears to 'blur the distinction between documentary and fiction film at the level of style' (Carroll 2006a: 137). But then how should we distinguish Morris's *particular* aestheticization from another? Is it more or less truthful, manipulative or misleading? Carroll admits, in more general terms, however that 'documentary seems a lot closer to fiction film than was original supposed' (Carroll 2006a: 137). In short, the very making of documentaries – aside from a consideration of re-enactment – suggests fabrication, fakery and fictionalization. As you might expect by now, Morris has a considered opinion on this point:

> Critics argue that the use of re-enactments suggests a callous disregard on the part of a film-maker for what is true. I don't agree. Some re-enactments serve the truth, others subvert it. There is no mode of expression, no technique of production that

will instantly produce truth or falsehood. There is no *veritas* lens – no lens that provides a 'truthful' picture of events. There is *cinema-vérité* and *kino pravda* but not cinematic truth. (Morris ibid)

Unlike philosophers who debate whether one form of filmic representation is more true than another (seeking perhaps a bona fide distinction between fiction and nonfiction), Morris turns representation and cognition upside down: 'The engine of uncovering truth is not some special lens or even the unadorned human *eye*; it is unadorned human *reason*' (Morris ibid).

Meanwhile, philosopher Gregory Currie, for example, 'rules out from the category of documentary a film that heavily relies on re-enactments or animation', while Carroll says that such work – including Morris's – remains documentary insofar as the 'film-maker's intention is for the audience to entertain the content of a film assertorically' (Carroll 2006a: 138). So even if Morris's work is stylized or aestheticized, Morris's intention that the work be considered – categorically – a work of documentary should confirm its status as such.[3] Carroll calls this kind of documentary a 'film of presumptive assertion' – a neologism meant to capture, as Carroll says, 'what people mean to talk about when they speak informally of "documentary" and "non-fiction films"' (Carrol 2006b: 169). Also relevant is Currie's distinction between 'trace' and 'testimony', where, for example, a photograph is a trace and a painting is a testimony, since this division suggests that Morris has achieved the blending or hybridization of the two modes of representation (Currie 2006: 142–43). The films that couple (present-day) interviews with re-enactments (of past events) issue forth traces *and* testimonies.

The Interrotron and the art of re-enactment have come together with special force in what might be referred to as Morris's 'war documentaries' – a series of films, beginning most emphatically with the Oscar-winning *The Fog of War: Eleven Lessons from the Life of Robert S. McNamara* (2003), continuing in *Standard Operating Procedure* (2008), and culminating with renewed vigour a decade later with *The Unknown Known*, an extended interview with former US Secretary of Defense, Donald Rumsfeld. This triptych portrait of contemporary warfare – its makers, its functionaries and its often confounding logic – draws the philosophical and emotional interest of the intimate interview and the re-enactment of the past into the crosshairs of some of the single most ethically wrenching episodes of recent American history – from Vietnam to Abu Ghraib, and more broadly to the evolving 'war on terror'. Morris, once again, is a gifted reader of his own work and its significance; reflecting on *Standard Operating Procedure*, in which the circumstances surrounding some of the most famous photographs taken at Abu Ghraib are re-enacted by actors in a highly aestheticized style:

> I'm well aware of the fact that I'm making a movie about photographs […]. I was interested in how pictures can often mislead us, they can reveal things and also conceal things at the same time. And that irony is something which I believe is the heart of the movie. (Shaeger 2008)

The act of framing, as well as the frame itself, provides additional content beyond what we commonly take to be the ostensive subject.

After watching *The Unknown Known*, the critic David Denby tendered this unifying assessment of its director and the weave of ambitions that define his films:

> Amused and outraged, a darkly comic intellectual crossed with a fierce moralist, Errol Morris has returned again and again in his work to two related issues: the difficulty (but not the impossibility) of anyone's being able to grasp the reality of a complex situation; and the special power of human vanity to produce self-deception and outright lies. (Denby 2014)

Denby's comment demands a *double* double-take, for it suggests a hybrid description of the nature of this film-maker, and an account of his twofold project. Morris's blended role, in Denby's characterization, reflects a sceptic's worry about whether we perceive reality or make it. Morris's attention to evidence – and his recreation of it in the form of re-enactment – suggests that if we cannot see something right the first time, we might if we try, try again. And if Morris's subjects are not always enlightened by his presentation of evidence, or reorientated because of it, perhaps viewers of his films can be.

Yet, if there is a lie to be sussed and sorted, who (or what) is lying: we, the viewers, or the photographic evidence itself? The interrogated subjects, or those who act as their representatives? Moreover, how that deception unfolds is not always apparent, especially when the occlusion may be a matter of human limitations (of mind, memory or moral discernment), or even, we should admit, when it is a function of malicious intention. Is it, contra Denby, possible to grasp 'the reality' of a complex situation? – or is that just the sort of presumption that someone like Rumsfeld would like to promote as a prophylactic to truth and accountability, as a ploy for their endless deferral? Though they share the space of a film, in *The Unknown Known*, Morris and Rumsfeld do not appear to share a reality. Perhaps it is useful to say, more generally, that Morris helps us consider the difference between blind spots and self-protecting delusions, for these are indeed unknowns that leave us in a fog – and worse.

Thus, as Morris has radically reorientated our perception of remarks by McNamara and Rumsfeld, so has he presented still photographs in such a way that viewers are forced to rethink more than their relationship to 'enhanced interrogation' and the strategies for prosecuting the 'war on terror'. More fundamentally, viewers must also reconsider their relationship to photographic representation as such: what they see, what they think they see, and what they believe based on what they have seen. Philip Gourevitch collaborated with Errol Morris on a 2008 book with the same title as the film, *Standard Operating Procedure* (later changed to *The Ballad of Abu Ghraib*), in which Morris articulates the philosophical stakes of his filmic investigation. In film after film, and study after study, Morris underscores the unsettling phenomenon that finds how we often believe what we want to see – as if reality were more truly a series of *fata morgana*. We see things – make connections and inferences – without ocular proof. Like Wittgenstein's development of aspect-seeing, Morris aims to help us see again – see anew – and so often, quite troublingly, see for the first time.[4]

As if bringing things full circle, or at least coalescing decades worth of filmic practice, philosophical reflection and forensic study – from *The Thin Blue Line* to *Standard Operating Procedure* – Morris published a book entitled *A Wilderness of Error: The Trials of Jeffrey MacDonald* (2012), described as 'the literary equivalent of one of [his] movies. It's a rough-hewed documentary master class', and another effort to display the artful and rational reading of evidence against the occasionally deluding effects of compelling narratives (Garner 2012). The continuity between Morris's films and his prose arguments (and increasingly prominent *New York Times* blog postings), suggest that his methodologies reveal the literary nature of film and the filmic nature of consecutive, logic analysis.

The late film critic Roger Ebert, who placed Morris's *Gates of Heaven* on his 'Ten Greatest Films of All Time' list, once said: 'After twenty years of reviewing films, I haven't found another film-maker who intrigues me more. [...] Errol Morris is like a magician, and as great a film-maker as Hitchcock or Fellini' (qtd at errolmorris.com n.d.). While the praise is high and well-deserved, it carries the wrong metaphor: Morris is not a magician but a sceptic who knows we habitually believe what we see (or, more dangerously, believe before, or at odds with, what we see), and thus stand in need of another look, a closer look. That is, we do not watch his films so

the magician's *legerdemain* can entertain us with mystery and spectacle – we have enough of that – rather we watch Morris's films in order to learn how we are beguiled by our senses and our thoughts about what we perceive – by the gaps and elisions, the false connections and misplaced inferences that complicate, and sometimes ruin, our lives or the lives of others. Morris would then be better served not by a celebration of his status as a magician, but instead by acclaim for his work as a philosophically astute film detective.

David LaRocca

References

Carroll, Noël (2006a) 'Introduction to Part III: Documentary', in Noël Carroll and Jinhee Choi (eds), *Philosophy of Film and Motion Pictures: An Anthology*, Oxford: Blackwell. pp. 137–40.
————— (2006b) 'Fiction, Non-Fiction, and the Film of Presumptive Assertion: A Conceptual Analysis', in Noël Carroll and Jinhee Choi (eds), *Philosophy of Film and Motion Pictures: An Anthology*, Oxford: Blackwell, pp. 154–72.
Currie, Gregory (2006) 'Visible Traces: Documentary and the Contents of Photographs', in Noël Carroll and Jinhee Choi (eds), *Philosophy of Film and Motion Pictures: An Anthology*, Oxford: Blackwell, pp. 141–53.
Denby, David (2014) 'Field Maneuvers', *The New Yorker*, 21 April, http://www.newyorker.com/magazine/2014/04/21/field-maneuvers. Accessed 24 August 2015.
Errolmorris.com (n.d.) 'Biography', http://errolmorris.com/biography.html. Accessed 24 August 2015.
Garner, Dwight (2012) 'A New Angle on a 1970 Murder Case', *The New York Times*, 10 September, http://www.nytimes.com/2012/09/11/books/a-wilderness-of-error-by-errol-morris-on-the-macdonald-trial.html. Accessed 24 August 2015.
Morris, Errol (2008) 'Play It Again, Sam (Re-enactments, Part One)', *The New York Times*, 3 April, http://opinionator.blogs.nytimes.com/2008/04/03/play-it-again-sam-re-enactments-part-one/?_r=0. Accessed 29 January 2016.
Shaeger, Nick (2008) 'Errol Morris on *Standard Operating Procedure*', *ifc.com*, 22 April, http://www.ifc.com/fix/2008/04/errol-morris-on-standard-opera. Accessed 24 August 2015.

Notes

1. See 'Errol Morris's Secret Weapon for Unsettling Interviews: The Interrotron' and the following link for an illustration by Steve Hardie (whose design and use antedates Morris's) of the mechanics of the Interrotron: http://www.fastcodesign.com/1663105/errol-morriss-secret-weapon-for-unsettling-interviews-the-interrotron. See also http://www.whiterabbitdesigncompany.com/interrotron.html. Accessed 24 August 2015.
2. For a contrast to this approach, see Morris's, *First Person* (Bravo, 2000–01; two seasons), a series of television interviews employing the Interrotron.
3. See also in *Philosophy of Film and Motion Pictures: An Anthology*, 'Visible Traces' (Currie 2006); and 'Fiction, Non-Fiction, and the Film of Presumptive Assertion' (Carroll 2006b).
4. See *Seeing Wittgenstein Anew: New Essays on Aspect-Seeing*, ed. William Day and Victor Krebs (Cambridge: Cambridge University Press, 2010); and my 'The False Pretender: Deleuze, Sherman, and the Status of Simulacra', *Journal of Aesthetics and Art Criticism* (69: 3, 2011), pp. 321–29.

JEFF NICHOLS
Independent Visions of Rural America

The term 'hicksploitation' is specific to American films. It usually refers to the regionally produced films made for drive-ins in the 1960s and 1970s, then for the burgeoning home-video market of the early 1980s. In these films, rural characters were stereotypical rednecks who brewed moonshine, fought with the local (usually corrupt) police, and seduced the local farmer's daughter who wore cut-off jean shorts. This stereotype made its way to the mainstream through popular TV series like *Hee Haw* (CBS, 1969–97) and *The Dukes of Hazard* (CBS, 1979–85) and later in such mainstream films as *Next of Kin* (John Irvin, 1989) and *Sweet Home Alabama* (Andy Tennant, 2002). These series and films largely portrayed rural Americans as either racist, violent rednecks or purely noble people who show 'city folk' how to live their lives in a simpler, happier manner. No shades of grey were allowed.

A few independent films – notably *Sling Blade* (Billy Bob Thornton, 1996), *The Apostle* (Robert Duvall, 1997) and *George Washington* (David Gordon Green, 2000) – maintained the eccentricities found in the insular communities they portrayed without mocking their characters for their beliefs or behaviour. Not surprisingly, all three film-makers mentioned were raised in rural areas not much different from the worlds they present in their films. With *Shotgun Stories* (2007), *Take Shelter* (2011) and *Mud* (2013), Jeff Nichols joined that small list of independent film-makers from the South (Nichols was raised in Arkansas) attempting to bring a more honest look at the blue-collar American South and Midwest to a wider audience.

Shotgun Stories is a film that reaches back to the Bible and Greek mythology for its tale of brother against brother, but its setting and characters are straight out of the rural American South of William Faulkner. Set amongst the cotton fields and economically depressed small towns of South-East Arkansas, it is the type of film that takes viewers to a section of the country rarely seen. It also defies everything viewers expect of its characters. Son Hayes (Michael Shannon) and his brothers Boy (Douglas Ligon) and Kid (Barlow Jacobs) grew up being both beaten and ignored by their alcoholic father. After abandoning his family, their father found religion and quit drinking. Instead of returning to his family to make amends, he started a new family, spawning another set of brothers and a simmering resentment from his first wife that she passed on to her children.

Where the first set of brothers are struggling to get by, working menial jobs, the second set, having been raised by two loving parents, own a large farm and are well-adjusted. When his father dies, Son makes the bad decision to go to the funeral and speak his mind about what kind of man is being buried, sparking a feud between the two sets of brothers that threatens to turn deadly. Much like *Sling Blade* before it, *Shotgun Stories* is initially so blunt in its depiction of its characters' borderline poverty that it threatens to tip over into hicksploitation territory. Naming the first set of brothers Son, Boy and Kid invites the audience expectation of a comedy about a trio of bumpkins that do not even have real names. But as more is learned about their father and the way the brothers were raised, their names take on a tragic undertone of siblings who never felt paternal love.

Mud © 2013 Brace Cove Productions, Everest Entertainment,
FilmNation Entertainment, Lionsgate

Nichols does not shy away from the sadder points of the character's lives. Viewer expectations would be that these three live in a house that is starting to deteriorate, drive older vehicles that are rough in appearance from years of wear and tear, and sport deep accents. Nichols provides all these details but also adds tender moments that catch viewers emotionally off-guard. A scene in which the brothers manoeuvre a television outside to a picnic table ends with a shot of the trio watching TV under the stars that is both funny and touching. Son's job at a catfish farm is portrayed as dirty, hard work but is filmed with the lyrical beauty of a Terrence Malick film. Despite its low budget of $250,000 and a first-time director in Nichols, *Shotgun Stories* was shot on 35mm film in anamorphic widescreen, giving it a professional sheen. Combined with a script that is smart and sad in equal measure, and a powerful lead performance by Shannon that proved to be the actor's breakthrough, the impressive technical craft helps elevate *Shotgun Stories* to one of the finest debut films of its decade.

Even with its carefully drawn characters and classically tragic story, the film's setting and the accents of its characters still caused some viewers to lump it into the hicksploitation genre. Nichols recalled his frustration when the film was misunderstood:

> When we took it up to Tribeca to premiere it in the U.S., they were giving me positive reviews but even one positive review referred to the three characters as 'fools,' I think. And someone said, 'It's hicksploitation, through a David Gordon Green filter.' It angered me to hear people talk about these characters like that, because they weren't fools and they weren't stupid. (Leifeste 2013)

Nichols's second feature, *Take Shelter*, is a compelling look at a Midwestern family that struggles to stay together when husband and father Curtis (Shannon) begins having apocalyptic nightmares. He dreams of an oily substance falling from the sky, massive storms and tornadoes, his dog attacking him, and savages kidnapping his child. The nightmares seem so real to Curtis that he begins to prepare for the end of the world, modernizing his storm shelter and stocking it with supplies. But is Curtis really having premonitions or is he sinking into mental illness? His mother developed schizophrenia when she was the age Curtis is now and he worries that he may be going down the same path.

Despite the presence of Shannon once again in the lead role, Nichols does his best to make *Take Shelter* a very different film from *Shotgun Stories*. Curtis is a relatively successful man. He is a supervisor at the quarry where he works, allowing for a comfortable middle-class lifestyle. His marriage to Samantha (Jessica Chastain) is solid and loving. Their daughter Hannah (Tova Stewart) is deaf, but her doctors have high hopes for an inner-ear implant that may grant her hearing. Curtis and his family are far better off than the tortured characters in *Shotgun Stories*. The main connection between the two films is the theme of adult children dealing with the tragic legacy of their parents and struggling not to make the same mistakes.

The film is further differentiated by its sense of place. Instead of the back roads of Arkansas, a small Ohio town is the setting. While the town looks almost like it could be a suburb, the characters are blue-collar workers and have a flat Midwestern twang to their accents. This extra effort to differentiate a small town in the northern Midwest from rural South-East Arkansas was no accident. 'I told the actors that we're in Ohio, so do Ohio,' Nichols said. 'I have to be very honest in the places that we're filming. How people in that place talk, what they eat, what kinds of cars they drive. Not everyone drives a cool '70s pickup truck' (Koehler 2011).

For *Take Shelter*, Nichols had a much larger budget of $5 million and it shows in the impressive special effects that bring to life Curtis's visions. But the director does not let the film ever turn into an apocalyptic spectacle. It stays firmly rooted in Curtis and Samantha's marriage and the struggles they face as a result of his nightmares and possible mental illness.

Mud is Nichols's largest production to date. Stocked with stars and well-regarded character actors, it also introduces a touch of magical realism to the director's usually well-rounded look at rural life. Taking heavy doses of inspiration from the works of Mark Twain, the film follows Ellis (Tye Sheridan), an adolescent boy living along a tributary of the Mississippi River in rural Arkansas. His family makes their living catching and selling fish. This livelihood has become a source of strain on his parents' marriage and he routinely takes off in his father's boat with his best friend Neckbone (Jacob Lofland). One day the boys take the boat to an island in the middle of the Mississippi and meet Mud (Matthew McConaughey). Mud is wanted for killing a man who was beating his girlfriend. He tells the boys this and claims to only be in the area because he is supposed to meet up with his childhood girlfriend before they make their escape. The romanticism of Mud's story appeals to Ellis and he and Neckbone agree to help Mud connect with his girlfriend and escape the island.

The characters of Mud and his girlfriend Juniper (Reese Witherspoon) are the closest Nichols has come to adhering to clichés. Mud is full of superstitions and folk tales that at times make him sound like the kind of simpleton found in a broad comedy using Southerners as comic relief. Juniper is barely a character. She is merely a sketch of a woman who enjoys the romance of having Mud pursue her without wanting to deal with the actual downside of being with a wanted felon. Thankfully, Mud develops beyond being a possibly mentally challenged man-child to take responsibility for his life. Juniper never develops, but is not present in the film enough to drag it down. But the film, while named after Mud, is actually a coming-of-age story about Ellis. Frustrated and angry about the slow-motion dissolve of his parents' marriage, he wanders the film looking for proof of the old cliché that love can conquer all obstacles. Instead he finds even a starry-eyed dreamer like Mud has his limits when it comes to believing in a 'happily ever after'.

Of the three films discussed, *Mud* has a generally lighter tone. When it turns darker as Ellis realizes that he cannot force people into being happy even though he thinks they should be, it comes as a bit of a surprise, but Nichols is interested in bringing some pragmatism to the film, both about the characters and the general view of

audience members who have a set idea of what a light film about the South is supposed to be. 'I think the biggest problem is the South is a lyrical place,' Nichols explained. 'It's a place we want to romanticize, and I just don't think that's always necessary' (Brown 2012). While the lesson that the film imparts is hardly original, thematically, it fits in with Nichols's first two films. All three deal with children inheriting the problems of their parents. Ellis just has to deal with his issues earlier than Son in *Shotgun Stories* or Curtis in *Take Shelter*.

Mud also presents characters that could be mere one-joke rednecks and treats them with the humanity that has come to be expected from Nichols. Neckbone, in particular, is a charming character who could have just served as comic relief; looking like the type of kid that would be a bully in most films, Neckbone is Ellis's voice of reason, cautious about Mud and how much he should be helped, he is also unfailingly loyal as a best friend and maintains a sunny disposition through most of the film. His character is another subversion of the stereotypes Nichols is working against.

After *Mud*, Nichols made the move to studio film-making where he continued to chronicle the rural American way of life. Although only five features into his career – and as such it seems unfair to pigeonhole him as the director who only subverts the unfortunate stereotypes established by hicksploitation films – Nichols's voice is certainly a welcome addition to the contemporary American independent landscape.

Matt Wedge

References

Brown, Emma (2012) 'Jeff Nichols' Southern Exposures', *Interview Magazine*, March, http://www.interviewmagazine.com/film/jeff-nichols-mud/. Accessed 15 October 2013.

Koehler, Robert (2011) 'Take Shelter: Jeff Nichols' Age of Anxiety', *Cinema Scope*, July, http://cinema-scope.com/cinema-scope-magazine/interviews-take-shelter-jeff-nichols-age-of-anxiety/. Accessed 2 November 2013.

Leifeste, Linc (2013) 'A Conversation with Jeff Nichols', *Oxford American*, 23 April, http://www.oxfordamerican.org/articles/2013/apr/23/interview-jeff-nichols/. Accessed 11 November 2013.

TYLER PERRY
Independent Media Mogul

When *Temptation: Confessions of a Marriage Counselor* opened to $20 million at the domestic box office in 2013, it was Tyler Perry's ninth film to surpass the $20 million mark on opening weekend, joining a rather exclusive company that only included Steven Spielberg and Robert Zemeckis. Perry has been directing films for less than a decade, but has already become an industry unto himself. While many may question his 'independent spirit', Perry certainly works outside of the norms of Hollywood, as his Tyler Perry Studios in Atlanta has become a remarkable example of regional film-making. Despite his reputation as a niche director, the National Association of Theatre Owners recognized his box office viability, awarding him the 2011 Visionary Award, one of its highest honours. Furthermore, Perry's films provided a steady stream of revenue for Lionsgate, before their decision in 2014 to not renew their collaboration. He is one of the few film-makers who has become his own brand, even using it in the titles of his films (always with the moniker 'Tyler Perry's…'). Perry's work has been far too easily discounted by scholars and critics, and a curt dismissal of the most powerful African American film-maker today is almost wilful ignorance.

Even before he started making films, Perry had established himself as the most successful African American playwright, perhaps in history. Although most of the country had not heard of him before the release of *Diary of Mad Black Woman* in 2005, he had already made his name within the black community, touring his plays on the chittlin' circuit (those venues historically catering to the African American population) and selling homemade videos out of the boot of his car. Some have accused Perry of only being a businessman, or of running a factory, albeit one which continually churns out films and television episodes at an astounding rate. His religiously themed plays were especially known for bringing in church audiences, following in the tradition of the 1983 musical *Mama, I Want to Sing!* (lyrics and book by Vy Higginsen and Ken Wydro), the 'black Jazz Singer' that some have accused of destroying 'legitimate' African American theatre in New York. That musical's legacy lives on over thirty years later in the films, plays and television shows of Perry.

Despite a tide of overwhelming negative reviews for *Diary of Mad Black Woman*, the film grossed over $50 million domestically, almost ten times its modest budget, but most importantly, launched Perry's film career. Although he did not direct it (it was directed by Darren Grant), Perry was credited as writer and producer, and has directed all of his films since, although he has become just as known as an actor. Perry has primarily become associated with his trickster Madea figure, a large, elderly woman that Perry plays himself, who has appeared in *Diary of Mad Black Woman*, *Madea's Family Reunion* (2006), *Meet the Browns* (2008), *Madea Goes to Jail* (2009), *I Can Do Bad All by My Myself* (2009), *Madea's Big Happy Family* (2011), *Madea's Witness Protection* (2012) and *A Madea Christmas* (2013), all of which originated as stage plays. Perry also authored *Don't Make a Black Woman Take Off Her Earrings: Madea's Uninhibited Commentaries on Love and Life* (2006),

Madea Goes to Jail © 2009 Lionsgate, Tyler Perry Studios

written from the Madea persona. Although Perry has expressed a desire to retire the character, she is intimately linked with Perry, especially in the popular consciousness, as most still have limited experience with Perry's work. In general, his Madea films do the best financially, although none have yet eclipsed the $100 million benchmark, with *Madea Goes to Jail*'s $90 million gross coming the closest. But Perry's films have to do well domestically, as they perform very poorly in other territories, where his niche films have too limited an appeal for overseas audiences. Despite drawing from broad comedy and universal melodramatic tropes, are his films too culturally specific to reach international audiences?

Many have criticized Madea for reviving the mammy (albeit in drag) stereotype, but the character more often subverts it. For one, she is not the devout, Christian matriarch that we think of with images of the mammy, but depicted as irreligious and a common criminal, ignorant of the Bible, and constantly encouraged by other characters to get back into church again. Furthermore, she is not the self-sacrificing matriarch, but more selfish. In fact, her daughter Cora, who has been raised by her father Mr Brown, is depicted as more mature and charitable than her. There is also the absurdity of an elderly 6'5" woman who was once a stripper, a past Madea often (and proudly) admits to.

Perry's acting roles outside of his own films have been limited. His cameo in *Star Trek* (JJ Abrams, 2009) surprised many viewers, but despite this lack of experience, he was given the title role in *Alex Cross* (Ro Cohen, 2012), following Morgan Freeman's portrayal of the character in *Kiss the Girls* (Gary Fleder, 1997) and *Along Came a Spider* (Lee Tamahori, 2001). *Alex Cross* grossed considerably less than its predecessors and fared no better with critics. Perry is serviceable in the role, but his inability to connect to his core audience with this role, combined with its lackluster script and direction, means that future roles in dramatic/action films seems less likely, although he would later appear in a supporting capacity in David Fincher's successful thriller *Gone Girl* (2014).

Perry's prolificacy stands almost unrivalled. Just considering his films alone, he would already be considered one of the most prolific film-makers, typically releasing two films a year. But his work in television seems even more impressive, considering his involvement. Perry launched into television with the syndicated series *House of Payne* (2007–2012, with pilot episodes first airing in 2006), which became the longest-running (in terms of number of episodes) black sitcom in American history with 254 episodes. *Meet the Browns* (TBS, 2009–2011, 140 episodes) and *For Better or Worse* (TBS, 2011–) would follow. In 2013, Perry launched two more series, the soap opera *The Haves and the Have Nots* (OWN), and the sitcom *Love Thy Neighbor* (OWN), again displaying his love for both melodrama and comedy, respectively. He then quickly followed his film *The Single Moms Club* (2014) a few months later with an OWN (Oprah Winfrey Network) series entitled *If Loving You Is Wrong* (2014–), another soap opera. All of his television series are set in Georgia, as are most of his films. Perry and his work have become synonymous with Atlanta, despite being born in New Orleans. His TV shows also have given him a stable of talent to draw from, as several of the cast members from his various series would appear later in his films. He prides in giving talented actors (such as *House of Payne*'s LaVan Davis) the break that they never seemed to get in Hollywood.

Yet Perry's films and television endeavours have certainly not been without controversy. Perry has received a barrage of criticism from within the black community, perhaps most infamously from Spike Lee, who labelled his TV shows *House of Payne* and *Meet the Browns* 'coonery and buffoonery', comedy in the tradition of Amos 'n' Andy (Gane-McCalla 2009). Lee, who has never been soft-spoken in his criticism of certain other film-makers, may have been more concerned that, after twenty years on top, he finally had a challenger to his role as the most influential African American film-maker. Indeed, Lee has since backpedalled on some of his comments, even hinting that he would be amenable to working with Perry in the future.

While American cinema has become increasingly dominated with films marketed and geared to juvenile boys and the vast majority of them Bechdel test failures, Perry is one of the few major film-makers whose films are dominated by roles for women. Still, many critics have questioned how 'feminist' his films actually are, while some have deemed his films as regressive in their implementation of a Moynihan-esque narrative.[1] Even *The Single Moms Club*, which initially seems like it supports single motherhood – and indeed promotes networks for them which cross ethnic and class barriers – eventually becomes a traditional Hollywood narrative of heterosexual romance, as all five women are paired off by the end of the film. If critics have been harsh towards Perry's films and television shows, he has faired even less favourably with much of the general public, at least those represented on websites such as IMDb. The vitriol spewed out towards his films (in some cases, even before their release) seems at least racially motivated, one of the best examples disproving any idea that the United States is now a post-racial society.

Despite this deluge of controversy, only recently have scholars begun examining his popularity, as well as the messages and themes of his films. Central to the majority of his films is the role of the church within the African American community, perhaps most obvious in *I Can Do Bad All by Myself*. While the Christian film industry has been one of the notable players in the independent scene, Perry's films rarely are discussed in the same conversation (perhaps because it is an industry primarily associated with white evangelicals), despite the similarities in rhetoric. While perhaps less evident in his television work, black church traditions and homiletics inform almost all of his films. According to Perry,

> Hollywood is finally waking up to the fact that people who go to church also go to the movies. I'm not sure what took them so long to see that – or how long they'll

keep it up. But at least we're getting the chance to prove that there's an audience for movies with the right message. (Bowles 2006)

Perry's collaborations have rarely been discussed, such as his partnership with veteran TV producer Reuben Cannon, which ended in 2011, or his collaboration with Toyomichi Kurita, an acclaimed veteran director of photography who has also worked with Alan Rudolph, Robert Altman, Nagisa Oshima, Takashi Miike and Forest Whitaker, but has worked with Perry more than any other director, with six films to date. Perry has also created a formidable partnership with Oprah Winfrey that may also have a significant impact on his work. Winfrey had been critical of Perry at times in the past, but they teamed up to executive produce and promote Lee Daniels's *Precious* (2009), and Perry now even has four shows airing on the Oprah Winfrey Network (OWN). *Precious* may have been Perry's attempt to attach himself to more prestigious fare, but this Sundance favourite was such a dark film that it might not have reached as large an audience without the ringing endorsements of Perry and Winfrey. While advocating the film, Perry also spoke for the first time concerning the specifics of his own history of child abuse that he suffered. Born Emmett Perry Jr, he changed his name to 'Tyler' to distance himself from his abusive father, while also crediting his faith with helping him heal.

Because of his cult origins in the chittlin' circuit, it took a few years for Perry to gain more mainstream acceptance. *The Family That Preys* (2008), starring Kathy Bates, was arguably his first crossover film, one that featured white characters almost as much as black characters. Its tale of a wealthy, Southern white family also influenced *The Haves and the Have Nots*, although the latter is much more sombre and less hopeful than the earlier work. Perry further examined class differences, particularly between upper-class whites and middle/working-class blacks in *Madea's Witness Protection* and *The Single Moms Club*. Another example of Perry's interest in branching out into other cultures is one of his most recent films, *A Madea Christmas*. Perry tackles several topics new for him in the 'Madea' series: views on interracial marriage within the black community, the so-called 'War on Christmas', and manmade environmental changes that harm small farm communities.

Few have incorporated generic analysis of Perry's film and TV series, while fewer still have examined his place within the historical context of African American film-making, although both topics are conjoined. Perry's films are infused with a combination of comedy and melodrama. While some critics alternatively received *Temptation* as high camp, our reception of the film changes when understood as a direct descendent of the Spencer Williams tradition of biblical morality plays. Race films of the 1920s and 1930s were often melodramatic (e.g. Oscar Micheaux), and Williams's films especially catered to overtly religious audiences in the South. In *Temptation: Confessions of a Marriage Counselor*, we are almost surprised when Judith (Jurnee Smollett-Bell) does not pay the ultimate price for her adulterous affair (which certainly could have been possible given the film's generic conventions), but her getting the HIV virus, losing her husband, and acquiring a 'spinsterish' look serve as their own sort of death sentence. Perry's films can be labelled preachments, even if they are also entertaining.

Daddy's Little Girls (2007), *The Family That Preys* and *I Can Do Bad All by Myself* are easy entrées for those first encountering Perry's work. Perry made his first official Tyler Perry Studios film, *Daddy's Little Girls*, in order to depict a positive black father figure. It is also one of his only films in which he is not in front of the camera, as Perry wanted to focus on becoming a better director by becoming more intentional about camera placement and movement. Perhaps Perry's best (and darkest) film to date was also his least personal, *For Colored Girls* (2010) – an adaptation of Ntozake Shange's womanist choreopoem *for coloured girls who have considered suicide / when the*

rainbow is enuf (1974), a landmark in African American theatre. Although Perry's film was criticized for its lack of fidelity, Perry's Brechtian decision to retain most of the play's poems/soliloquies establish it as one of the more memorable stage-to-screen adaptations in recent years, with superb performances from its lauded cast.

So what's next for this 'independent mogul'? The release of Tina Gordon Chism's *Peeples* (2013) suggests his interest lies in producing films in a similar vein to his own. His unrealized project *Jazz Man's Blues* was rumoured to have starred Diana Ross (who didn't want the role) and then Whitney Houston (who died before filming could begin). Recent films have struggled, as *A Madea Christmas* was the least successful of his Madea films (adjusting for inflation), while *The Single Moms Club* brought the lowest domestic gross of any film he has directed. But his shows continue to draw sizable ratings for a cable network.

Still, noteworthy questions remain as we carefully examine Perry and his work. What does the ridicule that Perry receives say about his adoring fans who consume his product? Are they ignorant? Unaware of other (black) entertainment options? Should Perry's work receive more sophisticated and complex modes of interpretation than have previously been proffered by his detractors? Even if one does not much care for Perry's work, how does his success impact the future of African Americans in film and television, especially in positions such as directors, writers and (heaven forbid) heads of studios? These are the types of questions, among others, that future scholars and fans encountering Perry will need to address.

Zachary Ingle

References

Bowles, Scott (2006) 'Hollywood Turns to Divine Inspiration', *USA Today*, 14 April, http://usatoday30.usatoday.com/life/movies/news/2006-04-13-religion-based-movies_x.htm. Accessed 9 July 2015.

Gane-McCalla, Casey (2009) 'Spike Lee Compares Tyler Perry to Amos and Andy', *NewsOne*, 28 May, http://newsone.com/191851/spike-lee-compares-tyler-perry-to-amos-and-andy/. Accessed 9 July 2015.

Notes

1. 'Moynihan-esque' refers to *The Negro Family: The Case for National Action* (1965), better known as 'The Moynihan Report', penned by Assistant Secretary of Labor Daniel Patrick Moynihan. It traced the increased poverty and social problems of African Americans at the time to the inordinate amount of single-mother families.

KELLY REICHARDT

Lost in Oregon

American independent film-makers often use locations familiar to them, such as their hometown, to create character-driven films on low to modest budgets. Kelly Reichardt is the exception. Although she was born and raised in Miami-Dade County, Florida and is currently a visiting assistant professor at Bard College in New York, Reichardt's last four feature-length films – *Old Joy* (2006), *Wendy and Lucy* (2008), *Meek's Cutoff* (2010) and *Night Moves* (2014) – all take place in various locations across the State of Oregon. Since he has contributed as writer and co-writer for these films, the Oregon-based author Jon Raymond has had an obvious influence on Reichardt's cinematic setting. Together, this symbiotic relationship between writer and director, their perpetual return to Oregon and visual interplay between protagonists and the environment, help to shape the everyday American experience in a way that imparts emotional texture and character ambiguity. Typically, their focus is on outcasts or drifters whose stories take place in transitory and unmemorable locations such as parking lots, woodland areas and desert terrains. An unromanticized depiction of the drifter's experience and the spaces they inhabit creates an unsettling atmosphere for individuals who are also burdened with personal dilemmas. Furthermore, the oblique narrative structure of these films is juxtaposed with specific geographical West Coast markers that foreground the character's physical and emotional quest for survival. Despite the director's persistent reference to Oregon landmarks through dialogue and visual signposts, these characters, in the tradition of American independent cinema, never arrive at the destination of fulfilment. Instead, the individual journeys seen in Reichardt's work result in alienation, uncertainty and irretrievable loss.

In all aspects of her film-making, from development to postproduction, Reichardt's work can be classified as minimalist and intimate. Shot on 16mm film stock with a six-person crew, *Old Joy* was produced in Oregon for a mere $30,000. Reichardt collaborated with the New Jersey indie rock group Yo La Tengo to create a spartan soundscape with two guitars that set the rhythm of the film's journey between two old friends from Portland to the Cascade Mountains. A short story by Raymond and inspired by photographer Justine Kurland's images of burned forests, naked men and women in natural tableaux (Rodriguez-Ortega), *Old Joy* involves two friends Mark (Daniel London) and Kurt (Will Oldham, also known as American singer-songwriter Bonnie 'Prince' Billy) who reunite for a weekend road trip to camp and to visit the Bagby Hot Springs located deep within the mountainous region. From the film's outset, these friends are on divergent paths as Mark and his partner Tanya (Tanya Smith), who are living in a suburban Portland neighbourhood, are expecting their first child while Kurt, who lives on the outskirts, is about to become evicted from his apartment.

On the surface, *Old Joy* loosely incorporates the characteristics of a buddy-road-trip genre in the likes of *Easy Rider* (Dennis Hopper, 1969), in which two men seek liberation by travelling across various American iconographic landscapes. This freedom is illustrated by the physical journey from the city, which has clearly marked signposts and semi-congested highways to the remote Cascade Mountains where there are no longer any

Night Moves © 2014 DeLeon Productions, Film Science, Maybach Film Productions, RT Features, Tipping Point Productions

official road maps that point them in the direction of their destination. Once they've departed from their home comforts though, Mark must rely on Kurt's marijuana-inflected memory of the area which forces them to retrace their path. Approaching an unmarked sign, Mark proclaims, "We've entered a whole new zone", signaling that this road trip deviates beyond the ordinary.

With nightfall fast approaching and nowhere to sleep, the slow-paced narrative and confined space facilitate the exposure of unspoken tensions between the two men. When they do eventually settle on a spot, the Volvo's headlights illuminate the space as a dumping ground for urbanites' discarded furniture. Despite its initial appearance as a remote landscape, the city manages to inculcate itself upon the woods which also communicates to the viewer that whatever Mark and Kurt are pretending to leave in the past resurfaces in the present. At night, the campfire's embers provide the only source of light that spotlights both Kurt's emotional unravelling thinly veiled by confidence about complex theoretical analysis of the universe and Mark's festering look of disdain. The story contains the essential ingredients to rekindle old friendships: quality car time, no urban distractions and a campfire. However, their inability to articulate feelings that could lead to openness and reconciliation creates tension rather than intimacy in their friendship.

This pressure permeates throughout and is skillfully played out the following morning at a local diner. Kurt silently admits defeat when he accepts directions to the Hot Springs from a waitress. However, he quickly reassumes his role as a cocksure navigator. And with a deadpan stare towards the road, Mark responds, "I never doubted you man." Even though they arrive at their destination point, they are behind schedule and not even the overwhelming sound of water flowing or steam rising out of the hot springs can save this decaying relationship. In fact, Kurt seems to recognize this and tells his friend about a dream he had in which a shop assistant reassures him with the Chinese proverb 'sorrow is nothing but worn out joy'. Once they return to the city, these characters lack the transformative experience typically associated with a buddy-road-trip genre. Instead,

Mark drives away from his friend and turns on the radio, drowning out the affective debris left over from a road-trip turned sour. Kurt lingers on the street intimating he is waiting for someone, before wandering off to a destination unknown.

If the open-endedness of watching Kurt wander the streets in *Old Joy* conveys the loneliness of marginal figures in the Pacific Northwest, the young heroine Wendy (Michelle Williams) in Reichardt's follow-up *Wendy and Lucy* inhabits the destitute and her immobility signals the erosion of counterculture idealism in America. Shot on 16mm film stock in eighteen days and with a skeletal crew who also make brief appearances in the film, Reichardt remains faithful to her minimalist approach to film-making. Furthermore, after having scouted locations all over the country, she acquiesced to Raymond's original inspiration for his short story and shot *Wendy and Lucy* near the author's home in North Portland, Oregon in an area which she describes as 'a soulless, in-between place' (Van Sant 2008). The predicaments Wendy faces along with Reichardt's observational style are reminiscent of the economic hardships thrust upon the characters in Italian neo-realist cinema.

As the film opens, Wendy is en route with her dog Lucy (played by Reichardt's dog, which also features in *Old Joy*) in search of work at a cannery in Ketchikan, Alaska. In line with its marginalized perspective, it begins with a shot of an Oregon train yard at twilight. Wendy calls out to Lucy who has run off into the surrounding wooded area. In the next shot, Lucy is peering through the trees at a raucous group of drifters drinking and sitting by a campfire, who are, in authentic neo-realist fashion, actual train-hopping youths (Van Sant 2008). She tentatively joins them and engages in a conversation with Icky (Will Oldham) who may have a job lead for her in Ketchikan. Despite this friendly exchange, Wendy's encounters with people are relatively brief. The film resigns itself to an unsentimental portrayal of a drifter with self-enforced detachment. She constantly hums to herself, calculates every penny in a notebook, and feeds her dog from the trunk of her car. With one long durational take, Reichardt focuses on Wendy opening her trunk, placing the dog bowls on the ground, and tipping the large bag of food into the bowl. This ritualistic behaviour provides a source of comfort for a young woman living on the margins of society.

These patient observational shots not only reveal the character's habitual behaviour but also that her car embodies a home of sorts. The magnitude of Wendy's reliance on her vehicle to function as both domicile and mobility is fully realized when, after sleeping in a Walgreen's parking lot, the engine refuses to start and she becomes stranded in a transitory location or non-place. With the help of the store's security guard Wally (Walter Dalton), she manages to push the vehicle off the lot and onto the road. Wendy's road journey is further problematized when she abandons Lucy outside the supermarket after she is arrested for stealing a tin of dog food only to discover that her companion has now disappeared. Once again, Wendy is forced to rely on the kindness of Wally, who assists her in locating Lucy. Although an unlikely friendship develops between the two, there is minimal dialogue and interaction, thereby leaving the spectator to contemplate Wendy's backstory or central motivation besides her Alaskan destination point. Always shot from a distance, Wendy represents the displaced but also displaces herself from the community, and the in-between spaces she inhabits throughout the film are emblematic of her indeterminate future.

Set in 1845 and based on an actual event during a historical period when the Oregon region was jointly occupied by the United States and Great Britain, *Meek's Cutoff* depicts emigrants who were headed for the West Coast. They hired frontiersman Stephen Meek (Bruce Greenwood) as their guide after he claimed there was a shorter route to the Willamette Valley. Instead, many pioneers perished while attempting this torturous journey across the desert-like, rock-strewn landscape in the hopes of a promising life. Shot in the Oregon desert town of Burns, Reichardt once again teams up with Raymond as scriptwriter and Michelle Williams as the most individuated character in the film, a pioneer's wife named Emily Tetherow.

Along with a more substantial production budget of $2 million and an established cast, the film's historical setting bears the markings of genre – the western – and shatters these expectations by eschewing the widescreen format for the square-shaped 1.33:1 aspect ratio. In true Reichardt fashion, her visuals privilege realism over majestic scenery. The film is shot using natural light and opens with a static long shot of men and women crossing a river with their wagons and belongings. The amplification of the rushing water foreshadows its relevance throughout the rest of the narrative in which the characters struggle to find any potable water source. Instead of building dramatic conflict between civilized order and the lawless frontier, Meek's Cutoff emphasizes the arduous everyday tasks for working-class pioneers. In fact, the cast attended a week-long pioneer course in order to learn how to authenticate such physical labours of handling cattle, building fires, knitting and packing wagons (Quart 2011). The true harsh weather conditions of the Oregon desert also contributed to the film's authenticity. Reichardt employs long observational shots of pioneers trekking across the arid landscape and magnifies the sound of squeaking wheels and natural environment. Accentuating duration and the senses, the spectator experiences the characters' urgent search for water.

Although there is tension building between the three emigrant families and Meek, who they have entrusted with their lives, it is not a dichotomous relationship of good versus evil, hero versus villain. For instance, when Meek (Bruce Greenwood) states, 'We're not lost, we're just finding our way,' Emily (Michelle Williams) solemnly but quietly responds, 'I certainly hope so.' Discussions between the men encompassing the route that Meek is leading them along are barely audible to the wives or viewers. When they capture a Native American Cayuse Man (Rod Rondeaux), they collectively agree to keep him alive despite their natural apprehensions and Meek's vehement protestations. The isolation that builds between the characters is influenced by the vast unforgiving landscape that threatens their very survival. In the film's opaque ending, the emigrants set their prisoner free and Meek informs him, 'I'm taking my orders from you now.' When the Cayuse man turns and walks away from the camera into the desert, we infer that the characters' survival lies as much in the balance as this moment in Oregon's history.

Those who reside on the fringes of Oregon society are revisited again in *Night Moves*, but this time they are armed with more than just liberal-minded life philosophies. They are enraged by the ineffective rhetoric of conventional activism. So, longing for a new way to live, three characters unite to employ radical environmental action as a tool for voicing their ecological concerns. The film's plot is injected with suspense alongside Reichardt's haunting nature shots that evoke the stillness of Oregon's scenery. However, this does not have the conventional rhythm of a thriller. Instead, the adrenaline rush of activism is juxtaposed with submerged emotional tensions between characters and static views of agrarian beauty. This internalized drama and slow nightmarish fallout of a mission resembles Claire Denis' *White Material* (2010), which involves a French coffee plantation owner who is caught in a civil war in an unnamed African rural setting. The protagonists in both films also share a relentless commitment to their individual causes even when faced with an overwhelming sense of defeat.

Shot from an activist's perspective, *Night Moves* focuses on the trio's careful planning and execution of their federal crime – the bombing of a local hydroelectric dam along the Santiam River – and the conflicts that arise between these three relative strangers. Josh (Jesse Eisenberg), who works for a small yet self-sustainable organic-farm community and lives in a yurt on the property, presents himself as the most committed environmentalist of the group. Armed with fundamentalist principles, he provides the tenuous link between the other two activists. Dena (Dakota Fanning) is a young liberal arts school dropout from the East Coast who is employed at a New Age spa near the farm. Harmon (Peter Sarsgaard) is an ex-Marine who lives in a mobile home in the secluded wilderness near the dam's site. Although the film is situated within the world of the aggrieved

environmentalist, this is a moral tale that raises questions about whether good intentions override potentially harmful (and possibly useless) results.

Much of the film follows Josh who has a serious demeanor. Although his environmental quest is largely pathological, he shows compassion for nature by rescuing a bird's nest, then carefully removing a dead deer from the road. Dena, who comes from the East Coast and is genuine in her desire for environmental change, acts as the wealthy benefactor for the operation that requires the purchase of a $10,000 speedboat and 1,500lbs of ammonium-based fertilizer for the creation of the bomb. The speedboat is given the name 'Night Moves' to reflect the trio's planned evening insurrection. Despite her youthful disposition, Dena demonstrates her ingenuity when the other two male members come up shorthanded. Yet, her own uncertainties begin to surface when an unexpected turn of events threatens to increase the severity of their crime. Harmon, who is considerably older and presumably more mature than the other two, is cast in an unfavourable light when he is caught out on numerous lies. Collectively, the trio shares a disdain for corporate entities. However, the combination of Josh's fanaticism, Dena's *naïveté* and Harmon's dishonesty helps to amplify the story's delicate balance between a perfectly executed plan and a disastrous awakening.

Despite illuminating us with the characters' personality flaws, we empathize and root for these outcasts because their conviction sheds light on the real impact of climate change, government interference and corporate greed on this Northwest landscape. As Josh points out, the dam is 'killing all the salmon so you can run your iPod every second of your life'. Since there is very little dialogue throughout the film, the conversations that do cut through the silence in *Night Moves* help to highlight the gravity of contemporary environmental issues, although Reichardt offers no grand solution to the problem. Even though the organic farm provides a sanctuary to the ethically minded, it is a small business that relies on the generosity of the cooperative model to survive. There is also a defeatist tone added to the trio's mission when they sail up the river towards the dam and stare in silence at the wastelands already produced by the human impact on nature. What *Night Moves* presents then, is a refreshing look into the various debates surrounding environmental commitment that circulate from within the activist community. Ultimately, the characters' radical efforts to make a statement and save the salmon are perceived as reckless and useless. Still, it is difficult to shake the urgency of the film's message, or the memory of its three drifters who follow the other outcasts in Reichardt's work to date by daring to challenge the status quo.

Tamara Courage

References

Quart, Leonard (2011) 'The Way West: A Feminist Perspective', *Cineaste*, Spring, pp. 40–42.

Rodriguez-Ortega, Vicente (2006) 'New Voice: An Interview with Kelly Reichardt', *Reverse Shot*, Autumn, http://www.reverseshot.com/article/reichardt_interview. Accessed 22 September 2013.

Van Sant, Gus (2008) 'Kelly Reichardt', *BOMB Magazine*, Autumn, http://bombsite.com/issues/105/articles/3182. Accessed 22 September 2013.

JASON REITMAN
The Rise and Fall of Generation X

Jason Reitman's career is a typical example of how the notion of indie has changed to become – year after year– a significant part of the US film industry. His career was possible through the process of the branding and commodification of indie 'as a philosophy'. Indie cannot be read as a mere aesthetic product of an ethic opposed to the mainstream. Following the success of movies such as Steven Soderbergh's *sex, lies, and videotape* (1989), studios started to invest in auteurs and emerging directors who trained as independents. This renewed scenario where mainstream capitals encountered independent auteurship built a sort of 'system' named *Indiewood* (Biskind 2004). Jason Reitman himself is perceived as a slippery director who moves across that thin line between *indie* (in its average meaning)[1] and *quality*: the so-called 'Oscar movies'.[2] It is no longer possible to relate to contemporary indie film as if it were a mere mode of production (Tzioumakis 2012). Indie nowadays has much more to do with what we may call 'a spirit' – as derived from Edgar Morin (1962) – and 'a style'. A certain usage of film language has become immediately recognizable as indie. Ways of shooting (a lot of close-ups, flat wide-angle shots, opposition between fixed or handheld camera); narrative recurrences (where movies tell the story of contemporary alienation either in the city or in the suburbs, generational clashes, coming-of-age); and actors (both labelled as indie or 'A'-list stars used in different contexts), who become vectors of that 'spirit' through minimal and downplayed acting. Those elements allow indie films to portray the indie culture even if they are produced in a mainstream environment.

The aim of this essay is to analyse Jason Reitman's career through two perspectives. On one side, the thematic aspects in his cinema: how he tells and describes American everyday contemporary life, filtering it through the generational lens of the Generation X 'crisis'.[3] On the other side, the stylistic aspects: how an emerging director manages to craft a style, film after film, thanks both to his ability and to the freedom derived from his box office success. I do not want to discuss if it is possible to consider Jason Reitman an auteur, as I would prefer to consider his evolution as a director.[4]

Lawrance Kasdan's ensemble drama *The Big Chill* (1983) tells the story of a group of former political activists during the 1968 protest movements now facing a sort of midlife crisis. Their will to change the world is overshadowed by embourgeoisement and life responsibilities. Jason Reitman analyses this kind of process – the merging of new kinds of duties and the midlife crisis of so-called rebels of the Generation X – in a renewed context (from the 1960s protests to the symbolic shift from the 1990s to the New Millennium). Reitman's characters belong to the *creative class*, as defined by the sociologist Richard Florida (2002) as those in their thirties/forties who seem to face some kind of crisis due to the loss of their 'purity'. Apparently, they lead a commodified and compromised existence where lost purity underlies the Freudian *unheimlich* they are not able to face. The way characters like Nick Naylor (Aaron Eckhart, *Thank You for Smoking* [2005]), Mark Loring (Jason Bateman, *Juno* [2007]), Ryan Bingham (George Clooney, *Up in the Air* [2009])

Up in the Air © 2009 DW Studios, The Montecito Picture Company,
Rickshaw Productions, Paramount Pictures

and Mavis Gary (Charlize Theron, *Young Adult* [2010]) behave suggests a universe of similarities: as if they were variations on the same note, as if they belong to the same ideological horizon.[5] They also face different personal crises, including the fall of some kind of relationship and the awareness of being adult. All Reitman's characters have weak and fallen sentimental relationships. They all face delusions and traumas that work as an epiphany – in *Young Adult*, for example, Mavis Gary travels back home to achieve a new sense of awareness about her not belonging to the native town of Mercury. Her sense of extraneousness is so deep she will not face the state of things, especially since she is perceived by locals as the sophisticated woman from the big Minneapolis who actually 'made it', achieving a better life as a successful writer. In the beginning of Reitman stories, characters are all portrayed as people who live with ironic distance. This kind of detachment is employed as a way to behave in open opposition to *the generation of the Fathers*, the Baby Boomers. This ironic distance, then, creates not only detachment, but an authentic state of solitude that can be overthrown thanks to an epiphany.

In a certain way, it is possible to state that Jason Reitman uses irony to criticize his own generation, although not in a radical way (he was born in 1977). Irony as a key to interpreting the world leads, in Reitman's view, to an exacerbated individualism that wipes out connections between people (even when characters don't live alone, they seem incapable of connecting). Reitman's characters move in non-personal, non-connotated landscapes. Not only *Up in the Air*'s *non-lieux*, but also flats and houses. From the Lorings' mansion – where Mark doesn't even have a place for his own musical goods but a small storage room – to Mavis Gary's singles-shaped apartment, they live in these non-personal places where individualism has atomized people, living as islands with no personalities.

These 'big themes' that Reitman develops film after film have to be included in a wider and bigger state of mind in contemporary American culture, which seems to

overturn the interpretative keys of irony and detachment. According to some critics and columnists, such as John D Fitzgerald (2012), and recurrent theses explained in books such as *Reality Hunger: A Manifesto* (Shields 2010), we can now talk about *new sincerity*.[6] Reitman's cinema is not, as we have already stated, a radical cinema. In spite of this, reading some recent work by Geoff King (2013: 23–76) it is possible to underline the way movies such as *Juno* work to build an empathic connection with the viewer. King writes of a quirky-by-design attitude that exacerbates what was described by James MacDowell (2010) as a renewed sensibility whose core is 'the empathy of *naïveté*' in the way these stories are told and the way the style develops (as we will see, style is a distinctive feature). *Young Adult* is the last chapter of a process that also includes *Juno* and *Up in the Air*. Because of his considerable success, Reitman then had the possibility of working freely on a personal script – thanks to Diablo Cody – even in a studio context, thereby moving towards the *new sincerity* that seems to interest ever growing parts of American culture.

Geoff King has analysed how phenomena such as mumblecore related to the new landscape of American indie cinema (2013: 122–68). The way this kind of 'wave' was born and developed – with a strong connotation in terms of style and cultural context – and the critical success it gained, allowed it to become a filter that slowly melted into the so-called institutional indie. *Young Adult* is, like Noah Baumbach's *Greenberg* (2010), one example of how mumblecore influenced an indie aesthetic that needed renewal due to its stylization. Mumblecore somehow trashed that aesthetic and drove it towards a more 'sincere' nature. Handheld camera; obsessive focus on details; interest in moving in natural space (rebuilding the space of the *cinéma-vérité*); and working to find a contact between the comic-like aesthetic of quirky and the realism that mumblecore brought back to the indie debate, thanks to its obsessive and almost political amateurness.

Young Adult came out as the end of a path in which Reitman tried to build his personal style. It's no use to calculate the amount of 'auteureness' of the director; we should rather emphasize how his style became more defined and personal film after film, along with Reitman's credibility in the studio system. This credibility was gained thanks to box office breakouts such as *Juno* and *Up in the Air*. Reitman's movies work in a new productive system but are still considered and connotated as independent, and somehow lateral, in quality. These aspects, along with the stories they tell (from *Juno*'s teenage pregnancy to the role of the individual during the economic crisis in *Up in the Air*), reveal a director who is able to work in order to build a convergence point between different systems and cultural schemes that were the core of the Indiewood ideology. On one side, *Juno* works on the quirky aesthetic (from comic-like opening titles to alternative clothes worn by Ellen Page, and the curious objects shown throughout the movie: a phone-burger, a car-bed) and the style that Wes Anderson institutionalized in *The Royal Tenenbaums* (2002) (fixed shots, images built as a theatre stage and *tableaux vivant*, descriptions, long takes). On the other side, *Up in the Air* works as a quality movie and has much less to do with quirky – and what King named 'quirky by design' – but rather looks for another convergence: the omnipresent *wesandersonish mise-en-scène* and the quest for realism (e.g. showing truly unemployed people fired by companies during the big crisis as side actors) to create an empathic connection with the audience. The way George Clooney works to build his character of Ryan Bingham here is central: Bingham is described as a cynic and detached X-er; his face reflects not only the collapse and the failure of an economic system, but of an entire generation. Reitman never shows the entire body of the actor, just details. He fragments it in places, spaces and *non-lieux*. His body is shown as a full figure only in the marriage sequence when, along with Alex (Vera Farmiga), he gains a bit of affection in what we may call a true and traditional epiphany.[7]

The film ends with a close-up of Clooney's face with his voice-over stating the evidence of his pure solitude in the skies of America. His face is no longer unaware and detached, but tired and aware. The experiences he went through (he now knows that Alex cannot be his fiancée because she has a family waiting for her in Chicago) ripped back the curtains, the empty shell he once thought indestructible. Reitman's work on the *mise-en-scène* of Clooney's Ryan Bingham's facial expressions allows him to get closer and closer to that *new sincerity* core that is starting to be considered a new post-economic crisis ethos. Style in *Young Adult*, then, pushes minimally towards this new configuration. Reitman is now able to work in complete freedom due to the audience success of his two previous features.[8]

By telling the story of the fall-with-no-redemption of Mavis Gary (interesting: there is no redemption for Reitman's characters), the director seems to adopt the previous *Up in the Air*'s stylistic improvements; the way he worked on the details of Bingham-the-empty-shell sublimated in that very last close-up. Mavis Gary's physical characteristics are also framed in close-ups: her make-up, sunglasses, gadgets. Also, emphasis is placed on her obsessive gestures, such as tearing her hair. Jason Reitman not only gets closer to his characters, he also distances himself from the more institutional indie *mise-en-scène*. *Young Adult* seems to give up the quirky aesthetic (e.g. no wide-angle lens, more realistic photography) for a more realistic and 'close' way of shooting, with an abundance of handheld camera as it follows the main character in her descent into a nervous breakdown. When she explodes, attacking her ex-boyfriend at his child's secular baptism, the camera not only tells us about her mental instability, but also about her material decay (the make-up has faded, the perfection she was looking for ruined). Style is less 'fixed' and more 'mobile': more interested in moving around the characters and expressing their inner feelings.

There are many clues, then, about the stylistic evolution of Jason Reitman, most of which fall in the period of transition between *Up in the Air* and *Young Adult*. This evolution suggests that he initially focused on getting the attention of the studios through box office success in order to gain credit, credibility and freedom in the system, and his work is moving towards a more personal and refined narration and style.

Hamilton Santià

References

Biskind, Peter (2004) *Down and Dirty Pictures: Miramax, Sundance, and the Rise of Independent Film*, New York: Simon & Schuster.

Collins, Jim (1993) 'Genericity in the 90s: Eclectic Irony and the New Sincerity', in Jim Collins, Hilary Radner and Ava Preacher Collins (eds), *Film Theory Goes to the Movies*, New York: Routledge, pp. 242–63.

Coupland, Douglas (1991) *Generation X: Tales for an Accelerated Culture*, New York: St Martin's Press.

Fitzgerald, Jonathan D (2012) 'Sincerity, Not Irony, Is Our Age's Ethos', *The Atlantic*, 20 November, http://www.theatlantic.com/entertainment/archive/2012/11/sincerity-not-irony-is-our-ages-ethos/265466/. Accessed 23 August 2015.

Florida, Richard (2002) *The Rise of the Creative Class: And How It's Transforming Work, Leisure and Everyday Life*, New York: Basic Books.

Jameson, Fredric (1991) *Postmodernism: The Cultural Logic of Late Capitalism*, Durham: Duke University Press.

Jenkins, Henry (2006) *Convergence Culture: Where Old and New Media Collide*, New York: New York University Press.

King, Geoff (2013) *Indie 2.0: Change and Continuity in Contemporary American Indie Film*, London: IB Tauris.

MacDowell, James (2010) 'Notes on Quirky', *Movie: A Journal of Film Criticism*, Issue 1, http://www2.warwick.ac.uk/fac/arts/film/movie/contents/notes_on_quirky.pdf. Accessed 23 August 2015.

Morin, Edgar (1962) *L'Esprit du temps*, Paris: Éditions Grasset Fasquelle.

Pescatore, Guglielmo (2006) *L'ombra dell'autore: Teoria e storia dell'autore cinematografico*, Rome: Carocci.

Shields, David (2010) *Reality Hunger: A Manifesto*, New York: Knopf.

Tzioumakis, Yannis (2012) *Hollywood's Indies: Classics Divisions, Specialty Labels and the American Film Market*, Edinburgh: Edinburgh University Press.

Wallace, David Foster (1993) 'E Unibus Pluram: Television and U.S. Fiction', *Review of Contemporary Fiction*, 13: 2, pp. 151–94.

Notes

1. The criticism, response and analysis of indie cinema have focused on a cinema removed from the mainstream, opting for several discrepancies in style and narrative through a minimal *mise-en-scène*; a broader, challenging narrative (thus defying the tradition of transparency in mainstream cinema); and innovative themes, as this cinema told what nobody else would. Through indie cinema, moreover, it was possible to filter a whole range of references to alt culture, e.g. its music, fashion and lifestyle.

2. As much as any other label, *quality* may identify a wide range of movies and topics, although most of them align with a cinematographic model aiming not only at cashing millions but also at specific narrative values, to offer a cinema that 'raises the bar' with quality entertainment for the general audience. The process, according to which this cinema doesn't address a specific and targeted audience but the masses, makes *quality* very similar to indie as this is perceived in contemporary culture. This is why there is often confusion around films displaying elements that may be adopted in both cases, as happens in Jason Reitman's work.

3. Generation X addresses a generation with birth dates ranging from the early 1960s through to the early 1980s. The label derives from Douglas Coupland's popular book which, through an innovative narrative implant (where the wider corpus of text is sided by definitions and features of a new urban phenomenology), describes a horizon of precariousness and absence of political, economic and emotional reference points. As if Generation X lived in its own skin, as a result of Reagan politics in the 1980s: the consequences of late capitalism theorized by Fredric Jameson (1991).

4. The issue of authorship, still plenty of possible interpretations especially considering the productive status of cinema due to new interpretative methodologies (i.e. Henry Jenkins's [2006] convergence), is a field in which analysis risks getting stuck. It is not important to look for the author's signature, as much as to identify recurrences in his cinema capable of making his opera carry on a shared discourse and interact in several contexts that use and consume cinema on several levels. Among the latest contributions on the issue of authorship, I may refer to Guglielmo Pescatore's (2006) argumentation according to which the contemporary author, aware both of the postmodern horizon he moves in and the impossibility to be recognized as a traditional auteur, tries to enrich his directing experience with recurrences acting on several levels to shape a reference map indicating several grades of authorship.

5. Perhaps arguments such as 'ideological horizon' are bold, but if there is something that gets close to an ideological structure for the generations that have experienced what is commonly intended as the collapse of great narratives, then it is irony as a key to reading the world. According to David Foster Wallace (1993), this dictatorship of irony allows us to face contemporaneity with cynicism and detachment, bringing along some sort of disillusionment which forces us to level and deny the differences between everything. As if there were no longer opposed systems but everything is equal to everything.

6. *New sincerity* is not something that comes new. In film studies, for example, John Collins had already used it in 1993. In that context, though, his analysis focused on the possibilities that the mergence of digital could offer to the cinematographic story in terms of empathy and verisimilitude.

7. The theme of coming back home is a recurring one in American narratives. Both in movies and literature, the trope is employed to tell the individual and collective crisis of a generation. Beyond the metaphor of coming back as a return to childhood, somewhere to seek comfort and consolation from a situation (texts that account for coming back home, often start with a main character finding themselves at a point in which they realize themselves to be stuck), a strong conflict arises between the urban context that the main character longs to leave behind and the suburban dimension, where coming back home represents a suspension of time, like a bubble that is outside the narrative stream. But there are no fixed rules in this case either; we should rather talk about recurrences and variations – both concern the scope of coming back home, which may not lead to any transformation of the character – i.e. *Five Easy Pieces* (Bob Rafelson, 1975) – and the destination of home, where the contrast is no longer between different geographies but may happen within the same urban frame (see *The Royal Tenenbaums*).

8. Produced on a budget of $6 million, *Juno* grossed $231 million worldwide while *Up in the Air* cost $25 million and grossed $166 million worldwide.

ROBERT RODRIGUEZ

Genre, Nostalgia and Mexican American Heroes

It has been more than two decades since the young Mexican American film-maker Robert Rodriguez burst upon the US independent scene with *El Mariachi* (1992), a film which received as much attention for what it achieved with such a small budget and Mexico-based production as its enjoyably inventive narrative, drawn from a cross-cultural pastiche of masculine genres.[1] Today, the average budgets for Rodriguez's films have increased greatly and, though he has released two more commercial instalments in the *El Mariachi* series – *Desperado* (1995) and *Once Upon a Time in Mexico* (2003) – his films have diverted into very different modes of what could be broadly called the action-adventure film.[2] However, I would argue that Rodriguez's film-making is still primarily defined by that which brought *El Mariachi* so much attention: the way in which he uses inventive cost-cutting film techniques to retain a high level of creative control over his work; and the way in which he employs a nostalgic, cross-cultural pastiche of genres and archetypes in placing Mexican and Mexican American characters centre stage.

In this essay, I will look at three different and prominent generic trends within Rodriguez's film-making, chronologically as they first appeared, in order to chart how his film-making has evolved. I will begin with his career-defining *El Mariachi* series, before continuing to focus on the ethnically infused family film *Spy Kids* (2001) that spawned three sequels, and concluding with his 'Mexploitation' film *Machete* (2010). It shall be my argument that these three key generic strands within Rodriguez's film-making are united by the way in which he uses his creative control over his films, through his own production company and adopting dual roles as writer, director and editor, and controlling additional elements from the score to the on-set cooking, to recreate a nostalgic pastiche of film genres from his own film-fan past. I will argue that all these films, from *El Mariachi* to *Machete*, can be seen as a product of ethnic wish-fulfilment on Rodriguez's part in that he recreates these forms in such a way as to assimilate his own Mexican American identity into nostalgic images of mainstream popular culture, be that action-hero films, family films or 1970s-style exploitation film-making.[3]

The following description of the character of El Mariachi (Carlos Gallardo, Antonio Banderas), as discussed by the star that portrays him in the later two films in the trilogy, captures what is innovative about the character and Rodriguez's particular approach to his action-adventure, 'tortilla western' hero in that he aims to integrate minority Hispanic identities into US genre film-making.

> This character is created from action, he is created from movement. He is not a discursive or a speech character. He is basically a classical hero in that aspect. Speaks very little and moves very, very smoothly. We tried in the first one [*Desperado*] and we are continuing in the sequel [*Once Upon a Time in Mexico*]

Machete Kills © 2013 1821 Pictures, AR Films, Aldamisa Entertainment, Overnight Films, Quick Draw Productions

now doing the same thing, just trying to create a character that is not a typical action hero. He is a guy who moves like a bullfighter, he moves like a flamenco dancer. You know, just trying to add a little bit to the character's Spanish flavour. (Rodriguez 2003)

This character is on one level a 'classical hero' of the action-adventure genre, drawing on iconography from a range of cross-cultural genres, part silent, mythical spaghetti cowboy, part warrior-adventurer hero with brutal and balletic action prowess.[4] But he is also very specifically a Hispanic hero, drawn from Spanish and Mexican iconography most explicitly in his identification both verbally and visually as a, or rather 'the', Mariachi but also in his fighting style, which Banderas tellingly identifies as akin to the ultimate macho figures of the 'flamenco dancer' and matador. Only *El Mariachi* and the final installment *Once Upon a Time in Mexico* can really be considered truly 'independent' from Hollywood in terms of their production context, and *Once Upon a Time in Mexico* leans heavily on the Hollywood-shaped character of its predecessor *Desperado*.

It is notable that in these two films the character of El Mariachi can be identified as fighting, at least in part, for Mexico rather than purely for his own vengeance. The first incarnation of El Mariachi, portrayed by Mexican actor Carlos Gallardo rather than Banderas, is a humble mariachi who is forced to become a warrior in order to save his Mexican border town and the woman he loves from the exploitation of a US druglord. The version of El Mariachi portrayed by Banderas a decade or so later in *Once Upon a Time in Mexico* is a much more polished and spectacular action-hero, but despite its more complex and action-packed plot, the film still concludes with El Mariachi saving the Mexican president. It must be noted though that this film, arguably because of its higher profile, is less explicitly anti-US, with the threat to the president originating from an internal Mexican coup.

At first glance, *Spy Kids* could not be further removed from Rodriguez's previous feature films in terms of its genre, narrative or target audience which is perhaps why it was the first film produced at Rodriguez's own independent Troublemaker Studios, where he would be freer to depart from audience expectations of a 'Robert Rodriguez film'. As the following quote from Alexander Walker's review suggests, however, the film is similar to Rodriguez's *El Mariachi* films in that it succeeds as a 'legitimate piece of crossover entertainment' while presenting its Hispanic characters as heroic figures and in this case part of an ideal family.

> But the film's most unusual feature is its ethnic flavouring: the family in it, whose values get far more stress laid on them than is customary in these dysfunctional times, are all Spanish-American talents. [...] Yet the fun, fantasy and feel good factor enable it to be a legitimate piece of crossover entertainment for every shade of ethnicity and every age bracket. (Walker 2001)

In the production notes for *Spy Kids*, Rodriguez expresses his desire to create an imaginative family film in the mode of those he enjoyed watching as a child, citing *Chitty Chitty Bang Bang* (Ken Hughes, 1968) and *Willy Wonka and the Chocolate Factory* (Mel Stuart, 1971) as specific inspirations.[5] Elsewhere in these production notes, the colourful, fantastical and imaginative visual elements in the film are also aligned with Hispanic cultural influences, comparing some of the set designs to the work of Spanish architect Antoni Gaudí, again suggesting a fusion of US and Hispanic cultures. Despite taking place in a radically different generic world to the other films discussed here, its Hispanic heroes show notable similarities with those portrayed in the *El Mariachi* series and *Machete*. The spy father Gregorio Cortez (Antonio Banderas) can be read as an *El Mariachi*-like action hero recast as a suburban father, with the film's narrative suggesting that Gregorio is nostalgic for his former life as a childless man of action.

Spy Kids also features the character of Machete Cortez, portrayed by Danny Trejo, who not only shares the same name as his Machete character but is also a similarly unlikely hero. Machete Cortez is the wayward brother of Gregorio who is initially reluctant to be a hero, but jumps through a plate glass window in the conclusion of the film to save his family. This scene could be seen as paving the way for Trejo to be cast as the leading hero in *Machete* nine years later, with Rodriguez taking the character into 'Mexploitation' territory. As the director has explained:

> 'Whenever you do an exploitation film, you want to have an issue to explore and it just so happens to be immigration in Machete,' Rodriguez said when the film was released in theatres. What he called 'old-time exploitation flicks' would approach hot-button issues differently than the studios would. Their makers could move more quickly, 'so (the films) always had an avant-garde feel to them. I wanted to capture that spirit in Machete.' (Blundell 2012)

In *Machete* this 'hot-button' issue is explored through its graphically violent revenge narrative, with Danny Trejo as the titular grizzled, bandit-like Mexican *federale* (cop) Machete. Like the *El Mariachi* and *Spy Kids* series this film employs genre conventions, in this case evoking the visual and narrative style of exploitation cinema, to integrate a minority Mexican identity and render it heroic for US audiences, creating *Machete* and its less explicitly political sequel *Machete Kills* (2013) as 'Mexploitation' films.[6] Rodriguez's *Machete* similarly encourages its audience to identify with Trejo's character, rather than viewing him as an ethnic other, as in the range of marginalized *bandido*-type roles that have characterzed the actor's career. When placed within the brutal revenge narrative and the deliberately grainy 'Grindhouse'-style cinematography, Trejo's screen image

no longer seems oppositional, but rather he is perfectly assimilated as the ideal hero for this Mexploitation cinematic world.[7] This is a cinematic world in which literal and figurative attacks on illegal Mexican immigrants within the United States can be fought with cartoonish Mexican machismo, with massive mounted motorcycle guns and machetes held high. The hyper violence of the film is much more extreme and spectacular than Rodriguez's first film, *El Mariachi*, but the films do share some notable similarities in terms of the politics of their heroes, their revenge narratives and emulation of low-cost production styles and techniques from the cinematic past. Both El Mariachi and Machete are wronged by corrupt, powerful Anglo-Americans and seek revenge, and the way in which *Machete* adopts the style of an exploitation film is similar to the way in which Rodriguez adopted the same production models for *El Mariachi* that were used to produce the cheap *narcotrificante* (drug-trafficking films) that were once a staple of Mexican cinema.

 As this essay has demonstrated, though it is not present in all of his films, there is a recurring preoccupation with creating Mexican American or more broadly Hispanic heroes within Robert Rodriguez's independent film-making across a range of genres. At the time of writing, Robert Rodriguez is imminently set to produce Hispanic heroes in a new onscreen context, becoming CEO of his own El Rey cable television network that is due to launch in late December 2013.[8] This network aims to produce entertainment specifically targeted at English-speaking US Hispanics, while still appealing to a crossover audience with popular genre shows. One of its first productions will be a series that focuses on a 'Hispanic James Bond', which could be seen as a *Spy Kids* for grownups.

Victoria Kearley

References

Blundell, Graeme (2012) 'Cold Steel a Perfect Tool for Revenge', *The Australian*, 16 January, p. 27.

Rodriguez, Robert (2003) 'The Anti-hero's Journey' [Featurette], *Once Upon a Time in Mexico* [DVD], UK: Sony Pictures Home Entertainment.

Walker, Alexander (2001) 'The Under-age Agents' [Review], *The Evening Standard*, 12 April, p. 17.

Notes

1. Much of the US and UK publicity of the film and attention from reviewers centred on the fact that the film was made for only $7,000 dollars and how inventive it was with such a small budget. For examples of such reviews, see www.rottentomatoes.com/elmariachi. Accessed 13 December 2013.

2. The films in the *El Mariachi* series are comprised of US/Mexico co-production *El Mariachi* (1992); Columbia-produced *Desperado* (1995); and *Once Upon a Time in Mexico* (2003), made at Rodriguez's own independent Troublemaker Studios. In comparison to *El Mariachi*'s estimated budget of $7,000, the estimated budget for *Once Upon a Time in Mexico* was $29 million.

3. CLB Taylor raises the idea that Rodriguez's films express a desire to nostalgically recreate his own film fan past, in 'Identity Is an Optical Illusion: Film and the Construction of Chicano Identity' (unpublished doctoral thesis, University of Birmingham, 2001, p. 168), but I have furthered this idea to incorporate the ethnic revisions argument here.

4. The warrior-adventurer narrative exists across action-adventure genres and centres on a story of a man who is forced to become a warrior in order to survive or right a wrong.

5. These production notes formed part of the UK press pack for the film, held at the British Film Institute Library.

6. 'Mexploitation' is a term used to describe an exploitation film which employs or engages with elements of Mexican culture. My thanks go to Stephen Pye who first alerted me to the characterization of Machete as 'Mexploitation'.

7. *Grindhouse* (2007) was a commercially unsuccessful collaboration between Rodriguez and Quentin Tarantino that aimed to bring exploitation film-making back to the big screen. It is comprised of a double bill of Rodriguez's *Planet Terror* (2007) and Tarantino's *Death Proof* (2007). *Machete* evolved from a fake 'Grindhouse'-style trailer for the then non-existent film that formed part of this double-bill programme.

8. For more information on the El Rey network, see its website http://www.elreynetwork.com. Accessed 12 December 2013.

GEORGE A ROMERO
King of the Dead

The career of George A Romero, now into its sixth decade, can in many ways be held up as archetypal of American independent film-making, encompassing as it has: low-budget releases that have become financial as well as critical successes; ongoing tensions between artistic vision and commercial sensibilities; the frustrations of projects trapped in 'development Hell'; unhappy dalliances with major production/distribution companies – Orion Pictures on *Monkey Shines* (1988) and *The Dark Half* (1993) – and the acquisition of 'cult' status outside of the mainstream. Romero and his films, though, can also be seen to exist outside of the definitions of 'independent' as we have come to think of them in the twenty-first century, largely due to his body of work almost entirely consisting of horror movies. Even today, the horror genre is still often dismissed, as heavy metal can be when discussing music, as somehow being unworthy of serious critical discussion and acceptance, even if box office returns and the hero worship afforded many of the genre's leading figures suggest that the general public, at least, have an undying appetite for horror in all of its evolutionary guises.

Not a director one would associate with any overtly auteurist tendencies or stylistic tics, the director's films are, nonetheless, clearly his. Though visceral in terms of graphic gore, at times to censor-baiting degrees, and laced with mordant humour, many of Romero's films are noteworthy on an academic/critical level for carrying a strong undercurrent of sociocultural and political commentary – though much of this is as projected onto the films as it is integral to them – variously evoking the Vietnam War, race, alienated youth, feminism and vivisection to class, consumerism, governmental conspiracies, mass media, isolationism and gender. At various intervals, Romero and his associates have also successfully challenged, or bypassed, the norms of film financing, distribution and marketing, issues that are as important to any release as the onscreen material itself.

From his directorial debut, *Night of the Living Dead* (1968), to the unfortunate, poorly realized, CGI-riddled nadir of *Survival of the Dead* (2009), Romero has fought a long, often frustrating and perhaps career-hindering battle to retain full artistic control of his work. The genial director (also editor, cinematographer, screenwriter and sometimes actor) has worked in and through the eras of John Cassavetes, New Hollywood, Video Nasties, the Hollywood Blockbuster, Sundance and Torture Porn, frequently at odds with the themes and styles that were *du jour* during those periods. Romero's admirable CV includes working with legendary special effects guru Tom Savini; author Stephen King; and Italian horror director Dario Argento, firmly establishing, via *Night of the Living Dead*, *Dawn of the Dead* (1978) and *Day of the Dead* (1985), the zombie as a globally recognized cultural phenomenon and embracing alternate storytelling mediums and new film-making technologies. Often appearing, Hitchcock-like, in many of his own films,

Night of the Living Dead © 1968 Image Ten, Laurel Group

Romero has, alongside directing sixteen films, helmed ads for video games (*Resident Evil*), penned his own comic-book – *The Death of Death* (2004) as part of DC Comics' Toe Tags series) – and executive produced, among others, Savini's colour-remake of *Night of the Living Dead* (1990) and the television series *Tales from the Darkside* (Syndicated,1984–88).

Born in New York City in 1940, and a graduate of the renowned Carnegie Mellon University in Pittsburgh, Pennsylvania (the area where many of his films would go on to be shot), Romero began his career shooting shorts and commercials in the early 1960s. Inspired to make a horror movie after directing a segment of the children's television series *Mister Rogers' Neighborhood* (PBS, 1968–2001), in which the titular figure underwent a tonsillectomy, Romero, along with a group of friends, would found the independent company Image Ten before co-writing and directing his debut film. Now rightly regarded as a landmark horror movie – due to its explicit gore, unflinching documentary-style cinematography, contemporary setting and African American lead – *Night of the Living Dead* was shot on 35mm black-and-white stock, a move that reflected the film's meager $114,000 budget, but would subsequently gross $18,000,000. It's important to note that as the casting of Duane Jones in the lead role was, as Romero has always stated, simply a case of the actor providing the strongest

audition, the film's subsequent reading as being a comment on race is predicated on happenstance rather than directorial intent.

A bona fide hit by anyone's reckoning, *Night of the Living Dead* – one of the original Midnight Movies – along with the likes of Alejandro Jodorowsky's *El Topo* (1970) and John Water's *Pink Flamingos* (1972) – remains a prime example of independent film-making reaping rich rewards, both financial and artistic. At the very dawn of the 'New Hollywood' – a year before Dennis Hopper's *Easy Rider* (1969) – Romero and his compatriots would, presciently and inadvertently, show that an alternative to the crumbling behemoth that was the Hollywood studio system was possible. Frustratingly for Romero, both financially and legally, errors in copyrighting when the film's original title *Night of the Flesh Eaters* was jettisoned eventually led to the film entering the public domain. This meant that the director and the investors made nothing off its home-media releases, with the subsequent friendship-straining, pressures of legal issues with co-writer, John A Russo, over the title of *Return of the Living Dead* (1985), which the latter was involved with, adding to the film's somewhat chequered off-screen history. As a counterpoint to these unfortunate elements, *Night of the Living Dead* was eventually selected by the Library of Congress as a film deemed culturally, historically or aesthetically significant and preserved in the National Film Registry.

It wouldn't be until *Dawn of the Dead* in 1978 that Romero would again achieve the same level of box office success and attention, with the four films he directed before that being a mixed bag in terms of themes and genres, critical reception and financial returns. The little-seen *There's Always Vanilla* (1971) was a rare excursion into non-horror territory, centring on the relationship between a young man and his older lover, while *Season of the Witch* (1972) focused on a bored suburban housewife's involvement in witchcraft and murder. Neither film would attract commercial or critical rewards, though both conform to the director's vision of a deep-rooted malaise in contemporary American society, never more apparent than during the late 1960s and early 1970s. With the under-appreciated *The Crazies* (1973), Romero would return to the theme that dominates his filmography: social breakdown. Rather than a zombie epidemic, *The Crazies* revolves around the leaking of a manmade virus and the violent anarchy it brings to a small Pennsylvanian town. Clearly metaphorical, *The Crazies* addresses social cohesion, mass hysteria and chemical warfare while castigating both the American government and military. Science run amok, the unpopular war in Vietnam, media manipulation and the perceived erosion of civil liberties are evoked through a fantastical, yet plausible, narrative. Remade, and relocated to Iowa, in 2010 by Breck Eisner, *The Crazies* is often overlooked when 1970s horror is discussed, living as it does in the shadows of the genre's big hitters of the era – *The Texas Chain Saw Massacre* (Tobe Hooper, 1974), *The Last House on the Left* (Wes Craven, 1972), *Halloween* (John Carpenter, 1978) and Romero's own *Dawn of the Dead*.

Prior to the release of *Dawn of the Dead*, Romero wrote and directed *Martin* (1976), a contemporary take on vampirism that ranks as the director's personal favourite of his own films, as well as being the first project taken on by Laurel Entertainment, the production company founded at the time by Romero and Richard P Rubinstein. As close as Romero has come to directing an 'arthouse' movie, *Martin*, starring John Amplas in the title role, is a deeply intense character study that eschewed the standard conventions of the 'vampire' movie in favour of gritty realism. More a psychological thriller than a horror movie, *Martin* repositions the Gothic in the modern world, the titular 'vampire' alienated and left spiritually empty by the coldness of contemporary society. Romero would eventually leave Laurel Entertainment in 1985 after directing *Day of the Dead*, with the company itself merging with Aaron Spelling Productions in 1988.

Dawn of the Dead, featuring a score by Dario Argento and the Italian progressive rock band Goblin, became Romero's second heavyweight release, shot on an estimated budget of $1.5 million it took over $55 million worldwide, making it one

of the most financially successful independent features of all time on a cost/return basis. More comic and graphic, though equally as bleak, in tone than *Night of the Living Dead*, the sequel would fully launch the career of Tom Savini, a groundbreaking special effects technician and one of the director's most frequent collaborators. *Dawn of the Dead* would also see one of the most successful challenges to the Motion Picture Association of America's (MPAA) draconian system of film classifications. Unsurprisingly, given the film's excess of graphic gore, the MPAA demanded cuts to the film in order to achieve the financially desirable R rating in the United States. Sticking to their guns, knowing, as the MPAA themselves agreed, that the film would lose its potency if snipped at, Romero and Rubinstein would sidestep the MPAA completely and convince United Film Distribution (UFD) to release the film unrated. With many theatres reticent to screen unrated films and many media outlets point blank refusing to deal with them, this was a risky stance, one that saw Warner Bros and American International Pictures eventually shy away from the film. However, Romero, Rubinstein and the UFD's decision – an entirely legal one – proved wildly successful. For the second time in his career, Romero (and his associates) circumvented traditional film-making routes in favour of retaining artistic control, striking another blow for independent film-making in the United States.

Relatively bigger budgets would follow for Romero, and the director followed *Dawn of the Dead* with the offbeat *Knightriders* (1981), an adventure drama centring on the lives of a motorcycle jousting troupe starring a young Ed Harris that, though being a fine film, proved too esoteric for mainstream consumption. In 1982, Romero would team up with Stephen King (on screenwriting duties) for the portmanteau horror *Creepshow*, an homage to the EC Comics of the 1950s and possibly the director's most mainstream film to date. Starring Leslie Neilsen, Ed Harris, Ted Danson and Adrienne Barbeau, *Creepshow* heightened the more overt comic book stylings glimpsed in *Dawn of the Dead* in an effective, enjoyable and, at times, idiosyncratically gory film. Another independent feature, *Creepshow* would spawn two sequels (1987, 2006), the first of which Romero would pen and Laurel would produce. In 1985, Romero completed his original 'Dead trilogy' with *Day of the Dead*, which like the instalment before it was released unrated by UFD in order to preserve the director's artistic control of the project. The decision to once again go down this route, however, would see the financing side of things go against Romero, as a promised budget of $7 million was slashed in half, forcing a scaling back of the production and a major rewrite of the script. Failing to either ignite the box office or many critics, the nihilistic, dialogue-heavy *Day of the Dead* is the director's favourite of the original trilogy and in Sarah (Lori Cadille) has a lead female protagonist who is every bit as emotionally strong, intelligent and physically capable as Sigourney Weaver's Ripley in the *Alien* franchise (Ridley Scott, 1979, James Cameron, 1986, David Fincher, 1992, Jean-Pierre Jeunet, 1997).

A financially and artistically fallow period of run-of-the-mill films, missed opportunities and stalled projects dominated the director's career for twenty years post-*Day of the Dead*. Having previously, for various reasons, missed out on bringing Stephen King's bestsellers *Salem's Lot* (1975) and *The Stand* (1978) to the big screen, Romero would go on to leave the adaptation of King's *Pet Sematary* (1989) when filming was delayed, to be replaced by Mary Lambert. After helming *Monkey Shines* and one half of *Two Evil Eyes* (1990) (with Dario Argento directing the other), Romero would eventually bring a King adaptation to fruition with *The Dark Half*. None of these films, or *Bruiser* in 2000, would bring the director much box office or critical success however, and only his return to the Dead universe with *Land of the Dead* (2005) would see Romero receiving anything like the attention he commanded during the eras of *Night of the Living Dead* and *Dawn of the Dead*. The new 'Dead trilogy' was completed with *Diary of the Dead* (2007) and *Survival of the Dead*, as Romero integrated gated communities, corporate

power and the Internet Age into his visions of social collapse. A pale shadow of his original 'Dead trilogy', the latter zombie films are chiefly to be celebrated for their existence, as Romero has continued to do things his way: on low budgets, with artistic control, outside of the Hollywood machine.

Romero's films may not always have lived up to expectations, but the way in which they were made is a credit to his fiercely independent spirit.

Neil Mitchell

PAUL SCHRADER
The Infant and the Cadaver

Popularly known as the screenwriter of *Taxi Driver* (Martin Scorsese, 1976), Paul Schrader's work in cinema extends well beyond this seminal collaboration with Martin Scorsese and Robert De Niro, from his beginnings as a film critic to his continued career as a director. When asked how his background as a critic influenced his work as a film-maker he uses a telling example to outline the two modes of approaching the cinematic medium. Responding cautiously, he explains that for him the analytical impulses of the critic may be

> as much for good as bad, maybe in fact more for bad. Because a critic in many ways is like a medical examiner. You know, you open up the cadaver, and you want to see how and why it lived. And a writer, a film-maker, is, on the other hand, much like a pregnant woman. You know, you're just trying to keep this thing alive and nurse it and feed it and hope that it comes out alive. And so you have to be very careful not to let the medical examiner into the delivery room. You know? Because he will kill that baby. He'll just tear it apart and say, 'Oh, this is an interesting baby!' Rip! (qtd in Museum of the Moving Image 1999)

As explicitly proposed in these two scenarios, a film may be treated as an infant in delivery, or a deceased body prepared for autopsy. An overly binaristic division to be sure, but relatable to those involved in the pursuits of generating and studying artwork, and illustrative of the suspension of self-doubt necessary for any creative endeavour. It's also instructive for approaching Schrader's body of work. Whether directing his own scripts or writing scripts for films directed by Scorsese, Peter Weir and Sydney Pollack, or adapting stories from Russell Banks, Elmore Leonard, Ian McEwan, Harold Pinter and his brother Leonard Schrader, his projects offer compelling visions of what cinema can be in the present moment. Working almost exclusively in the Hollywood system, these personal, often tortured views of life in America in which a protagonist is set on a self-destructive path, knowing or unknowingly taking action that is harmful to themselves, and ultimately against their best interests. Following Schrader's suggestively gendered distinction between the 'pregnant mother' film-maker and male 'medical examiner' critic, his projects often centre on the male psyche and demonstrate an obsession with self-analysis that opens up to larger cultural anxieties of the time.[1] Within the film industry this has led him towards character studies, often classified as biopics (*Raging Bull* [Martin Scorsese, 1980], *Mishima: A Life in Four Chapters* [1985], *Patty Hearst* [1988], *Auto Focus* [2002]). Their conclusions usually court an act of violence, negotiating a cathartic moment of sacrifice, redemption or transcendence. These structural and thematic concerns are integral to his own critical texts on other film-makers, and offer a suitable entry into both practices. As the above excerpt demonstrates, Schrader is endlessly self-critical in his many candid interviews, going so far as stating he probably shouldn't have done this or that film. However, his work on-set is all the more fascinating for its analytical dissection and unique theoretical foundations, his work on the page enlivened by their creative application.

Light Sleeper © 1992 Carolco Pictures, Grain of Sand Productions,
Seven Arts

Named after his mother's two favourite biblical figures, Paul Joseph Schrader was
born 22 July 1946 in Grand Rapids, Michigan to parents Charles and Joan Schrader.
Raised in a strict Dutch Calvinist community, Paul and his older brother Leonard were
famously prohibited worldly entertainment, and did not see any films until their late
teens. Paul in fact cites a reliance on the craft of storytelling around the family dinner
table as an important component of his creative development, claiming in pubic
appearances and lectures that

> screenwriting is part of the oral tradition, not part of the literary one. And that a
> movie is something that is told, and it has to be told. And that you tell and you
> outline and you re-tell, and you do this over and over. (qtd in Museum of the
> Moving Image 1999)

The first film he saw, *The Absent-Minded Professor* (Robert Stevenson, 1961), did not
impress; however *Wild in the Country* (Phillip Dunne, 1961) starring Elvis Presley, left
a mark. While enrolled at Calvin College with the intention of becoming a minister,
Schrader took film courses at Columbia University in New York City in the summer of
1967. While there, a fateful encounter with critic Pauline Kael compelled him to redirect
himself towards film criticism as a career. He became assistant editor at the *Calvin
College Chimes* (edited by his first wife Jeannine Oppewall) before being ousted in the
midst of its political activities, and after graduating became one of the first fellows at
the American Film Institute's (AFI) Center for Advanced Film Study in Beverly Hills. After
resigning in protest to AFI's dismissal of much of its research staff, he enrolled in UCLA's
Film Master's programme through Kael's influential recommendation, and produced the
thesis that would become the book *Transcendental Style in Film: Ozu, Bresson, Dreyer*
(1972). Turning to film-making against Kael's wishes and open doors, having broken up
with Oppewall as well as the woman he'd left her for, he wrote *Taxi Driver* in a very low
place.

The film was a touchstone in the second wave of New Hollywood, as well as a breakthrough for the kind of transcendence Schrader had described in *Transcendental Style in Film*. In it he'd focused on the austere works of Yasujiro Ozu of Japan; Robert Bresson of France; and Carl Theodor Dreyer of Denmark, arguing towards recognition of a common film form emerging across cultures that strives to express the holy or ineffable, offering ample references to earlier means of artistic-religious expression. Perhaps providing justification for his own works' forays into pornography, violence and 'low' genre in the commercial medium of film, here he stresses that in each age the transcendental finds its proper level and style, and that 'Sometimes that style uses more abundant means, sometimes more sparse means' (Schrader 1972: 168).

Taxi Driver's violent catharsis, in which self-imposed isolation leads De Niro's veteran protagonist to murderous action against opposite poles of the social spectrum: a presidential candidate and a pimp abusing a child, could be interpreted as a violent twist in Schrader's theorization of transcendence. It also began a handful of films spread across his career that tell strikingly similar stories as each negotiates these common problems of violence and transcendence. This loose series works in the existentialist tradition of Sartre and Camus, featuring a Dostoevskian antihero he's variously described as The Peeper, The Wanderer, The Voyeur and The Loner (Kouvaros 2007). They resemble each other not due to a shared character or continuous history, but a common soul tracked across four decades of life. Composed of 1976's *Taxi Driver*, *American Gigolo* (1980) and *Light Sleeper* (1992), the cycle was casually referred to as 'the man in a room' trilogy until its fourth instalment, *The Walker* (2007), made it a tetralogy. As Schrader has explained, when 'the man' is in his twenties he is angry and working as a taxi driver (Robert De Niro as Travis Bickle), in his thirties he's narcissistic and a prostitute (Richard Gere as Julian Kaye), in his forties he's anxious and a drug dealer (Willem Dafoe as John LeTour), and in his fifties he's superficial and a society walker (Woody Harrelson as Carter Page). *Light Sleeper* bookends *Taxi Driver*, as the man has now moved to the back seat of the hired car as he travels New York delivering drugs. *The Walker* bookends *American Gigolo*, with the man brought out of the closet, now a gay Washington DC socialite accompanying married women to parties, much like the Los Angeles activities of *American Gigolo*'s prostitute (Kouvaros 2007).

As their names subtly indicate, they exist in an unmoored state (Travis – 'travel'; LeTour – 'tour'; 'Carter'; 'Page'). As Schrader has commented, they each perform an important service for people, but once it's done they don't matter to them and become non-people, disappearing. As such, these passive characters

> see life from the outside, they drift about, watch the high and the low, the educated and the vulgar, and they're sort of detached from it all. Really quite pure at an intellectual level. It's like the character in *Taxi Driver* says, 'I'll take anybody, it doesn't matter to me.' It's that kind of cold detachment that allows them to be part of the world but not really in it, and to be incorporeal in a way, like souls that are looking for a body to inhabit. (Jackson 2004: 232–33)

That detachment allowed for a stunning perspective within the Vietnam era in *Taxi Driver*, while *American Gigolo* offered a compelling view of sex and consumption in the 1980s, and *The Walker* connected to the ongoing pristine facade and hidden machinations of Washington. However, *Light Sleeper*'s historical resonance as well as narrative and thematic significance within Schrader's body of creative and critical work has largely been overlooked; shocking, as he's repeatedly called it his most personal film (qtd in Museum of the Moving Image 1999). As Roger Ebert wrote at the time of its release, 'In film after film, for year after year, Paul Schrader has been

telling this story in one way or another, but never with more humanity than this time' (1992). A brief examination of this remarkable and flawed film should provide a fitting summation to this essay on the work of this film-maker/critic.

Set over a long Labor Day weekend during a sanitation strike, *Light Sleeper* is the only film Schrader has shot in New York to date. Mid-level dealer John LeTour runs drugs to clients around Manhattan, sitting in a hired car observing the nocturnal city and addicts he encounters. A former user himself, he's come clean approaching middle age, and works out of the entrepreneurial Ann's (Susan Sarandon) stylish apartment along with Robert (David Clennon). Dealing in powder cocaine rather than the newer, demanding crack, the three friends are posed as remnants of spiritual New Age counterculture, with Ann considering a switch to dealing natural cosmetics rather than coke. John encounters his former romantic partner Marianne (Dana Delany) on the street by chance; however, she's resistant to his interests in her life, as she's also 'gone clean'. A death brings about an intimate reunion between the two, and another compels John to violent action, and eventual acceptance of a new chapter of his life.

Schrader based the film on his own former drug dealer in New York, from years earlier. He'd been thinking of a mid-life crisis follow-up to *Taxi Driver* and *American Gigolo*, and all but given up when 'John' came to him in a dream in September 1990. He wrote the first draft in two weeks, and had finished by Christmas, starting shooting the following March (Macaulay 1992). Schrader tracked down the full trio of the real-life subjects for John, Ann and Robert, even having Dafoe go on deliveries with his counterpart. While only Robert is characterized as gay in the film, both men were homosexuals. John later tragically died from AIDS (Schrader 2003). Throughout, John appears in his bare New York room, a mattress on the floor next to a desk. Dafoe reads his journal in voice-over, everything from memory tricks to remember users' names, to the realization that he's done with the dealing business. A moody soundtrack by Michael Been offers another level of narration, quasi-religious lyrics running as counterpoint to the drama and rich imagery by DP Ed Lachman. Garbage bags fill the streets, and a sense of dread and alienation pervades the film, beyond its characters' preoccupation with luck in the face of police surveillance, health and forced redirection of life paths.

The conclusion, which follows an act of revenge on John's part, has been discussed as *Light Sleeper*'s crucial flaw. Not surprisingly, this has been expressed most critically by Schrader himself, feeling he'd written himself into a corner, and could only find a means of catharsis through violence. Yet this deadlock may prove *Light Sleeper* to be Schrader's best film, his critical and creative impulses in constant motion.

Joel Neville Anderson

References

Jackson, Kevin (2004) *Schrader on Schrader*, New York: Faber and Faber.

Ebert, Roger (1992) 'Light Sleeper', *Roger Ebert*, http://www.rogerebert.com/reviews/light-sleeper-1992. Accessed 15 February 2016.

Kouvaros, George (2007) 'Pretending That Life Has No Meaning: Interview with Paul Schrader', *Rouge 10*, http://www.rouge.com.au/11/schrader.html. Accessed 23 August 2015.

Macaulay, Scott (1992) 'Movie High: Scott Macaulay Interviews Paul Schrader about *Light Sleeper*', *Film-maker Magazine*, Autumn, http://film-makermagazine.com/archives/issues/fall1992/movie_high.php#.Vdl0a84VflI. Accessed 23 August 2015.

Schrader, Paul (1972) *Transcendental Style in Film: Ozu, Bresson, Dreyer*, Berkeley, CA: University of California Press.

Museum of the Moving Image (1999), 'Paul Schrader' [Discussion following
 screening of *Affliction* (1997) at the Museum of the Moving Image, Chief
 Curator David Schwartz], *Pinewood Dialogues*, 10 January, http://www.
 movingimagesource.us/dialogues/7/view/224. Accessed 23 August 2015.
Schrader, Paul (2003) Director's commentary, *Light Sleeper* [DVD], UK: Momentum
 Pictures.

Notes

1. While these are most often set in America, he's also ventured elsewhere,
 as with *Mishima: A Life in Four Chapters*, *The Comfort of Strangers* (1990),
 Dominion: Prequel to the Exorcist (2005) and *Adam Resurrected* (2008), plus
 his screenplays for *The Last Temptation of Christ* (Martin Scorsese, 1988) and
 The Jesuit (Alfonso Pineda Ulloa, 2014).

STEVEN SODERBERGH
Cinematic Revolutionary

Steven Soderbergh is distinctive both in his diversity and the difficulty he poses to systematic analysis. His films are distinctly his, yet it is hard to say what their commonalities are. Thematically, there are few obvious links between *Out of Sight* (1998) and *Che: Part One* (2008), or *Ocean's Eleven* (2001) and *Side Effects* (2013), and he has traversed a number of genres including neo-noir (*The Underneath* [1995]), science fiction (*Solaris* [2002]) and biopic (*Erin Brockovich* [2000]). If there are commonalities in his films, they are best found in their style, which combine Soderbergh's various talents. As well as directing, he also served as editor and cinematographer on eight of his films, including *Bubble* (2005), *The Good German* (2006) and *Behind the Candelabra* (2013), with a recognizable feature of his films being the way they look and how they play with the visual properties of cinema.

Soderbergh was born in Atlanta, Georgia in 1963, before his family moved to Charlottesville, Virginia, and, subsequently, Baton Rouge, Louisiana. While in high school, Soderbergh made short Super-8mm films, using second-hand equipment often borrowed from LSU (Louisiana State University) students. He also enrolled in the film animation class at LSU for high school students and used second-hand equipment to make 16mm films, including *Janitor* (1978). After graduating from high school, Soderbergh moved to Hollywood, working as a game show scorer and cue card holder, as well as a freelance film editor. However, his success was limited and he returned to Louisiana where he continued to make short films and write scripts. In 1985, the rock group Yes hired Soderbergh to direct a concert film for the band, *Yes: 9012 Live* (1985), wich earned the director a Grammy nomination for Best Music Video, Long Form, and greater success was to follow. In 1987, Soderbergh filmed *Winston*, and later expanded this short into his first feature *sex, lies, and videotape* (1989), the film that would bring him international attention when he was awarded the Palme d'Or at the Cannes Film Festival. At 26 years of age, Soderbergh was the youngest ever recipient of this award. *sex, lies, and videotape* would also win the Independent Spirit Award for Best Director, and receive an Oscar nomination for Best Original Screenplay. Furthermore, the film would come to be credited as kick-starting the growth of American independent cinema in the 1990s, which includes such landmark films as Quentin Tarantino's *Reservoir Dogs* (1992) and *Pulp Fiction* (1994); Kevin Smith's *Clerks* (1994); and Bryan Singer's *The Usual Suspects* (1995).

Since this recognition, Soderbergh has been remarkably prolific, directing 26 feature films and several documentaries and TV episodes. His films during the 1990s, including *King of the Hill* (1993) and *The Underneath* and *Schizopolis* (1996), were not major critical or commercial successes. *Out of Sight* was his next high profile film, receiving great critical acclaim and effectively launching the credible film career of George Clooney following the disastrous response to

sex, lies, and videotape © 1989 Outlaw Productions, Virgin

Batman & Robin (Joel Schumacher, 1997). Subsequently, Soderbergh's projects received greater mainstream recognition, culminating in 2001 when the biopic *Erin Brockovich* and the multi-stranded drug-trade thriller *Traffic* (2000) were both nominated for Best Picture at the Academy Awards. Soderbergh was nominated for Best Director for both films, only the second director to receive this honour since Michael Curtiz was nominated for *Angels with Dirty Faces* and *Four Daughters* in 1938. While *Gladiator* (Ridley Scott, 2000) picked up Best Picture, Soderbergh was awarded Best Director for *Traffic*, which also picked up Best Supporting Actor for Benicio Del Toro; Best Adapted Screenplay for Stephen Gaghan; and Best Editing for Stephen Mirrione. Julia Roberts received Best Actress for her performance in *Erin Brockovich*.

Following these accolades, Soderbergh continued to work with high-profile performers, including Clooney and Roberts along with Brad Pitt and Matt Damon in the *Ocean's* trilogy (2001, 2004, 2007), the first of which remains Soderbergh's biggest box office success with a domestic gross of $183 million. Alongside directing, Soderbergh has also produced a number of films. Many of these were in collaboration with Clooney through their production company Section Eight, including *Insomnia* (2002), *The Jacket* (2004), *Syriana* (2005) and *Michael Clayton* (2007). Clooney and Soderbergh dissolved the company in 2006 (Jones 2006).

The typical Soderbergh film takes a somewhat distanced view, making frequent use of wide-angle shots with varying levels of focus and lighting, intercut with close-ups that, despite capturing the action, do not create a sense of intimacy. The opening scene of *Traffic* presents a car in the middle of desert scrub, barely distinguishable within the heat haze. The second shot reveals two men speaking in Spanish, the darkness of their clothes and hair in stark contrast to the shimmer outside. The film's final scene features a children's baseball game and one of the same men, Javier Rodriguez (Benicio Del Toro). The baseball game has a similar visual palette, the bright lights turning everything a sandy colour, apart from the black silhouettes of the spectators. *Traffic* uses

similar cinematographic quirks throughout its duration, presenting Mexico in yellowed, desaturated stock, while Washington appears blue and washed out. A different but equally effective device is used in *The Good German*, shot entirely in black and white, with 1940s-style credits and even back projection for some sequences. The multi-stranded narrative approach of *Traffic* appears later in *Contagion* (2011), which like *Side Effects* has an almost sickly pallor to its visual palette, suggesting the medical concerns of the narrative through the cinematography. The images of *Ocean's Eleven* display a shimmering quality in which the characters almost bleed into the dazzling lights of the Las Vegas strip, their unassailable cool making them barely corporeal.

What is strikingly similar about these visual techniques is that they do not have the obvious effect. One might expect the different visual styles to draw the viewer in and make one feel more involved in the drama. Instead the opposite is true and the effect is alienating. The contrasting colours in *Traffic* emphasize that the film is presenting different parts of the drug trade, while *The Good German* is an overt homage to 1940s film noir (albeit with stronger language). *Contagion* and *Side Effect*s may be about medical issues, but both theme and appearance are in tension with the narrative. In the former, the multi-stranded narrative features characters all over the world affected by the deadly virus, but not enough time is spent with any one character or group to get more than an impression of their situation. In the latter, issues of medical ethics and mental health are abandoned in favour of conspiracy plots and problematic sexual politics. A sense of presentation is recurrent throughout Soderbergh's oeuvre, as though the director is unwilling to suggest that he is depicting anything real. He is an explicitly postmodern film-maker, drawing attention to the artificiality of the simulacra that he presents through overt stylistic flourishes, many of which echo other films, genres and film-makers (Holt 2002: 309).

Soderbergh's use of editing is another matter, however, as it does serve to draw the viewer in and, therefore, creates a tension with the cinematography. This is especially apparent in *Out of Sight*, *The Limey* (1998), *Solaris*, *Haywire* (2011) and *Che: Part One*, all of which make extensive use of flashbacks and flashforwards to convey mood and suggest the characters' thoughts. Flashbacks in these films do not simply convey information about what happened previously, they inform the mood of the 'present' and help to further the cinematic narrative. In *Out of Sight*, the inherent ingenuity and decency of Jack Foley (George Clooney) is given background at key moments, helping the viewer to understand why he makes particular decisions. *The Limey* uses sequences from an earlier film in star Terence Stamp's career, *Poor Cow* (Ken Loach, 1967), as some of its flashback scenes, and these inform the regret of Stamp's character Wilson as he seeks to avenge his daughter's murder. *The Limey* also plays an interesting trick on its viewer, as its opening shot is actually the end of the story, and while the viewer may believe they are seeing Wilson setting off on a journey from which he will (may?) return, he is already returning. The discontinuous editing, therefore, gives a sense of melancholy that Wilson has completed his mission and now has only his memories ahead of him, as that is all that we see from the opening shot onwards.

Solaris is perhaps the best example of Soderbergh's use of emotive editing. A film about grief and mourning, it uses a similar technique to *The Limey*, with footage from the beginning appearing again at the end. This disrupts the viewer's understanding of the film's chronology – has the whole film been Chris Kelvin's (Clooney) recollection of his mission to the space station that orbits the distant planet Solaris? Or does the film's conclusion include his recall of events from before he left? This ambiguity relates to Kelvin's own experience aboard the space station, as he encounters memories that have taken form, interacting with them in the present while flashbacks show the original events. Or do they? Is Kelvin hallucinating or imagining everything?

The oneiric editing offers no clarification, the viewer left uncertain about the events of the narrative. But this uncertainty need not be a frustration, as it serves to express the confusion of Kelvin's grieving state of mood, the sense that those we love do not entirely leave us when they die. In the case of *Solaris*, this sense becomes more tangible, thanks to the expressive and emotionally charged editing.

Loved ones are not the only things that haunt and propel the cinema of Soderbergh, as his most ambitious project, *Che*, offers different views on its subject matter. *Che: Part One* and *Che: Part Two* (2008) are very different films, both in terms of style and content. *Che: Part One* uses expressive editing to link the ideals of the Cuban Revolution with its wider impact, cutting between black-and-white footage set in 1964 and colour set in 1955–58. The 1964 sequences feature Ernesto 'Che' Guevara (Del Toro) addressing the United Nations about the potential for further revolution across Latin America, while the 1955–58 sequences portray the actual revolution in Cuba. By cutting between the war and its aftermath, the film demonstrates what the war was fought for, and what potential Cuba's revolution had for wider social reform.

Che: Part Two, however, tells its story of Che's guerilla war in Bolivia more straightforwardly, with scarcely any disruption to the chronology. This makes it a far more pessimistic film, as it depicts the decline and destruction of what Che fought, lived and ultimately died in vain for. Whereas in Cuba, Castro's revolutionary forces had popular and political support, in Bolivia, there is no such support, and without it (combined with American assistance), the guerilla fighters are overwhelmed and defeated. An extraordinary point-of-view shot summarizes the perspective of Che perfectly: at the point of Che's death, when he is executed as a prisoner of war, the viewer sees the execution from Che's POV, including the fatal shots, a collapse to the floor and the last thing he sees as the camera fades to black. This is the closest Soderbergh comes to a direct political statement – the viewer sees Che's life and everything that he stood for fade away. Does this mean socialist revolutionary principles are dead as well? Only the viewer can decide that. The film's final shot, its only flashback, is of Che on the boat that originally brought him to Cuba; footage that is also used in *Che: Part One*, the more hopeful, optimistic chapter. Che on the boat is like an archive image, a memory, and memorializes this extraordinary individual who tried to change the world, and was ultimately thwarted by a lack of support.

Soderbergh is himself something of a cinematic revolutionary, his work consistently trying to change our perception of cinema. This is demonstrated by his use of the tools of editing and cinematography to disrupt simple engagement with the cinematic text. Whether working in transnational productions like *Che*, quirky TV projects like *Behind the Candelabra*, mainstream studio pictures like the *Ocean's* franchise, or independent films like *Magic Mike* (2012), Soderbergh has pushed the boundaries of how cinema can tell stories and express meaning, emphasizing the fluidity of space and especially time within the cinematic medium.

Since 2011, Soderbergh has indicated that he will be retiring from film-making, instead moving into theatrical and television production, as well as painting (Schilling 2013). *Behind the Candelabra* was produced by HBO although it received a theatrical release in Europe. This movement between cinema – both independent and studio – and television, is indicative of Soderbergh's fluidity and versatility. He has said that television offers more opportunities for the projects that interest him (Schilling 2013), so even if his retirement from film proves permanent, the diverse and idiosyncratic career of this remarkable film-maker looks set to continue, while his oeuvre remains a fascinating tribute to the potential of cinema.

Vincent M Gaine

References

Gaine, Vincent M (2013) 'Movies on Mentality', *Vincent's Views*, 15 April, http://vincentmgaine.wordpress.com/2013/04/15/movies-on-mentality/. Accessed 15 October 2013.

Holt, Jennifer (2002) 'Steven Soderbergh', in Yvonne Tasker (ed.), *Fifty Contemporary Film-makers*, London: Routledge, pp. 303–10.

Jones, Jennifer (2006) 'George Clooney Closes Down Section Eight!', *Screenrush*, 21 July, http://www.screenrush.co.uk/news/films/news-18390426/. Accessed 15 October 2013.

Schilling, Mary Kaye (2013) 'Steven Soderbergh on Quitting Hollywood, Getting the Best Out of J-Lo, and His Love of Girls', *Vulture*, 27 January, http://www.vulture.com/2013/01/steven-soderbergh-in-conversation.html. Accessed 15 October 2013.

TODD SOLONDZ
In Search of Lost Time

At the turn of the millennium, Todd Solondz was one of the poster boys of American independent cinema. The film school dropout was featured on the hippest talk shows, festivals and magazine covers. Critics called him the new Woody Allen (Rose 2001). He was cynical, geeky and withdrawn; a middle-class white Jewish kid from New Jersey with a sharp eye and a quick pen. The director's breakthrough film, *Welcome to the Dollhouse* (1995), parodied the American Dream. His controversial ensemble film *Happiness* (1998), took the mickey out of the suburbs. Both his debut film *Fear, Anxiety and Depression* (1989) and *Storytelling* (2001) are exposés of celebrity culture. There were insults at capitalism and consumerism, jeers at the nuclear family and whiteness, masculinity and the bourgeoisie. His CV read like a manual of the postmodernism so in vogue at the time. Solondz's name was ready to be written into the annals of cinema history.

A decade on, Solondz's film *Dark Horse* (2011) was shown at only a scattering of cinemas. It grossed a mere $159,000. Reviews of the film were scarce, and not always positive. Just like that, Solondz was all but forgotten. It wasn't that the director had lost his touch. By most accounts, *Dark Horse* was a clever, poignant and funny film.[1] The problem was that its wit and comedy no longer appealed to the younger audiences. As critic Ann Hornaday put it in the *Washington Post*, Solondz was still tapping 'the same bitter water' from a well that had dried out (2012). It was time 'to consider moving on' – presumably to the sweeter sources that directors like Miranda July and Wes Anderson had unearthed. To write a history of the cinema of Todd Solondz is to write a history of the rise and fall of postmodernism, of the fate of the 'smart film', and of the last days of Generation X.

There are few studies of postmodernism that do not begin by stating that there is no such thing as postmodernism, that it is nothing more than a makeshift label for a variety of concepts, strategies and stylistic registers. There are, however, a number of keywords and buzz phrases that nonetheless pop up in each description. One of the most important notions, certainly, is what Fredric Jameson described as the 'senses of an end': the end of History and ideology in the realm of politics; the end of the grand narrative, truth and the subject in philosophy; of signification in language; and of utopia, expression and affect – i.e. modernism – in the arts (Jameson 1984: 53).

In cinema, such senses of an end have tended to be translated, variously, as eclecticism (the end of the auteur) and pastiche (the end of History); reflexivity (the end of the grand narrative); and irony (the end of, well, just about everything). The films of Brian De Palma and Quentin Tarantino, for instance, indiscriminately draw on intertexts without regard for history or context. Christopher Nolan's *Memento* (2000) dismantles the principles of cinematic narration, memory and identity, a strategy also visible in movies like David Fincher's *Fight Club* (1999) and David Cronenberg's *Existenz* (1999). Elsewhere, directors like Sam Mendes and Alexander Payne took to regarding everything, however beautiful or tragic, from an ironic distance. In *Election* (1999), Payne sits back disaffectedly as the life of the film's protagonist falls apart, never offering his sympathies, never extending a hand; whilst

Dark Horse © 2011 Double Hope Films

American Beauty's (1999) Lester Burnham is himself unconcerned about his pending death. Jeffery Sconce (2002) aptly called these films 'smart' films: not only are these films smarter than their blockbuster contemporaries, they also outwit their protagonists.

A child of his generation, Solondz adopts all of these strategies. In his breakthrough film *Welcome to the Dollhouse*, he infers wide-ranging intertextual knowledge of 1980s teen films so as to undermine the expectations that they helped raise: that parents love their children in spite of appearances, that persistence pays off, that ugly ducklings turn into beautiful swans. A magnificent Heather Matarazzo features as miserable 11-year-old schooler Dawn Wiener. Wiseacre, stubborn, poorly dressed and bespectacled, she is misunderstood by her teachers and bullied by her savage schoolmates. To make matters worse, her parents ignore her, doting instead on her wiz-kid older brother Mark (Matthew Faber) and cutesy ballerina sister Missy (Daria Kalinina).

Yet Dawn, in the tradition of the 1980s Hollywood outsider, perseveres, convinced these experiences are of passing nature. Solondz stylistically supports Dawn's idle hopes by manipulatively referencing 1980s teen films like *Sixteen Candles* (John Hughes, 1984) and *The Breakfast Club* (John Hughes, 1985). Dawn chucks out her geeky backpacks in favour of short, colourful rock-and-roll tops and begins to pursue her own destiny, accompanied by a soundtrack of teenage rebellion and redemption songs like 'Sweet Candy' and 'Evening of Desire'. However, as the film progresses it becomes clear that Dawn's desires will never be fulfilled. If anything, her pop culture-inspired pursuits land her in even more trouble. Her frivolous new outfits mismatch, she offends the only friend she has and is raped by one of her schoolmates. At home, she is to blame for her sister's kidnapping by a paedophile neighbour and her father's ensuing mental breakdown. 'Mark,' she asks her brother at the end of the film, 'is eighth grade better than seventh?' 'Not really,' he replies. 'What about ninth?' she continues, still hopeful. Mark shakes his head. 'Junior high school sucks.' 'High school is better,' he adds, but only because 'it's closer to college'.

The generic label often attached to Solondz's films is that of the tragicomedy. A subtraction of tragedy and comedy, a tragicomedy is a tragedy in which the tragic is what is funny whilst what is funny is the stuff that is tragic. To be sure, a tragedy is not the same as a tragic event. We use the adjective 'tragic' to describe the sudden death of a Hollywood starlet, a plane crash or a fatal school shooting. We speak of a tragedy only when such an event is the outcome of a conflict between our perception of the world and the reality of that world. In a tragedy, people believe the world is a puzzle that can be solved, whereas sometimes in reality pieces do not fit: what is true for one person, or one discipline, or culture, after all, may not be true at all for another. The tragicomedy, crudely put, is the genre that laughs at these miserable incongruences: here downfall is presented as slapstick, death supported by a laugh track.

In *Welcome to the Dollhouse*, tragedy ensues from Dawn's mistaken perception of the world. She believes, in line with the cinema of John Hughes, that hardship is followed by redemption. Yet Solondz begs to differ. He sees the world as unfair and indifferent. What is perhaps most tragic is Dawn's eventual realization that things will not change for the better anytime soon.[2] The film's final shot portrays Dawn meekly sitting on a school bus with her joyous classmates, despondently singing along to the cheerful, uplifting school anthem, a song that she now understands was not written with children like her in mind.

Solondz, however, does not empathize with Dawn, nor does he seem to suggest that the viewers should. Indeed, he seizes every opportunity to distance himself and the viewer from his sad protagonist. Images of Dawn being bullied are paired with a shot of her beheading one of her sister's dolls; tropes of loneliness and abandonment are followed by her verbally abusing her only friend, the fragile Ralphy (Dimitri DeFresco). This is not to say that Solondz dislikes Dawn, or suggest we should. Rather, he seems to balance her misery with that which is inflicted by her so as to take a neutral position and postpone judgement. It is here, where the horrors onscreen are treated with directorial indifference, that the film is at once tragic and painfully funny.

In *Happiness*, Solondz's best known and most controversial film, judgement is also postponed. The film follows the extended Jordan family and its friends and neighbours as they suffer through life. Each of them is, as the title suggests, in search of happiness: Lenny, the *pater familias*, seeks happiness in loneliness; his eldest daughter Trish, looks for it in the picture-perfect nuclear family; middle daughter Helen tries for existentialist writing; young Joy in pure love; son-in-law Bill in paedophilia; and Helen's neighbour Allen in anonymous sexual harassment. None of them, however, finds it, incompatible as their desires are with those of the other people around them. Tragic as the events that unfold may be – Lenny cannot stay alone, Trish's husband is a paedophile rapist, Helen realizes she has no feelings of her own – the film keeps its moral distance.

The film tutors its viewers in the ways of the 'smart' film straight from the get go. Fading from black are neatly handwritten title cards, accompanied by a romantic though melancholic soundtrack. Cut to an unexpected frontal medium-long-shot of two people sitting stiffly behind a table in a restaurant. She is breaking up with him, and he does not take it all that well. While the man bursts out in tears, waiters begin to walk by and the noise of other guests grows louder. Instead of drawing closer or zooming in to capture the drama, however, the camera stays where it is, seemingly unperturbed. It is precisely this discrepancy, between the classical romance of the credit sequence, the agony of this enclosed moment, the banality of the wider world around it and the indifference of the camera – that creates the humour. The break-up is certainly tragic, but because of its contextualization, because the weight of its drama is not balanced by the cinematic means, it also turns ridiculous. As Cavey McKittrick asked: should one cry, laugh or do both at once, and cringe? (2001).

Happiness would be Solondz's biggest success, both critically and commercially, winning numerous awards and pocketing over $3 million at the international box office. The subsequent *Storytelling*, a clever two-part film about race, sexuality and celebrity culture, earned less than a million, while the experimental *Palindromes* (2004), in which a pregnant 13-year-old girl is played by eight different actors of varying age, sex and race, only made half of that. In an attempt to return to form, perhaps, Solondz in 2009 wrote and directed *Life During Wartime*, a sequel of sorts to *Happiness*. With the characters now played by different actors, the film focuses on the aftermath of the events of the first film: Trish (Allison Janney) has difficulties keeping up appearances; her pedophile ex-husband Bill (Ciaran Hind) tries to come to terms with what he has done; Helen (Ally Sheedy) still hasn't found her feelings; and Joy (Shirley Henderson) mourns the suicide of Allen (Michael K Williams). If the film occasionally feels more sympathetic towards its struggling protagonists, it also still makes fun at their despair: at Trish's medicine abuse, at Helen's superficiality. 'Squirm-inducing,' Hornaday wrote in the *Washington Post* (2010); *The New York Times'* AO Scott called it a 'queasy limbo between mirth and anguish […] These people are so clueless, so bad at communication, so ridiculous that they must be suffering for our amusement' (2010).

In spite, or maybe because of his return to *Happiness*, Solondz's success would not return. *Life During Wartime* earned a mere $281,000 in box office revenues in the United States. His last film to date, *Dark Horse*, only merited a fraction of that. In an ironic turn of events, Solondz's vision of reality, one that was once shared by millions, was no longer compatible with the outlook of cinemagoers. The cynical postmodern sensibility that was dominant in the 1980s and 1990s had given way to an altogether more empathetic, sincere and optimistic structure of feeling: metamodernism. The 'smart' film, meanwhile, had been abandoned as the independent film-makers genre of choice in favour of the so-called 'quirky' cinema associated with the films of Spike Jonze, Miranda July and Michel Gondry. It is no surprise that Douglas Coupland recently wrote a sequel to his best-selling novel *Generation X: Tales for an Accelerated Culture* (1991) called *Generation A* (2009): we're starting anew. Like Antigone and Othello, but more still like Dawn and Joy, Solondz sees and acts upon one reality whereas everyone else has come to see another: tragedy. But there is no need to feel for him. This is how he has always wanted it – and don't we treat the protagonists of tragedies as heroes?

Timotheus Vermeulen

References

Hornaday, Ann (2010) 'Disquieting Family Bonds, Revisited', *The Washington Post*, 13 August, http://www.washingtonpost.com/gog/movies/life-during-wartime,1161452.html. Accessed 19 January 2010.

——————— (2012) 'A Stunted State of Development', *The Washington Post*, 12 August, http://www.washingtonpost.com/gog/movies/dark-horse,1123272.html. Accessed 19 January 2015.

Jameson, Fredric (1984) 'Postmodernism, or the Cultural Logic of Late Capitalism', *New Left Review*, 146 (July–August), pp. 53–92.

McKittrick, Cavey (2001) '"I Laughed and Cringed at the Same Time": Shaping Pedophilic Discourse around *American Beauty* and *Happiness*', *The Velvet Light Trap*, 47 (Spring), pp. 3–13.

Rose, Steve (2001) 'Life After Happiness', *The Guardian*, 26 November, http://www.theguardian.com/culture/2001/nov/26/artsfeatures. Accessed 19 January 2015.

Sconce, Jeffrey (2002) 'Irony, Nihilism and the New American "Smart" film',
 Screen, 43: 3, pp. 349–69.
Scott, AO (2010) 'Shades of "Happiness", Appalling and Funny', *The New York
 Times*, 22 July, http://www.nytimes.com/2010/07/23/movies/23life.html.
 Accessed 19 January 2015.

Notes

1. *Dark Horse* was the *New York Times* Critics' Pick, for instance, with AO
 Scott describing the film as 'brilliant'. See, AO Scott, 'Adulthood Calling, to
 Faraway Minds and Lost Ambitions' (*New York Times*, 7 June 2012), http://
 www.nytimes.com/2012/06/08/movies/todd-solondzs-dark-horse-stars-
 jordan-gelber.html?partner=rss&emc=rss&_r=0. Accessed 19 January 2015.
2. And as it turns out never, seeing as one of Solondz's later films, *Palindromes*,
 opens with Dawn's suicide.

WHIT STILLMAN
Social Class and Identity

In a review of Jason Wood's *100 American Independent Films* (2004), film critic and novelist Kim Newman offers a mild criticism to what he sees as the author's naive idealization of non-mainstream film in America:

> He sets out the independent sector as a space that welcomes voices unheard in the mainstream, though he never addresses the fact that these are as likely to be rich white guys like Whit Stillman and Paul Thomas Anderson as black women like Julie Dash or the other minority types behind *Swoon*, *Tongues Untied* or *Chan Is Missing*. (Newman 2004: 37)

Newman's comment, though fair on purely logical grounds, raises an important issue in relation to Stillman's work. The casual dismissal of Stillman and Anderson based on their social class in particular, arguably speaks to a larger prejudice within film and popular culture as a whole. This maligning of the upper classes is something which Stillman himself is conscious of, as he told *Psychology Today* in 2000:

> I decided not to be disrespectful ipso facto of the bourgeoisie. The idea that the bourgeoisie is all bad is just not true. In the film of our culture, there are always those terrible upper-middle class people who are so snobbish. I think it's the absolute reverse. If there's any group that's a little bit kinder than other people it tends to be that group. (Marano 1998)

Although Stillman describes himself as a 'social climber' who was never fully comfortable in the upper-class homes of his peers, even a casual perusal of Stillman's biography would lead the reader to believe that he is of a higher social ilk than the average American. Whit's great grandfather was the railroad and banking magnate James Jewett Stillman, who was amongst the richest men in America at the turn of the twentieth century, and his father John Sterling Stillman was a Democrat politician who served as Assistant Secretary of Commerce under his Harvard classmate John F Kennedy. Whit also attended Harvard, working in publishing and journalism before turning his attention to film-making. Stillman's advantaged background is without question reflected in his four films to date, all of which deal with various constitutions of the young, educated white upper-middle-classes in heavily ironized but ultimately affectionate terms. As a result, his work has often been seen, for better or worse, as a rescue project for the cultural representations of the privileged classes. Indeed, in 2000 an entire issue of the conservative journal *The Intercollegiate Review* was given over to discussion of Stillman's work.

Metropolitan © 1990 Allagash Films, Westerly Films

Is this a fair assumption to make? Stillman is certainly unashamed in basing his films around the world of the upper middle classes. In *Metropolitan* (1990), the action centres around a band of college kids passing time on the debutante circuit while home in New York for Christmas vacation, whereas *Barcelona* (1994) follows the cultural misadventures of two socially haughty ex-pat siblings in Spain as they pursue their burgeoning careers. The college graduates populating the exclusive clubs of *The Last Days of Disco* (1998), meanwhile, are only slightly preceded in age by the group of preppy young women who associate with those lower on the totem pole under the guise of 'youth outreach' in the campus comedy *Damsels in Distress* (2011).

Although the settings change, there is a remarkable uniformity to the principal characters in Stillman's films – with very few exceptions, they are well-bred, single, white, urbanite, educated Americans. When there is a player that falls outside of this archetype, any differences are equalized by qualifying them as aspirational. In *Metropolitan*, both Tom (Edward Clements) and Nick (Chris Eigeman) lack the financial resources of their peers but nevertheless manage to entrench themselves within the group by performing important roles. Nick is the firebrand orator who ensures that his strongly-worded opinions are at the forefront of the group's many intellectually-framed discussions, the majority of which inevitably revolve around the implications of belonging to what one character calls the UHB (Urban Haute Bourgeoisie). Tom, on the other hand, is kept around as the quietly perceptive would-be love interest of the ever-popular Audrey (Carolyn Farina). Despite the pair being the characters who, from a socio-economic perspective, belong the least, they are unquestionably the two who are most keenly attached to the group in a moral and intellectual sense. When Nick is ejected from the peer group following a physical altercation with the absurdly

named lothario Rick von Sloneker (Will Kempe), he regretfully urges Tom to 'maintain the standards and ideals of the UHB'. In the case of Tom, his initial opposition to the snobbish nature of the debutante scene has by the end of the film transformed into despondency at the group's parting of ways.

The most profound case of aspiration, though, is seen in *Damsels in Distress* through the character of Rose (Megalyn Echikunwoke). The only black protagonist in all of Stillman's films, her visual difference from the norm is displaced through her adoption of the most bourgeois accent possible: costume drama English. Rose is so far removed from stereotypical representations of her own ethnicity that her mimicry of the equally cliché superficial accoutrements of the upper classes is portrayed deadpan; as no more or no less comical than the young white women of the film. In other words, all of Stillman's principal protagonists are drawn from, or are drawn to, a very narrow social palette, which results in his films emanating exclusively from within the world of the modern urban bourgeoisie.

The notion that Whit Stillman's films amount to a defense of the American bourgeoisie is further compounded by the way in which the writer-director constructs his narratives. Although there are 'events' (such as the shooting of Fred [Chris Eigeman]) in *Barcelona*, and the closing of the nightclub in *The Last Days of Disco*), Stillman's films more typically progress through ensemble conversation rather than actions or plot points, and therefore the chance for any outright heroes or, more to the point, grandiosely despicable villains to emerge is greatly diminished. While there are certainly characters who the average viewer is likely to find disagreeable, such as the condescending playboy Xavier (Hugo Becker) in *Damsels in Distress* and the self-involved, sharp-tongued Charlotte (Kate Beckinsale) in *The Last Days of Disco*, they are never completely condemned and overall Stillman's characterizations are fair-handed in reflecting the imperfections of individuals.

However, there is ample material in the four films to dispute the notion that Stillman idealizes his social class. While Stillman insists that there is nothing wrong with the bourgeois per se, he also inflects a heavy dose of humour and self-mockery in the characterizations and behaviour of his protagonists. This is seen primarily in the heavily theatrical, almost minutiae-free style of dialogue given to the protagonists in *Metropolitan*, *The Last Days of Disco* and *Damsels in Distress*. In the almost complete absence of everyday conversation, the verbal exchanges tend to be based on abstract ideas related to either emotions or inevitably social class, position and identity. As James Bowman points out in relation to *Metropolitan*, the construction of the characters is so far removed from reality that

> there are plenty of people from any sociologically identifiable equivalent of the urban haute bourgeoisie, even those who have lived all their lives on the Upper East Side of Manhattan, who nevertheless would see the characters in *Metropolitan* as being quite as alien as they appear to most Americans. (Bowman 2000: 15)

The decline of bourgeois which had been hinted at in the first three films finally comes to fruition in *Damsels in Distress*, the only one of Stillman's works to be set within the institution which acts as the social glue for the bonds formed in his earlier work: college. Whereas in the previous films the protagonists largely mixed within their own cultural ranks (even the Spanish women who become involved with the brothers in *Barcelona* went to college abroad and speak relatively fluent, urbane English), here we see the refined quartet of lead characters mingling with a variety of what could only be described as regular people, and it is in these interactions that we see the knowing absurdity of Stillman's bourgeois characterizations.

After a failed love affair, Violet (Greta Gerwig) runs away to an off-campus motel and visits a roadside diner, where the patrons and staff alike are bemused by her verbose, pseudo-scholarly manner of speech. The disparity between Violet and the 'real' social world is exaggerated by the similarly stereotypical tone of the gruff, straight-to-the-point waitress (an ironically-cast Carolyn Farina from *Metropolitan*) and the saltiness of the two railway workers eating a predictably hearty breakfast. Even when on campus, the four are frequently surrounded by people who seem to share nothing in common with them in terms of appearance or behaviour. This is most clearly seen in the oafish fraternity-men that the Damsels choose to spend time with, who are constructed in primeval fashion to the extent that they at times literally struggle to form a coherent sentence. As well as being devoid of any meaningful verbal capabilities, their college boy etiquette is commonly portrayed as so barbaric that even Belushi's Bluto might wince at their unabashed idiocy. When Violet and company come up with the idea of improving the personal hygiene of a particular frat house through delivering carefully packaged bars of soap, the immediate response of the men is to use the unopened envelopes as Frisbees. The heavy use of stereotype in both the constructions of the Damsels (who are a more comic version of the pseudo-intellectual, impeccably dressed protagonists found in earlier films) and those that surround them only serves to emphasize both the ridiculous pomposity and lack of realism of the bourgeois subcultures which Stillman's previous work had almost exclusively pictured. Only when we see Stillman's world finally meet the (in this case, literally) great unwashed do we see that a heavy dose of irony was always intended; the bourgeois characters may have discussed serious matters, but they were not meant to be taken wholly seriously.

The focus on social class is, however, not the total sum of Stillman's concerns. More generally, his films speak to the quest for identity amongst fragile young psyches. This is spelled out from the very first scene of Stillman's debut film *Metropolitan*, which finds Audrey complaining about the cut of her debutante dress and unhappily assessing herself in the mirror. Audrey lacks the sexual confidence of her peers and is left bereft of self-esteem when her tacit advances are rebuffed by Tom, who, for the majority of the film, prefers the more obvious charms of man-eater Serena Slocum (Ellia Thompson). This character archetype of the timid, insecure heroine is initially mirrored in *The Last Days of Disco* through Alice (Chloë Sevigny). Her best friend through circumstance (the two were acquaintances in college who now work together at a publishing firm in the city) is the impeccably beautiful and imperiously self-assured Charlotte, who early on in the film carelessly informs Alice that 'maybe I'm a little cuter than you' and frequently reminds her that she was disliked in college due to her perceived frigidity. Unhappy with her image, Alice attempts to sexually liberate herself by having a one-night stand and is subsequently carnally adventurous throughout the film. Whereas Audrey never really gets past her insecurities, the older Alice cuts the shackles loose and, by the end of the film, outgrows her peers both personally and professionally. After the club which their social live revolves around closes and the 1980s economy begins to shrink, Charlotte and the rest of the group are left unemployed, single and somewhat in the social wilderness. Alice, meanwhile, has gone through the same experiences of club life and its associated excesses, but has instead advanced her career and is in a happy, stable relationship. Similar transformations occur in *Barcelona*, where the neurotic, permanently stressed salesman Ted (Taylor Nichols) learns to mellow and accept the flaws of himself and those around him, and Lily (Analeigh Tipton) in *Damsels in Distress*, who eventually stops attempting to fit in with her eccentric peers and happily accepts her own regular, Type B personality.

Ultimately, the concerns with social class, etiquette and the bourgeois which permeate Stillman's films at surface level barely conceal that most typical facet of cinema dealing with young Americans: the search for oneself.

Michael Smith

References

Bowman, James (2000) 'Whit Stillman: Poet of the Broken Branches', *Intercollegiate Review*, 35: 2, pp. 15–19.

Marano, Hara Estroff (1998) 'The Soul of Whit Stillman', *Psychology Today*, 1 May, https://www.psychologytoday.com/articles/199805/the-soul-whit-stillman?collection=10039. Accessed 18 July 2015.

Newman, Kim (2004) 'Sound and Silence', *Sight & Sound*, 14: 11, p. 37.

Wood, Jason (2004) *100 American Independent Films*, London: Palgrave Macmillan.

QUENTIN TARANTINO
Bloody Pulp

No director working in American independent film for the last twenty years has had such a significant impact on popular culture as Quentin Tarantino. Not only have his films redefined the genres they inhabit, his successes have changed the business model of independent film distribution; his casting decisions have made and occasionally resurrected careers; his soundtrack albums have revived forgotten groups and performers; and his esoteric taste in cinema has directed the attention of millions to undervalued, hidden or neglected work which was previously the province of small enthusiastic cults. As a scriptwriter, his witty pop culture-primed dialogue has earned itself its own adjective. As a director, he has tested limits of taste and endurance while at the same time producing mass entertainment and picking up prestigious awards including Oscars and a Palme d'Or. From video-store clerk and budding actor, Tarantino has emerged triumphant as the fanboy turned cinephile auteur par excellence and one of the most publicly recognized celebrity film directors currently working today.

Thus far, his career can be neatly divided into two parts. The first half runs from his stunning debut *Reservoir Dogs* (1992) through the first 'independent' blockbuster *Pulp Fiction* (1994) to *Jackie Brown* (1997).[1] Each film furthered his reputation as a startlingly original director within the crime genre. Then there was a six-year gap before he returned with the two volumes of his *Kill Bill* (2003, 2004) saga and subsequent genre-skipping riffs which have won ever larger audiences and commercial success, with the exception of the blip of the 2007 *Death Proof* episode of the *Grindhouse* collaboration with Robert Rodriguez. Aside from directing, his early screenplays for *True Romance* (1993) and *Natural Born Killers* (1994) were both made into major motion pictures by senior directors Tony Scott and Oliver Stone respectively, and Tarantino has built up a circle of protégés and collaborators, including Rodriguez, Eli Roth and Roger Avery. His name recognition is such that a number of films, such as Wong Kar-wai's *Chung Hing sam lam/Chungking Express* (1994), Zhang Yimou's *Ying xiong/Hero* (2002) and RZA's *The Man with the Iron Fists* (2012), have been released in the United States under the 'Quentin Tarantino Presents…' banner.

Though generically aligning himself with Roger Corman-style 'B'-movies, with the exception of *Reservoir Dogs*, Tarantino has never been tightly constrained by a low budget. Although a radically different film-maker, Tarantino shares with Paul Thomas Anderson and Terrence Malick a kudos-enabled financial freedom, due in large part to his solid relationship with the Weinstein brothers, which has allowed him to develop his own vision. With many big name Hollywood stars happy to work for scale just to have the chance of appearing in one of his productions, his films also benefit from an enviable surfeit of star power.

In a cameo in Rory Kelly's character study *Sleep with Me* (1994), Tarantino (playing Sid) offers a frenetic queer reading of *Top Gun* (Tony Scott, 1986), but this motor-mouthed geeking out is not about idolizing iconic movies. Rather, Tarantino revels in unravelling hidden meanings or 'massive subversion', as Sid insists. Tarantino brings to pulp an obsessive analysis and self-awareness, an alertness of the possibility that everything says something else.[2] The opening lines of *Reservoir Dogs* belong to Tarantino the actor (playing Mr Brown): 'Let me tell you what "Like a Virgin" is about.' *Kill Bill Vol. 2* (2004)

Django Unchained © 2012 Columbia Pictures, The Weinstein Company

features a lengthy deconstruction of the DC comic book character Superman. Likewise, Jules (Samuel L Jackson) in *Pulp Fiction* first recites/recreates and then deconstructs a passage of Ezekiel 25:17, not as Biblical heuristics but as an actor suddenly considering the meaning of some stale dialogue: 'I never gave much thought to what it meant. I just thought it was a cold-blooded thing to say to a motherfucker before I popped a cap in his ass.' Comic books, television shows, pop song lyrics and passages from the Bible are all hiding places from which meaning can be unpicked. The importance is not the weight/authenticity of the text itself – everything is equally valid and nothing is sacred – so much as the gleaning of truths, the act of reading, especially when that reading tears out a more subversive possibility. Ultimately no one cares what is in Marcellus's briefcase, except that going after it is the meaning of life and death.

Along with a myriad of 'B'-movie influences, Tarantino was initially inspired by Jean Luc Godard; his production company is named after Godard's *Bande à Part* (1964) and his films are laced with *nouvelle vague* allusions.[3] More significantly, Tarantino found in Godard the inspiration to use American crime genre cinema as a starting point for his own effusive experiments. In an interview for the 10th Anniversary Edition DVD edition of *Reservoir Dogs*, he reveals:

> The most influential piece of film criticism which applied to my aesthetic, which applied to me – I was very young – I remember reading it at Philippe's, that French sandwich place […] I'm reading her [Pauline Kael's] review of *Band of Outsiders*, […] 'It's as if a couple of movie-crazy young Frenchmen were in a coffee house and they've taken a banal American crime novel and they're making a movie out of it based not on the novel but on the poetry that they read between the lines.' And when I read that I said, 'That's my aesthetic! That's what I want to do! That's what I want to achieve!' (Tarantino 2003)

Reservoir Dogs is a tightly plotted heist movie in which the heist is absent. We see the build-up and the aftermath. Chronology is complex with a snapping back and forth from post- to pre-heist and back again. In a scene of particular bravura, Mr Orange (Tim Roth), who is actually an undercover cop, recounts a scripted story – 'an amusing anecdote' – which he must learn by heart and use as a way of infiltrating a gang of robbers. We see him in a rooftop rehearsal, as well as telling the story in a bar to the assembled crooks, but Tarantino goes one further and shows a re-enactment of the story – what should in fact be a flashback – with the cop stepping into the scene and talking over the frozen characters.

Everyone's an actor. The black-suited robbers are in costume, everyone uses pseudonyms and everything's a story. 'I bet you're a big Lee Marvin fan,' one tough guy tells another after a face-off. And yet the violence, the blood and the pain – Mr Orange, bleeding to death and screaming – ground the postmodern banter and tricksy-ness in a tangible 'reality' of physical danger. Despite career-long accusations of a cavalier attitude to violence, Tarantino's early films are rarely flippant about violence. In Tarantino's universe, the last words you hear before being burnt alive might be an apt quotation from *The Wizard of Oz* (Victor Fleming, 1939), but you are still covered in gasoline as a psychopath plays with his Zippo. And there is a deeply ingrained morality that informs the characters' actions. Mr Orange must confess his real identity to Mr White (Harvey Keitel) and thereby put himself at the mercy of the man he has betrayed; and White will see justice done though it almost certainly means his own destruction. The self-serving non-tipping Mr Pink (Steve Buscemi) is an aberration and one who won't escape punishment.[4]

The same karmic run-around informs Tarantino's second film, *Pulp Fiction*. A Los Angeles-set *Canterbury Tales* of crime, *Pulp Fiction* tells three intertwined tales – 'Vincent Vega and Marcellus Wallace's Wife', 'The Gold Watch' and 'The Bonnie Situation' – along with accompanying prologues and epilogues. The film continues and indeed elaborates on the strengths of Tarantino's debut: the complex chronology, the killer soundtrack, the reinvention of John Travolta and the introduction of Samuel L Jackson. The black humour, fizzing dialogue and startling violence mark this as the quintessential Tarantino film. But once more accusations of glibness were misplaced. 'Oh, man! I shot Marvin in the face,' is hilarious and horrific, but Marvin was also a traitor, setting up his friends to be killed so his own accidental murder represents a harsh comeuppance. Jules (Samuel L Jackson) and Vincent Vega (John Travolta) will be stripped of their blood-splattered *Reservoir Dogs*-cool suits and Jules will have a change of heart. Vincent – who shot Marvin and who does not repent – will later/earlier come to his own sticky end when he exits a bathroom once too often. Morality is not the preserve of the moral. Vincent the hit man and Lance, his drug dealer, talk about the ignominy of an unknown vandal who scratched Vincent's car: 'They should be fucking killed,' Lance says. 'No trial, no jury, straight to execution.' Fidelity to the boss, or the sentimental value of a gold watch, loyalty to a friend or even an enemy – as in the section with Marcellus (Ving Rhames) and Butch (Bruce Willis) – count more than mere survival.

Jackie Brown represents a departure, shifting focus away from youth to maturity and away from men to women. The film is more conventionally chronological and eschews many Tarantino-esque touches. As a result, many who generally dislike Tarantino almost universally make a point of liking *Jackie Brown*. The violence, for instance, is downplayed, often off-screen, or seen from a distance. Even the locations are obstinately dowdy. Rather than the cool metafictional world of *Pulp Fiction*, Tarantino's third feature takes place in mundane shopping mall food courts; on waste ground; and in airport car parks. The titular heroine, played with sassy aplomb by Pam Grier, is caught between Ordell Robbie (Samuel L Jackson), an arms dealer for whom she smuggles cash, and the feds who want to use her to bring Ordell down. With the help of a bail bondsman Max Cherry (Robert Forster), she plots to take control of her own life, rip off Ordell and stay out of jail. Although an accomplished film in its own right, *Jackie Brown* marked an impasse for Tarantino who, in making his first unoriginal work i.e. an adaptation, seems to be casting around for inspiration.

Tarantino's return to the screen following a six-year hiatus would come with the initially massive and then appropriately bifurcated *Kill Bill* story. His attention remains focused on a woman: the Bride (Uma Thurman), who, having been left for dead during her wedding rehearsal, seeks her bloody revenge on her former assassin colleagues and her ex-lover/boss Bill (David Carradine). An exuberant mishmash of revenge tragedy, kung fu, gangster film, yakuza, spaghetti western and anime, the films represent a heady mix, which refuses to settle, and his characters, with the exception of Michael Madsen's sad cowboy Budd and perhaps Bill himself, seem little more than ciphers at the service of moving the scene from one generic set-piece – and one genre – to another. Continuing the exercise in genre, *Death Proof* is

an occasionally entertaining pastiche. The call back to *Reservoir Dogs* in the diner scene, however, reveals how flimsy and ultimately uninteresting the characters are. Rodriguez's *Planet Terror* (2007) – being more wholeheartedly parodic – is surprisingly the more successful film of the *Grindhouse* double bill.

Tarantino's practice of linking characters (e.g. the Vega brothers) and products (Red Apple cigarettes and Kahuna Burgers) between films has had the side effect of creating a parallel Tarantino-scripted universe, and with *Inglourious Basterds* (2009) the generic experiment also leads to an alternative history. With an increasingly tenuous connection to the 'real world', Tarantino's latest two films play out as fantasies and essays in genre. *Inglourious Basterds* is not really a 'war film'; the war as a historical reality is almost entirely absent. Everything is once more a film, but the urgency of *Reservoir Dogs* has dissipated. Lt Aldo Raine (Brad Pitt) and his eponymous dirty bunch are introduced but we never get to know them and anyway they are soon wiped out. There's a *Reilly Ace of Spies* (ITV, 1983) character (Michael Fassbender), who likewise is soon dispatched. And Shosanna (Mélanie Laurent) has a *Kill Bill*-style revenge subplot inspired by the film's spaghetti western prologue, 'Once Upon a Time in Nazi Occupied France'. But each chapter still plays like a *Pulp Fiction* vignette. The cinema setting allows the cinephile in Tarantino to show off and even to hand out some meta-criticism of violence, as a Nazi version of *Saving Private Ryan* (Steven Spielberg, 1998) plays out for the Reich top brass in the final act, but the film – despite its epic ambition and monumental cheek – feels lightweight. Whereas *Reservoir Dogs* takes a 'B'-movie premise and turns it into a Jacobean tragedy, *Inglourious Basterds* makes history conform to the Tarantino movie world.

Likewise, *Django Unchained* (2012) has moments of delight but we are once more in Tarantino's universe where political injustice can be righted by a simplistic (if gratifying) fantasy of revenge. The plotting has become almost carelessly loose, the dialogue likewise lacks snap, and Jamie Foxx's Django (similar to Shosanna) is a bizarrely insipid creation.[5] The latter two films have also forefronted Tarantino's borrowing: the titles explicitly refer to Italian films which Tarantino cites as influences, but such 'massive subversion' is no longer necessary. Subtext is now text. In fact, although lately Tarantino can boast of having made a war movie, a western and a martial arts revenge film, the genre that these films most comfortably inhabit is the beguiling, darkly witty and giddily entertaining experiment in cinema that is, 'A Quentin Tarantino Film'.

John Bleasdale

Reference

Tarantino, Quentin (2003) Interview, *Reservoir Dogs* [DVD], 10th Anniversary Edition, United States: Lions Gate.

Notes

1. *Pulp Fiction* was released by Miramax (post-Disney acquisition) widely across the United States and crossed the $100 million mark at the box office that was then the industry standard for 'blockbuster' status.
2. The speech in *Sleep with Me* was actually written by Tarantino collaborator Roger Avery, but it is entirely in keeping with Tarantino's own practice.
3. The effect of bleeping out the name of Uma Thurman's protagonist in *Kill Bill* was lifted directly from Jean-Luc Godard's *Made in U.S.A.* (1966).
4. Albeit not death, as a close listening to the closing moments of *Reservoir Dogs* will attest.
5. In an interview on Jay Leno's *Tonight Show*, broadcast 27 November 2013, Tarantino referred to how, in writing *Inglourious Basterds* and *Django Unchained*, the screenplays were more like blueprints for the films, and the films themselves were found in production: 'I wouldn't recommend that process.'

GUS VAN SANT
The Boy Next Door

'I don't date guys over 40,' says Scott Smith (James Franco) to the tipsy, grinning Harvey Milk (Sean Penn) at the very opening of Gus Van Sant's biopic, *Milk* (2008). By this point the director was safely into middle age himself, with a career spanning two decades and a reputation that had lurched from leftfield indie innovator to something approaching Hollywood respectability (with some interesting looping detours along the way). His films have almost exclusively focused on the adolescent – and post-adolescent – male psyche, with a very particular queer melancholy that delineates him from similarly focused frat-boy contemporaries.

It isn't too much of a push to say that Van Sant has a type: vulnerable, slightly greasy, kind but defensive when cornered, male and beautiful. If there's an actor we associate with him it is still likely to be River Phoenix – the doomed early 1990s pin-up who appeared in two Van Sant films – *My Own Private Idaho* (1991), and an uncredited cameo in *Even Cowgirls Get the Blues* (1993) – before overdosing in a Hollywood nightclub. Although getting on for a quarter of a century ago, *My Own Private Idaho* still looms over a career that has branched out into mainstream acceptance with *Good Will Hunting* (1997) and *Milk* as well as the boundary pushing American minimalism seen in *Gerry* (2002) and *Last Days* (2005).

Mike Waters, Phoenix's role in *My Own Private Idaho*, is the archetypal Van Sant male – fatherless, introspective and cute. A narcoleptic rent-boy with a fixation on his best friend Scott Favor (Keanu Reeves), the character offered Phoenix an opportunity to break away from his child-star career, tragically never bettered. The death, along with rumours of the director's implied complicity in encouraging the supposedly straight-laced star to experiment with drugs on the set of the film, evidently hit Van Sant hard. Phoenix is the inspiration behind the character of Felix Arroyo, the impossibly good looking young star whose death haunts the film-maker (well, infomercial-maker) protagonist of Van Sant's only published novel, *Pink* (1997).

The pretty boy outsider type has popped up in a number subsequent works, and embodied by actors like River's brother Joaquin in *To Die For* (1995); Matt Damon in *Good Will Hunting*; Rob Brown in *Finding Forrester* (2000); John Robinson, Alex Frost, Eric Deulen, Elias McConnell in *Elephant* (2003); Michael Pitt in *Last Days*; Gabe Nevins in *Paranoid Park* (2007); James Franco, Emile Hirsch, Diego Luna in *Milk*; and Henry Hopper in *Restless* (2011). Whilst maybe not as aesthetically determined as the Hitchcock Blonde or Fellini's buxom temptresses (hairstyles come and go, and body shapes range from buff to scrawny), these figures are united by their outlook and temperament – lost puppies in need of a home (and occasionally a good wash).

In Van Sant's first commercially distributed feature, *Mala Noche* (1985), his later-developed critical eye for 'rough trade' is clearly present.[1] Set in Van Sant's adopted home of Portland, Oregon (where many subsequent features would take place), the film follows Walt (Tim Streeter) and his frustrated attempts at seducing Johnny (Doug

Restless © 2011 Imagine Entertainment, Sony Pictures Classics

Cooeyate), a significantly younger Mexican. After that came *Drugstore Cowboy* (1989), featuring a more classically straight protagonist, Bob (Matt Dillon), a mostly functioning prescription drug junkie trying to hold together his makeshift family as they search elusive highs and try to avoid the law. A trope that would reappear in later works *To Die For*, *Paranoid Park* and (arguably) *Good Will Hunting*, the heterosexual coupling is mostly sexless, with our male hero seemingly a 'victim' to female advances. Here, Bob's tepid libido can be put down to his overstimulation of other senses. Likewise, in *Paranoid Park* a traumatized Alex (Gabe Nevins) appears barely conscious as he loses his virginity to the high school classmate who has selected him for the task. Straight sex is often viewed as an alienating, disjointed experience. But if Van Sant seemed notably unmoved by straight sexual pairing, *My Own Private Idaho* was the last time unequivocally queer desires would surface in his work until *Milk*. This giddily romantic mashup of Shakespearean high drama and a Wim Wenders-esque road movie was a critical hit that soon developed a cult following, Van Sant subsequently stumbled with the strange but flat Tom Robbins adaptation *Even Cowgirls Get the Blues* and the crossover pitch *To Die For* that placed his familiar alienated teens in a more traditional neo-noir format.

The trope of teenagers seeking alternative family circumstances would be reprised in the film-maker's next two mainstream targeted works, *Good Will Hunting* and *Finding Forrester*. Known largely for launching the careers of co-writers and stars Matt Damon and Ben Affleck, *Good Will Hunting* joins *Finding Forrester* in its exploration of intergenerational male mentoring (cf. William Burrough's junkie priest in *Drugstore Cowboy* and William Richert as the charismatic Bob in *My Own Private Idaho*). Van Sant's own father, a travelling salesman successful enough to help fund some of his son's early projects, was absent for many short periods in childhood. In interviews, Van Sant has spoken of the hours 'waiting at the window, doglike, watching the empty street for him to return' (Sager 2008). This absence runs through many of the director's films, with fathers either dead (*Restless*), dying (*My Own Private Idaho*), abusive (*Good Will Hunting*), alcoholic (*Elephant*) or simply gone.

A preoccupation with youth has led Van Sant to focus on the effects of upbringing, rather than any nurturing instinct, but in *Milk* he shifted his attention to study the awkward transition into maturity. Harvey Milk, on the very cusp of 40 as the film opens, but with a penchant for significantly younger men, grows into his role as a father figure for San Francisco's young gay community; putting together a 'home away from home' for various strays and misfits, and spurring them into political activism. The director's own paternalism can perhaps be best seen in his nurturing relationships with younger film-makers. After supporting Affleck and Damon by bringing *Good Will Hunting* to the screen, Van Sant has served as executive producer for a number of fledgling queer directors like Jonathan Caouette (*Tarnation* [2003]), Cam Archer (*Wild Tigers I Have Known* [2006]) and Xavier Dolan (*Laurence Anyways* [2012]).

In 2002, after the most baffling film in his catalogue, the remake – and near facsimile – of Hitchcock's *Psycho* (1998), Van Sant's cinema drifted into newfound attention to languidness. Nominally inspired by the work of Hungarian 'slow cinema' maestro Bela Tarr, Van Sant, aided by the great cinematographer Harris Savides (who had joined up with Van Sant firstly on *Finding Forrester*), began a series of films with a loose improvisational feel dominated by lengthy steady-cam takes. *Gerry*, the first in this so-called 'Death trilogy' was, despite the marketing-friendly casting of Matt Damon and Casey Affleck, perhaps the most punishing of all. With only two speaking roles, the film followed a pair of early-twenties Jocks lost in the wilderness.

Whilst begrudgingly acknowledged by critics, *Gerry* would most likely have gone down as a formalist footnote in the director's biography were it not for his follow-up, *Elephant*. Winning the Palme D'or at Cannes in 2003, the film put Van Sant firmly back on the arthouse auteur map, re-establishing a credibility that had begun to slip after his move to the mainstream. (He would receive the festival's special 60th anniversary prize in 2007 for *Paranoid Park*.) The title of the film also suggested another inspiration, the late British director Alan Clarke, whose 1989 television film of the same name had taken an oblique look at the Northern Ireland 'Troubles', pioneering the long steady-cam takes that would later become Tarr's trademark. Like Clarke's film, Van Sant's *Elephant* tracks the movements of a killing, its camera calmly observing events – here, the killers and the event were inspired by the tragic Columbine High School Massacre. Unlike Clarke, who's unreadable killer was a study in ambiguity, Van Sant chose to posit a number of hypotheses for the killing, seemingly taunting the media's (and the audiences') impossible desire to make sense of the senseless. Despite his ongoing fascination with teenage life, *Elephant* was Van Sant's first and only film to choose a high school as its primary setting. As much as *Gerry* had circled the familiar but unknowable landscape of the New Mexico desert, here the camera crawls through the ubiquitous corridors and cafeterias of American High Schools, of which international audiences are uncannily familiar.

In 2007, *Paranoid Park* saw Van Sant return to school, but here (as in *To Die For*) the institution ranks as a minor inconvenience in the real business of adolescence. The film also saw the director edge away from the neatly patterned look of his 'Death trilogy' for a more eclectic audio-visual style. Mimicking the mild schizophrenia of the adolescent mind, the film's tonal confusion comes about through a patchwork of film stocks and a sound mix that dreamily blends Nino Rota and Elliott Smith. Gabe Nevins was cast from open auditions: another doe-eyed teen lost to the world. Many saw the film as an aesthetic return to *Mala Noche*, with Van Sant's queer eye now effortlessly rising above mere subject matter. The boys remain eerily the same.

In 2011 came *Restless* with Henry Hopper cast in his first major role. As the son of Dennis Hopper, critics and audiences were quick to spot similarities in both face and demeanour, but in his role as Enoch – the funeral-crashing loner who romances a terminal cancer patient – the young actor more closely resembles Phoenix's Mike in *My*

Own Private Idaho. His mixture of haunted shyness and cocky insolence is right out of the director's textbook. A much less challenging project than *My Own Private Idaho*, *Restless* is a classically shot sentimental romance, where the love (perhaps a first for Van Sant) is both requited and straight.

Rob Dennis

Reference

Sager, Mike (2008) 'Gus Van Sant: What I've Learned', *Esquire*, 16 December, http://www.esquire.com/entertainment/interviews/a5455/gus-van-sant-quotes-0109/. Accessed 14 July 2015.

Note

1. Van Sant's true debut *Alice in Hollywood* (1981) remains locked away in the director's archive.

WAYNE WANG
Deconstructing Identities

Wayne Wang's independent films aim to explore the identities of the Chinese diaspora. Unlike his other studio productions, his independent projects are more like personal essays that investigate this never-ending and perhaps unsolvable question. Alongside John Woo and Ang Lee, Wayne Wang is a well-known ethnic Chinese figure who has gained a reputation in film-making in the United States. Perhaps what makes Wang different is that, apart from his studio projects, he also maintains an interest in making low-budget independent films. His first feature, *A Man, a Woman, and a Killer*, came out in 1972, but it was his second film, *Chan Is Missing* (1982), that gained attention from critics and the industry. Wang established himself alongside other directors who were making independent films during the 1980s, with Jim Jarmusch and Spike Lee arguably being his contemporaries. Film has become a tool for independent directors such as Wang to deconstruct or have a closer look at an object or phenomena that they wish to explore. In this respect, American independent follows the ethos of the French New Wave in its exploration of subjects through critical and reflexive filmic essays.

Wang's independent works also aim to speak to a specific target audience: those who share a similar cultural background to himself, and those who are also struggling through an identity crisis. As he once revealed:

> The audience I wanted to reach was the Asian-Americans of my generation [...] The only aspect I thought about for the American audience was the aesthetics, the more formal aspect: the structure of the film, how it was shot, and taking a film noir and reworking it. (cited in Ferncase 1996: 30)

Critics have often summarized most of Wang's films as representations of Asian Americans' lives and identities, and the cultural clashes they face as diaspora. I disagree with such a narrow categorization. Although Wang mentioned identifying his target audience in the above interview, the main theme that appears again and again in his personal projects, I would argue, is the deconstruction and complication of identities. This theme appears in his works as an open question, rather than an answer.

The hybridity of identity is crucial to those who migrate from one country to another. Originally born and raised in Hong Kong, Wayne was given his western name by his parents in memory of John Wayne. Perhaps since his birth, he was destined to have a connection with America, a country in which he later studied and settled down. After finishing his studies in Hong Kong, Wang moved to the United States and attended Foothill College. Later on, he studied fine arts at California College of Arts and Crafts and graduated with a Master's degree in 1972. Apart from his Hong Kong heritage, Wang was also influenced by his Mainland Chinese cultural heritage from his parents, who arrived in Hong Kong from the Mainland as refugees before his birth.

Dim Sum: A Little Bit of Heart © 1985 Orion Classics

During his early career, Wang was always moving around. His first feature, *A Man, a Woman, and a Killer*, never gained domestic distribution and, after that failure, he continued to make several short films but without success. Wang returned to Hong Kong in an attempt to further his career, but an unpleasant experience soon sent him back to the United States. He began to question his identity, and wondered why he couldn't fit in anywhere. After his return, he settled in San Francisco's Chinatown for some community service work; and that was when he began to realize the cultural clash between American and Chinese culture.

> I realized that the Chinese and the American worlds don't necessarily blend that well together. You sort of bounce back and forth between the two. And coming to terms with that and expressing that collision of cultures inside myself were emotional reasons for the birth of Chan Is Missing. (cited in Ferncase 1996: 31)

Chan Is Missing is generally described as a detective film or film noir, though I disagree with this description and fear that perhaps such stereotypical identification is a lingering aesthetic cultural haunt from the detective character Charlie Chan, who has appeared in film, television and radio series. Wang also mentioned in the interview (Ferncase 1996) that certain genre aesthetics were adopted in order to cater to domestic taste. Are genres suitable to be used to describe an independent film? I remain critical of such categorizations. As many independent films are personal projects for the film-makers themselves, the simplistic and unconsidered label of genre denies the auteurism in any such project. *Chan Is Missing* functions as a self-reflexive metaphor for the director to acknowledge that the true and authentic identity that he has been looking for does not exist. This 'detective film noir' in fact offers deep philosophical enlightenment – when you want to learn about yourself, you do not look outwards, you look inwards.

This philosophical message is revealed implicitly several times in the film. The loose narrative follows San Francisco taxi drivers Jo (Wood Moy) and Steve (Marc Hayashi) who are looking for a missing man, Chan Hung, who owes them a large sum of money. During the process of looking for this missing man, the pair discover that Chan has been involved in various incidents that relate to cultural assimilation. Chan's disappearance thus becomes even more mysterious, and the act of 'looking' gradually becomes the act of 'investigating'. The hope to find Chan is therefore a wish to 'solve a mystery'. The 'mystery' here, however, is used as 'self-orientalizational' reflexivity – the purpose of which, I argue, is to deconstruct identity. Since perhaps Thomas Burke's short story collection *Limehouse Nights* (1916), and the later exploitation and in some degree ideological formation of the opium den and the potential for danger in Chinatown, 'mystery' has become a part of the merchandise that is associated with Chinatown.

No one knows why Chan has gone missing and Wang never reveals the truth in the film. However, what is revealed is an attempt at self-orientalization by the main character Jo. He becomes very interested in Chan's disappearance and, by putting the pieces together as a detective would, comes up with the supposition that Chan might have been involved in a murder case. Is Jo really a detective? Is the Chinatown *Limehouse* mystery still lingering? Wang cleverly puts all these complicated issues around identity in juxtaposition: Jo's obsession with finding Chan is, in fact, a search for his own identity, a search for his own truth. After looking around for many days, Jo and Steve still have no sign of the missing man. In the end, their money is returned through Chan's daughter, but the taxi drivers still do not know what has happened. Perhaps it is not a mystery or a murder case after all. Chinatown is not always scary.

Although *Chan Is Missing* looks like a detective film on the surface – where you might find references to Charlie Chan – it in fact deconstructs stereotypical understandings of Chinese identities, including those of ethnic Chinese. All the people that Jo meets during the search have different opinions regarding who Chan really is. Identity therefore, is based on what people think of you and how you react towards them, as interactions. Further subtle evidence of how Wang uses the film to question identity can be found in a cross-culture joke in a scene that takes place in a Chinese restaurant: a waiter tells another worker that, if the customers cannot be patient for their wonton, just tell them to read the word backwards – 'notnow'!

Thus identity is changeable and in constant flux. Perhaps the making of *Chan Is Missing* helped Wang to settle the riddle in his mind about his own identity crisis. This highly personal project is filled with intimate portraits, with documentary footage shot around Chinatown that captures ordinary people's everyday lives and their genuine expressions. If the above is not enough to make the case for Wang's deconstruction of identity, this hidden trick perhaps may reinforce my argument: actor Marc Hayashi, who plays the role of Steve, is in fact a Japanese American. Also, the actress playing the daughter of Chan Hung, even though she looks Chinese to many, is also a Japanese actress named Emily Yamasaki. Do we know what Chinese is and how Chinese should be?

A similar theme of identity deconstruction can be found in his other independent projects, such as *Dim Sum: A Little Bit of Heart* (1985), *Eat a Bowl of Tea* (1989), *The Princess of Nebraska* (2007) and *A Thousand Years of Good Prayers* (2007). In *Dim Sum: A Little Bit of Heart*, Wang once again deconstructs the Chinese American identity into a complicated and individualized phenomenon. The film tells the story of Chinese immigrant widow Mrs Tam (Kim Chew), who wishes to see her daughter Geraldine (Laureen Chew) get married, and to visit China before she dies. However, Mrs Tam's longing to see China one last time and her wish to see her daughter married are not representative of Chinese American women, as all the Chinese characters in the film

are different. For example, Geraldine, who was born and raised in America, lives a very western lifestyle, but at the same time respects her mother in a traditional way. Also, at the beginning of the film, we see a bartender who has just finished his work and is about to go home. He takes out a bun from his pocket and begins to eat it. The bun is the well-known *Cha siu bao*, so this small act triggers the audience's assumption that this is a character who is struggling to fit into the western lifestyle.[1] However, later on in the narrative we learn that he is in fact very westernized as he also very much appreciates whiskey and hamburgers. These characters are influenced by both Chinese and American culture in different ways, with elements of both sides integrated into their personality. Thus through these characters Wang reveals the hybridity and individuality of Asian American identities. In *Dim Sum: A Little Bit of Heart*, Wang plays the same cheeky deconstruction trick as he did in *Chan Is Missing* – the actress Amy Hill, who plays Amy Tam, the widow's other daughter, is in fact a Japanese-Finnish mixed American. If one does not pay attention to the credits or research the performers' backgrounds, it would be easy to assume that all the actors and actresses who are playing 'ethnic Chinese characters' are in fact Chinese.

Although his independent films are based on a written narrative, Wang often shoots with a handheld camera, and these works can almost be treated as anthropological studies. Instead of representing the culture of the Chinese diaspora, Wang's documentary style allows his films to unpack the culture of the Chinese diaspora. The characters speak for themselves, they speak to the director, and they also speak to the audience. Although the 'Chinese theme' also appears in Wang's studio projects, such as *The Joy Luck Club* (1993) and *Snow Flower and the Secret Fan* (2011), and in his documentary *Soul of a Banquet* (2014), these films instead use the theme of Chinese as a form of urban cultural merchandise.

As a Chinese American independent director, Wang has succeeded in deconstructing the singular representation of Asian American identity through the complication of character construction and juxtaposition. By teasing the audience with subtle tricks, his sense of humour will continue to pique the interest of those who are willing to dig deeper and put in the effort necessary to realize the individuality within the so-called 'Asian American identity'.

Hiu M Chan

References

Burke, Thomas (1916) *Limehouse Nights*, Charleston, SC: BiblioBazaar.
Ferncase, Richard K (1996) *Outsider Features: American Independent Films of the 1980s*, Westport, CT: Greenwood.

Note

1. *Cha siu bao* is a Cantonese bun, filled with barbecue-flavoured *cha siu* pork.

TI WEST

The Garage Kubrick of Horror

Writer-director-editor Ti West's *The Roost* (2005) is rather rough-edged, but its cinematic intelligence and love of horror shine through. Framed as an instalment in Channel 13's 'Friday Night Frightmare Theater', it is hosted – in black and white, with the reduced frame and apparent resolution of an old television set – by the horror mansion's admirably cadaverous butler (Tom Noonan). Accompanied by a theremin and an organ played by a skeleton automaton, he indulges – like EC's Cryptmaster – in magnificently feeble wordplay, full of alliteration and foreboding. The ensuing film follows four twentysomethings taking a lonely back road to a childhood friend's wedding. It is Halloween, approaching midnight, and a horror story plays on the radio. While Brian (Sean Reid) and Trevor (Karl Jacob) sleep, siblings Elliott (Wil Horneff) and Allison (Vanessa Horneff) chatter inconsequentially, barely audible, as if half-heartedly fleeing a mumblecore movie. None of them notices the four small white crosses by the side of the road.

Such confident switching between styles and tones, and self-reflexivity regarding medium and genre, are hallmarks of West's films. The layering of narrative levels – the funhouse kitsch of a late night television show, in which is embedded an apparently more realistic film, in which is embedded more kitsch horror – only hints at the extent to which his filmic universe is horror all the way down. He eschews the knowingness of *The Cabin in the Woods* (2012). He refuses to let his characters fall into stereotyped patterns, leaving them blandly ordinary, almost undifferentiable, and his cast's performances are so determinedly low-key as to suggest not acting but mere being. This sense of flatness and duration rather than complexity and depth – pushed to an even greater extreme in *Trigger Man* (2007) – is key to West's depiction of the post-industrial subject: isolated, monadic, disconnected, with relationships that are just tenuous, force-of-habit connections to a haemorrhaged past. While overt allusions – to *The Texas Chain Saw Massacre* (Tobe Hooper, 1974), *Halloween* (John Carpenter, 1978), *Evil Dead II* (Sam Raimi, 1987), *The Blair Witch Project* (Daniel Myrick and Eduardo Sánchez, 1999) and, stripped of its pompous self-regard, *Funny Games* (Michael Haneke, 1997) – anchor the film within a specific heritage of horror, *The Roost* destabilizes the viewer through a cunning evocation of, and interplay between, revenge-of-nature, vampire, zombie, off-road and slasher movie paradigms as the characters, like the audience, try to work out into exactly what kind of nightmare they have fallen.

The inventiveness with which *The Roost* depicts the twentysomethings' car crash – squealing brakes and discordant wailing on the soundtrack, a wildly lurching camera that actually shows nothing but the dashboard – is not merely low-budget necessity but the introduction to West's aesthetic of calculated withholding. Like Val Lewton and Jacques Tourneur, West relies on darkness to create a sense of uncertainty and lurking danger. Shot after shot features dark borders surrounding barely lit spaces. Torches and headlights crisscross the gloom, revealing nothing. When an elderly farmer, diminished and made vulnerable in extreme long shot, approaches a barn, a dark figure races from the edge of the screen as if to attack him – but it is only his shadow. While West's budget does stretch to some gory effects, which he clearly relishes, his film relies much more extensively on the careful manipulation of off-screen space

The Inkeepers © 2011 Dark Sky Films, Glass Eye Pix

and especially, courtesy of regular sound designer Graham Reznick, off-screen sound. Ominous sound bridges between parallel scenes create a decentred, ubiquitous air of menace; when Elliott and Brian hack with farming implements at a rabid/zombified cop, we see nothing of the bloody ordeal, but we hear it in grotesque detail from traumatized Allison's point-of-view. *The Roost's* formalistic attention to the distinctions between image and soundtrack come across like the work of a garage-Kubrick, while West's intermittent reliance on a static camera looking out from the darkness into a distant rectangle of bilious artificial light, accompanied by the soundtrack's screeching dissonance, recalls nothing so much as Michael Snow's structuralist epic *Wavelength* (1967).

Shot for $10,000 and almost entirely on a restless handheld camera, *Trigger Man* pares West's aesthetic down to the bone. Digital zooms rack focus so quickly as to function like jump cuts. Frequent reframing sometimes implies an observer, but more typically leaves the status of the shot uncertain, endlessly deferring its possible meaning (West's use of a subjective handheld camera in 'Second Honeymoon', his surprisingly unremarkable contribution to the portmanteau *V/H/S* (2012), is less effective, perhaps because of being tied to character viewpoints). Various narrative paradigms are evoked but discarded, potential narrative lines open up but, never returned to, stick there in the memory like turnings-not-taken in the garden of forking paths. Sean (Sean Reid), who has married into a wealthy family, drives his SUV into a run-down New York neighbourhood to collect Reggie (Reggie Cunningham) and Ray (Ray Sullivan) to go hunting. They have known each other for years, but how is never explained. There is a vague sense that Reggie has seen military service – Iraq and Afghanistan, never mentioned, haunt the final sequences of the film. His relationship is perhaps on the rocks, and Ray has fallen out with his neighbours. Such minimal characterization is again well served by a determined refusal of performance and stereotype that flattens all affect. The three men drive off into *Deliverance* (John Boorman, 1972)/*Southern Comfort* (Walter Hill, 1981) territory, but despite their jackass behaviour there are no locals to offend. Reggie and Ray talk about *Predator* (John McTiernan, 1987), the soundtrack recalls Ennio Morricone's score for *The Thing* (John Carpenter, 1982), and West reuses a location from his student monster-in-the-woods film, *Prey* (2001), but the Brandywine Creek contains no unearthly creature. Although riflescopes repeatedly sweep the trees, nothing is ever glimpsed that could pose a mystery or a threat.

Compounding these uncertainties is the remorseless uneventfulness of the first half of the film, in which cuts are more startling than anything that happens in front of the camera.

Rather than sculpting in time, West whittles down his audience's patience, testing viewer endurance as he extends the duration between incidents, distending the build-up of suspense until it becomes something else, something mesmeric – enthralling and tedious. That the film eventually resolves into bloody confrontations – reworking *The Most Dangerous Game* (Irving Pichel, 1932), it replaces the baroque Count Zaroff (Leslie Banks) with a huntsman/sniper who is just some other bored white guy picking off passers-by from an abandoned industrial plant – is almost as disappointing as it is a relief.

Cabin Fever 2: Spring Fever (2009) was taken away from West and re-edited with new material (in 2010, he quit his second director-for-hire franchise movie, *A Haunting in Georgia*, over creative differences). However, certain aspects of this witty sequel to Eli Roth's joyless debut betray West's likely touch. It frequently looks as if it was shot in the 1970s, is set in the 1980s, and features Alexi Wasser because she resembles a tall blonde cross between Shelley Duval and Sissy Spacek. It plays with and against stereotypical characters and situations: the 'popular rich kid' is an unattractive jerk with ridiculous hair and a violent temper; the 'henpecked Principal' is gay; and the film itself seems appalled by the horrible mistreatment of the 'lovelorn fat girl'. Reworking elements of *The Crazies* (George A Romero, 1973) and *Carrie* (Brian De Palma, 1976), its most unexpected allusion is a sustained riff on *E.T.: The Extra-terrestrial* (Steven Spielberg, 1982). The central male friendship is straight out of *Superbad* (Greg Mottola, 2007), and while much of the flesh-melting, blood-vomiting action has a humorous edge to it, this homosocial bond against the terrors of regular high school life renders several set-pieces – the painful blow-job from a girl with braces and coldsores; the bloated, bloody penis gouting puss; the liquefied afterbirth pouring out from a girl who miscarried in the showers – quite effectively abject. Also noteworthy are the title and credits sequences – Lawson Demming's opening animation overlays ecological interconnectedness with the circuits of capital; Ana Maria Alvarado's closing animation emphasizes commerce as the route of infection spreading across borders from, rather than into, the United States – which resonate with West's own depiction of post-industrial subjectivity.

West's penchant for Kubrickian wide-angle lenses to isolate his characters from each other, and for cameras that slowly track or zoom in or out, comes to the fore in his next two movies as writer-director-editor, *The House of the Devil* (2009) and *The Innkeepers* (2011). The former, claiming like *Trigger Man* to be based on true events, is set in the midst of the 1980s satanic child-abuse panic. To replicate the look of an early-1980s television movie, it was shot on Super 16 and its title sequence has a series of freeze frames and scrolling yellow credits that fade in and out; Dee Wallace has a cameo; and Jocelin Donahue, who plays protagonist Samantha, more than slightly resembles Jessica Harper, Margot Kidder and Karen Allen. In order to earn enough money to move out of her college dorm, Samantha agrees to babysit an unseen old lady in a remote house on the night of a lunar eclipse. Oddly depopulated locations, and careful framing and blocking further emphasize her isolation. A gliding camera creates spaces in which danger might lurk. Dimly lit spaces and open doorways in the background and along the edge of the frame make the screenspace perilous. In a masterful twenty-minute giallo sequence, Samantha wanders around the house, exploring, killing time and goofing around – including a *Risky Business* (Paul Brickman, 1983) homage – and slowly begins to suspect her employers are not what they claim. The audience knows a little more, since we have seen her best friend murdered and are treated, partway through this sequence, to a glimpse of the grisly aftermath of the Satan worshippers' ritual sacrifice of the real homeowners. This excruciatingly quiet passage in which little actually happens generates such tension that audiences actually jump when a doorbell rings. Having painstakingly built a mystery, West abruptly plunges Samantha (and the audience) into a bloody ordeal as Satanists impregnate her with their master's spawn.

The Innkeepers is set in the Yankee Pedlar Inn, where *The House of the Devil*'s cast and crew stayed during filming, and includes Leanne Rease Jones (Kelly McGillis), an actress-turned-new-age-healer partly based on Dee Wallace. Aimless Claire (Sara Paxton) and college dropout Luke (Pat Healy) are the only staff left at the closing-down hotel. Claire believes Luke has seen the ghost of Madeline O'Malley (Brenda Cooney), who, jilted at the altar, committed suicide in her room, only for the hotel owners to hide her body until they could secretly dispose of it. Claire wants to find evidence of the haunting and lay the troubled spirit to rest. The film exposes the fragility of the not-exactly-friendship between co-workers, and repeatedly foregrounds the cash-nexus at the core of such relationships. Any friendliness between staff and guests can snap back into antagonism without warning and, as ever, West's protagonists are unencumbered by family and the spaces they occupy are almost devoid of other people. In a genuinely troubling exchange, the equally alienated barista (Lena Dunham) at the nearby and likewise deserted coffee shop suddenly starts talking about her boyfriend (they have been together for a year, but he has never said he loves her, except on IM, which is like saying it during sex – it does not really count). There is something inappropriate, almost obscene, about her presumption, and Claire understandably flees.

The Yankee Pedlar is a third-rate, but rather less remote, Overlook Hotel, and West eschews the patriarchal horrors of *The Innkeepers*'s major influences, *The Shining* (Stanley Kubrick, 1980) and *The Changeling* (Peter Medak, 1980), in favour of a female-centred tale. If the physical manifestations of the ghosts, especially Madeline's corpse bride, are a little disappointing (there is a J-horror simplicity and a distinctly television-movie quality to them), *The Innkeepers* demonstrates West's mastery of genre and medium in his single most effective withholding: Claire persuades Luke to accompany her into the cellar to summon and question Madeline; tension mounts until Claire tells the even more terrified Luke that the ghost is directly behind him; but all we see is a close-up of Luke, too scared to turn around.

West is arguably the most significant American horror film-maker to emerge in the new millennium, and with *The Sacrament* (2013) he will have directed as many features in eight years as his mentor/producer Larry Fessenden has done in nearly thirty. It is not yet clear whether the freedoms and constraints of low-budget productions will enable West to develop further, or branch out into other genres, or whether he will begin to find more appropriate bigger-budget projects, but his place in American horror is already secure.

Mark Bould

ALICE WU
Saving Face

The emergence and development of Asian American independent cinema is closely related to the political struggles and cultural practices of the 1960s and 1970s, by means of chronicling the lives of ordinary Asian Americans and reconstructing their history in films. It should be noted that the earliest attempts made by Asian Americans to depict life in the Asian diaspora can be traced back to as early as the period of the 1910s and 1920s. For instance, in 1916, Marion Wong, the first Chinese American director on record, made *The Curse of Quon Gwon: When the Far East Mingles with the West*. Another early example is *Lotus Blossom* (1921) by James B Leong, who wanted to reach the mainstream American movie audience as well as Chinese in China. However, it was not until the mid-1980s that a large number of film-makers of Asian origin began to expand the visibility of Chinese Americans.

The Asian American independents provide an alternative voice to the popular American representation of traditional minorities. Film-makers like Ang Lee, Wayne Wang, Peter Wang, Pam Tom, Peter Chow, Jue Sharon, Tony Chan, Quentina Lee, Frank Lin, Jessica Yu, Justin Lin, Shirley Sun, Tze Chun, and Evans Chan, amongst others, have paved the way for low-budget movies. However, a number of formidable barriers to the expansion of Asian American cinema still remain, such as distribution and finance.

Perhaps this explains why *Saving Face* (2004) was the first and only film by Alice Wu, who spent five years trying to finance her feature project. The production was only made possible after a screenplay contest, where her work captured the attention of one of the judges, prominent producer Teddy Zee. *Saving Face* was inspired by Wu's own experience, not only as a second-generation Chinese, but as a lesbian coming out of the closet in a close-knit Chinese American community. Much like Ang Lee's breakthrough feature *The Wedding Banquet* (1993), *Saving Face* is also a film centring on the family conflict of homosexuality and traditional Chinese family values. By bringing the issue of homosexuality to the screen, a topic that many Chinese families tend to run away from, *Saving Face* can be viewed as part of a continuous effort to show negotiated Chinese family ethics in the immigration context.

The story of *Saving Face* spans three generations of a Chinese American family: Wil (Michelle Krusiec) lives in Manhattan, while her mother Ma (Joan Chen) and grandparents live in Flushing, the second largest Chinatown in New York City. The plot interweaves and juxtaposes two important secrets. Ma, a 48-year-old widow, is banished from the family when her father discovers that she is pregnant. Refusing to reveal the identity of the baby's father, Ma is forced to move to Manhattan to live with her daughter Wil, who at the same time also attempts to hide a secret from her mother. Wil is in love with the daughter of her boss at the hospital, the dancer Vivian (Lynn Chen). Whereas Ma is pressured by her father to marry Cho, a sweet but boring man, as a condition to be allowed to return to Flushing, she pressures her daughter Wil to find a boyfriend, when in fact she already knows that Wil is a lesbian and that Vivian is her girlfriend.

Saving Face (2004) Destination Films, Forensic Films, GreeneStreet Films, Overbrook Entertainment

The theme of the film is made clear by the suggestive title *Saving Face*, which directly references the social concept of 'face'. The metaphor of 'face' is a key concept in Chinese communities (Lee-Wong 1999). Anchored between two senses – self-presentation and social evaluation – 'face' revolves around the perspective of other people and evaluating oneself on the basis of how others would. In order to protect family 'face', the mother and daughter are both supervised by the patriarchal figure in the family and by the overseas Chinese community. Believing that their sexuality is not a matter of private concern, Wil and Ma are urged into sexual restraint.

The film's narrative consistently points to the dilemma that Wil has to face as a lesbian Chinese woman. Wil's life is divided between her career as a promising Manhattan surgeon and her family living in Flushing. Before she gets involved with Vivian, her life is punctuated with matchmaking dances with unmarried men set up by her mother. However, her life is abruptly changed after Ma shows up pregnant on her doorstep. Wil is forced to combine two very different worlds, embodied by a Chinese mother who insists on her daughter's heterosexual marriage, and by her Americanized lover who wants Wil to come out of the closet.

The opening scene is rather illuminating: in a high-angle shot, the camera looks down at an Asian female figure with her hand on the sink and her arms wide open; more interesting is that she is wearing a white facial mask. Only at a later stage in the film is the audience informed that using a white mask is actually an idea of Wil's mother. The camera focuses on the whiteness of this image: the mask, the T-shirt that she is wearing, and the sink. The profession of this woman is made clear by the next scene in which she is wearing a blue medical coat and her face is covered by a white mask. The camera frames her right hand holding the scissors; meanwhile, another hand appears in the frame to cut the thread. She is placed in the foreground and a male figure is standing in the background, observing the surgery. During all of these scenes, the camera actively keeps the face in the centre of the frame. The 'whiteness' stands out in relation to social

norms of what beauty is and what marks success. While the first scene focuses on the construction of the whiteness as a beauty standard, the hospital scene on the narrative level serves to connect whiteness with professional success. The face of the woman in both scenes is covered behind a white mask.

Wil's homosexual identity as a 'secret' is progressively revealed through her interaction with Vivian, who appears to be a very charming and assertive female figure. Both of their careers are closely related to the body. Whereas Wil is a doctor who performs surgery, Vivian is a ballet dancer who does modern dance. Influenced by their own professions, Wil and Vivian have different views on their bodies. Vivian comes from a less conventional family where she can be open about her sexual identity. She pursues her own professional interest, and her broken Chinese suggests that she is less constrained by Chinese culture. Wil, on the other hand, is still bound by a symbolic order that she is hesitant to break loose from.

The difference between Wil and Vivian is explained through an intimate scene. In a high-angle shot, the camera looks down on Vivian, who rests her head on Wil's body. 'I can hear your stomach,' Vivian remarks while Wil responds. 'What does it say?' Vivian smiles, 'Blub, blub. It's not very articulate.' When asked about hers, Vivian replies proudly, 'Mine sings arias [...] spouts poetry, proofs.' What emerges from the intimate conversation in a closed environment is Vivian's perception of Wil: someone who is too burdened by her imposed sexual and ethnic identity to express herself fully. When Wil, following Ma's suggestion, rushes to the airport to persuade Vivian not to go to Paris, Vivian says to Wil, 'You're too scared to look the world in the eye, and let it watch you fall in love. You're off and running without a fight.' Vivian's decision to leave Wil is visualized through a shot of her disappointed face upon seeing Wil's suggestive body movement – such as a lowering of her head – as a reaction to her last request: 'Kiss me. Right here, in front of all these people.' What Vivian demands from Wil is a symbolic act of coming out of the closet, a self-acceptance and reaffirmation of her gay identity. Being subject to the public gaze, Wil's reaction has reinforced the closet.

Ma appears to be both victim and victimizer, as well as both liberal and traditional. As a middle-aged Chinese widow, Ma lives in a Chinese community in New York with her parents. Her father is a respectable scholar, a community leader, and a devoted follower of traditional Chinese culture. The figure of Ma, in whom Wu places her vision for liberal change, is often shown to be trapped. Having difficulty in reconciling her own needs with family needs, she often resorts to exactly the same traditional Chinese cultural values from which she is trying to break free. Thus, in most cases Ma is presented as a typical Chinese daughter and mother. In order to please her father, she was forced to marry a man whom she did not love, and has been a widow for many years. Like every other Chinese mother in the film, she is concerned about her daughter's clothes, marriage, and the friends with whom she is hanging out. The image of a Chinese mother is vividly conveyed through specific details of Ma's interactions with Wil, Wil's black friend and neighbour Jay (Ato Essandoh), and Wil's lover Vivian.

To begin with, Ma and another Chinese woman secretly arrange a date for their children. Ma takes Wil to the dance party. Before entering into the hall, Ma starts to arrange her daughter's clothes neatly. Ma's remarks on Wil's clothes – a V-neck blue shirt with dark pants – are illuminating: 'I see men's clothes are still in style. Let me button that for you. People are going to think.' Clearly, her idea of femininity and good behaviour are informed by the vision of traditional womanhood held by her generation.

The character of Ma is depicted more vividly through her interactions with Jay, the racial 'other', and Vivian, the sexual 'other'. On the one hand, the mother figure Ma presented in *Saving Face* is endowed with powers so great as to affect her daughter's private life. Under Ma's will, her daughter dutifully returns home every week to attend the obligatory social gathering, even though Wil knows that her mother aims to have

her meet a man. On the other hand, Ma is also experiencing an identity crisis, caught in between two conflicting worlds, represented respectively by the strong traditions of her parents and friends, and the Americanized world of Wil. Being pregnant as a Chinese widow, Ma is seen as a disgrace and thus is banished by her family and her friends. Thrust into Wil's world that seems unfamiliar to her, Ma has to make herself feel safe and secure. Her distrust of Jay and Vivian comes from both her role as a Chinese mother, and as a pregnant Chinese widow.

Being black and unable to speak Chinese, Jay is at first not welcomed by Ma. When Wil invites him to join them for dinner, Ma serves Jay dinner on a paper plate. Ma is influenced by an idea in the minds of many East Asians that light skin is a sign of beauty. It is evident in her remark that 'I should eat less soy sauce so that my baby does not get stained'. She also reminds Wil to use as little soy sauce as possible, as it is bad for the skin. Her comments then explain the beginning scene in which Wil is wearing a facial mask to whiten her face. Jay is not outwardly affected by Ma's attitude, as he smiles to Ma 'thank you', and asks Wil to let her mother stay. It is then perhaps not surprising that Ma and Jay become friends at a later stage of the film, when they are seen sitting on the couch watching Chinese TV dramas together. Meanwhile, Jay also starts to use facial masks according to Ma's suggestion. Ma's acceptance of Jay's racial and cultural difference to a certain extent is made possible by Jay's assimilation into Chinese culture.

Ma exhibits the same distrust with regard to Vivian. Even though Vivian is Chinese, her broken Chinese does not bring her closer to Ma. When Wil brings Vivian over for dinner and tells Ma that Vivian is a dancer, Ma deliberately interprets it as 'wu nu' (a Chinese word referring to dancing girls, who in fact practice prostitution). The exclusion of Vivian is epitomized by Ma demeaning Vivian's profession. The interaction becomes more complicated when the camera captures Ma's look of embarrassment when asked by Vivian, 'How is your baby doing?' Ma strategically turns to Wil and pats her, 'My baby is fine, but she is too busy and I can barely see her.' For Ma, the pregnancy is still a family 'secret' that should not be shared with anyone outside the family, let alone discussed over dinner. When Ma realizes the extent of Vivian's relationship with Wil, she soon shifts the topic to Vivian's boyfriend. Feeling insecure and unsafe in the presence of Jay and Vivian, as well as the larger American world they stand for, Ma tries to set up Vivian with Jay. In a way, one can interpret Ma's behaviour as an attempt to exclude Vivian from Wil's life, so as to 'correct' her daughter's sexual orientation.

The grandmother's death serves as a turning point in the film: it drives Ma to marry a man to fulfil her father's wish, yet it also drives the mother and daughter together, when the daughter shows up to interrupt the wedding, thereby saving Ma from an unwanted marriage. As a result, the wedding is stopped, the identity of Ma's secret lover is revealed, the guests are astonished, and Ma runs away from the ceremony. It is the reconciliation of two selves inside Ma that turns her into a new woman, eventually serving to empower her daughter. It is not until she accompanies Vivian's mother to bring the separated lovers back together that she finally achieves her personal enlightenment and becomes a mother in a real sense rather than a victim or victimizer. *Saving Face* places narrative emphasis on a journey from maternal loss to regaining maternal presence.

Furthermore, Wu presents a compassionate view of the lesbian relationship and the Chinese community in transition. Family face, which traditionally functions as the main self-governing mechanism in the Chinese community, is challenged by a changing social and cultural context. The negotiation of family face is still ongoing though, as suggested in the closing lines of the film. The grandfather is not off the stage, as he speaks, 'The moment that girl is born, I'm coming over every day. God knows how she'll turn out if she's brought up by you two.'

Asian American independent films have thrived since the 1980s, often shining a light on the lives of the Asian Americans, who were formerly hidden behind the complexities

of political conflicts. *Saving Face*, like so many other Asian American independent films with a complex Chinese American family setup – that is, films depicting immigrant families, employing transnational capital and crew, and circulated on the international cinema circuit – usually aim to appeal to both domestic and international audiences. These films are indeed culturally important for their depiction of the contemporary Chinese overseas community and their exploration of social and cultural transformation, and therefore, are often seen as tools for political activism.

However, some problems are still worth our reconsideration: is an ethnic 'insider' perspective necessarily more authentic than the 'outsider' viewpoint? Is self-representation produced by Asian American film-makers meant to create positive images? What is emphasized in the ethnic artworks? If it is the ethnic, then what does this ethnic encompass – politics, social context or an ethnic culture? Is a film that deals with ethnicity necessarily meant to establish an oppositional culture, in opposition to the mainstream representation? One may be increasingly aware that it is difficult, or even impossible, to assign a single homogenous voice or perspective for interpreting Asian American independent films.

Qijun Han

Reference

Lee-Wong, Song-Mei (1999) *Politeness and Face in Chinese Culture*, Frankfurt: Peter Lang.

RECOMME READING

Culture & Industry Studies

Aaron, Michelle (2004) *New Queer Cinema: A Critical Reader*, Edinburgh: Edinburgh University Press.

Allen, Michael (2002) *Contemporary US Cinema*, London & New York: Routledge.

Anderson, John (2000) *Sundancing: Hanging Out and Listening in at America's Most Important Film Festival*, New York: Avon.

Ashby, Arved (2013) *Popular Music and the New Auteur: Visionary Film-makers after MTV*, New York: Oxford University Press.

Berra, John (2008) *Declarations of Independence: American Cinema and the Partiality of Independent Production*, Bristol: Intellect.

Biskind, Peter (2004) *Down and Dirty Pictures: Miramax, Sundance and the Rise of Independent Film*, London: Penguin Bloomsbury

Clover, Carol J (1993) *Men, Women, and Chain Saws: Gender in Modern Horror Film*, Princeton: Princeton University Press.

Diawara, Manthia (1993) *Black American Cinema*, London & New York: Routledge.

Feng, Peter X (2002) *Identities in Motion: Asian American Film and Video*, Durham & London: Duke University Press.

Ferncase, Richard K (1996) *Outsider Features: American Independent Films of the 1980s*, Westport, CT: Greenwood.

Field, Allyson & Horak, Jan-Christopher (2015) *L.A. Rebellion: Creating a New Black Cinema*, Berkeley, CA: University of California Press.

Gerard, Norman (2009) *Fizzle: The Unspectacular Demise of American Independent Films & the Decade of the Digital Revolution*, Bloomington, New York: iUniverse.

Guerrero, Ed (1993) *Framing Blackness: The African American Image in Film*, Philadelphia: Temple University Press.

Holmlund, Chris & Wyatt, Justin (2004) *Contemporary American Independent Film: From the Margins to the Mainstream*, London: Routledge.

James, David E (1989) *Allegories of Cinema: American Film in the Sixties*, Princeton: Princeton University Press.

Jenkins, Henry (2006) *Convergence Culture: Where Old and New Media Collide*, New York: New York University Press.

King, Geoff (2002) *New Hollywood Cinema*, London: IB Tauris.

———— (2005) *American Independent Cinema*, London: IB Tauris.

NDED

—————— (2009) *Indiewood USA: Where Hollywood Meets Independent Cinema*, London: IB Tauris.

—————— (2013) *Indie 2.0: Change and Continuity in Contemporary American Indie Film*, London: IB Tauris.

—————— (2015) *Quality Hollywood: Makers of Distinction in Contemporary Studio Film*, London: IB Tauris.

King, Geoff, Molloy, Claire & Tzioumakis, Yannis (2012) *American Independent Cinema: Indie, Indiewood and Beyond*, London & New York: Routledge.

Kramer, Gary M (2006) *Independent Queer Cinema: Reviews and Interviews*, New York: Harrington Park Press.

Levy, Emmanuel (2001) *Cinema of Outsiders: The Rise of American Independent Film*, New York: New York University Press.

Lewis, Jon (1998) *The New American Cinema*, Durham, NC: Duke University Press.

Merritt, Greg (1999) *Celluloid Mavericks: A History of American Independent Film*, New York: Thunder's Mouth Press.

Monaco, Paul (2001) *The Sixties: 1960–1969 (History of the American Cinema)*, Berkeley: University of California Press.

Mottram, James (2006) *The Sundance Kids: How the Mavericks Took Back Hollywood*, London: Faber & Faber.

Murray, Rona (2010) *Studying American Independent Cinema*, Leighton Buzzard: Auteur.

Nama, Adilufu (2015) *Race on the QT: Blackness and the Films of Quentin Tarantino*, Austin, TX: University of Texas Press.

Newman, Michael (2011) *Indie: An American Film Culture*, New York: Columbia University Press.

Ortner, Sherry B (2003) *Not Hollywood: Independent Film at the Twilight of the American Dream*, Durham & London: Duke University Press.

Perkins, Claire (2011) *American Smart Cinema*, Edinburgh: Edinburgh University Press.

Perren, Alisa (2012) *Indie, Inc.: Miramax and the Transformation of Hollywood in the 1990s*, Austin, TX: University of Texas Press.

Pierson, John (1997) *Spike, Mike, Slackers and Dykes: A Guided Tour through a Decade of American Independent Cinema*, London: Faber & Faber.

Pribram, E Deidre (2002) *Cinema & Culture: Independent Film in the United States, 1980–2001*, New York: Peter Lang.

Reekie, Duncan (2007) *Subversion: The Definitive History of Underground Cinema*, London & New York: Wallflower Press.

Rogers, Anna Backman (2015) *American Independent Cinema: Rites of Passage and the Crisis Image*, Edinburgh: Edinburgh University Press.

Sargeant, Jack (2009) *Naked Lens: Beat Cinema*, New York: Soft Skull Press.

Sorrento, Matthew (2012) *The New American Crime Film*, Jefferson, NC: McFarland & Co.

Thrower, Stephen (2008) *Nightmare USA: The Untold Story of the Exploitation Independents*, Godalming: FAB Press.

Tyler, Parker (1969) *Underground Film: A Critical History*, New York: Grove Press.

Tzioumakis, Yannis (2006) *American Independent Cinema: An Introduction*, Edinburgh: Edinburgh University Press.

Tzioumakis, Yannis (2012) *Hollywood's Indies: Classics Divisions, Specialty Labels and American Independent Cinema*, Edinburgh: Edinburgh University Press.

Vachon, Christine (2007) *A Killer Life: How an Independent Film Producer Survives Deals and Disasters in Hollywood & Beyond*, New York: Simon & Shuster.

———— (2004) *Shooting to Kill: How an Independent Producer Blasts Through Barriers to Make Movies that Matter*, New York: Bloomsbury.

Vogel, Amos (2005) *Film as a Subversive Art*, New York: CT Editions

Williams, Linda Ruth & Hammond, Michael (2006) *Contemporary American Cinema*, Glasgow: Open University Press.

Director Studies

Adams, Jeffrey (2015) *The Cinema of the Coen Brothers: Hard-Boiled Entertainments*, New York: Columbia University Press.

Aldama, Frederick Luis & Rodriguez, Alvaro (2015) *Critical Approaches to the Films of Robert Rodriguez*, Austin, TX: University of Texas Press.

Andrew, Geoff (1998) *Stranger than Paradise: Maverick Film-makers in Recent American Cinema*, London: Prion.

Berg, Charles Ramirez (2014) *The Cinema of Robert Rodriguez*, Austin, TX: University of Texas Press.

Michael Bliss & Christina Banks (1996) *What Goes Around Comes Around: The Films of Jonathan Demme*, Carbondale & Edwardsville: Southern Illinois University Press.

Bloom, Livia (2010) *Errol Morris: Interviews*, Jackson, MI: University of Mississippi Press.

Browning, Mark (2011) *Wes Anderson: Why His Movies Matter*, Santa Barbara, CA: Praeger.

Carney, Ray (2001) *Cassavetes on Cassavetes*, London: Faber & Faber.

Curry, Christopher Wayne (1999) *A Taste of Blood: The Films of Herschell Gordon Lewis*, London: Creation Books.

Dawson, Nick (2012) *Dennis Hopper: Interviews*, Jackson, MI: University of Mississippi Press.

Dewaard, Andrew & Tait, Colin (2013) *The Cinema of Steven Soderbergh: Indie Sex, Corporate Lies, and Digital Videotape*, London & New York: Wallflower.

Dombrowski, Lisa (2008) *The Films of Samuel Fuller: If You Die, I'll Kill You!*, Middletown, CT: Wesleyan University Press.

Dumas, Chris (2013) *Un-American Psycho: Brian De Palma and the Political Invisible*, Bristol: Intellect.

Fallows, Tom & Owen, Curtis (2008) *George A Romero*, Harpenden: Pocket Essentials.

Fine, Marshall (2007) *Accidental Genius: How John Cassavetes Invented the American Independent Film*, New York: Miramax.

Fuchs, Cynthia (2002) *Spike Lee: Interviews*, Jackson, MI: University of Mississippi Press.

Fuller, Samuel (2004) *A Third Face: My Tale of Writing, Fighting and Film-making*, New York: Applause.

Gallagher, Mark (2013) *Another Steven Soderbergh Experience: Authorship and Contemporary Hollywood*, Austin, TX: University of Texas Press.

Gibson, Jon M & McDonnell, Chris (2008) *Unfiltered: The Complete Ralph Bakshi*, New York: Universe.

Hanson, Peter (2002) *The Cinema of Generation X: A Critical Study*, Jefferson, NC: McFarland & Co.

Hertzberg, Ludvig (2001) *Jim Jarmusch: Interviews*, Jackson, MI: University of Mississippi Press.

Hill, Derek (2008) *Charlie Kaufman and Hollywood's Merry Band of Pranksters, Fabulists & Dreamers: An Excursion into the American New Wave*, London: Kamera.

Ingle, Zachary (2012) *Robert Rodriguez: Interviews*, Jackson, MI: University of Mississippi Press.

Jackson, Kevin (2004) *Schrader on Schrader*, London: Faber & Faber.

Johnson, David T (2012) *Richard Linklater*, Urbana & Chicago: University of Illinois Press.

Johnstone, Nick (1999) *Abel Ferrara: The King of New York*, London: Faber & Faber.

Kapsis, Robert (2009) *Jonathan Demme: Interviews*, Jackson, MI: University of Mississippi Press.

Kaufman, Anthony (2002) *Steven Soderbergh: Interviews*, Jackson, MI: University of Mississippi Press.

King, Lynnea Chapman (2014) *The Coen Brothers Encyclopedia*, Lanham, Boulder, New York & London: Rowman & Littlefield.

Kouvaros, George (2008) *Paul Schrader*, Urbana & Chicago: University of Illinois Press.

Kunze, Peter C (2014) *The Films of Wes Anderson*, New York: Palgrave Macmillan.

Laine, Tarja (2015) *Bodies in Pain: Emotion and the Cinema of Darren Aronofsky*, Oxford & New York: Berghahn.

Lee, Spike, (1988) *Gotta Have It: Inside Guerrilla Film-making*, New York: Simon & Schuster.

LoBrutto, Vincent (2010) *Gus Van Sant: His Own Private Cinema*, Santa Barbara, CA: Praeger.

Massood, Paula (2008) *The Spike Lee Reader*, Philadelphia: Temple University Press.

MacDonald, S (2005) *A Critical Cinema: Interviews with Independent Film-makers*, Berkeley: University of California Press.

McDonagh, Maitland (1995) *Film-making on the Fringe: The Good, the Bad and the Deviant Directors*, New York: Citadel Press.

Morrison, James (2007) *The Cinema of Todd Haynes: All That Heaven Allows*, London & New York: Wallflower.

Muir, John Kenneth (2009) *Eaten Alive at a Chainsaw Massacre: The Films of Tobe Hooper*, Jefferson, NC: McFarland & Co.

Murphy, JJ (2007) *Me and You and Memento and Fargo: How Independent Screenplays Work*, New York: Continuum.

Page, Edwin (2005) *Quintessential Tarantino*, London: Marion Boyars.

Parish, James Robert (2001) *Gus Van Sant: An Unauthorised Biography*, New York: Thunder's Mouth Press.

Peary, Gerald (2013) *Quentin Tarantino: Interviews*, Jackson, MI: University of Mississippi Press.

Piazza, Sara (2015) *Jim Jarmusch: Music, Words and Noise*, London: Reaktion.

Resha, David (2015) *The Cinema of Errol Morris*, Middletown, CT: Wesleyan University Press.

Rowell, Erica (2007) *The Brothers Grim: The Films of Ethan and Joel Coen*, Lanham, MD: Scarecrow.

Seitz, Matt Zoller (2013) *The Wes Anderson Collections*, New York: Abrams.

Server, Lee (1994) *Sam Fuller: Film Is a Battleground*, Jefferson, NC: McFarland and Co.

Skorin-Kapov, Jadranka (2015) *Darren Aronofsky's Films and the Fragility of Hope*, New York: Bloomsbury.

Sperb, Jason (2013) *Blossoms and Blood: Postmodern Media Culture and the Films of Paul Thomas Anderson*, Austin, TX: University of Texas Press.

Stanfield, Peter (2011) *Maximum Movies: Pulp Fictions: Film Culture and the World of Samuel Fuller, Mickey Spillane, and Jim Thompson*, New Brunswick, NJ: Rutgers University Press.

Sterrit, David (2013) *Spike Lee's America*, Cambridge: Polity.

Stone, Rob (2013) *The Cinema of Richard Linklater: Walk, Don't Run*, London & New York: Wallflower.

Suárez, Juan Antonio (2007) *Jim Jarmusch*, Urbana & Chicago: University of Illinois Press.

Waxman, Sharon (2005) *Rebels on the Backlot: 6 Maverick Directors and How They Conquered the Hollywood Studio System*, New York: HarperCollins.

White, Rob (2013) *Todd Haynes*, Urbana & Chicago: University of Illinois Press.

Williams, Tony (1997) *Larry Cohen: The Radical Allegories of an Independent Film-maker*, Jefferson, NC: McFarland & Co.

Williams, Tony (2003) *The Cinema of George A Romero: Knight of the Living Dead*, London: Wallflower.

Winkler, Peter L (2011) *Dennis Hopper: The Wild Ride of a Hollywood Rebel*, London: Robson Press.

Wood, Jason (2002) *Steven Soderbergh*, London: Kamera.

Key Films

Carney, Raymond (2001) *Shadows*, London: BFI.

David, Glyn (2008) *Superstar: The Karen Carpenter Story*, London & New York: Wallflower.
————— (2011) *Far from Heaven*, Edinburgh: Edinburgh University Press.

Guerro, Ed (2001) *Do The Ring Thing*, London: BFI.

Hervey, Ben A (2008) *Night of the Living Dead*, London: BFI.

Hill, Lee (1996) *Easy Rider*, London: BFI.

Jaworzyn, Stefan (2003) *The Texas Chain Saw Massacre Companion*, London: Titan.

King, Geoff (2007) *Donnie Darko*, London & New York: Wallflower.
————— (2010) *Lost in Translation*, Edinburgh: Edinburgh University Press.

Perkins, Claire & Verevis, Constantine (2014) *US Independent Film-making after 1989: Possible Films*, Edinburgh: Edinburgh University Press.

Polan, Dana (2000) *Pulp Fiction*, London: BFI.

Powell, Danny (2006) *Studying Donnie Darko*, Leighton Buzzard: Auteur.

Reid, Mark A (1997) *Spike Lee's Do the Right Thing*, Cambridge: Cambridge University Press.

Rose, James (2013) *The Texas Chain Saw Massacre*, Leighton Buzzard: Auteur.

Rosenbaum, Jonathan (2000) *Dead Man*, London: BFI.

Seitz, Matt Zoller (2015) *The Wes Anderson Collection: The Grand Budapest Hotel*, New York: Abrams.

Tzioumakis, Yannis (2009) *The Spanish Prisoner*, Edinburgh: Edinburgh University Press.

Film Criticism & Film Guides

Battcock, Gregory (1967) *The New American Cinema: A Critical Anthology*, New York: Dutton.

Berra, John (2010) *Directory of World Cinema: American Independent*, Bristol: Intellect.
————— (2013) *Directory of World Cinema: American Independent 2*, Bristol: Intellect.

Foster, Audrey & Winston Dixon, Wheeler (2002) *Experimental Cinema: The Film Reader*, London & New York: Routledge.

Hillier, Jim (2000), *American Independent Cinema: A Sight & Sound Reader*, London: BFI.

Hoberman, Jim (2003) *The Dream Life: Movies, Media and the Myth of the Sixties*, New York: The New Press.

Hoberman, Jim & Rosenbaum, Jonathan (1983) *Midnight Movies*, New York: Da Capo Press.

Holm, DK (2008) *Independent Cinema*, London: Kamera.

LoBrutto, Vincent (2002) *The Encyclopedia of American Independent Film-making*, Westport, CT: Greenwood.

Lyons, Donald (1994) *Independent Visions: A Critical Introduction to Recent Independent American Film*, New York: Balentine.

Winter, Jessica (2006) *The Rough Guide to American Independent Film*, London: Rough Guides.

Wood, Jason (2009) *100 American Independent Films*, London: Palgrave Macmillan.

AMERICAN INDEPENDENT CINEMA ONLINE

Articles, Blogs, News, Podcasts and Reviews

Ain't It Cool News
http://www.aintitcool.com
News, interviews, reviews and development gossip courtesy of Harry Knowles and his team of industry 'spies'; Hollywood blockbusters feature heavily, but staffers also hit the festival circuit to find out about forthcoming independent releases and their directors.

Bright Lights Film Journal
http://www.brightlightsfilm.com
Bright Lights Film Journal is a popular-academic hybrid of film analysis, history and critical commentary that examines commercial, exploitation and independent cinema from a variety of vantage points.

Cineaste
http://www.cineaste.com
One of America's leading film publications with a focus on the art and politics of cinema. Coverage of American independent cinema is provided through articles on new releases and retrospective pieces.

Daily Grindhouse
http://dailygrindhouse.com
News, reviews and festival reports with an emphasis on horror, fantasy and science fiction; an ideal resource for coverage of the current exploitation scene.

Electric Sheep
http://www.electricsheepmagazine.co.uk
An online magazine for lovers of cult cinema; coverage of American cinema is largely devoted to films that exist outside the Hollywood mainstream.

Emanuel Levy
http://www.emanuellevy.com
The website of Emanuel Levy, film critic and author of *Cinema of Outsiders: The Rise of American Independent Film*; Levy offers reviews, news from the independent sector, interviews with film-makers and festival information.

Film Comment
http://filmlinc.com/film-comment
Published by the Film Society of Lincoln, Film Comment is a well-regarded journal that includes coverage of new releases and retrospectives, interviews with major directors and festival reports.

Film-maker Magazine
http://film-makermagazine.com
Film-maker Magazine is devoted to independent cinema with reviews and in-depth interviews that are consistently interesting and informed; the website also features an extensive list of useful resources for aspiring film-makers.

Flickering Myth
http://www.flickeringmyth.com
Film and television review site with a consistent focus on the independent world through news, reviews, trailers, interviews and filmmaker profiles.

The Hollywood Reporter
http://www.hollywoodreporter.com
Industry news and reviews with an emphasis on the Hollywood mainstream, but some coverage of the independent world and the speciality sub-divisions of the major studios.

Independent Film Channel
http://www.ifc.com
IFC was the first network to be completely devoted to independent cinema and related programming, operating under the mantra 'Always Uncut'; news and reviews from the independent world with digital downloads and coverage of significant events.

Indie Film
http://www.gkindiefilm.com
The blog of academic and American indie cinema specialist Geoff King with reading resources and occasional posts regarding recent releases.

Indie Slate Magazine
http://www.indieslate.com
Indie Slate tracks independent film and video production, with speculation on the future of the sector in relation to current market trends, interviews with film-makers, distributors and producers and advice for those entering the industry.

Indiewire
http://www.indiewire.com
News, information and networking website for independent-minded film-makers, industry professionals and audiences; reviews of the latest releases and interviews with leading directors are also posted daily.

JJ Murphy
http://www.jjmurphyfilm.com
The website of JJ Murphy, independent film-maker and author of *Me and You and Memento and Fargo: How Independent Screenplays Work*; Murphy offers insightful reviews of independent features, longer articles about key film-makers and screenwriting resources.

Little White Lies
http://www.littlewhitelies.co.uk
The website of the bi-monthly magazine Little White Lies which offers news, reviews, interviews and festival coverage which often includes American independent films.

Next Projection
http://nextprojection.com
Well-informed reviews website with regular coverage of independent releases from the festival circuit plus theatrical and VOD releases.

Notes on Metamodernism
http://www.metamodernism.com
Webzine that documents current trends across aesthetics and culture; American cinema is one of many topics considered by contributing academics and critics.

The Playlist
http://blogs.indiewire.com/theplaylist/
Now affiliated with trendsetting website Indiewire, The Playlist provides coverage of new releases alongside retrospective pieces with considerable discussion of American independent cinema and quality television.

POV Blog
http://www.pbs.org
Documentary blog with coverage of current releases, interviews with film-makers, progress reports of in-production projects and articles that explore issues related to the practices of documentary film-making.

The Projection Booth
http://projection-booth.blogspot.com
Regular podcast hosted by Mike White and Rob St Mary which often selects American independent features for retrospective discussion; episodes have covered such varied titles as *Bone*, *Female Trouble*, *Ghost Dog: Way of the Samurai*, *The Limey*, *Reservoir Dogs* and *Two-Lane Blacktop*.

Realscreen
http://realscreen.com
News from the world of independent production which covers all aspects of the sector: features, documentaries, animation, television projects and festivals.

Screen Anarchy
http://screenanarchy
News, reviews and festival reports from the world of cinema with some coverage of the American independent sector, particularly exploitation or genre movies.

Senses of Cinema
http://www.sensesofcinema.com
Online journal devoted to a serious yet eclectic discussion of cinema that includes the American independent sector; Senses of Cinema is concerned with ideas about particular films and major bodies of work, but also raises theoretical and philosophical issues related to film studies.

Sight & Sound
http://www.bfi.org.uk/sightandsound
The website of Sight & Sound magazine, published by the BFI, which covers international cinema through reviews of new releases and retrospective articles; some coverage of American independent cinema with reference to key films and leading directors.

The Talkhouse
http://thetalkhouse.com/film/
Artists discuss the work of their contemporaries to promote dialogue between creators who may never have interacted otherwise; film-making participants have included Allison Anders, Dave Boyle, Mary Harron, Lloyd Kaufman, David Lowery and Alex Ross Perry.

Variety
http://www.variety.com
Breaking entertainment movie news, reviews, industry coverage and reports from major festivals; there is an emphasis on the Hollywood mainstream, but the independent sector and studio sub-divisions also receive attention and analysis.

WTF with Marc Maron
http://www.wtfpod.com
Directors and actors from the American independent scene are often guests on comedian Marc Maron's incisive podcast; recent highlights include in-depth conversations with Paul Thomas Anderson, Mark & Jay Duplass, Crispin Glover, Ethan Hawke, Harmony Korine, Richard Linklater, Parker Posey, Lynn Shelton and Joe Swanberg.

Art, Culture and Events Organizations

American Film Institute
http://www.afi.com
The American Film Institute preserves the history of the motion picture through its archive, providing an authoritative record of American films from 1893 to the present; the AFI also provides leadership in the fields of film, television and digital media, supporting initiatives that engage the past, the present and the future of the moving image arts.

The Film Foundation
http://www.film-foundation.org
The Film Foundation is a nonprofit organization established in 1990 by Martin Scorsese, dedicated to ensuring motion picture history by providing annual support for preservation and restoration projects at leading film archives.

The Film Society of Lincoln
http://www.filmlinc.com
America's pre-eminent film preservation organization was established in 1969 to celebrate American and international cinema, and also to recognize new film-makers; the society organizes the New York Film Festival and publishes the cinematic journal *Film Comment*.

Rooftop Films
http://www.rooftopfilms.com
Rooftop Films now annually screens more than 25 features and 150 shorts in themed programmes of underground cinema that have been held outdoors in such cities as New York, Philadelphia, Pittsburgh and Toronto.

Databases

American Film Institute
http://www.afi.com
Arguably the most authoritative film database on the web, including entries on nearly 60,000 American features and 17,000 shorts produced from 1893–2011.

Box Office Mojo
http://www.boxofficemojo.com
US box office information updated daily with regular analysis of market trends, both in the United States and overseas with a very useful database of box office figures and release dates.

Directory of World Cinema
http://www.worldcinemadirectory.org
The website for the Directory of World Cinema series featuring film reviews and biographies of leading directors; an ideal starting point for students of World Cinema.

Internet Movie Database
http://www.imdb.com
The most popular source of information for international cinema and industry news with pages devoted to individual films, directors, actors and key crew members; an entire section – IMDb indie – is devoted to the independent sector.

Distributors

Arrow Film Distributors
http://www.arrowfilms.co.uk
Distributor of arthouse and genre movies from around the world that aims to please cultists with great artwork and extras packages; American independent titles include *The Exterminator*, *King of New York*, *Maniac Cop*, and many Russ Meyer features.

A24
http://a24films.com
This new kid on the block is fast making waves with titles that are generating critical discussion and breaking out of the speciality market; releases to date include *The Bling Ring*, *The End of the Tour*, *Laggies*, *A Most Violent Year*, *Obvious Child* and *Spring Breakers*.

The Criterion Collection
http://www.criterion.com
Distributor of classic and cult titles that has become famous for the remastering of films for the DVD market and the level of attention devoted to artworks and extras packages; American independent films include *Crumb*, *Down by Law*, *Hoop Dreams*, *The Killing of a Chinese Bookie*, *Rushmore*, *Slacker* and *Stranger Than Paradise*.

The Film-Makers' Cooperative
http://film-makerscoop.com
The Film-Makers' Cooperative is the largest archive of independent and avant-garde films in the world with more than 5,000 films, videotapes and DVDs in its collection.

IFC Films
http://www.ifcfilms.com
The distribution arm of the Independent Film Channel; titles include *Ain't Them Bodies Saints*, *Boyhood*, *Life During Wartime*, *Paranoid Park* and *Welcome to New York*.

Magnolia Pictures
http://www.magpictures.com
Distributor of independent features from around the world combing genre fare with arthouse titles; American independent films include *Drinking Buddies*, *The Girlfriend Experience*, *The House of the Devil*, *Prince Avalanche*, *Results* and *Tangerine*.

Peccadillo Pictures
http://peccapics.com
Peccadillo Pictures is one of the leading UK distributors of independent cinema, with an emphasis on gay and lesbian features: their catalogue includes such American independent titles as *All Over Me*, *And Then Came Lola*, *Pornography: A Thriller* and *Trick*.

Roadside Attractions
http://www.roadsideattractions.com
Distributor of the type of quality adult fare that is now being overlooked by the major Hollywood studios; releases include *Dear White People*, *Joe*, *Love & Mercy*, *Mud*, *The Skeleton Twins*, *Winter's Bone* and *Z for Zachariah*.

Strand Releasing
http://www.strandreleasing.com
Distributor of independent cinema from around the world with many notable lesbian and gay titles in their catalogue; American independent titles including *Ellie Parker*, *The Living End*, *Mysterious Skin*, *Rhythm Thief* and *Swoon*.

THINKFilm
http://www.thinkfilm-inc.com
Innovative independent distributor of *Before the Devil Knows You're Dead*, *Down in the Valley*, *Gerry*, *Half Nelson*, *The King*, *Noise*, *Primer* and *Shortbus*, among others.

Troma Entertainment
http://www.troma.com
Schlock specialists that have achieved almost forty years of independence by releasing such 'classics' as *Class of Nuke 'Em High*, *Sizzle Beach USA* and *The Toxic Avenger*.

The Weinstein Company
http://www.weinsteinco.com
The company formed by Bob and Harvey Weinstein after leaving Miramax Films; recent films include *The Butler*, *Django Unchained*, *Fruitvale Station*, *The Immigrant*, *Southpaw* and *St Vincent*.

Zeitgeist Films
http://www.zeitgeistfilms.com
Zeitgeist set out to capture 'the spirit of the times' with a range of documentaries and features that includes *Bill Cunningham New York*, *Poison* and *Trouble in the Water*.

Festivals

American Independent Film Festival
http://www.film-fest.us
The festival focuses on the work of new film-makers that present new approaches to working with limited budgets; venues are often closely connected to prominent film schools.

Asian American Film Festival of Dallas
http://www.asianfilmdallas.com
The Asian Film Festival of Dallas is a nonprofit organization dedicated to celebrating and supporting emerging and established Asian and Asian American film-makers.

Essential Independents: American Cinema, Now
http://www.essentialindependents.com
A celebration of American independent cinema held across various Australian cities, which mixes the latest titles with retrospectives of cult favourites and era-defining classics.

New York Film Festival
http://www.filmlinc.com
The New York Film Festival has been a major non-competitive event since it was founded in 1963 by Amos Vogel and Richard Roud with films being selected by the Film Society of Lincoln Centre.

New York International Independent Film and Video Festival
http://www.nyfilmvideo.com
The NYIIFVF is a competitive event that aims to provide exposure for film-makers and screenwriters, with art and music events in addition to film screenings.

Raindance
http://www.raindance.co.uk
London-based film festival devoted to alternative cinema which regularly includes the latest American independent titles in its international line-up.

Slamdance
http://www.slamdance.com
Slamdance serves as a showcase for emerging talent in the film industry with entry limited to feature films that have been produced for less than $1 million.

Sundance Film Festival
http://www.sundance.org/festival/
The Sundance Film Festival is America's leading event for independent cinema; the website features programme announcements, details of related activities and a ticket-ordering facility.

SXSW
http://sxsw.com/film
The South by South West Film Conference and Festival intends to discover new talent while providing networking opportunities for those operating in the world of independent film.

Telluride Film Festival
http://telluridefilmfestival.org
Operated by the National Film Preserve, the Telluride Film Festival screens new independent features each year and has hosted the premieres of such classics as *Blue Velvet*, *Mulholland Drive*, *Roger and Me* and *Stranger Than Paradise*.

Tribeca Film Festival
http://www.tribecafilm.com/festival
The Tribeca Film Festival was founded in 2002 as a response to the 11 September 2001 attacks on the World Trade Center to revitalize the Tribeca area; the programme consists of independently produced feature films, documentaries and shorts.

Web Streaming

Coffee Shorts
http://www.coffeeshorts.co.uk
Watch independent short films online including animation, documentary, experimental, narrative, music videos and trailers.

Fandor
http://www.fandor.com
Fandor is a curated social movie streaming service that encourages users to discover, watch and share independent films of exceptional quality from around the world.

Indie Movies Online
http://www.indiemoviesonline.com
Indie Movies Online is a fully licensed video-on-demand site that is committed to supporting independent film-makers by acquiring new movies and making them available online.

Indieflix
http://www.indieflix.com
Indieflix believe that every good movie has an audience and aims to connect independent film-makers with audiences by providing a forum to stream features and shorts.

Mubi
http://www.mubi.com
Stream a wide variety of independent features on a per-film basis or with a subscription; Mubi also offers a Daily Notebook with news from the world of international cinema.

Questions

1. Who is the director of *Mala Noche*, *Gerry* and *Paranoid Park*?

2. What is the title of Wayne Wang's breakthrough feature about San Francisco taxi drivers?

3. In which state are all of Kelly Reichardt's films set?

4. *9½ Weeks*, *Wild Orchid* and *Delta of Venus* are the product of which erotic auteur?

5. Who plays the overly-demanding music teacher in *Whiplash*?

6. The character of Machete made his debut in which Robert Rodriguez adventure?

7. Who is the director of *Walking and Talking*, *Friends With Money* and *Enough Said*?

8. Which of Whit Stillman's films is set on a college campus?

9. Who is the director of *Shadows*, *Faces* and *Husbands*?

10. Who plays the title role in *Inside Llewyn Davis*?

11. Who is the director of *Rushmore*, *Moonrise Kingdom* and *The Grand Budapest Hotel*?

12. In which Todd Haynes film does Julianne Moore play a 1950s suburban housewife?

13. Natalie Portman stars as a distressed ballerina in which Darren Aronofsky film?

14. Who is the director of *The House of the Devil*, *The Innkeepers* and *The Sacrament*?

15. Who plays Alien in Harmony Korine's youth movie *Spring Breakers*?

16. *Citizenfour* concerns which government whistleblower?

17. Bruce Willis and Joseph Gordon-Levitt play the same character in which Rian Johnson film?

18. Who is the director of *Juno*, *Young Adult* and *Up in the Air*?

19. Who plays the drug dealer at the centre of Paul Schrader's *Light Sleeper*?

20. Who is the young actor who ages throughout *Boyhood* as Mason Jr?

21. Who is the director of *Hedwig and the Angry Inch*, *Shortbus* and *Rabbit Hole*?

22. Which of Larry Cohen's films revolves around a killer mutated baby?

23. Which film by Abel Ferrara details the real-life case of Dominique Strauss-Kahn?

24. Johnny Depp travels through the Wild West in which Jim Jarmusch film?

25. Who is the director of *Lost in Translation*, *Somewhere* and *The Bling Ring*?

26. Ben Affleck and Javier Bardem feature in which Terrence Malick film?

27. George A Romero paid tribute to EC comics with which horror anthology?

28. Who is the multitasking mogul behind *Madea's Family Reunion*, *Madea Goes to Jail* and *A Madea Christmas*?

29. Who is the director of *Fritz the Cat*, *Heavy Traffc* and *Coonskin*?

30. Which film was Dennis Hopper's follow-up to *Easy Rider*?

31. Who is the director of *Kicking and Screaming*, *Greenberg* and *Frances Ha*?

32. Which film marked the directorial debut of the photographer William Klein?

33. Who directed the New Orleans documentary *When the Levees Broke: A Requiem in Four Acts*?

34. Jeff Daniels, Melanie Griffith and Ray Liotta star in which Jonathan Demme road movie?

35. Who directed the horror musical *Phantom of Paradise*?

36. Who plays the title role in Jeff Nichols's drama *Mud*?

37. Todd Solondz revisited the characters of *Happiness* with which belated sequel?

38. Which book by the documentarian Errol Morris deals with the art of photographic representation?

39. Who stars as self-absorbed writer in *Listen Up Philip*?

40. Radha Mitchell and Ally Sheedy play lovers in which Lisa Cholodenko film?

41. Who is the director of *Underworld USA*, *Shock Corridor* and *White Dog*?

42. Which television news satire stars Jake Gyllenhaal, Rene Russo and Bill Paxton?

43. Which independent company produced *Fireproof*, *Courageous* and *War Room*?

44. Which actors play the mismatched labourers in David Gordon Green's buddy movie *Prince Avalanche*?

45. Who plays the bereaved young man out for revenge in *Blue Ruin*?

46. Which drama by Alison Anders takes place in Echo Park, Los Angeles?

47. Who is the director of *Yellow* and *Undoing*?

48. What is the title of Shane Carruth's second feature?

49. What is the name of the production company that was owned by Steven Soderbergh and his regular collaborator George Clooney?

50. Who is the director of *House of Games*, *Things Change* and *The Spanish Prisoner*?

answers on next page

Answers

1. Gus Van Sant
2. *Chan Is Missing*
3. Oregon
4. Zalman King
5. JK Simmons
6. *Spy Kids*
7. Nicole Holofcener
8. *Damsels in Distress*
9. John Cassavetes
10. Oscar Isaac
11. Wes Anderson
12. *Far from Heaven*
13. *Black Swan*
14. Ti West
15. James Franco
16. Edward Snowden
17. *Looper*
18. Jason Reitman
19. Willem Dafoe
20. Ellar Coltrane
21. John Cameron Mitchell
22. *It's Alive*
23. *Welcome to New York*
24. *Dead Man*
25. Sofia Coppola
26. *To the Wonder*
27. *Creepshow*
28. Tyler Perry
29. Ralph Bakshi
30. *The Last Movie*
31. Noah Baumbach
32. *What to do with Polly Maggoo?*
33. Spike Lee
34. *Something Wild*
35. Brian De Palma
36. Matthew McConaughey
37. *Life During Wartime*
38. *Believing is Seeing: Observations on the Mysteries of Photography*
39. Jason Schwartzman
40. *High Art*
41. Samuel Fuller
42. *Nightcrawler*
43. Sherwood Pictures
44. Paul Rudd and Emile Hirsch
45. Macon Blair
46. *Mi Vida Loca*
47. Chris Chan Lee
48. *Upstream Color*
49. Section 8
50. David Mamet

NOTES ON CONTRIBUTORS

The Editor

John Berra is a lecturer in Film and Language Studies at Renmin University of China. He is the author of *Declarations of Independence: American Cinema and the Partiality of Independent Production* (Intellect, 2008) and the editor of the previous volumes of the *Directory of World Cinema: American Independent* (Intellect, 2010/13). He has contributed to *World Film Locations: New York* (Intellect, 2012), *A Companion to Film Noir* (Wiley Blackwell, 2013), *World Film Locations: New Orleans* (Intellect, 2013), *US Independent Film-making After 1989: Possible Films* (EUP, 2015) and *A Companion to Indie Film* (Wiley Blackwell, forthcoming).

The Contributors

Joel Neville Anderson is a film-maker/researcher working in personal documentary and experimental film/video pursuing a PhD in the University of Rochester's graduate programme in Visual and Cultural Studies. His work has recently been featured in scholarly journals and collections including *Film on the Faultline* (Intellect, 2015), *InVisible Culture: An Electronic Journal for Visual Culture* and volumes in the Directory of World Cinema series. He also curates JAPAN CUTS: Festival of New Japanese Film at Japan Society in New York. Joel is based in Flushing, Queens.

John Bleasdale is a writer based in Italy.

Marco Bohr is a photographer, academic and researcher in visual culture. He received his PhD from the University of Westminster in 2011 and was appointed Lecturer in Visual Communication at Loughborough University in 2012. He has contributed to the *Directory of World Cinema: Japan 2* (Intellect, 2012), *Frontiers of Screen History: Imagining European Borders in Cinema, 1945–2010* (Intellect, 2013), *On Perfection: An Artists' Symposium* (Intellect, 2013) and the *Directory of World Cinema: American Independent 3* (Intellect, 2015). He has also contributed to the *Dandelion Journal*, the exhibition catalogue for 'Modernity Stripped Bare', held at the University of Maryland in 2011, and the artist book *Kim Jong Il Looking at Things* (Jean Boîte Éditions, 2012). In 2013, Marco was awarded a fellowship by the Japan Foundation for his ongoing research on the photographic representation of post-tsunami landscapes.

Mark Bould is Reader in Film and Literature at the University of the West of England, and co-editor of *Science Fiction Film and Television*. His most recent books are *Science Fiction: The Routledge Film Handbook* (Routledge, 2012), *Africa SF* (Paradoxa, 2013), *SF Now* (Paradoxa, 2014) and *Solaris* (BFI, 2014).

Martin Carter is principal lecturer in Stage & Screen at Sheffield Hallam University. He has contributed to collections such as *Ealing Revisited* (BFI, 2012), *East Asian Film Stars*

(Palgrave MacMillan, 2014) and the *Directory of World Cinema: Britain 2* (Intellect, 2015) as well as reviews for *Vertigo* and *The Journal of British Cinema and Television*.

Hiu M Chan is a PhD candidate at the School of Journalism, Media and Cultural Studies, Cardiff University.

Tamara Courage is a PhD candidate and teaches in the department of Film, Theatre and Television at the University of Reading. Her research focuses on urban spaces, mobility and memory in contemporary Chinese independent cinema.

Rob Dennis writes about, and teaches, film and media in London. He has contributed to the *Directory of World Cinema: American Independent* (Intellect, 2010/13) and the *Directory of World Cinema: American Hollywood* (Intellect, 2011). He has also written for *Vertigo* magazine and *Film International*.

Marc DiPaolo (English PhD, Drew University) is author of *Emma Adapted: Jane Austen's Heroine from Book to Film* (Peter Lang, 2007) and *War, Politics and Superheroes: Ethics and Propaganda in Comics and Film* (McFarland and Co., 2011). He has edited two anthologies about progressive Christianity and co-edited (with Bryan Cardinale-Powell) *Devised and Directed by Mike Leigh* (Bloomsbury, 2013) and (with Wayne Stein) *Ozu International: Essays on the Global Influences of a Japanese Auteur* (Bloomsbury, 2015).

Chris Dumas is the author of *Un-American Psycho: Brian De Palma and the Political Invisible* (Intellect, 2012). His work has appeared in *Critical Inquiry*, *Cinema Journal* and *Camera Obscura*.

Martin Fradley has taught film, television, media and cultural studies at the University of East Anglia, the University of Aberdeen, Edge Hill, Keele and Manchester University, amongst others. He is a regular contributor to *Film Quarterly* and is a contributing co-editor of *Shane Meadows: Critical Essays* (Edinburgh University Press, 2013). His recent work has appeared in collections such as *The Handbook of Gender, Sex and Media* (Wiley-Blackwell, 2012), *Postfeminism and Contemporary Hollywood Cinema* (Palgrave, 2013) and *Tainted Love: Screening Sexual Perversities* (IB Tauris, 2016).

Kenji Fujishima was born in Queens, New York in 1985. Though there were some stirrings of his love for movies in his teenage years – thanks to both initial encounters with the film criticism of Pauline Kael and the horror section of his local video store – it wasn't until he directed his energies towards journalism at Rutgers University in his college years that his cinephilia truly blossomed. Subsequently, he hasn't looked back, as contributor to *Slant Magazine* and *The Wall Street Journal*, and co-features editor of *Movie Mezzanine*, among other outlets.

Vincent M Gaine is an independent researcher based in Norwich, England. His research focuses on liminality and social tensions in contemporary American cinema. He is the author of *Existentialism and Social Engagement in the Films of Michael Mann* (Palgrave Macmillan, 2011). He has published articles in *Cinema Journal* and the *Journal of Technology, Theology and Religion*, as well as book chapters on postfeminism, the superhero genre, transnational cinema and race in historical film. He is a regular contributor to the Directory of World Cinema series as well as the *Journal of American Studies of Turkey*.

Qijun Han has a BA (with honours) from Nanjing University, majoring in English Studies, and has an MA in American Studies from Utrecht University. From 2009 to 2013, she carried out her PhD at the Research Institute for History and Culture, also at Utrecht University. In

January 2014, she received her doctorate for her thesis entitled 'The Ties That Bind: The Chinese American Family in Transnational Chinese Cinema', which examined the cinematic construction of Chinese identities in the United States. She has published several articles on Chinese family culture, the cinematic representation of Chinese family conflict in the migration context, and Chinese cinema in the 1920s. She is currently an assistant professor in the School of Foreign Studies at Nanjing University of Science and Technology.

Adam Hartzell has been a contributing writer to Koreanfilm.org since 2000. He has written for various websites, the quarterly *Kyoto Journal*, and has contributed to *The Cinema of Japan and Korea* (Wallflower, 2004) and the *Directory of World Cinema: South Korea* (Intellect, 2013). He writes often about the films of Hong Sangsoo, such as for a retrospective of his work held in San Francisco and a paper delivered at the *Society for Cinema and Media Studies Conference* in Seattle in 2014. He was part of 'The Invasion of the Cinemaniacs' series of Bay Area Now 7 at Yerba Buena Center for the Arts in San Francisco.

Zachary Ingle received his PhD in Film and Media Studies at the University of Kansas. He has contributed to the *Directory of World Cinema: Belgium* (Intellect, 2014); the *Directory of World Cinema: Australia and New Zealand 2* (Intellect, 2014); the *Directory of World Cinema: Japan 3* (Intellect, 2015); *World Film Locations: Las Vegas* (Intellect, 2011); *World Film Locations: Paris* (Intellect, 2012); *World Film Locations: Prague* (Intellect, 2012); *World Film Locations: Marseilles* (Intellect, 2013); *World Film Locations: Boston* (Intellect, 2014); and *World Film Locations: Shanghai* (Intellect, 2014). He has also contributed to *Fan Phenomena: Star Wars* (Intellect, 2013) and *Fan Phenomena: Marilyn Monroe* (Intellect, 2014). He also recently edited *Fan Phenomena: The Big Lebowski* (Intellect, 2014) and *Robert Rodriguez: Interviews* (University Press of Mississippi, 2012), and co-edited both *Identity and Myth in Sports Documentaries* (Scarecrow Press, 2013) and *Gender and Genre in Sports Documentaries* (Scarecrow Press, 2013).

Martin Zeller-Jacques is a lecturer in Film and Media at Queen Margaret University. His primary research interest is in serial narratives in contemporary media, with a particular focus upon television serials and transmedia storytelling. He also maintains significant research interests in adaptation studies and feminist/gender studies. In addition to publishing articles in a number of edited collections, he has contributed to several volumes of Intellect's Directory of World Cinema and to their World Film Locations series.

Victoria Kearley was awarded a PhD in Film Studies by the University of Southampton in 2015. The representation of Hispanic and Latino masculinities in contemporary Hollywood cinema was the subject of her doctoral thesis, which considered how popular genre conventions and star personas can reconfigure traditional conceptions of race, gender and sexuality within mainstream cinema. She has worked as a part-time lecturer at the University of Portsmouth and the University of Southampton and has served as the postgraduate representative for the Society of Cinema and Media Studies' Latino/a Caucus.

Angelos Koutsourakis is a postdoctoral research fellow at the University of Queensland. He is the author of *Politics as Form in Lars von Trier* (Bloomsbury, 2013), and the co-editor (with Mark Steven) of *The Cinema of Theo Angelopoulos* (Edinburgh University Press, 2015). His articles have appeared (or are in press) in *Cinema Journal*, *New Review of Film and Television Studies*, *Studies in European Cinema*, *Cinema: Journal of Philosophy and the Moving Image*, *Journal of Contemporary European Studies*, *International Journal of Performance Arts and Digital Media*, *The Brecht Yearbook*, *Senses of Cinema*, *Kinema: A Journal for Film*, *Audiovisual Media*, and many more.

Gary M Kramer is the author of *Independent Queer Cinema: Reviews and Interviews* (Harrington Park Press, 2006) and the co-editor of *Directory of World Cinema: Argentina Volume 1* (Intellect, 2014) and *Volume 2* (Intellect, 2016). His work appears regularly in *Gay City News*, *Philadelphia Gay News*, *The San Francisco Bay Times*, and online at *Salon*, *Slant*, *Fandor*, and *indieWIRE*. He regularly covers film festivals for *Film International*.

David LaRocca, PhD, is a visiting scholar in the Department of English at Cornell University, a lecturer in Screen Studies at Ithaca College, and a lecturer in value theory at the State University of New York College at Cortland. He is the editor of *The Philosophy of Charlie Kaufman* (University Press of Kentucky, 2011), *The Philosophy of War Films* (University Press of Kentucky, 2014) and *The Philosophy of Documentary Film* (Lexington, forthcoming). He has also contributed essays to volumes on Spike Lee, the Coen brothers, Tim Burton and Michael Mann. He is the author, most recently, of *Emerson's English Traits and the Natural History of Metaphor* (Bloomsbury, 2013). He attended Werner Herzog's Rogue Film School and is the director of *Brunello Cucinelli: A New Philosophy of Clothes* (2013).

John Marmysz teaches philosophy at the College of Marin in California. His interests focus on the problem of nihilism and its cultural manifestations. He is the author of *Laughing at Nothing: Humor as a Response to Nihilism* (SUNY Press, 2003), *The Path of Philosophy: Truth, Wonder and Distress* (Wadsworth, 2012), *The Nihilist: A Philosophical Novel* (No Frills Buffalo, 2015), and co-editor (with Scott Lukas) of *Fear, Cultural Anxiety and Transformation: Horror, Science Fiction, and Fantasy Films Remade* (Lexington Books, 2009). He has written articles and reviews for *Film and Philosophy*, *Film-Philosophy*, *The Journal of Popular Culture*, *The Journal of Aesthetics and Art Criticism*, *Film International* and the *International Journal of Scottish Theatre and Screen*. He has also contributed entries to other volumes in the Directory of World Cinema series.

David Marr is a writer and musician who lives in Athens, GA. He is a board member of the Athens Film Arts Institute, which supports and oversees Ciné, Athens's nonprofit community arthouse cinema. He is a former film columnist for *Flagpole* magazine, and now works at the University of Georgia's Willson Center for Humanities and Arts.

Neil Mitchell is a freelance writer and editor based in Brighton, UK. Among others, he is the editor of *World Film Locations: London* (Intellect, 2011) and the author of *Devil's Advocates: Carrie* (Auteur, 2014). He is also the film coordinator of the Australia & New Zealand Festival of Literature & Arts.

Shelley O'Brien is a senior lecturer in Film Studies at Sheffield Hallam University, UK. Her MPhil is entitled 'Body-Horror Movies: Their Emergence and Evolution' (2000). She specializes in horror cinema and music and sound in film, and is currently supervising three PhD students. Her most recent publication is 'Killer Priests: The Last Taboo?' in *Roman Catholicism in Fantastic Film: Essays on Belief, Spectacle, Ritual and Imagery* (McFarland and Co., 2011). She has presented conference papers on Spanish horror, torture porn, cult cinema, soundscaping in horror, Riz Ortolani and the scoring of violence in Italian horror cinema, and rape/revenge movies.

Hamilton Santià has a PhD in Film Studies from the University of Turin. His work focuses on the cultural sphere of American Indie, from style to consumption. He has published essays in books and peer-reviewed magazines on subjects such as

James Bond, Jason Reitman, Wes Anderson, the new authorship in Indie Cinema and mumblecore. He is also active in non-academic publishing; so far he has published a novel and a non-fiction music book. He contributes to several daily newspapers and cultural website.

Jack Sargeant is the author of numerous books, essays and articles on underground film, outsider art and the more unusual aspects of culture. His books include *Deathtripping: The Extreme Underground* (Soft Skull Press, 2008), *Naked Lens: Beat Cinema* (Soft Skull Press, 2009) and *Flesh and Excess: On Underground Film* (Amok Books, 2016). He has also contributed to numerous essay collections, including *From the Arthouse to the Grindhouse: Highbrow and Lowbrow Transgression in Cinema's First Century* (Scarecrow, 2010) and *The End: An Electric Sheep Anthology* (Strange Attractor, 2010). In addition, his writings have appeared in magazines including *The Fortean Times*, *FilmInk*, *Real Time* and *The Wire*. For more than two decades, Sargeant has curated film programs and art exhibitions, presenting programs at film festivals, arts spaces and special events across the world. He has programmed retrospective seasons at the ICA London and ACMI Melbourne, and guest programmed screenings at the Chicago Underground Film Festival, the Sydney Underground Film Festival, ATA San Francisco and many others. He is currently the Program Director of the Revelation Film Festival, Perth.

Carlos Segura is a film-maker and writer based out of New York City. A founder of Cinespect, a film culture site sourced online in *Forbes* and *The Wall Street Journal* among other outlets, he has also been a guest programmer at Spectacle Theater in Brooklyn, NY.

Steven Shaviro is the DeRoy Professor of English at Wayne State University. He is the author of *The Cinematic Body* (University of Minnesota Press, 1993), *Post-Cinematic Affect* (Zero Books 2010), *Melancholia, Or, the Romantic Anti-Sublime* (REFRAME, 2012), *The Universe of Things: On Speculative Realism* (University of Minnesota Press, 2014) and a forthcoming book on music videos.

Michael Smith was awarded his PhD from the University of Leeds in 2013. His research examined the representation of women in early post-war Japanese cinema, particularly focusing on how the key political and social issues of the period affected their onscreen portrayal. In 2012, he curated a retrospective on the actress and film-maker Kinuyo Tanaka for the Leeds International Film Festival. He has also contributed to the *Directory of World Cinema: American Independent 2* (Intellect, 2013).

David Sterritt is chair of the National Society of Film Critics, editor-in-chief of *Quarterly Review of Film and Video*, chief book critic of *Film Quarterly*, contributing writer at *Cineaste*, co-chair of the Columbia University Seminar on Cinema and Interdisciplinary Interpretation, and film professor at the Maryland Institute College of Art. His books include *The Films of Alfred Hitchcock* (Cambridge University Press, 1993), *Robert Altman: Interviews* (University Press of Mississippi, 2000), *Spike Lee's America* (Polity, 2013) and *The Cinema of Clint Eastwood: Chronicles of America* (Wallflower/Columbia University Press, 2014).

Tom Ue was educated at Linacre College, University of Oxford, and at University College London, where he has worked from 2011 to 2016. His PhD examined Shakespeare's influence on the writing of George Gissing. Ue has held visiting fellowships at Indiana University, Yale University, and the University of Toronto

Scarborough, and he was the 2011 Cameron Hollyer Memorial Lecturer. He has published widely on Gissing, Conan Doyle, E. W. Hornung, and their contemporaries. Ue is the Frederick Banting Postdoctoral Fellow in the Department of English at the University of Toronto Scarborough and an Honorary Research Assocate at University College London.

Timotheus Vermeulen is an assistant professor of cultural theory at the University of Nijmegen, where he also co-directs the Centre for New Aesthetics. He has written extensively on metamodernism, contemporary aesthetics, film and television. His most recent book is *Scenes from the Suburbs: The Suburb in Contemporary US Film and Television* (Edinburgh University Press, 2014)

James L Vujicic is a freelance film writer. He holds an MA in Film Studies from the University of Kent, in which he focused his thesis on early French film criticism and questions of national and transnational cinema. He has also contributed to the *Directory of World Cinema: American Hollywood 2* (Intellect, 2015). Interests include Hollywood and independent cinema, Asian and Eastern-European cinemas. He is currently teaching in Japan.

Matt Wedge is a film critic and fiction writer. He holds a BA in film from Columbia College Chicago. He writes film criticism for his personal website, *Obsessive Movie Nerd*, and is a contributing writer to the cult film website *Daily Grindhouse*. He currently lives in Lexington, KY.

Carl Wilson is an associate lecturer in Media at the Sheffield College. Writing on a variety of media topics, his work has recently appeared in the Directory of World Cinema series and the World Film Locations series. He has contributed essays to *Fan Phenomena: Jane Austen* (Intellect, 2015) and *Women Screenwriters: An International Guide* (Palgrave Macmillan, 2015). He is currently developing the multimedia digitization archive project at Kelham Island Museum, Sheffield, UK.

Sean Wilson graduated from UWE Bristol with a degree in Film Studies and English. A love of films from a young age led him to a career in film journalism, beginning with freelance writing for the likes of *Devon-Cornwall-Film*, eventually leading into a position as content editor for the UK's *Cineworld Magazine*. Since taking up this position, he has supplied content for the print and digital editions of the magazine, and also its online blog. He is also an avid lover of film soundtracks and writes regular reviews for *mfiles*. His reviews can also be found at *Bristol 24/7*.